An Introduction to Visual Culture

An Introduction to Visual Culture provides a wide-ranging introduction to the now established interdisciplinary field of visual culture.

Tracing the history and theory of visual culture, from painting to the World Wide Web, *An Introduction to Visual Culture* asks how and why visual media have become so central to everyday life.

This new, thoroughly updated second edition has been adapted to match the changes and developments within the field since the publication of the first edition a decade ago. An improved text design and colour images make this an even more valuable teaching tool. Brand new features in the second edition include Key Image studies and a Key Words section in each chapter, which discuss a selection of important terms and the debates that surround them.

In this innovative, thoroughly revised edition, Nicholas Mirzoeff explores:

- the rise and growing importance of visual culture;
- a wide range of visual forms, including painting, sculpture, photography, television, cinema, virtual reality, and the Internet;
- the importance of "race" and ethnicity, gender and sexuality, and the body in visual culture;
- key images, from Holbein's *The Ambassadors*, to images from *Blade Runner* and the Abu Ghraib atrocities;
- the importance of images of natural disaster and conflict, such as Hurricane Katrina and the ongoing war in Iraq.

Nicholas Mirzoeff is Professor of Media, Culture, and Communication at New York University. He is the author and editor of several books including *Watching Babylon* (1995) and *The Visual Culture Reader* (2002), now also in its second edition.

"Nicholas Mirzoeff's new synthesis of visual culture study is a tour-de-force comparative reading that begins where most comprehensive books in the field leave off, with globalization. The text models an urgency about the need for simultaneous engagement with visual histories and with the everyday vernaculars of global visual cultures. In his scintillating style, Mirzoeff moves between topics in the history of visual culture, such as the conjuncture of photography and slavery, to more recent concerns such as the political dynamics of the gazes that converge around contemporary sites such as the hyperhouse or McMansion, the new domestic paradise with its big screens and soaring spaces, and the Hummer, the US roadway's ubiquitous icon of the war on terror. If, as Mirzoeff tells us, visuality has alienated vision from its users, then this lively and impassioned account is certain to put readers right at the heart of the problem with a spectrum of examples through which to work it through. As Mirzoeff writes, visual culture is not just about sight. Rather, it's a comparative mode of critical practice into which readers can enter, through this kind of direct and nuanced engagement with both the hidden archive and the ubiquitous everyday."

Lisa Cartwright, *Professor of Communication and Science Studies, University of California at San Diego, USA*

"In this updated and expanded second edition of his provocative *An Introduction to Visual Culture*, Nicholas Mirzoeff takes us on a momentous journey through visual culture to our own network society. As a careful historian and dextrous theorist, by interweaving modalities of visuality, the author tracks a path – sometimes utopian, more often dystopian – in search of a possibility just beyond our grasp: the dream of transculture as *the* sign of our democratic politics. For Mirzoeff, such a journey is only feasible by way of the interdisciplinary field of Visual Culture Studies where visual culture is understood as the study of 'the place of visuality in the division of the sensible.' He is right."

Marquard Smith, *Founder and Editor-in-Chief,* Journal of Visual Culture, *and Principal Lecturer in Visual Culture Studies, University of Westminster, London*

An Introduction to Visual Culture

Second Edition

Nicholas Mirzoeff

Routledge
Taylor & Francis Group

LONDON AND NEW YORK

First edition published 1999
by Routledge
2 Park Square, Milton Park, Abingdon, Oxon OX14 4RN

Simultaneously published in the USA and Canada
by Routledge
270 Madison Ave, New York, NY 10016

Second edition published 2009

Routledge is an imprint of the Taylor & Francis Group, an informa business

© 1999, 2009 Nicholas Mirzoeff

Typeset in Perpetua and Bell Gothic by
Keystroke, 28 High Street, Tettenhall, Wolverhampton
Printed and bound in Great Britain by
Bell & Bain Ltd, Glasgow

British Library Cataloguing in Publication Data
A catalogue record for this book is available from the British Library

Library of Congress Cataloging in Publication Data
Mirzoeff, Nicholas, 1962–
An introduction to visual culture / Nicholas Mirzoeff.—2nd ed.
p. cm.
Includes bibliographical references.
1. Art and society. 2. Visual communication. 3. Visual perception. 4. Mass media.
5. Communication and culture. 6. Postmodernism. I. Title.
N72.S6M57 2009
306.4′7—dc22
2008043740

ISBN10: 0–415–32758–X (hbk)
ISBN10: 0–415–32759–8 (pbk)

ISBN13: 978–0–415–32758–9 (hbk)
ISBN13: 978–0–415–32759–6 (pbk)

CONTENTS

List of illustrations vii
Preface xiii
Illustration acknowledgments xvi

INTRODUCTION Global Visual Cultures: Paradox and Comparison 1

KEYWORD The Division of the Sensible 17

CHAPTER 1 Sight becomes Vision: From al-Haytham to Perspective 21

KEYWORD Culture as Transculture 41

CHAPTER 2 "1492": Expulsions, Expropriations, Encounters 45

BREAKOUT IMAGE *The Ambassadors*: Slavery and the Gaze 63

CHAPTER 3 Slavery, Modernity and Visual Culture 68

KEYWORD Visuality 89

CHAPTER 4 Panoptic Modernity 94

KEYWORD Modernity 113

BREAKOUT IMAGE Photography and Death 119

CHAPTER 5 Imperial Transcultures: From Kongo to Congo 127

KEYWORD Race 147

CHAPTER 6 Sexuality Disrupts: Measuring the Silences 153

KEYWORD The Fetish and the Gaze 169

CHAPTER 7 Inventing the West 176

KEYWORD Empire and the State of Emergency 192

CHAPTER 8 Decolonizing Visions 197

KEYWORD Networks 218

CHAPTER 9 Discrete States: Digital Worlds from the Difference Engine to Web 2.0 224

BREAKOUT IMAGE *Blade Runner* 245

CHAPTER 10 The Death of the Death of Photography 250

KEYWORD Spectacle and Surveillance 264

CHAPTER 11 Celebrity: From Imperial Monarchy to Reality TV 271

BREAKOUT IMAGE The Abu Ghraib Photographs 287

CHAPTER 12 Watching War 292

Index 310

6 Sexuality Disrupts

6.1	Thomas Eakins, *The Gross Clinic* (1875)	157
6.2	Albert Lloyd, "Bishop Tucker and Pygmy Lady," from *In Dwarf Land and Cannibal Country* (London, 1899)	161
6.3	Herbert Lang, *A "Parisienne" of the Mangbetu Tribe* (1910–14)	162

Keyword: The Fetish and the Gaze

A still from *Rear Window* (1954)	172
Clementina, Lady Hawarden, *Study from Life* (c. 1864)	174

7 Inventing the West

7.1	The Orient Express webpage	177
7.2a	A still of Mickey Mouse from Disney film *Steamboat Willie* (1928)	179
7.2b	A still of Mickey Mouse from Disney film *Fantasia* (1940, re-released 2000)	179
7.3	Norman Rockwell cover for *Saturday Evening Post* (1942)	181
7.4	A still from *High Noon* (1952)	184
7.5	A still from *The Searchers* (1956)	185
7.6	A still from *Brokeback Mountain* (2005)	187
7.7	Stills from *There Will Be Blood* (2007)	189

Keyword: Empire and the State of Emergency

Benito Mussolini (c. 1934)	193

8 Decolonizing Visions

8.1	Renée Stout, *Fetish No. 2* (1988)	201
8.2	Trigo Piula, *Ta Tele* (1988)	202
8.3	Cheri Samba, *Paris Est Propre* (1989)	203
8.4	Nyarubuye Memorial Plan, National Museum of Rwanda	207
8.5	Kigali Genocide Memorial, Rwanda	208
8.6a	Yinka Shonibare, MBE, *Cha Cha Cha* (1997)	210
8.6b	Yinka Shonibare, MBE, *Scramble for Africa* (2003)	211
8.7	Samuel Fosso, *Untitled* (1977)	212
8.8	Rotimi Fani-Kayode, *White Feet* (1989)	213
8.9	Samuel Fosso, *The Chief: he who sold Africa to the colonists* (1997)	214
8.10	Zwelethu Mthethwa, *Sugar Cane Cutters* (2003)	215

4.5 The Elgin Marbles: east pediment of the Parthenon 104
4.6 Lumière brothers, *Arrivée d'un train (à la Ciotat) (Arrival of
 a Train in La Ciotat)* (1895) 109

Keyword: Modernity

Gustave Caillebotte, *Paris Street; Rainy Day* (1877) 115
Lewis Hine, *Powerhouse Mechanic* (1921) 116
Eadweard Muybridge, *Horse Galloping* (1872) 117

Breakout image: Photography and Death

Hippolyte Bayard, *Self-Portrait As A Drowned Man* (1840) 121
Eugene Atget, *Mur des Fédérés* (1871) 123
Eugene Atget, *Au Tambour, 63 quai de la Tournelle* (1908) 123
Robert Capa, *Near Cerro Muriano (Córdoba front) September 5, 1936* 124
Robert Capa, *Indochina, May 25, 1954* 124

5 Imperial Transcultures

5.1 Camille Coquilhat, "Map of the Congo River," from *Sur Le
 Haut Congo* (Paris, 1888) 130
5.2 Herbert Lang, *Flocks of Birds on the Congo River* (c. 1910) 131
5.3 Musée Royale de l'Afrique Centrale, Tervuren, Belgium 132
5.4 Albert Lloyd, "Arrival of the Steamer," from *In Dwarf Land
 and Cannibal Country* (London, 1899) 135
5.5 Adolphus Frederick, "A Station Village in the Congo," from
 In the Heart of Africa (London, 1910) 135
5.6 Adolphus Frederick, "A Glade in the Virgin Forest," from
 In the Heart of Africa (London, 1910) 136
5.7 Marguerite Roby, "Leaving Elizabethville," from *My
 Adventures in the Congo* (London, 1911) 136
5.8 M. French-Sheldon, "Untitled," from her *Sultan to Sultan:
 Adventures in East Africa* (Boston, 1892) 137
5.9 Herbert Lang, *Danga: A Prominent Mangbetu Chief* (1910–14) 138
5.10 Herbert Lang, *Chief Okondo in Dancing Costume* (1910) 139
5.11 Anon., *Nkisi Power Figure* (c. 1900) 141
5.12 Anon., *Nkisi Kozo* (c. 1900) 143
5.13 Unknown Kongo artists, *European Figures* (c. 1900) 144

Keyword: Race

Supermax prison 150
Asylum seeker detention center 151

Keyword: Culture as Transculture

José Bedia, *The Little Revenge From the Periphery* (1993) 43

2 "1492"

2.1 Alhambra Palace, Granada, Spain (1238–1358) 48
2.2 El Transito synagogue, Toledo, Spain (1366) 48
2.3 Jimmy Durham, *Untitled (Caliban's Mask)* (1992) 54
2.4 A still from *1492: The Conquest of Paradise* (1992) 56
2.5 A still from *Alien* (1979) 56
2.6 Coco Fusco and Guillermo Gómez-Peña, *Two Undiscovered
 Amerindians Visit Buenos Aires* (1992) 58

Breakout image: *The Ambassadors*

Hans Holbein the Younger, *The Ambassadors* (1497/9–1543) 62
Hans Holbein the Younger, Detail of the globe in *The Ambassadors* 66

3 Slavery, Modernity and Visual Culture

3.1 Vincent Van Gogh, *The Potato Eaters* (1884) 71
3.2 Josiah Wedgwood, *Am I Not A Man And A Brother?* (c. 1787) 71
3.3 *Description of a Slave Ship* (1789) 73
3.4 José Campeche, *Woman on Horseback* (1785) 74
3.5 Isaac Belisario, *Jonkonu* (1836) 74
3.6 *Toussaint Louverture* (c. 1802) 75
3.7 Jacques-Louis David, *Napoleon Crossing the Alps at the
 Saint-Bernard Pass* (1800) 75
3.8 Joseph Turner, *The Slave Ship* (1840) 76
3.9 Hercule Florence, *Sketch from Brazil* (1833) 78
3.10 J.T. Zealy, *Renty Congo* (1850) 80
3.11 M.H. Kimball, *Carte-de-Visite of Emancipated Slaves Brought
 from Louisiana by Colonel George H. Hanks* (1863) 81
3.12 Photograph of Sojourner Truth 83
3.13 Kara Walker, *Slavery! Slavery! Presenting a GRAND and
 LIFELIKE Panoramic Journey into Picturesque Southern
 Slavery* (1997) 86

4 Panoptic Modernity

4.1 Damiens being broken on the wheel during the French
 Revolution (c. 1757) 95
4.2 Panopticon. Blueprint by Jeremy Bentham (1791) 97
4.3 The Crystal Palace from the northeast (1854) 97
4.4 Claude Monet, *Impression: Sunrise, Le Havre* (1872) 102

ILLUSTRATIONS

Introduction

0.1 9/11. The World Trade Center, New York City, after being hit by
 two planes on September 11, 2001 2
0.2 The Apple iPhone (2008) 3
0.3 A screenshot from *The Sims 3* 3
0.4 René Descartes, from *Optics* (1637) 4
0.5 Representational art from the Dura Europos synagogue 8
0.6 Claude Niquet the Younger, *Declaration of the Rights of Man
 and the Citizen* (1789) 10
0.7 A still from *The Matrix* (1999) 12
0.8 Devastation after Hurricane Katrina 13
0.9 Mothers of the Plaza de Mayo, Buenos Aires 15

1 Sight becomes Vision

1.1 The *camera obscura* 23
1.2 The visual pyramid 24
1.3 Piero della Francesca, *The Flagellation of Christ* (c. 1450) 27
1.4 The Hall of Mirrors, Versailles, France 34
1.5 From Gaultier de Maignannes, *Invention nouvelle et briève,
 pour reduire en perspective* (1648) 35
1.6 Charles Le Brun, *Chancellor Seguier* (c. 1655–61) 36
1.7 Hyacinthe Rigaud, *Louis XIV* (1638–1715) 37
1.8 Joseph Wright of Derby, *An Experiment on a Bird in the
 Air Pump* (1768) 38

Keyword: Networks

Troy Bennell, *Noongar Song Lines, Part I* 219
Silk Road Map 219
Telegraph Connections (*Telegraphen Verbindungen*) (1891) 220
Claude Chappe's Optical Telegraph on the Litermont near Nalbach,
 Germany (in use 1792–1846) 220
Wikipedia visual culture entry 222

9 Discrete States

9.1 *Apollo Belvedere* 226
9.2 An example of a stereoscope and stereoscope slide 226
9.3 A reconstruction of Babbage's Difference Engine No. 1
 (1824–32) 228
9.4 Plan for Babbage's Analytical Engine (c. 1837) 229
9.5 A Jacquard Loom (c. 1825) 230
9.6 The Enigma machine (c. 1930s) 232
9.7 An E*Trade ad, "Money Out the Whazoo" (2000) 237
9.8 will.i.am, "Yes We Can" 240
9.9 YouTube screen 240

Breakout image: *Blade Runner*

Stills from *Blade Runner* (1982) 246

10 The Death of the Death of Photography

10.1 Cindy Sherman, *Untitled Film Still* (1979) 251
10.2 O.J. Simpson on the covers of *Time* and *Newsweek* 252
10.3 A still from *Habit* (2001) 259
10.4 A still from *Habit* (2001) 260
10.5 Penny Siopis, *AIDS–Baby–Africa* (1996) 262

Keyword: Spectacle and Surveillance

Guy Debord, from *The Society of the Spectacle* comic book 265
AdBusters, *Big Mac Attack!* 266
Anti-terrorism CCTV camera poster (Metropolitan Police) 268
A still from *The Lives of Others* (2006) 269

11 Celebrity

11.1 Postcard of Queen Victoria as Empress of India 273
11.2 Prince Charles and his fiancée Lady Diana Spencer at Balmoral 276

11.3 Diana and Sarah Ferguson, then Duchess of York, at Ascot
 (1984) 276
11.4 Diana, Princess of Wales sits in front of the Taj Mahal (1992) 277
11.5 Diana in Valentino 280
11.6 A still from Jennicam by Jennifer Ringley 280
11.7 Flowers at Kensington Palace 283
11.8 A still from *The Queen* (2006) 284
11.9 Tabloid images of the Spears family 285

Breakout image: The Abu Ghraib Photographs

Photographs taken at Abu Ghraib Prison, Iraq (c. 2004) 290

12 Watching War

12.1 Camp X-Ray, Guantánamo Bay Naval Base, Cuba 294
12.2 Mark Wallinger, *State Britain* (2007) 295
12.3 Cai Guo Qiang, *Move On, Nothing to See Here* (2006) 296
12.4 Critical Art Ensemble, *Free Range Grain* (2004) 297
12.5 "The Man on the Box," a photograph taken at Abu Ghraib
 Prison, Iraq (c. 2004) 298
12.6 "Welcome to US Naval Base, Guantánamo Bay." A still from
 Die, Terrorist, Die (2002) 301
12.7 "Gory" from http://www.NowThatsFuckedUp.com 302
12.8 A hyperhouse 305
12.9 Big Screen Paradise 305
12.10 Stills from *When the Levees Broke* (2006) 307
12.11 Poster for *An Inconvenient Truth* (2006) 309

PREFACE: TO MY OLD
AND NEW READERS

It's ten years since the first edition of this book and much has changed. When the first *Introduction to Visual Culture* appeared there was a handful of graduate programs in visual culture in the US, UK and Australia. Now there are programs all over the world from Argentina to Mexico and Turkey, across Europe and in every Anglophone nation. That situation made writing a new edition easier and harder at once. Easier because I don't feel the need to justify or campaign for visual culture as a field – it's happening, with or without this book. Harder because there are so many more needs to cater to and I could not possibly meet them all. So for a long time I thought it was just impossible to do another edition. It was the graciousness of those who were kind enough to read the first edition and tell me in person or via Routledge that they would like to see an updated version, which made me feel I had some chance to do it. It has meant a great deal to me to hear students and others talk about the impact the book had on their academic lives and that made me feel I had some kind of a responsibility to continue the project. As I did the first time, I have tended to follow my own sense of the field, garnered from teaching, reading and interacting with my peers. There are now, of course, other excellent guides to the practice of visual culture (especially *Practices of Looking* by Marita Sturken and Lisa Cartwright, and anything by W.J.T. Mitchell) and I have not tried to score points off them. Instead I have tried to make this book consistent with what I felt were its strengths the first time and to improve on its weaknesses.

The specific points of that strategy are made at length in the text but a few general issues bear commenting on here. I have always seen this book as mapping some points within a wider network of visual culture. Unlike standard textbooks, it is not intended to be comprehensive and I do not know whether that would even be possible. I hope that readers will imagine and develop ways that their own knowledges could be interlinked with the nodes that I have mapped here,

without thinking that I have ignored their region or time period for some nefarious reason. I am, for example, very much aware that I do not have a great deal of expertise in Asian visual culture (and none at all in Asian languages) and it is not widely represented in the book. That in no way means that I think it is unimportant: to the contrary, I hope someone writes an account of visual culture from the Chinese, Indian or Japanese point of view that intersects where it needs to with that of the Atlantic world mostly described in this book and then the two can be read and taught together. Indeed, rather than describing "the" history of visual culture, the book aspires only to offer a genealogy for the present crises in visuality.

The most obvious changes are that the book now follows a historical time line (broadly speaking) and there are breakout sections on key words and images. While there are important reasons of method behind the narrative format that I describe in the text, there is also an ease of use that comes with a more clearly identifiable framework. I noticed that readers of the first edition made more use of the historically organized first part than the thematic second part and that motivated the reorganization here. In order to allow the chapters to move more easily, I also separated out key terms of theoretical use for visual culture and some key visual issues into individual sections. Feel free to use these however you would like: they are placed so as to be relevant to the adjacent chapters but can also be read independently or not at all. These sections also responded to different requests from readers for more theoretical discussion and from other readers for more narrative. If there is ever another version of this book it will undoubtedly be online and will allow for a more flexible form of linking than the traditional book.

Two final points that I thought were clear in the first edition and seemed not to be so. In order to make this book teachable and readable, I have chosen to take positions on issues as clearly as I could. I am aware that some nuance and subtlety of the kind expected in a scholarly monograph is lost that way but I felt it would be more useful to mark out a position and let others debate it. One thing that we have perhaps all learned in the last decade is that the difference between visual culture and (say) art history is not all that important compared with such things as war and climate change. Finally, many wits pointed out that there were not many pictures in a book devoted to visual culture. On the one hand, were I to link a series of images together with minimal text, I would be an artist and that I most certainly am not. On the other, the number of illustrations in books is a business decision not a personal choice, with museums and archives now charging fees for reproductions that range from modest to exorbitant. This is a good example of the attention economy: when this book was an untried new project we had only a small budget for reproductions. Now that you have all been so kind as to offer it your attention, we were given a more substantial one. However, then as now, I hope that people can supplement whatever illustrations there are in the text with relevant ones of their own.

I want to end by thanking everyone who has been associated with the visual culture project and has given this book their attention and energy, above all

the students at the University of Wisconsin-Madison, SUNY Stony Brook and latterly NYU whose alternating energy and boredom told me when I was getting it right and wrong. In the field of visual culture I owe special debts for reasons they will know to Zainab Bahrani, Geoff Batchen, Jon Beller, Ann Bermingham, Susan Buck-Morss, Jill Casid, Wendy Chun, Laurie-Beth Clark, Allen Feldman, Coco Fusco, Brian Goldfarb, Jack Halberstam, Amelia Jones, Louis Kaplan, Tara McPherson, Tom Mitchell, Erica Rand, Shelley Rice, Joan Saab, Mary Sheriff, Ella Shohat, Marq Smith, Terry Smith, Bob Stam, Marita Sturken and many others. For general inspiration thanks to Tina Campt, Dipesh Chakrabarty, Beth Coleman, Lenny Davis, Hank Drewal, Stephen Duncombe, Karen Finley, Alex Galloway, Faye Ginsburg, Jennifer Gonzalez, Ray Guins, Cai Guo-Qiang, Saidiya Hartman, J&K, Ann Kaplan, Carlo Lamagna, Norman Kleeblatt, Ira Livingston, Agnes Lugo-Ortiz, Iona Man-Cheong, Dana Polan, Carl Pope, Jacques Rancière, Andrew Ross, Maren Stange, Greg Sholette, Neferti Tadiar, Nato Thompson and Warren Zanes. Research assistance from first Elizabeth Patton and then Max Liboiron, especially in regard to the visual images, was vital. At Routledge, I would like to extend special thanks to Rebecca Barden, who commissioned both editions of this book and to Natalie Foster who saw it through to publication with the able assistance and energy of Charlotte Wood, Maggie Lindsey-Jones and Emma Wood at Keystroke, and Fiona Wade. Above and beyond all formulas of gratitude, as ever, Kathleen.

ILLUSTRATION ACKNOWLEDGMENTS

The following were reproduced with kind permission. While every effort has been made to trace copyright holders and obtain permission, this has not been possible in all cases. Any omissions brought to our attention will be remedied in future editions.

0.1 9/11. The World Trade Center, New York City, after being hit by two planes on September 11, 2001. Photo by Spencer Platt / Getty Images

0.2 The Apple iPhone (2008)

0.3 A screenshot from *The Sims 3* (Electronic Arts, 2009)

0.4 René Descartes, from *Optics* (1637)

0.5 Representational art from the Dura Europos synagogue, mid-2nd Century AD. Courtesy of Dura Europas, Syria / The Bridgeman Art Library

0.6 Claude Niquet the Younger (1770–1831), *Declaration of the Rights of Man and the Citizen* (1789)

0.7 A still from *The Matrix* (dir. Larry and Andy Wachowski, 1999). Courtesy of Warner Bros / The Kobal Collection

0.8 Devastation after Hurricane Katrina. Still from *When the Levees Broke: A Requiem in Four Acts* (dir. Spike Lee, 2006)

0.9 Mothers of the Plaza de Mayo, Buenos Aires. Photo by author

1.1 The *camera obscura*

1.2 The visual pyramid

1.3 Piero della Francesca (1410/20–92), *The Flagellation of Christ* (c. 1450). © Palazzo Ducale Urbino / Alfredo Dagli Orti

1.4 The Hall of Mirrors, Versailles, France, 17th Century. Courtesy of The Art Archive / Gianni Dagli Orti

1.5 From Gaultier de Maignannes, *Invention nouvelle et brève, pour reduire en perspective* (Paris 1648). Photo courtesy Bibliothèque Nationale, Paris

1.6 Charles Le Brun (1619–90), *Chancellor Seguier* (c. 1655–61). Courtesy of The Art Archive / Musée du Louvre Paris / Gianni Dagli Orti

1.7 Hyacinthe Rigaud (1659–1743), *Louis XIV* (1638–1715) Courtesy of The Art Archive / Galleria degli Uffizi Florence / Alfredo Dagli Orti

1.8 Joseph Wright of Derby, *An Experiment on a Bird in the Air Pump* (1768). Courtesy of National Gallery, London / The Bridgeman Art Library

José Bedia, *The Little Revenge From the Periphery* (1993). Courtesy of the George Adams Gallery

2.1 Alhambra Palace, Granada, Spain (built mainly between 1238–1358). Courtesy of The Art Archive / Manuel Cohen

2.2 El Transito synagogue, Toledo, Spain (built by Simon Levi, 1366). Courtesy of The Art Archive

2.3 Jimmy Durham, *Untitled (Caliban's Mask)* (1992). Glass eyes, button, PVC, glue

2.4 A still from *1492: The Conquest of Paradise* (dir. Ridley Scott, 1992). Courtesy of Due West-Legend-Cyrk / The Kobal Collection

2.5 A still from *Alien* (dir. Ridley Scott, 1979). Courtesy of 20th Century Fox / The Kobal Collection

2.6 Coco Fusco and Guillermo Gómez-Peña, *Two Undiscovered Amerindians Visit Buenos Aires* (1992). Courtesy of Coco Fusco

Hans Holbein the Younger (1497/9–1543), *The Ambassadors*. Courtesy of the National Gallery, London

Hans Holbein the Younger, Detail of the globe in *The Ambassadors*. Courtesy of the National Gallery, London

3.1 Vincent Van Gogh, *The Potato Eaters* (1884). Courtesy Van Gogh Museum, Amsterdam / The Bridgeman Art Library

3.2 Josiah Wedgwood, *Am I Not A Man And A Brother?* (c. 1787). Enamel medallion, American Philosophical Society Museum, Philadelphia

3.3 *Description of a Slave Ship* (1789)

3.4 José Campeche, *Woman on Horseback* (1785). Museo de Ponce, Puerto Rico

3.5 Isaac Belisario, *Jonkonu* (1836). Courtesy of the National Library of Jamaica

3.6 *Toussaint Louverture*. From a group of engravings done in post-Revolutionary France (c. 1802)

3.7 Jacques-Louis David, *Napoleon Crossing the Alps at the Saint-Bernard Pass* (1800). Courtesy of Musee Nat. du Chateau de Malmaison / Lauros / Giraudon / The Bridgeman Art Library

3.8 Joseph Turner, *The Slave Ship* (1840). Courtesy of the Museum of Fine Arts, Boston

3.9 Hercule Florence, *Sketch from Brazil* (1833)

3.10 J.T. Zealy, *Renty Congo* (1850). Courtesy of the Peabody Library, Harvard University

3.11 M.H. Kimball, *Carte-de-Visite of Emancipated Slaves Brought from Louisiana by Colonel George H. Hanks* (1863). The New York Historical Society

3.12 Photograph of Sojourner Truth

3.13 Kara Walker, *Slavery! Slavery! Presenting a GRAND and LIFELIKE Panoramic Journey into Picturesque Southern Slavery* (1997) or *Life at Ol' Virginny's Hole* (Sketches from Plantation Life). "See the Peculiar Institution as never before! All cut from black paper by the able hand of Kara Elizabeth Walker, an Emancipated Negress and leader in her Cause". Cut paper on wall, 12 x 85 ft (3.7 x 25.9m). Installation view at The Hammer Museum, LA, 2008. Image courtesy of Sikkema Jenkins & Co.

4.1 Damiens being broken on the wheel during the French Revolution (c. 1757)

4.2 Panopticon. Blueprint by Jeremy Bentham (1791)

4.3 The Crystal Palace from the northeast from Dickinson's *Comprehensive Pictures of the Great Exhibition of 1851* (1854)

4.4 Claude Monet, *Impression: Sunrise, Le Havre* (1872). Courtesy of Musée Marmottan, Paris / Giraudon / The Bridgeman Art Library

4.5 The Elgin Marbles: east pediment of the Parthenon. © The British Museum

4.6 Lumière brothers, *Arrivée d'un train (à la Ciotat) (Arrival of a Train in La Ciotat)* (1895). 35mm print, black and white, silent, approx. 45 seconds. Courtesy of The Kobal Collection

Gustave Caillebotte, *Paris Street; Rainy Day* (1877). Courtesy of the Art Institute of Chicago

Lewis Hine, *Powerhouse Mechanic* (1921)

Eadweard Muybridge, *Horse Galloping* (1872)

Hippolyte Bayard, *Self-Portrait As A Drowned Man* (1840)

Eugene Atget, *Mur des Fédérés* (1871)

Eugene Atget, *Au Tambour, 63 quai de la Tournelle* (1908). © The Museum of Modern Art, New York

Robert Capa, *Near Cerro Muriano (Córdoba front) September 5, 1936*. Courtesy of George Eastman House

Robert Capa, *Indochina, May 25, 1954*. Vietnamese troops advancing between Namdinh and Thaibinh. This is the last picture taken by Robert Capa with his Nikon camera before he stepped on a landmine and died at 14.55. Robert Capa © 2001 by Cornell Capa. Courtesy of Magnum Photos

5.1 Camille Coquilhat, "Map of the Congo River," from *Sur Le Haut Congo* (Paris, 1888)

5.2 Herbert Lang, *Flocks of Birds on the Congo River* (c. 1910). American Museum of Natural History

5.3 Musée Royale de l'Afrique Centrale, Tervuren, Belgium

5.4 Albert Lloyd, "Arrival of the Steamer," from *In Dwarf Land and Cannibal Country* (London, 1899)

5.5 Adolphus Frederick, "A Station Village in the Congo," from *In the Heart of Africa* (London, 1910)

5.6 Adolphus Frederick, "A Glade in the Virgin Forest," from *In the Heart of Africa* (London, 1910)

5.7 Marguerite Roby, "Leaving Elizabethville," from *My Adventures in the Congo* (London, 1911)

5.8 M. French-Sheldon, "Untitled," from her *Sultan to Sultan: Adventures in East Africa* (Boston, 1892)

5.9 Herbert Lang, *Danga: A Prominent Mangbetu Chief* (1910–14). American Museum of Natural History

5.10 Herbert Lang, *Chief Okondo in Dancing Costume* (1910). American Museum of Natural History

5.11 Anon., *Nkisi Power Figure* (c. 1900), Tervuren, Musée Royale de l'Afrique Centrale

5.12 Anon., *Nkisi Kozo* (c. 1900), Tervuren, Musée Royale de l'Afrique Centrale

5.13 Unknown Kongo artists, *European Figures* (c. 1900), Tervuren, Musée Royale de l'Afrique Centrale

Supermax prison

Asylum seeker detention center

6.1 Thomas Eakins (1844–1916), *The Gross Clinic* (1875) (oil on canvas). Courtesy of Jefferson College, Philadelphia, PA, USA / The Bridgeman Art Library

6.2 Albert Lloyd, "Bishop Tucker and Pygmy Lady," from *In Dwarf Land and Cannibal Country* (London, 1899)

6.3 Herbert Lang, *A "Parisienne" of the Mangbetu Tribe* (1910–14). American Museum of Natural History

A still from *Rear Window* (dir. Alfred Hitchcock, 1954)

Clementina, Lady Hawarden, *Study from Life* (c. 1864) © Victoria and Albert Museum, London

7.1 The Orient Express webpage

7.2a A still of Mickey Mouse from Disney film *Steamboat Willie* (1928)

7.2b A still of Mickey Mouse from Disney film *Fantasia* (1940, re-released 2000)

7.3 Norman Rockwell cover for *Saturday Evening Post* (1942). Printed by permission of the Norman Rockwell Family Agency. © 1942 Norman Rockwell Family Entities. © 1942 SEPS: Licensed by Curtis Publishing Co., Indianapolis, IN. All rights reserved. www.curtispublishing.com

7.4 A still from *High Noon* (dir. Fred Zinnemann, 1952)

7.5 A still from *The Searchers* (dir. John Ford, 1956)

7.6 A still from *Brokeback Mountain* (dir. Ang Lee, 2005)

7.7 Stills from *There Will Be Blood* (dir. Paul Thomas Anderson, 2007)

Benito Mussolini (c. 1934). Photo by Keystone / Getty Images

8.1 Renée Stout, *Fetish No. 2* (1988). Image courtesy of the artist and the Dallas Museum of Art. Collection of the Dallas Museum of Art

8.2 Trigo Piula, *Ta Tele* (1988). Collection of the artist

8.3 Cheri Samba, *Paris Est Propre* (1989). Courtesy Jack Shainman Gallery, New York

8.4 Nyarubuye Memorial Plan, National Museum of Rwanda. www.museum. gov.rw/2_museums/kibungo/nyarubuye/pages/text_nyarubuye2.htm

8.5 Kigali Genocide Memorial, Rwanda. Photo by Khanjan Mehta. Courtesy of the artist

8.6a Yinka Shonibare, MBE, *Cha Cha Cha* (1997). Wax print cotton textile, velvet, leather, acrylic, metal. Acrylic box: 25.5 x 25.5 x 20cm, (10 x 10 x 8in). Plinth: 44.5 x 44.5 x 111.5cm, (17 1/2 x 17 1/2 x 44in). Courtesy the artist, Stephen Friedman Gallery (London) and James Cohan Gallery (New York) and Poju and Anita Zabludowicz

8.6b Yinka Shonibare, MBE, *Scramble for Africa* (2003). 14 figures, 14 chairs, table. Dutch wax printed cotton textile. Overall: 132 x 488 x 280cm, (52 x 192 x 110in). Commissioned by the Museum of African Art, New York. Courtesy the artist, Stephen Friedman Gallery (London) and James Cohan Gallery (New York)

8.7 Samuel Fosso, *Untitled* (1977). Courtesy of JM Patras / Paris

8.8 Rotimi Fani-Kayode, *White Feet* (1989). Courtesy of the estate of Rotimi Fani-Kayode and Autography, London

8.9 Samuel Fosso, *The Chief: he who sold Africa to the colonists* (1997). Courtesy of JM Patras / Paris

8.10 Zwelethu Mthethwa, *Sugar Cane Cutters* (2003). Image courtesy of the artist and Jack Shainman Gallery

Troy Bennell, *Noongar Song Lines, Part I* (39 x 96, acrylic and sand on canvas). Courtesy of The Brigham Galleries, Nantucket, MA

Silk Road Map

Telegraph Connections (*Telegraphen Verbindungen*) (1891). Stielers Hand-Atlas, Plate No. 5, Weltkarte in Mercator Projection

Claude Chappe's Optical Telegraph on the Litermont near Nalbach, Germany (in use 1792–1846)

Wikipedia visual culture entry

9.1 *Apollo Belvedere*. Roman copy of a Greek 4th century BC original (marble). Courtesy of Vatican Museums and Galleries / The Bridgeman Art Library

9.2 An example of a stereoscope and stereoscope slide. Slide: Underwood and Underwood, *View of London*, c. 1860 © Victoria and Albert Museum, London. Stereoscope: Science & Society Picture Library / Science Museum

9.3 A reconstruction of Babbage's Difference Engine No. 1 (1824–32). Science & Society Picture Library / Science Museum

9.4 Plan for Babbage's Analytical Engine (c. 1837)

9.5 A Jacquard Loom (c. 1825). Science & Society Picture Library / Science Museum

9.6 The Enigma machine (c. 1930s). Science & Society Picture Library / Science Museum

9.7 An E*Trade ad, "Money Out the Whazoo" (2000)

9.8 will.i.am, "Yes We Can"

9.9 YouTube screen

Stills from *Blade Runner* (dir. Ridley Scott, 1982)

10.1 Cindy Sherman, *Untitled Film Still* (1979). Black and white photograph (8 x 10 inches). Courtesy of the Artist and Metro Pictures

10.2 O.J. Simpson on the covers of *Time* and *Newsweek*

10.3 A still from *Habit* (dir. Gregg Bordowitz, 2001)

10.4 A still from *Habit* (dir. Gregg Bordowitz, 2001)

10.5 Penny Siopis, *AIDS–Baby–Africa* (1996). Cibachrome photograph, 100 x 80cm © Artist's collection

Guy Debord, from *The Society of the Spectacle* comic book

AdBusters, *Big Mac Attack!* Courtesy www.adbusters.org

Anti-terrorism CCTV camera poster (Metropolitan Police)

A still from *The Lives of Others* (dir. Florian Henckel von Donnersmarck, 2006)

11.1 Postcard of Queen Victoria as Empress of India

11.2 Prince Charles and his fiancée Lady Diana Spencer at Balmoral. Photo by Tim Graham / Getty Images

11.3 Diana and Sarah Ferguson, then Duchess of York, at Ascot (1984)

11.4 Diana, Princess of Wales sits in front of the Taj Mahal during a visit to India, 11 February, 1992. Photo by Tim Graham / Getty Images

11.5 Diana in Valentino

11.6 A still from Jennicam by Jennifer Ringley

11.7 Flowers at Kensington Palace

11.8 A still from *The Queen* (dir. Stephen Frears, 2006)

11.9 Tabloid images of the Spears family

Photographs taken at Abu Ghraib Prison, Iraq (c. 2004)

12.1 Camp X-Ray, Guantánamo Bay Naval Base, Cuba

12.2 Mark Wallinger, *State Britain* (2007). Installation view at Tate Britain © Mark Wallinger. Photo credit: Sam Drake, Tate Photography © Tate, London 2008

12.3 Cai Guo Qiang, *Move On, Nothing to See Here* (2006). Painted resin with sharp objects confiscated at airport security checkpoints. Collection of the Artist. Installation view at the Iris and B. Gerald Cantor Roof Garden, the Metropolitan Museum of Art, New York, 2006 (detail). Photograph by Teresa Christiansen. Courtesy the Artist and The Metropolitan Museum of Art, New York

12.4 Critical Art Ensemble, *Free Range Grain* (2004)

12.5 "The Man on the Box," a photograph taken at Abu Ghraib Prison, Iraq (c. 2004)

12.6 "Welcome to US Naval Base, Guantánamo Bay." A still from *Die, Terrorist, Die* (2002). Grouchy Media

12.7 "Gory" from http://www.NowThatsFuckedUp.com, accessed October 25, 2005 (now defunct)

12.8 A hyperhouse. Photo by author

12.9 Big Screen Paradise

12.10 Stills from *When the Levees Broke* (dir. Spike Lee, 2006)

12.11 Poster for *An Inconvenient Truth* (dir. Davis Guggenheim with Al Gore, 2006)

GLOBAL VISUAL CULTURES

Paradox and Comparison

S INCE 1999, WHEN this book was first published, we have collectively seen more and less than we could have imagined. We saw the peace dividend disappear. We watched hijacked airplanes fly into buildings. Once again, people accused of crimes began to "disappear," rather than appear in court. We were shocked and awed by the live broadcast of the bombing of Baghdad. We gazed in horror at photographs and videos of torture and execution. We tried to explain that drawing cartoons of Muhammad was not the same as free speech. While we watched dead bodies float down the flooded streets of one of America's greatest cities, we heard officials tell us everything was under control. All around us what was once "nature," the backdrop to culture, insists we notice what has been done to it and what in turn it will do to us. People ask, how can you bear to look at all this? Very simply, there is no choice.

The paradox of visual culture is that it is everywhere and nowhere at once. We live in a world saturated with screens, images and objects, all demanding that we look at them. Work is mediated by screens and demands the virtuoso skills of a performing artist. Religions create spectacles of veiled women or of anti-evolution theme parks. At the same time, scholars of visual culture remind us that there is no such thing as a visual medium because all media are necessarily mixed. That is why the field is properly called visual culture, not visual media studies or visual studies. It compares the means by which cultures visualize themselves in forms ranging from the imagination to the encounters between people and visualized media. Collectively, its goal is to understand what W.J.T. Mitchell calls "the visual construction of the social field" (2005: 345). Therefore visual culture is not an object-based field in the manner of film studies or art history but a comparative one, analogous to comparative literature, rather than English, French or Spanish. By means of cross-cultural, cross-platform and cross-temporal comparison, visual culture endeavors to create

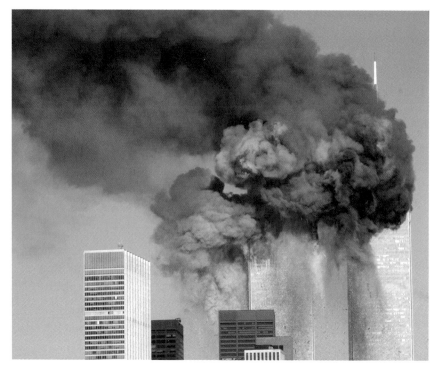

Figure 0.1 9/11. The World Trade Center, New York City, after being hit by two planes on September 11, 2001. Photo by Spencer Platt/Getty Images

a decolonial genealogy for the paradoxical convergence of war, economy, religion, the environment and globalized visual media. That is to say, this mode of comparison is not a lofty gaze from the ivory tower but a place in the midst of conflict. Visual culture compares in order to understand such conflicts. In an ideal world, therefore, it would not exist. In the world understood by such metonyms as 9/11, Abu Ghraib and Hurricane Katrina, visual culture is everywhere – and nowhere.

Visual culture is everywhere: all around us are screens on computers, game consoles, iPods, handheld devices and televisions, far outnumbering those used by the still-healthy cinema industry. Still- and moving-image cameras are ubiquitous, from personal and professional image making to closed circuit surveillance systems and intranets. Television has morphed from national broadcasting on three or four channels to global narrowcasting on hundreds. Where the Internet was once held to be the revival of text, there are already over 100 million video clips on YouTube, more than 3 billion photos on the file-sharing site Flickr, and over 4 billion on the social networking site Facebook. One billion people now have access to the Internet, the first global medium. Digital video games sustain a $20 billion a year industry in the United States alone, where the Electronic Arts game *The Sims* generated over $4 billion in lifetime revenues. Media estimates of the number of advertisements

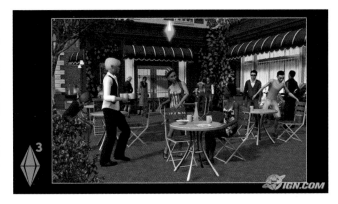

Figure 0.2 The Apple *iPhone* (2008)

Figure 0.3 A screenshot from *The Sims 3* (Electronic Arts, 2009)

seen per day range from hundreds to the now widely used figure of 3,000. Museums have ceased to be citadels of high culture and now offer a "museum experience" to millions in exhibitions that range from motorbikes to fashion and the popular art of Norman Rockwell – and that's just the Guggenheim Museum in New York. Contemporary art, once the arcane occupation of a few, is now the subject of global events, tabloid coverage and mass attendance. That there is such a thing as visual culture no longer seems in doubt.

Visual culture is nowhere: all mediatized representations are mixed, as Hans Belting has argued: "It is obvious that media come rarely by themselves and usually exist as what is called *mixed media*" (Belting, 2005: 314). This seems self-evident in reference to film, where a soundtrack is incorporated with the images, or to video that binds sound and image to the same tape, but is perhaps less clear in relation to older media. Art historians have long argued that painting and sculpture imply a mode of touch, as the artist touches the canvas or the stone in order to create the object. The light that "touches" the photographic film is the guarantee of the authenticity of the photograph, as much as that has been challenged and played with by photographers. Further, Marshall McLuhan showed that one medium becomes the content for another, newer form in the way that theater became the content for cinema. Worse still, the visual is an insubstantial distraction from the real, that which Guy Debord famously called the "spectacle," a copy that has no original. This parade of copies keeps us helplessly in thrall to the dominant order of commodity culture, so we are told, deluded into accepting the fake for the real like the drones in *The Matrix*, taking the shine of the new to be the light of the divine.

What, then, is the visual in visual culture? It is not simply sight. It concerns the place of visuality in the division of the sensible. In fact, visual culture is interested in sight only when it becomes vision, not as a physiological or neurological process, except when those sciences transform the broader understanding of the human. In this view, vision is never singular but involves all the senses and modes of psychology. Sight is never experienced in the pure state as something that might be called "the"

visual but is always rendered as vision, involving not just sensory data but the modulating frames of psychology, whether in terms of the conscious or unconscious mind. This argument is over a millennium old. It was first set out in the *Optics* of Ibn al-Haytham around 1000 CE (see Chapter 1).[1] The modern revolution that began with Arab optics instead imagined "vision" as an active world-making in which fragmentary sensory data are combined to make a "view" by which we literally and metaphorically see the world. In this sense, it is perfectly possible for a blind person to have vision and, indeed, René Descartes introduced this skeptical understanding to the West by creating a metaphor of vision as a material process, comparing it to the work done by the blind with canes or sticks. Just as the touch of the cane informs the user of the qualities of his or her environment, so did the eye "touch" what was seen and the mental sense of judgment interpret it. In this sense, vision is always a mixed mode of perception, but so too is touch and even the Protestant sense of hearing by which the faithful receive the word of God.

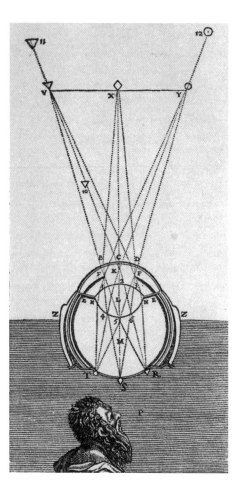

Figure 0.4 René Descartes, from *Optics* (1637)

There have been repeated efforts over the course of the past millennium to enact the transformation of sight into vision. In 1994, W.J.T. Mitchell argued with great impact that the emergent digital revolution had created what he famously called a "pictorial turn" (1994: 20). Mitchell was punning on the earlier revolution in the humanities of the 1960s that had been called "the linguistic turn," referring to the impact of structuralism and semiotics that led many scholars to treat all cultural forms as if they were language. Mitchell observed that there had now come to pass a pictorial turn in which

> *spectatorship* (the look, the gaze, the glance, the practices of observation, surveillance, and visual pleasure) may be as deep a problem as various forms of *reading* (decipherment, decoding, interpretation, etc.) and that "visual experience" or "visual literacy" might not be fully explicable in the model of textuality.
>
> (Mitchell, 1994: 16)

Despite the careful nature of this formulation, it attracted significant controversy. Recently, Mitchell himself has suggested that there has not been just one "pictorial turn" but many, reaching back to the earliest prohibitions against "graven images" in the Ten Commandments as evidence for this ebb and flow – for there would have been no need to prohibit images if they were irrelevant or lightly used (Mitchell, 2005: 348). As this example suggests, what is at stake in the contestation of the sensible is rarely the formal question of visual perception but the social organization and control that is mediated by it. This divide between the "police" and the people is not an incidental aspect or by-product of political power but is constitutive of it. The "policing" of the division of the sensible is, then, visual culture's mode of address to the complex questions of optics and visual representation. For, as Donna Haraway has argued, "vision is always a question of the power to see." Instead, she calls for the creation of "situated knowledges" that accept the inevitably partial viewpoint of such knowledges: "Vision requires instruments of vision; an optics is a politics of positioning. Instruments of vision mediate standpoints; there is no immediate vision from the standpoints of the subjugated" (Haraway, 1991: 193).

However, vision is not the terrain of visual culture until vision becomes visuality. Visualizing is not simply the production of objects that are visible. Nor is all vision visuality. Visuality is that which renders the processes of History visible to power. It is therefore "realistic" in that it describes the real, whatever its mode of representation. That is not to say that it is always mimetic, meaning directly imitative of actually existing forms as in the common-sense understanding of the photograph. Perhaps the most notorious recent instance of the ambivalences of visuality was the presentation of then-Secretary of State Colin Powell to the United Nations in 2002, claiming to show the sites of weapons of mass destruction in Iraq by means of satellite imagery. While something was certainly visible, subsequent events made it clear that what American intelligence services claimed to have seen was not in fact there.

It is important to note that visualization is a historically specific practice and term, formulated by the conservative Scottish historian Thomas Carlyle in 1840, together with its cognate form "visuality." Carlyle understood himself to be articulating a long tradition and has himself had a long influence on conservative thought, especially in his opposition to emancipations of all kinds and to representative democracy. Carlyle favored the triumph of the Hero, who alone could visualize History as it happened. Paradoxically, therefore, visual culture, which wants to be democratic rather than autocratic, is against visuality.

Conflicts

Indeed, visuality visualizes conflict. Its first form, one might even say its primal form, is that of the encounter between worlds that has come to be known as "1492." So this book frames visual culture as a postcolonial project in this long timeframe, rather than as an exploration of the recent past. In this sense, Natalie Melas has defined the postcolonial as "a condition linked to the cultural logic subtending the history of European conquests begun five hundred years ago, conquests that brought, for the first time, the world as an empirical totality into human apprehension" (2007: xii). 1492 set in motion the beginnings of a global society, marked by violence and displacement. This combination of expulsion and expropriation set the conditions under which the defining experience of modernity was the encounter between what anthropologist Greg Dening has called "Natives" and "Strangers":

> There is now no Native past without the Stranger, no Stranger without the Native. No one can hope to be mediator or interlocutor in that opposition of Native and Stranger, because no one is gazing at it untouched by the power that is in it. Nor can anyone speak just for the one, just for the other. There is no escape from the politics of our knowledge, but that politics is not in the past. That politics is in the present.
>
> (Dening, 2004: 11)

The result of these interactions is what Dening calls a "double vision," a cross-cultural encounter that takes place on the beach, often literally, sometimes metaphorically. The beach is the place of liminal encounter where what is seen is uncertain. For the demonstrators of May 1968, the beach lay under the cobblestones of a Paris they found repressive. Perhaps their slogan was not as otherworldly as it has often been taken to be.

Based on Hawai'ian terminology, Dening's terms are not as simple as they seem, for the authority figures in a "Native" society are also "Strangers." The encounter was at first a "view," namely the sight of others who had not been known to exist. It became political almost at the same moment in that it posed a question as to who had authority, the "Natives" or the "Strangers?" Therefore it was also an ethical

moment posing questions as to what is the right way to deal with encounter, by the rules of hospitality, by law, with a subset of questions as to which law, or by force? Almost from the first the answer tended to be that the Strangers would impose their view of the world by force, destroying what they took to be the idols of the Natives and compelling them to labor. That is to say, the imposition of a world-view was justified by religion and enacted in search of economic gain. As soon as the first Conquistador imposed his view of the world onto what had become the Americas, the encounter became dialectical. That is to say, in the manner later philosophized by Hegel, the question of whose History would be counted and how it would be made visible was now a relation between master and slave. Certainly there had been domination and slavery before 1492. What followed was distinct because it created a network of globalized trade from the commodity form of the human being, namely the slave, that visualized power. Perhaps encounter did not have to be violent, but in 1492 and thereafter it was and has formed the basis for modern visuality as the visualizing of conflict.

There have been three main grounds of that conflict. First and foremost has been war. For Carlyle, visuality was the viewpoint of the leader or Hero, manifested above all in war. His ideas were similar to those of military theorist Karl von Clausewitz, who held that leadership was characterized by the ability of a commander to create a mental picture of the widely extended modern battlefield. For example, Napoleon was known for his feints, designed to fool the enemy by creating a visible maneuver that then drew them into a trap. In Clausewitz's view, such tactics were the only way to achieve victory in then modern war, fought between closely matched and equipped forces. This view has become the standard depiction of modern war. In Stendhal's 1839 novel *The Charterhouse of Parma*, the naïve hero Fabrizio is so lost on the battlefield of Waterloo that he was not even sure he had been there. As a former soldier, Stendhal described more experienced French soldiers castigating their generals for their defeat. By the time of World War I, it was widely held that the British troops were, in the phrase of the time, "lions led by donkeys." As much as such formulae castigate actual leaders, they also hold leadership itself to be the determining factor in war. Carlyle adapted this notion for leadership in general so that we might rewrite Clausewitz's famous maxim "war is politics by other means" to read "visuality is war (by other means)." That is to say, visuality is the visualizing of the battlefield first but then it becomes a means to imagine other encounters as war.

The place of the image in religion has been at the center of debates worldwide for centuries (Latour and Weibel, 2002). The iconoclastic movement in the Eastern church in the eighth and ninth centuries CE led to a break with the Roman Catholic church, just as the Protestant Reformation of the sixteenth century was to condemn the place of images in religion. Although Islam and Judaism are now known for opposing representational images, that has by no means always been the case, as seen in the representational Jewish art at the Dura Europos synagogue from the third century. While Islam is now often described as being aniconic from the inception,

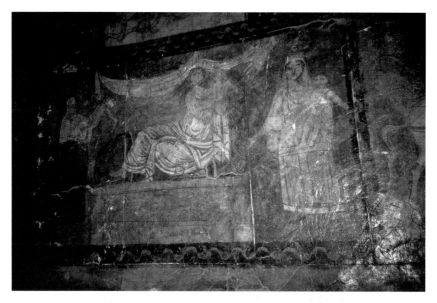

Figure 0.5 Representational art from the Dura Europos synagogue, mid-second
Century AD. Courtesy of Dura Europas, Syria/The Bridgeman Art Library

art historian Finbarr Barry Flood has shown that the proscription against images
came in the *Hadith*, or sayings of the Prophet, rather than in the Qu'ran itself, that
have been interpreted in very different ways (Flood, 2002). When the Taliban
ordered the destruction of the statues of Buddha at Bamiyan in 2001, they were
careful to ensure that Western media representatives had access to the scene as part
of their long-term use of global visual media to promote their archaizing form of
Islam. One should mention here the insistence of the anthropologist Alfred Gell
that art museums are thinly concealed places of religious worship (Gell, 1998). Thus
while no religion will ever claim to be idolatrous, reserving that description for the
heretical practices of others, they do often claim to be iconoclastic. However, others
will often represent that iconoclasm as barbarism, whether the Catholic condem-
nation of Protestants, or the art-lover's outrage at the destruction of a work of art.
What seems to me to be an icon is an idol as far as you are concerned, and that
difference has been remarkably effective in motivating violence.

 The crucial link in this drama of war and religion is that of the economy. As
Jonathan Beller puts it, "to look is to labor" (Beller, 2006: 2). All labor is not looking
but all looking in a commodity economy is work. It is work because it is alienated,
producing value for someone else and is not even work that is remunerated.
Advertising, television, film and the other visualized media that compromise every-
day life in today's commodity culture demand your looking to generate value for
someone else. The result is the "attention economy," the means by which value can
be created by attracting a person's attention (Beller, 2006). That value may be mone-
tized when you pay to get into a cinema; or generate advertising revenue by clicking

on a web ad; or it may be the value that a successful art gallery show creates by raising the status of the artist; or it may increase the revenue that a television station can charge for its advertising inbetween segments of the program that you are actually watching. One consequence of this process is that visuality has alienated vision from its users – you. That is to say, visuality appropriates the making of History to itself and leaves us with nothing but work. It's all work nonetheless and it's tiring.

Comparisons

None of these modalities of visuality exists by itself. They are necessarily imbricated with the others to a greater or lesser extent. Visual culture is therefore a comparative mode of critical practice. Its comparison of specific visual objects that are usually studied by medium-specific disciplines is motivated by the desire to work through the genealogy of these interfaces. For in the modern period, visuality has been dialectical, that is to say, it has moved forward by the productive and destructive interaction of opposed forms. Comparison is an old method, I am aware, but it has its virtues. Despite the advice of our police, there is something to see and we will not move on. Comparative work cannot be conducted using the short-term as a frame of reference. I would follow Gayatri Spivak in claiming "if a responsible comparativism can be of the remotest possible use in the training of the imagination, it must approach culturally diversified ethical systems diachronically, through the history of multicultural empires, without foregone conclusions" (2003: 12–13). In the case of visual culture, that historical requirement is given not by some historicist impulse but by the very nature of visuality as the visualizing of history.

In this book, I will make use of three primary modes of comparison without claiming to exhaust the possibilities available, namely the contemporary, the every-day and the network. By "contemporary," I do not intend just the recent past but rather the living together with others that has challenged understandings of time since the moment of encounter that I call 1492. Seventeenth-century Anglophone writers began to use the word precisely at the moment that the British colonial settlements in the New World had begun to develop into what historians now call the first British Empire. Suddenly, Britons had to imagine themselves sharing a political, economic and cultural space with others. The contemporary is, then, the relation of space and time that we have recently begun to call globalization. It is also the person or people with whom we are contemporary and the politics of that relation. In making comparisons, we need to ask with Jacques Derrida: "With whom? Whose contemporary? Who is the contemporary? When and where would we be, ourselves, we, in order to say . . . 'we' and 'you?'" (1997: 77). That is, to whom are we native and to whom stranger? What are the ethical and political conditions under which one can be a contemporary?

The everyday, by the same token, is not simply the experience of day-to-day existence but the recognition of the place of the "people" in History, following

revolutionary interventions such as the English Revolution of 1642–9, the 1789 French Revolution and what C.L.R. James called the first modern revolution, in present-day Haiti in 1791 (James, 1968). The possibility of revolution made it necessary to know the "people" and the popular, previously considered beneath the realm of knowledge. Philosopher Jacques Rancière retells a story in which the plebeians of Ancient Rome were in revolt. They demanded a treaty with the aristocrats of the Aventine Hill: "The patricians responded that this was impossible, because to make a treaty meant giving one's word: since the plebeians did not have human speech, they could not give what they did not have" (2004: 5). They could be heard but not understood. There is then a "forcing" of a certain disagreement or quarrel: "this quarrel is politics" (2004: 6). The very concept of the people, the demos in democracy, is foreign to power, designating precisely those outside power, who do not count. By "forcing" a conversation, the "people" have been and will always be accused of violence. By extension, the "everyday" of those who do not count was of no importance and it remains a constant political engagement to retain the place of the everyday as something of importance. That everyday is not reducible to the commodity – Barbara Kruger was being satirical when she made "I Shop Therefore I Am" – and it continues to change. At present, the figure of the migrant, the refugee and the asylum seeker is the other that cannot be counted and whose "everyday" must be accounted for. While Europe has comfortably indicted the

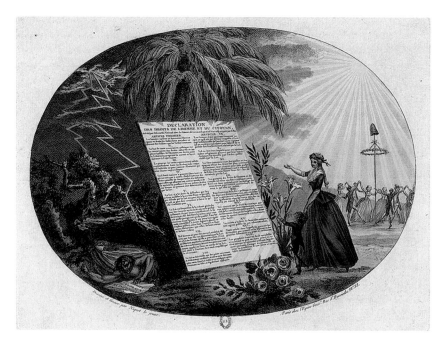

Figure 0.6 Claude Niquet the Younger (1770–1831), *Declaration of the Rights of Man and the Citizen* (1789)

United States for most geo-political crises, the invisibility and non-place of the migrant is as much of an issue in Europe as it is in the United States, Australia and even the Rainbow Nation of South Africa.

It is no coincidence that the modern police force and its classifying systems such as the numbering of houses were invented in post-revolutionary Paris by Napoleon and then developed in a Britain fearful of a repeat of French events in its territories (Foucault, 1977: 165). Once authority moved beyond the domain of the sovereign monarch into what became known as "society," all relationships became important, not just the power of the King over his subjects. Power was increasingly concerned with the surveillance of public and private spaces in order to contain the possibilities of change. As collective action succeeded in reducing the Western working day to first twelve, then ten, and finally eight hours, the space outside the workplace became the key site of everyday life. The "everyday" was in turn divided into the domestic, the public and the space of consumption. While the boundaries between these spaces were fluid, it can be said that the domestic was the space of shelter, childcare and the "care of the self." The public was the space of collective engagement, whether with media or art as in the case of cinemas, theaters, museums and galleries; or with the political, such as elections, demonstrations and strikes. Consumption has now grown from being the purchase of necessities to being the broadest arena of everyday life that has all but erased the public and thoroughly saturated the domestic. By contrast, Frantz Fanon insisted that the violence of colonial regimes was directed precisely at preventing the experience of something that might be called everyday life (Fanon, 1963). In societies centered around industrial production, life was experienced as a divide between work and non-work but in the colony all time belonged to the colonizers. Indeed, the critical reappropriation of everyday life as a source of resistance and meaning-making began in the period of decolonization, such as Roland Barthes's *Mythologies* (1956), shaped by the liberation war in Algeria, and Raymond Williams's *Culture and Society* (1958), written in the aftermath of the 1956 Suez crisis that made it apparent that the era of the British Empire was at an end.

These modes of comparison are knowable through and as networks. Networks connect points in space and time and allow for the circulation and exchange of people, goods, information and ideas. If the development of the Internet has made the idea of the network instantly intelligible, it is important to note here that the Web was first developed as a means of sending messages in the event of a nuclear war. At the same time, the effects of circulation and exchange long precede the electronic network. As the many scholars and activists of the African diaspora from Frederick Douglass and W.E.B. Du Bois to Angela Y. Davis have pointed out, it was chattel slavery that first placed bodies in motion as a mass commodity. The Atlantic triangle was formed by the exchange of goods for people in Africa, a resale of those people for money and the products of colonial plantations in the Americas, completed by the sale of those products in Europe. The profits generated by such ventures formed modern capitalism and sustained the projects of modernity itself.

The networks created by slavery and colonialism continue to exert their power. It is two former provinces of the Ottoman Empire – Palestine and Iraq – as well as that region of Central Asia that was the terrain of the "Great Game" between the imperial powers in the nineteenth century that dominate world news today, to take just one instance.

As the example of slavery most powerfully suggests, the body is the medium through which the network articulates its effects. Visualized modes of embodiment in those parts of the world where the effects of Atlantic slavery were felt have centered on the visualized distinction of racialization, epitomized in the naming of bodies as black or white. Clearly, the body is also the agent and victim of war. Even when not fighting, the soldier is subject to the regime of military discipline that subordinates the individual to the overall project through such reiterated performances as drill and presenting arms. The industrial economy subjected the worker to a discipline analogous to that of the soldier. In Charlie Chaplin's classic film *Modern Times* (1936), the mechanical machine threatened to destroy the human hero by catching him in its gears. *The Matrix* franchise (1999–2002) played on our fears that

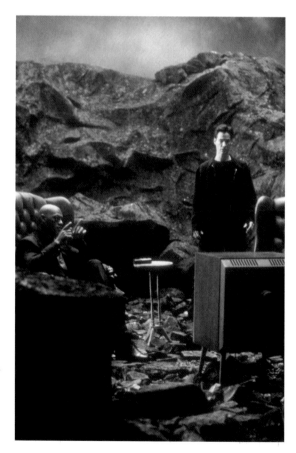

Figure 0.7 A still from *The Matrix* (dir. Larry and Andy Wachowski, 1999).
Courtesy of Warner Bros/ The Kobal Collection

we have become nothing more than bio-accessories to our digital machines. The care and deportment of the body is central to religions of all kinds, ranging from prohibitions on foods to questions of hygiene and clothing. Debates such as those concerning the appropriateness of women veiling themselves in Europe or over the representation of evolution in the United States continue to make religion central to contemporary visual culture. On the borders of Euro-America, the body of the migrant and the refugee can be treated as disposable. While the United States' policing of its border with Mexico has become rightly notorious, it should be added that the European Parliament has allowed migrants to be detained for as long as 18 months without trial, a ruling focused on the 5 million African migrants believed to be in Europe.

Now we face the challenge of a human-altered natural environment becoming hostile to human life due to our own collective actions over the period since the Industrial Revolution. The presence of carbon dioxide in the atmosphere is a palpable, if invisible, index of the cumulative effects of modernization in which no one individual or state can be held wholly responsible but to which we must all now respond. In the face of startling visible evidence of climate change, such as retreating glaciers, the devastation caused by Hurricane Katrina and Cyclone Nargis, and the transformation of regions of Spain, Australia and the United States into desert, it is striking that there is still no serious international response. Setting aside the important political and economic reasons for that hesitation for a moment, it helps us to understand how our response to visual culture has been fetishized throughout the modern period. First, people became perceived as commodities, allowing chattel slavery to become an institution whose importance could not for many years be questioned. With the rise of commodity fetishism in industrial societies, people became mediated by commodities. When capital accumulated to such a point that

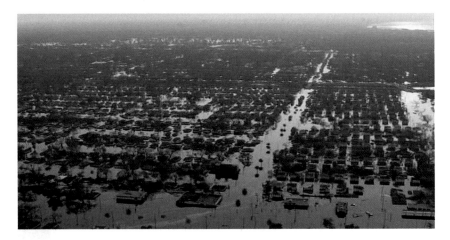

Figure 0.8 Devastation after Hurricane Katrina. Still from *When the Levees Broke: A Requiem in Four Acts* (dir. Spike Lee, 2006)

it became an image, in what has been called the spectacle, people became mediated by images. These modalities of visual fetishism did not succeed each other like monarchs in a dynasty, so much as evolve into different forms that overlapped and often refused to go away when they were supposedly "over." However, in the past half century, the potentially deceptive and misrepresentative capacities of visualized media of all kinds have been exposed over and again. Yet we find ourselves today in a situation where globalization, meaning that means of delineating social totality formed by global capital, is mediated by images.

What I have come to realize is that the long-standing project of discovering resistant and vernacular meanings in images has been thoroughly anticipated by the new deployment of the image as a weapon. Such images are hard, opaque and so resistant to critique that when the Abu Ghraib photographs were published in 2004, they had no effect whatever on the American elections of that year, for all their global impact, especially in the Middle East. For so many images were being shown and produced that the result was what I have called a "banality of images," in which the sense that a documentation of war could lead to change was overwhelmed by the sheer image flow (Mirzoeff, 2005: 67). This situation has developed over time. Whereas the photographic and televisual images of the Vietnam war were often held to be central to transforming Western attitudes to the conflict, numerous photo-journalists who had covered the Rwanda genocide in 1994 abandoned the profession once they realized that their work had been in vain, that even the sight of genocide, shown live on TV in some cases, did not generate a response.

In all these instances, the public was not duped but responding to the message literally and metaphorically delivered to it by the police: "move on, there's nothing to see here." The fetishism at work here is that, even as we continue to pass by, we know perfectly well that there is something to see, only that we are not authorized to look at it. More particularly still, what is set aside is beyond our ability to change or remedy, as in the case of global warming mentioned above. The boundary between the zone of the police and the policed is that which has been symbolically marked by the Mothers of the Plaza de Mayo in Buenos Aires since 1977. Each week in silence, the Madres have walked in a circle in view of the Presidential palace, refusing to accept that people can be "disappeared" and making themselves visible in order to claim justice. This divide between what is allowed to be seen and what is not accounts both for the lack of influential anti-war art and for the rise of the documentary, forming its own category in the 2008 Whitney Biennial for the best of contemporary art. As Rancière has argued, in the context created by "move on, nothing to see," politics itself can now be reconfigured as the construction of a political subject in a different relation of the visible and the sayable. In short, the visual image seems less important in its particular instances and more important in its proposing of a certain epistemology, or what Rancière calls the division of the sensible, than we had thought.

Visual culture has emerged as a means to create a modality of globalization for those visualized by visuality to claim the right to look at that which we are forbidden

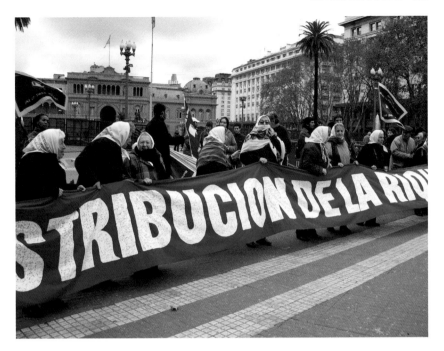

Figure 0.9 Mothers of the Plaza de Mayo, Buenos Aires. Photo by author

to see. The right to look is not voyeurism. It is an exchange of looks in which all parties both look and are looked at in the mutual pursuit of an understanding of the other. In Spivak's terms, "we stand outside, but not as anthropologist; we stand rather as reader with imagination ready for the effort of othering, however imperfectly, as an end in itself" (2003: 13). She is glossing Derrida here, who gives us the phrase "the right to look, the invention of the other" (1998: xxxvi). That look, according to Derrida, cannot be represented. It is the look that is exchanged when two people look into each other's eyes. Modernity has fetishized this look as love, everywhere visible, with its obscene other as pornography, if anything even more ubiquitous. In mainstream mediated representation, love and its image is a displacement of the desire for the right to look and pornography is the inadequate pharmaceutical alleviation for that desire. Visual culture, everyday, has to claim the right to look, to see the migrant, to visualize the war, to recognize climate change. In reclaiming that look, it refuses to do the commodified labor of looking, of paying attention. It claims the right to be seen by the common as a counter to the possibility of being disappeared by governments. It claims the right to a secular viewpoint. Above all, it is the claim to a history that is not told from the point of view of the police.

Note

1 All dates are given using the CE/BCE system rather than the Christian AD/BC to which they are numerically equivalent.

References

Beller, Jonathan L. (2006), *The Cinematic Mode of Production: Attention Economy and the Society of the Spectacle*, Lebanon, NH: Dartmouth College Press.

Belting, Hans (2005), "Image, Medium, Body: A New Approach to Iconology," *Critical Inquiry*, vol. 31, pp. 302–19.

Dening, Greg (2004), "Writing, Rewriting the Beach: An Essay," *Rethinking History: The Journal of Theory and Practice*, vol. 2, pp. 143–72.

Derrida, Jacques (1997), *The Politics of Friendship*, trans. George Collins, London: Verso.

—— (1998), *Right of Inspection*, trans. David Wills, photographs by Marie-Françoise Plissart, New York: Monacelli Press.

Fanon, Frantz (1963), *The Wretched of the Earth*, New York: Grove Press.

Flood, Finbarr Barry (2002), "Bamiyan, Islamic Iconoclasm, and The Museum," *Art Bulletin*, vol. 84 no. 4, pp. 641–59.

Foucault, Michel (1977), "Nietzsche, Genealogy, History," in Donald F. Bouchard (ed.), *Language, Counter-Memory, Practice: Selected Essays and Interviews*, trans. Donald F. Bouchard and Sherry Simon, Ithaca, NY and London: Cornell University Press.

Gell, Alfred (1998), *Art and Agency: An Anthropological Theory*, Oxford: Clarendon Press.

Haraway, Donna (1991), *Simians, Cyborgs and Women*, New York: Routledge.

James, C.L.R. (1968), *The Black Jacobins*, 2nd edn, London: Allison & Busby.

Latour, Bruno and Peter Weibel (2002), *Iconoclash*, Cambridge, MA: MIT Press.

Melas, Natalie (2007), *All the Difference in the World: Postcoloniality and the Ends of Comparison*, Stanford, CA: Stanford University Press.

Mirzoeff, Nicholas (2005), *Watching Babylon: The War in Iraq and Global Visual Culture*, New York: Routledge.

Mitchell, W.J.T. (1994), *Picture Theory*, Chicago, IL: University of Chicago Press.

Mitchell, W.J.T. (2005), *What Do Pictures Want? The Lives and Loves of Images*, Chicago, IL: University of Chicago Press.

Rancière, Jacques (2004), "Introducing Disagreement," trans. Steven Corcoran, *Angelaki*, vol. 9 no. 3, pp. 3–9.

Spivak, Gayatri Chakravorty (2003), *Death of A Discipline*, New York: Columbia University Press.

THE DIVISION OF THE SENSIBLE

The *forming* of the five senses is a labour of the entire history of the world down to the present.

(Marx, 1844: 141)

In this book, visual culture is the study of the "division of the sensible" within the regime of biopower. The "division of the sensible" is a central idea in the work of French historian and philosopher Jacques Rancière, who defines it as follows:

> I understand by this phrase the cutting up of the perceptual world that anticipates, through its sensible evidence, the distribution of shares and social parties. It is the interplay of those forms of sensible evidence that defines the way in which people do "their own business" or not by defining the place and time of such "business," the relation between the personal and the common, private and the public, in which these are inscribed. And this redistribution itself presupposes a cutting up of what is visible and what is not, of what can be heard and what cannot, of what is noise and what is speech.
>
> (2004a: 225)

This construction of the use of sensory evidence is not so much concerned with the biology of perception or the scientific understandings of sight as how the sensory is deployed to make social, cultural and above all political claims seem "natural." Rancière describes how the Greek philosopher Aristotle defines the citizen as someone who has a part in the functions of government, both governing and being governed: "However, another form of distribution precedes this act

of partaking in government: the distribution that determines those who have a part in the community of citizens" (2004b: 12). The "people" does not mean every person alive, but only those people who count and are counted.

For Aristotle a person who speaks is a political being (*politikon zoon*), often rendered as "political animal." However, even if a slave understands the language of its masters, he or she does not "possess" that language, that is to say participate in the community of language users and owners. Rancière uses an anecdote from Roman history to illustrate this apparent distinction. During a time of upheaval, the Roman Senate was surrounded by the people demanding change but the Senators announced that they could hear nothing but noise. Only the political elite could speak the language of politics and so the speech of the plebs on this subject was nothing but noise. These divisions are not just ancient history. To take one example, the nineteenth-century anthropologist Joseph Jacobs carried out research in London on color blindness and decided that it was "the most marked characteristic" of the Jews, even though he was himself Jewish. It was claimed to be a special defect of Sephardic Jews, 13.4 percent of whom were supposed to be color-blind. The cause of this problem was "the long continuance of Jewish life found in the cities, where so much less colour and especially so much less green is to be met with" (Jacobs, 1891: 83–4). This, according to Jacobs, was therefore the answer to the question, why have there been no great Jewish artists? This rather casually performed research became a standard of race science literature from its publication in 1885 to World War I.

It might be argued that a Jew or a proletarian could learn how to use their senses differently. The ancient philosophers were ready with an answer. For Plato argued that "it is right for the shoemaker by nature to make shoes and occupy himself with nothing else, for the carpenter to practice carpentry, and similarly all others" (Rancière, 2004a: 25). The division of the sensible was such that it took all an individual's time and effort to sustain their allotted task, leaving nothing available for other activities, an arrangement that was presented not just as convenient but as "right." In a related project, Rancière described how workers in the nineteenth century would stay up all night reading and writing, using the only time allowed to them, just as the enslaved had held dances and other ritual events at night. Rancière follows the thread of this shoemaker through Western philosophy, in locations as unexpected as Wagner's opera *Die Meistersinger*, where Hans Sachs the cobbler proposes that once a year the people should be allowed to judge music. Rancière notes that Marx was dismissed as a shoemaker (2004a: 61). We come to understand that "shoemaker is the generic name for the man [sic] who is not where he ought to be if the order of estates is to get on with the order of discourse" (2004a: 48). The shoemaker must not judge art, not so much to maintain the people in slavery as to keep the realm of philosophy sufficiently noble, to protect the very idea of an elite. It is noticeable that in the Year Two (1793–4), the anti-aristocratic moment of the

French Revolution, a shoemaker was appointed to be one of the judges for a painting competition.

In this very particular sense, politics itself becomes a form of aesthetics, if we understand aesthetics to mean "the system of *a priori* forms determining what presents itself to sense experience" (2004b: 13). The *a priori* was Kant's way to describe what is given and cannot be questioned. It is only what has already passed these defining but unquestioned filters that is consciously perceived by the "senses," which are for Rancière an already determined means of bodily interaction with exterior reality. In this view, the body is the first and most important medium. The result is that "politics revolves about what is seen and what can be said about it" but that is not all there is to see. Here lies the importance of visual culture as a theory of practice and the practice of theory. It can intervene in these modes of the distribution of the sensible as a way of doing and making at once. In this broad sense, artistic and critical activity make the world in which they act and cross the boundaries erected by the division of the sensible.

One of the primary goals of the division of the sensible was the avoidance of democracy as a form. According to Aristotle, power allocates specific attributes to each class: virtue to the "best" (*aristoi*), riches to the "few" (*oligoi*), and liberty to the "people" (*demos*). There are corresponding forms of government known as aristocracy, oligarchy and democracy in descending order of preference. For the liberty given to the people comes with only the obligation to obey leaders and no privileges to govern. In *The Laws,* Plato had shown that the power to govern comes under seven headings, beginning with that of parents over children, and continuing via that of the old over the young, masters over slaves and nobles over serfs. In general, says Plato, the superior nature should prevail over the inferior, with the difficulty being that few accept their place as being inferior. The sixth and central title of authority is that of those who know over those who do not. Finally, in seventh place, there is what Plato called "the choice of god," that is to say, the lottery that allocated places in Greek democracies. Democracy is thus the exceptional case because it is the very absence of title that gives title to power.

Now whereas Plato saw democracy as the exception to proper government, Rancière represents it as "the institution of politics itself" (Rancière, 1998: 170), meaning both its structure and its inception. Rancière shows that the *demos* has no "proper" place in the political and the institution of the people in democracy is "the supplement which disjoins the population" (1998: 172). That is to say, in democracy, the people are out of joint. A supplement is an addition which completes something – like the supplement to a dictionary – but also reveals that it was lacking in the first place and by implication will be lacking again. So no sooner has a dictionary issued a supplement than its editors must begin work again, tracking down and defining new linguistic usages. Democracy is a "supplement" in that it constitutes a "community" but one which is separate

from all other parts of society and is thus "void." That is to say, everyone must be part of the democracy or it is not a democracy so there is no meaningful definition of being a part of the democratic community.

Following from its exceptional character, Rancière sees democratic politics as that "part without part" in society that "specifically opposes the police" (1998: 176). Here the police "are not a social function but a symbolic constitution of the social," an instance of what W.J.T. Mitchell has called the "visual construction of the social and the social construction of the visual" (2005: 345). For Rancière, the police are the institutional form of the division of the sensible. The police say to us: "Move along, there's nothing to see." The police understand us – see us – not as individuals but as part of traffic, which must move on by that which is not to be seen. For, as Rancière has eloquently described it:

> the police say there is nothing to see, nothing happening, nothing to be done, but to keep moving, circulating; they say that the space of circulation is nothing but the space of circulation. Politics consists in transforming that space of circulation into the space of the manifestation of a subject: be it the people, workers, citizens. It consists in reconfiguring that space, what there is to do there, what there is to see or name. It is a dispute about the division of what is perceptible to the senses.
>
> (1998: 176–7)

Visual culture is a part of that dispute, that part which pertains primarily to the ways in which the "visual" has become divided from the rest of the sensorium, how such creatures as "visual media" come to be so called, and what the politics that surrounds such divisions might be and how they might be changed.

References

Jacobs, Joseph (1891), *Studies in Jewish Statistics, Social, Vital and Anthropometric*, London: D. Nutt.

Marx, Karl (1844 [1993]), *Economic and Philosophical Manuscripts*, New York: International Publishers.

Mitchell, W.J.T. (2005), *What Do Pictures Want? The Lives and Loves of Images*, Chicago, IL: University of Chicago Press.

Rancière, Jacques (1998), *Aux bords de la politique*, 2nd edn, Paris: La Fabrique. Translated by Kristin Ross (2002) as *May '68 and its Afterlives*, Chicago, IL: University of Chicago Press.

—— (2004a), *The Philosopher and His Poor*, Durham, NC: Duke University Press.

—— (2004b), *The Politics of Aesthetics*, trans. Gabriel Rockhill, London and New York: Continuum.

SIGHT BECOMES VISION

From al-Hay<u>th</u>am to Perspective

S OME DIVISIONS DIVIDE more than others. Some last longer than others. Philosophers like Martin Heidegger and Jacques Derrida have described what they call the "Western metaphysic," the key intellectual principles of the West, as originating in ancient Greece with the teachings of Socrates as transcribed by Plato. In this view, current philosophy still struggles with this legacy, however innovative moderns may think themselves to be. In the 1970s, an influential group of French historians, known as the Annales school, argued for the importance of the *longue durée* (the long run) in historical change, emphasizing the role of climate, geography and agriculture (Braudel, 1976). In the area of visual studies, there has been one decisive division in global thought that continues to direct the understanding of the visual. For ancient Greek, Indian and early Arab scholars, vision was not a problem of importance because the eye was held to engage in direct contact with the object of sight. How one saw was not a matter of significance if one knew what the object itself was. In the eleventh century CE, the Arab scholar Ibn al-Haytham radically transformed the understanding of sight. Far from being equivalent to its object, the eye received light from the external world that was refracted, inverted, judged and compared to previously stored memories. Sight, in short, became vision. Sensory perception was now understood to mediate external reality rather than simply transmit it. That understanding was not easily reached and has had to be revisited repeatedly.

For the Greeks, often held to be the originators of Western thought, sight was a second order question. Plato held that sight resulted from the interface of a ray sent out from the eye and a light emitted from the object itself. In the dark, no light came from the object so it could not be seen. This question of perception was inferior to Plato's primary concern with the Ideal, which could never be fully known either in the "real" or in artistic representation. In Plato's view, any such representation was

a copy of a copy (the original being the Ideal, the first copy being the physical object). He compared this reproduction as being like the shadows cast by a fire on a cave wall – you can see who or what cast the shadow but the image is inevitably distorted from the original's appearance. In other words, everything we see in the "real" world is already a copy. For an artist to make a representation of what is seen would be to make a copy of a copy, increasing the chance of distortion. Furthermore, the ideal state Plato imagined required tough, disciplined individuals, but the arts appeal to our emotions and desires. So there was no place for the visual arts in his Republic: "Painting and imitation are far from the truth when they produce their works; . . . moreover, imitation keeps company with the worst part in us that is far from prudence and is not comrade or friend for any healthy or true purpose" (Plato, 1991: 286). This mistrust of representation as inherently dangerous remains part of Western thought today. It was the guiding theme of *The Matrix*, in which appearances cover up "the desert of the real" created by machines.

Greek thought was not even sure whether the eye worked by absorbing rays of light from the outside (intromission) or by emitting its own rays to perceive exterior reality (extromission). Epicurus (341–270 BCE) held that the visible image of the object travels to the eye and is thereby seen. Euclid, Ptolemy and the Indian philosophers argued that the eye emits a ray that perceives the exterior world. Democritus combined both theories, arguing that objects emit a copy of themselves, which contracts in size until it enters the eye through the pupil. In each case, despite the apparent radical differences between intromission and extromission, the eye thus literally reconstructs a model of what is seen for the mind to judge and interpret. This model is precisely in accord with the visible object, making sight something like a relay or transfer in the case of intromission, or a precise version of touch in the case of extromission. Having no identity in itself, sight was not important except insofar as it might distract the viewer from more significant matters.

The Arab division of the sensible

It was the Arab scholar Abu 'Ali al-Hasan ibn al-Haytham (965–1041 CE), known in the West as Alhazen, who made a change in the division of the sensible possible by his reconceptualization of sight as vision. Born in Basra, in what is today Iraq, Ibn al-Haytham did most of his important work on optics in Cairo, critiquing the scholarship of his Greek and Arab predecessors. According to one account, he was in Cairo at the invitation of the Caliph al-Hakim, who wanted him to control the flow of the Nile. Realizing the task was impossible, Ibn al-Haytham feigned insanity and spent the rest of his life under house arrest in the Azhar mosque in Cairo (Smith, 2001: xv). Ibn al-Haytham experienced a different moment of transnational global culture than our own but perhaps his changing sense of how the world looked may have made it possible for him to rethink what had been accepted for centuries. No less than 180 texts are attributed to him, including 19 on optics. Writing as guest editor for the journal *Perception*, Alan Gilchrist noted Ibn al-Haytham's "astonishing

range of insights that we have been in the habit of crediting to far more recent Westerners" (1996). His most famous work, the *Book of Optics*, or *Kitab al-Manazir*, was structured, "according to whether and how the visual act is mediated" (Smith, 2001: xviii). Ibn al-Haytham's concept of vision, or *ibsar*, was noticably different to earlier works, as were his working methods. In the first section, Ibn al-Haytham described experiments with a "dark chamber," into which light enters through a small hole, forming an inverted image on the back wall. This device, known as the *camera obscura*, is often attributed to Western scholars like Roger Bacon or Leonardo da Vinci, although the Arab scholar al-Kindi had made one in the ninth century CE, and one was described in the *Mo Ching*, a Chinese text from the fourth century BCE (Howard, 1996: 1206). Taking the evidence of the *camera obscura* with a range of other observations, such as the "afterimage" seen when looking into the sun, Ibn al-Haytham demonstrated that light enters the eye as the cause of vision. Further, he deduced the existence of what he called a "visual pyramid," whose point was in the eye and whose base was at the object viewed. Unlike Euclid, who had used a similar figure to suggest how the eye "touched" objects with its emanating rays, Ibn al-Haytham deployed it to suggest how light entered the eye. From his work with the *camera obscura*, he further believed that the image formed in the eye was both refracted and inverted, leading him to suggest that the optic nerve was the site of vision. Although he did not understand the function played by the retina, Ibn al-Haytham produced a list of eight preconditions that must be met for visual perception to take place, beginning with the need for separation between the eye and the object, developing questions of size, distance, light and transparency and concluding with the need for healthy eyes. Vision was an embodied human function, reliant on light and material conditions, rather than a divine emanation.

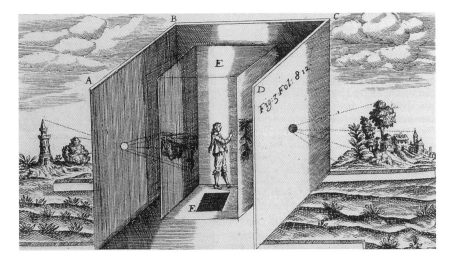

Figure 1.1 The *camera obscura*

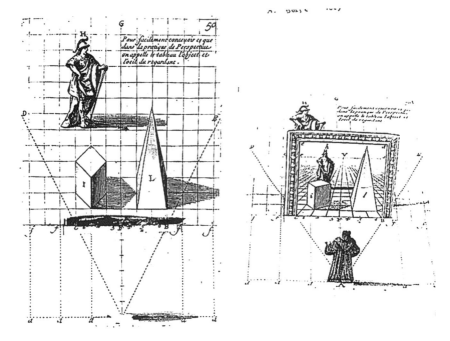

Figure 1.2 The visual pyramid

As intriguing as these material observations are, it is al-Haytham's observations on the process of perception that transformed his deductive inferences about sight into a division of the sensible concerning vision. He argued that only light and color were strictly speaking visible but vision consisted of adding a further twenty "intentions" to the physical observations. Some intentions were singular like distance, size and motion. Others were opposed pairs like beauty and ugliness. Light was modulated by many intentions such as transparency, opacity, shadow and darkness. These qualities are not "seen" in the material sense that light is seen but were inferences made by the faculty of discrimination. Vision was a modulation of sensory experience by these qualities, combined with an active "scanning" of what was to be seen by the eye's central ray. Foreshadowing later Western Enlightenment thought, al-Haytham argued that at birth humans are *tabulae rasae*, blank slates, onto which by repeated exposure, the qualities of discrimination are inscribed. To use his own phrase, they are "ensconced in the soul" (Smith, 2001: lxviv), based on a scale derived from our own bodies. Thus distance is at first ensconced as a multiple of arm-lengths or paces. By contrast, he argued that beauty is inherent, demonstrating this with the example that a person with blond hair and blue eyes would be exquisitely ugly. Vision thus correlates and assimilates the limited data of sense perception with the more complex processes of assessment retained in the memory. It is in the "imagination" that the resulting assessed "forms" or images are described,

inscribed and retained for later recall. Mark Smith concludes "seeing is knowing for Alhacen [al-Haytham], entailing the same sorts of syllogistic associations and culminating in the same sorts of conclusive realizations" (2001: lxxiii).

This interpretation of sight as an epistemology, or system of knowledge, was radical in the literal sense, in that it goes to the root of all understanding. The body becomes a medium, in which sensory memories are inscribed, allowing the perception of light and color to become the complex mediation of vision.

However, it was 200 or more years before al-Haytham's work was even widely known, much less accepted, in both Arabic and European intellectual circles. Even then, it was his work on light and sight that most influenced such writers as Roger Bacon and Leonardo da Vinci, while his intensely challenging ideas on perception have only recently been given full credit. Some of his work was not replicated until nineteenth-century scientists of perception like Helmholtz, whose work was widely influential on modern artists such as the Impressionists. Indeed, the Impressionist aesthetic that required the viewer to "complete" the impression would have made sense to al-Haytham. Some have suggested European bias against ascribing intellectual priority to Arab Muslims as the cause of the delay in crediting al-Haytham's work and that must surely be a factor. However, the Arab world was also slow to fully appreciate what al-Haytham had done. This persistent need to revisit a "discovery" shows that, just as genealogy requires a turn away from origins, it also must refuse the notion of a permanent and decisive break at one place and one time. The break is always in a state of "becoming" that is never complete. That is to say, first, any division of the sensible can be reworked, as we have seen with the extensive contestation in the United States of "settled" scientific knowledge, such as evolution or climate change. Second, no one moment, text, image or event, however dramatic, can by itself enact a new division of the sensible. The implications of al-Haytham's ideas could not be enacted by one body of research alone.

Understood in this manner, the radical individualism at the base of al-Haytham's perception theory had implications that extended beyond the geometry of optics. By depicting each person as an accumulation of sense perceptions, whose sense of judgment is dependent on the particular form of their own body, al-Haytham could have been interpreted as taking a position that opposed authority, whether divine or secular. Indeed, in seventeenth-century Amsterdam, Baruch Spinoza was expelled from the Jewish community and held to be a radical atheist for proposing a similar system of extension from the body. Spinoza held that "the object of the idea constituting the human mind is the body, or, a certain actually existing mode of extension, and nothing else" (2000: 124). That is to say, it is the "actually existent body" that shapes the mind and vice versa, rather than some idealized abstraction. Both al-Haytham and Spinoza attempted to conceal the radicality of their theses in a geometric argument of extreme caution, such that al-Haytham is often accused of being tedious to read. In this light it may be less of a coincidence that his new theory of optics was produced after he had had to elude the anger of an absolute monarch and feign insanity. If the potential radicality of his new ideas had been understood,

it would then simply have been more evidence of his unsound mind. That is to say, as sight became vision, it also became something to be policed.

Perspective and the police

The policing of vision was accomplished by perspective, a blend of theoretical innovation, syncretic fusion of existing practices, and technologies of social organization. The Arab optical discoveries were incorporated into European visual representation as the visual pyramid became a staple of medieval and early modern notions of vision. The adoption of a convention of converging lines to convey depth in Italian painting from the thirteenth century onwards was based on an attempt to represent this visual pyramid in art. Perspective is a system of depicting that convergence in relation to a "vanishing point," the place where the lines are taken to converge that is necessarily invisible because in reality objects do not converge. It can be seen as the merger of the visual pyramid with the zero. Ancient mathematics in Babylon and Greece did not use the zero, although Ptolemy did use it in his astronomy. The Indian philosopher Brahmagupta (598–668 CE) was the first to clarify the zero as a mathematical rule in 628 CE: "the sum of zero and a negative number is negative; the sum of a positive number and zero is positive, the sum of zero and zero is zero." It is now also known that the Mayans in present-day Central America had a base 20 system using zero as early as 665 CE. The use of the zero was distributed by trade routes, such as those based on the Silk Road (see **Networks**, pp. 218–23) as part of a place-system of numerals. It was then described by Muhammed bin Musa al-Khwarizmi (780–850 CE), a mathematican, astronomer and geographer, born in Kiva in present-day Uzbekistan, who did his important work in Baghdad as part of the court of the Caliph Harun al-Rashid. His algebra treatise *Hisab al-jabr w'al-muqabala* was the most famous and important of all of his works, whose title gives us the word "algebra." Yet it is a practical text, describing in al-Khwarizmi's words:

> what is easiest and most useful in arithmetic, such as men constantly require in cases of inheritance, legacies, partition, lawsuits, and trade, and in all their dealings with one another, or where the measuring of lands, the digging of canals, geometrical computations, and other objects of various sorts and kinds are concerned.

In another work, now lost in Arabic but known in its partial Latin translation, al-Khwarizmi defined zero as a place-holder in positional base notation, thus allowing a simple distinction between the numbers 26 and 206 that had previously had to be understood from context. Indebted to the then new ideas from India on the subject, al-Khwarizmi's work introduced this key abstraction to both Europe and China around 1200 CE. Leonardo Pisano, known as Fibonacci (1170–1250), studied in Algeria as a young man with his merchant father. His *Liber abaci* (1202) introduced zero to Europe, as well as offering a detailed section for merchants on accounting.

While he described the Hindu-Arabic numerals 1 through 9 as "numbers," he defined zero as a "sign." Christian theologians rejected the concept of zero as God could not tolerate nothingness. This religious view limited Western mathematicians and artists from making full use of it until the Renaissance.

Perspective is often presumed to have been invented in Italy by artists of the fourteenth and fifteenth centuries. These Renaissance artists were, however, well aware that their work was based on earlier efforts. In fact, many artists represented their use of perspective as the rediscovery of an art known to the Greeks and Romans. The sculptor Lorenzo Ghiberti assembled a selection of key sources for perspectival art that began with Alhazen (as Ibn al-Haytham was known in Europe) and included all the other leading medieval optical theorists (Kemp, 1990: 26). For artists, what mattered was less theoretical consistency than creating an effective illusion that was nonetheless carefully organized. In *On Painting* (1435), the first written description of perspective in painting, the artist and architect Leon Battista Alberti negotiated the legacy of Alhazen, the requirements of Church and State and the practicalities of artistic production. In order to avoid being accused of having created a void, Alberti insisted that the point was in fact visible, although Alhazen and most other writers had argued that an object is only visible when a visual pyramid can be formed. Specifically, he called the point a "sign," defining a sign as "anything that is in a surface so that it can be beheld by the eye" (Greenstein, 1997: 682). The sense of possible freedom that such an idea might suggest was carefully

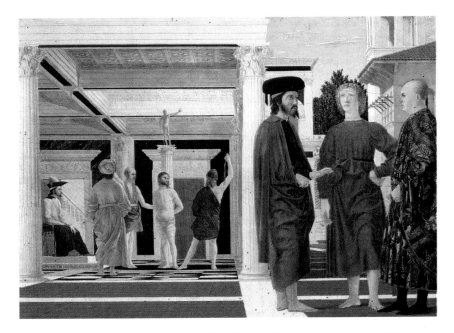

Figure 1.3 Piero della Francesca (1410/20–92), *The Flagellation of Christ* (c. 1450).
© Palazzo Ducale Urbino/Alfredo Dagli Orti

limited. Alberti's famous image of a history painting being the view seen through a window at once suggests transparency but also a fixed boundary to the image. The visual culture critic Anne Friedberg has recently shown that Alberti's system centered not on the geometry of perspective but the *istoria*, or history, told by a painting. The space was organized in relation to the dimensions of the human body with an emphasis on ensuring that no important figure was reduced in size without good reason. When Christ appears as a small figure in the background of Piero della Francesca's painting *The Flagellation of Christ* (c. 1450), it was precisely to empha-size the way in which the foreground figures (whose precise identity has been much debated by art historians) are utterly indifferent to the world-historical event taking place in the background. Note also that Piero created a perspective that either imagined the viewer to be on all fours down on the ground or represented the depicted figures as giants. Both schemes could have allegorical meanings such as the insignificance of ordinary people compared to the Gospel story or the sense of great events being depicted on the grand scale but neither were concerned with geometry.

In keeping with the notion of the visual pyramid, perspective theorized that only a relatively small angle was visible from its single-point, ranging from 45 to 60 degrees depending on the author. For, in the words of Leonardo da Vinci:

> Perspective is a rational demonstration whereby experience confirms that all objects transmit their similitudes to the eye by a pyramid of lines. By a pyramid of lines, I understand those lines which start from the edges of the surface of bodies and, converging from a distance meet in a single point; and this point, in this case, I will show to be situated in the eye, which is the universal judge of all objects.
>
> (Lindberg, 1976: 159)

Notice that Leonardo assumes that Alhazen's notion of the visual pyramid was not a theory but the product of rational experiment, which corresponds to reality. However, he then combined it with the Greek notion of similitudes – copies descending the pyramid into the eye – ignoring al-Ha<u>yth</u>am's demonstration of the centrality of light in entering the eye. The decisive point was that the eye is a "universal judge," an authority over and above exterior reality but one operating not according to individual impressions and memories but in accord with pre-existing divine and secular law.

With the exception of certain learned artists like Piero della Francesca and Paolo Uccello, it is clear that most Renaissance artists followed this compromise position. They provided for an overall sense of recession and depth without following a rigid geometric perspectival scale, especially in depicting the human figure. Perspective, although it limited space, did not constrain the figure. In Masaccio's *Tribute Money*, noted for its careful perspective, the figure of St. Peter appears no less than three times in order to promote the narrative. In his later work, Leonardo even came to reject the perspectival thesis altogether, claiming that "every part of the pupil

possesses the visual power and that this power is not reduced to a point as the perspectivists wish" (Kemp, 1990: 51). In this view, the eye is not one but many points, all of which can testify to the "visual power." That power was ultimately the law of God, who had ordered and created the world so that it could be understood. Consequently, many Renaissance artworks, particularly church decorations, were located so that a human viewer could not be at the designated perspectival viewpoint. In John White's analysis: "The advent of a focused perspective system makes no material alteration to a decorative pattern well established in [the thirteenth century] and itself unchanged from the time when spatial realism was of no concern to the viewer" (White, 1967: 193). The Renaissance use of perspective certainly changed the appearance of images but this change did not entail a new attitude to perception or reality.

Perspective is not important because it shows how we "really" see, a question that physiologists continue to grapple with, but because it allows us to order and control what we see. As Hubert Damisch has argued, it "does not imitate vision, any more than painting imitates space. It was devised as a system of visual presentation and has meaning only insofar as it participates in the order of the visible, thus appealing to the eye" (Damisch, 1994: 45). Perspective created a new means of representing visual power from already available materials. Systems of representation are not inherently superior or inferior, but simply serve different ends. While Westerners have taken one-point perspective to be the natural way to depict space since the fifteenth century, Chinese artists had known how to give the illusion of depth since the tenth century. However, they would also make long picture scrolls whose range of imagery cannot be seen at once and certainly not from one point. At the Imperial Chinese court, only the Emperor was held to be in a position to see everything, while all others had only a partial view. This system of power and knowledge organized space but did not require the viewpoint of perspective. It was also common for medieval Japanese artists to use "flat" conventions of pictorial space that are thought of as being modern in the West. The difference of Western perspective was not its ability to represent space but the fact that it was held to do so from one point.

For Leonardo, and one suspects the majority of his fellow artists, what mattered was not geometrical precision but this ability to convey "visual power." Perspective was one device by which artists sought to capture and represent visual power. Thus Alberti described the line which runs directly from the eye to the object as the "prince" of rays (Kemp, 1990: 22). The prince was the ruler of the Renaissance city states who commissioned the art of the period. His authority was celebrated by the fifteenth-century Florentine political theorist Niccolò Macchiavelli, whose name has come to describe ruthless use of power. The prince was not simply a metaphor for artists. When perspectival sets were used at the French royal palace of Versailles in the seventeenth century, King Louis XIV was seated directly on this line so that he alone had the perfect place from which to see the perspective. In creating any system of representation, there is a distinction between the ideal viewer imagined by the system and the actual viewer who looks at the image. In Renaissance and early

modern court culture, the ideal viewer and the actual viewer were often the same person – the king, prince or other authority figure for whom the work was made.

The notion of resemblance was thus at the heart of Renaissance perspective theory, from Leonardo's belief in similitudes to the equivalence of the ideal viewer and Absolute monarch in the perspective system. Resemblance was at the heart of the all-embracing system of natural magic, sharply distinguished from sorcery, or black magic. In the words of Giovanni Batista della Porta, whose *Natural Magic* (1558) remained influential until the late seventeenth century, magic was "a consummation of natural Philosophy and a supreme science" (Porta, 1650: 2). Magic, although based on a complex system of affinities and correspondences, was far from superstition, and indeed homeopathic medicine is still based on the principle of similitude. Vision was a key part of the magical "chain of being" that connected all knowledge to other knowledge. In Porta's view, "magic contains a powerful speculative faculty, which belongs to the eyes both in deceiving them with visions drawn from afar and in mirrors, whether round, concave or diversely fashioned; in which things consists the greatest part of magic" (1650: 4). He also made use of perspective to create "marvelous experiences . . . whose effects will transport you in forming diverse images" (1650: 339). Perspective was then an effect, rather than reality, a device that enabled the artist or magician to impress the viewer with their skill in creating something that resembled reality rather than representing it. In 1638 the French monk Niceron summed up the existing view of perspective as a form of magic: "True magic, or the perfection of sciences, consists in Perspective, which allows us more perfectly to know and discern the most beautiful works of nature and art, which has been esteemed in all periods, not only by the common people but even by the most powerful Monarchs on earth" (1638: Preface). Strikingly, Niceron assumed that perspective was in no way a recent development and was esteemed as much by ordinary people as Kings and Queens.

This understanding of perspective remained intact even when seventeenth-century scientists radically transformed the understanding of vision. The Dutch scholar Thomas Kepler was the first to argue that the lens of the eye presents an inverted image on the retina. But he did not assume that this change in understanding of the physical process of sight brought him any closer to understanding vision and continued to see the eye as a judge:

> I say that vision occurs when the image of the whole hemisphere of the world that is before the eye . . . is fixed on the reddish-white concave surface of the retina. How the image or picture is composed by the visual spirits that reside in the retina and the nerve, and whether it is made to appear before the soul or the tribunal of the visual faculty by a spirit within the hollows of the brain, or whether the visual faculty, like a magistrate sent by the soul, goes forth into the administrative chamber of the brain into the optic nerve and the retina to meet this

image as though descending to a lower court – this I leave to be disputed
by the physicists.

(Lindberg, 1976: 203)

For Kepler, the process of vision was still one that could only be described in terms
of legal authority. In the early modern European legal system, the judge was in a far
more powerful position than is typically the case today. There were no juries and
only the judge could call evidence and render verdicts. It is not surprising, therefore,
that even Dutch artists of his day who were extremely interested in perspective do
not seem to have taken account of Kepler's theories as they did not change the central
interest of the artist in capturing visual power. In fact both Samuel von Hoogstraten
and Samuel Marolois, Dutch artists who wrote important treatises on perspective,
adhered to the extromission theory of vision (Kemp, 1990: 119). Artists and visual
theorists alike were concerned with establishing a place from which to see, and thus
create the effect of perspective, rather than fully understanding the physiology of
perception which they took to be unknowable.

It has long seemed that the philosophy of René Descartes, set out in his famous
Discourse on Method (1637), marked a clear break with the concepts of vision that
had prevailed until his time. Descartes challenged past tradition by considering light
to be a material substance with concrete being, as the historian A.I. Sabra notes:
"The Cartesian theory was the first to assert clearly that light itself was nothing but
a mechanical property of the luminous object and of the transmitting medium"
(1982: 48). Rather than consider light a manifestation of the divine, he used everyday
metaphors to describe it, such as the use of sticks by the blind to replace their lost
vision. Like the stick, light touches the object under consideration directly. This
physical concept of light allowed Descartes to apply mathematics to all its charac-
teristics. For if light were a purely spiritual medium, no human device could measure
it. Thus by detailing the operations of refraction in the eye, that is to say the
"bending" of light rays by lenses, he was able to explain the old problem of the
perception of large objects.

Crucially, he displaced perception itself from the surface of the retina, where
Kepler had left it, to the brain. Thus the image formed on the retina was not exactly
the same as what is perceived. While Kepler was unable to explain the inversion of
the image on the retina, Descartes saw that inversion as part of the means by which
perception was relayed from the eyes to the brain. Thus he believed that "perception,
or the action by which we perceive, is not a vision . . . but is solely an inspection by
the mind." When we look at a rose, the sensation that it is red is then confirmed
by a judgment that it is in fact red, rather than appearing red because of a distortion
of the light. Judgment was, then, the essential aspect of Descartes's system of per-
ception, in which the sensory information perceived is nothing more than a series
of representations for the mind to categorize. He clearly distinguished his repre-
sentational theory from the preceding theory of resemblances, noting that the old
philosophers could not explain images because "their conception of images is

confined to the requirement that they should resemble the objects they represent."
By contrast, Descartes insisted on the conventional nature of representation, arguing
"it often happens that in order to be more perfect as an image and to represent an
object better, an engraving ought not to resemble it" (Descartes, 1988: 63). It was
then up to the judgment to discern the image for what it was supposed to represent.
While Descartes changed the understanding of the physics of vision, he continued
to rely on Kepler's model of the soul as the interpreting judge of sensory perception.
The difference was that he was so skeptical of sensory information that he mused:
"It is possible that I do not even have eyes with which to see anything" (Crary, 1990:
43). In the Cartesian system of vision, representation replaced resemblance. His
skepticism was at least in part engendered by his experiences as a soldier in the bitter
Thirty Years War (1618–48). This two-generation-long war of religion devastated
Europe. It produced the first anti-war visual images, made by the French artist
Jacques Callot. It was while taking refuge from the fighting in a warm stove (yes,
inside: they were designed as places of shelter from the bitter Northern cold) that
Descartes had his now legendary insight: "I think therefore I am." If perspective had
presented itself as the ordering principle by which monarchical society was run,
modernity saw both vision and power as objects of skepticism and doubt.

From this point on, the modern picturing of the world as representation became
possible. Perspective now took on a key role as the boundary between resemblance
and representation. For Descartes noted that resemblance did play a limited role in
his representational system, insofar as it recalls the shape of the seen object:

> And even this resemblance is very imperfect, since engravings represent
> to us bodies of varying relief and depth on a surface which is entirely
> flat. Moreover, in accordance with the rules of perspective they often
> represent circles by ovals better than by other circles, squares by
> rhombuses better than by other squares, and similarly for other shapes.
> Thus it often happens that in order to be more perfect as an image and
> to represent an object better, an engraving ought not to resemble it.

Descartes insisted that the same process took place in the brain, which interpreted
the sensory data presented to it. In Descartes's view, perspective is thus a natural
law, which can be observed in the images formed by the *camera obscura*, but also a
representation. Thus photography, which was immediately able to give a recog-
nizably accurate depiction of the shape of objects represented in one-point
perspective, displaced painting and the other visual arts as the prime representational
medium almost as soon as it was invented. This fusion of resemblance and repre-
sentation in perspective accounts for its centrality in all accounts of the Cartesian
legacy, where the two are often all but equated. Some critics have gone so far as to
think of Cartesianism as the "ancient scopic regime," that is to say, the dominant
theory of vision in early modern Europe from the mid-seventeenth century until
the outbreak of the French Revolution in 1789. Given that Descartes's work was so

sharply different from that of his predecessors, and so influential with scientists and philosophers, this view is tempting. From here, it is possible to generalize that "there is a singular and determining 'way of seeing' within modern Western culture" at any given moment (Jenks, 1995: 14). I suggest by contrast that visual culture is always contested and that no one way of seeing is ever wholly accepted in a particular historical moment. Just as power always creates resistance, so did the Cartesian way of seeing generate alternatives.

Cartesianism was accepted by scientists and philosophers, often working outside the network of royal patronage. However, artists and others working in visual media were far from immediately convinced by Cartesian theory. In 1648, Louis XIV established the French Academy of Painting to decorate his palaces and towns and provide drawings for the important royal tapestry manufactures. The Academy was granted a monopoly over art education and trained such artists as Boucher, Fragonard, Watteau and David. However, the Academicians were vehemently opposed to Cartesian theories of vision, based in part on politics, in part on optics. At first, they tried to use Michelangelo's method of organizing space around a multiple pyramid, which was seen as the form of "a flame, that which Aristotle and all other philosophers have said, is the most active element of all" (Pader, 1649: 5). Their first professor of perspective, Abraham Bosse, was a Protestant and had taken part in the Fronde, a civil war between the *Parlement* (Parliament) and the monarchy. Bosse insisted on teaching a geometric theory of perspective that made startling claims for the power of the technique: "The words PERSPECTIVE, APPEARANCE, REPRESENTATION and PORTRAIT are all the name for the same thing" (Bosse, 1648). In other words, learning perspective would enable a student to carry out all the necessary aspects of painting itself. Were that to be true, the all-important portrait of the king would be nothing more than a perspective that could be taught to anyone. This modern-sounding idea was contradicted by Bosse's belief that vision took place because the eye emitted rays to perceive objects, as long since falsified by Ibn al-Haytham. The Academy quickly fired Bosse but had to elaborate their own theory of perspective. They argued correctly that perspective could only reproduce the perception of one eye at a time, whereas we obviously see with two eyes. Furthermore, in strict perspective theory, only one spot provides the true angle of vision necessary to understand the perspective and it was unlikely that viewers would locate this position unaided (Mirzoeff, 1990).

These objections to the new optics permitted the Royal Academy to pursue political necessity. Its very existence depended on glorifying the King and presenting His Majesty as above all his subjects, no small matter in France after a century of civil unrest had culminated in civil war in 1648–53. Strict application of perspective could have meant that the King might appear smaller than one of his subjects, a politically impossible result. The Academic sense of seeing the King was best embodied in the Hall of Mirrors built for Louis XIV by the director of the Academy, Charles Le Brun. In a lengthy gallery, decorated with elaborate paintings and studded with mirrors, the courtiers could observe themselves and others paying homage to

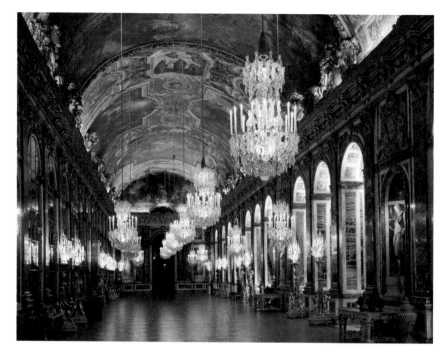

Figure 1.4 The Hall of Mirrors, Versailles, France, 17th Century. Courtesy of The Art Archive/Gianni Dagli Orti

the King and make sure that the appropriate protocols were performed. The King's domination of even his greatest subjects was thus made fully visible. Even away from the exalted depiction of the royal body, the Academy argued that the curves and surfaces of the human body were too subtle to be rendered in geometric perspective. The result would be an ugly, badly proportioned body that would damage the imagination "because these depraved and disorderly objects could recreate in the mind past reveries, or lugubrious dreams, which had previously been experienced in illness or fevers" (Huret, 1670: 93). In the Platonic tradition, the French monarchy believed that representations could produce physical disturbances, leading to political disobedience. Perspective had to be policed.

The Academy thus evolved a compromise. Buildings and background space were to be rendered in a perspectival fashion, conveying a sense of depth recession. This led to the creation of painted perspectival scenes to enhance the grandeur of a garden view, also known as a perspective. Figures, on the other hand, were to be depicted according to the classical scale of proportion. In this way, the primary figure in a painting would set the physical scale against which all others were measured and no other figure would exceed his size (gender intentional) or prominence. The advantage of this method was that it relied on the artist's own judgment to create visual space, rather than the increasingly complex mathematics of perspective that often demanded abstruse mathematical skills (see Figure 1.5). In its guide to students

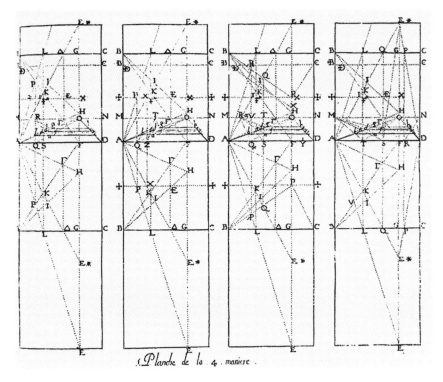

Figure 1.5 From Gaultier de Maignannes, *Invention nouvelle et briève, pour reduire en perspective* (Paris 1648). Photo courtesy Bibliothèque Nationale, Paris

entering the prestigious Rome Prize, the Academy advised paying attention to "perspective with regard to the arrangement of figures and of the source of light" (Duro, 1997: 74), rather than the control of space. This system was given the name "ordering" by the theorist Charles Perrault in the late seventeenth century and can clearly be observed in artists' practice. The Absolutist portrait was based on the idea that the King was everywhere and saw everything, a form of perception that could not be reduced to mathematics, scale or one point.

For example, when Le Brun painted a portrait of Chancellor Seguier, a leading political figure, he simply arranged the figures in a pyramid, with the Chancellor seated above on a horse, surrounded by attendants (who would themselves have been nobles) and shielded from the sun by two parasols. There was no architecture or other material objects to be rendered in perspective, rendering the question moot. By the time that Hyacinthe Rigaud made his portrait of the aging King Louis XIV in 1701, it was established that "the portrait of Caesar is Caesar," that is to say, the painting reflected and depicted Majesty not an individual and was not to be subjected to trivia such as realistic representation or perspective. Rigaud's giant portrait was 2.79 meters high. It depicted the 63-year-old king, by then addled with

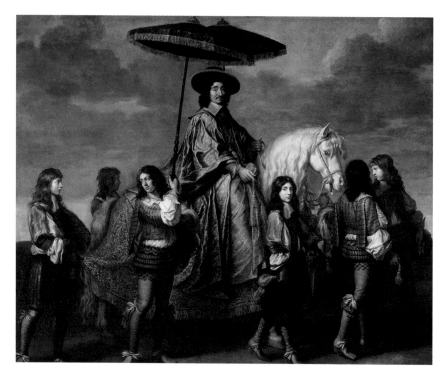

Figure 1.6 Charles Le Brun (1619–90), *Chancellor Seguier* (c. 1655–61). Courtesy of The Art Archive/Musée du Louvre Paris/Gianni Dagli Orti

gout, as a muscular and poised man in middle age, easily able to support his heavy robes and sceptre. This portrait and others like it was used as a substitute for the King himself when he happened to be away from Versailles. The courtiers would pay their respects to it on a daily basis and it was an offence known as *lèse-majesté*, or contempt of Majesty, to turn your back on the portrait, just as it would have been to do so to the King himself. According to the adage that "the King never dies," the portrait represents the eternal aspects of Kingship that were not affected by the actions or attributes of individual kings. Just as Alberti wanted his view through an open window to depict History, so too did the portrait of the King depict Majesty, not the likeness of an individual who happened at that time to be the monarch.

For the British philosopher Thomas Hobbes, knowledge was equal to power but power set the terms of knowledge. In his *Leviathan*, Hobbes imagined a nation as one giant body composed of all the individuals within that society. He did not share the Absolutist sense of a transcendent monarchy but instead subordinated everything to civil authority: "For it is the *Unity* of the Representer, not the *Unity* of the Represented, that maketh the Person *One*" (Hobbes, [1651] 1947: 85). That is to say, the picture or History of society is determined by the unity of civil authority, controlled by the state, rather than by what is seen therein. Against this view, the

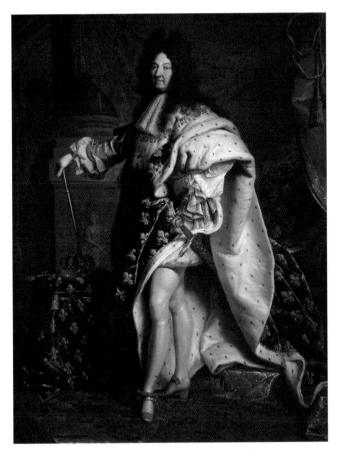

Figure 1.7 Hyacinthe Rigaud (1659–1743), *Louis XIV* (1638–1715) Courtesy of The Art Archive / Galleria degli Uffizi Florence / Alfredo Dagli Orti

scientist Robert Boyle appealed to what he called "the practice of our courts of justice here in England," meaning the necessity of two witnesses to generate a conviction (Shapin and Schaffer, 1985: 327). In Boyle's view, the observation of the Represented determined the status of what was seen, providing that observation was made by "reliable" witnesses, excluding Catholics, atheists, heretics and so on. Bruno Latour summarizes the difference:

> How can a society be made to hold together peacefully, Hobbes asks indignantly, on the pathetic foundation of matters of fact? . . . According to Boyle, the big questions concerning matter and divine power can be subjected to experimental resolution, and this resolution will be partial and modest.
>
> (Latour, 1993: 22)

Boyle's invention of the air-pump demonstrated what Hobbes took to be impossible, the possibility of a vacuum. The paradoxical existence of nothingness, long denied by Church authorities, threatened Hobbes's Leviathan by demonstrating the existence of the immaterial, something that cannot be described within civil authority. Though both systems speak of "representation," the representation of power denies the existence of nothingness, whereas the representation of experimental science seeks to demonstrate it and make it observable. A century later, in the painting of *An Experiment on a Bird in the Air Pump* by Joseph Wright of Derby (1768), the asphyxiation of a bird by the air pump has become a form of entertainment and reflection for its well-to-do audience, precisely the form of "witnesses" imagined by Boyle. It has, however, become common for modern theorists to assert that, in the words of film critic Christian Metz, perspective "inscribes an empty emplacement for the spectator-subject, an all-powerful position which is that of God himself, or more broadly, of some ultimate signified" (Metz, 1982: 49). Yet as we have seen it was precisely the concern of the absolutist monarchies of the seventeenth and eighteenth centuries to prevent such a floating position of power from being inscribed in visual culture, with the aim of keeping that power for themselves. Thus, one-point perspective was avoided for figures except where it was clearly the King that was to be the viewer, as in the royal theater. By the same token, Hobbes's

Figure 1.8 Joseph Wright of Derby, *An Experiment on a Bird in the Air Pump* (1768).
Courtesy of National Gallery, London / The Bridgeman Art Library

Republic kept all the power of Representing for itself but refused the idea of an ultimate form of representation or representing. Observational practice was subject to the judicial requirements of witnessing, an embodied form of seeing at a given time and place. Those witnesses constituted what has come to be known as the "public sphere," that literate and responsive segment of a nation state, which makes demands of the government and holds it accountable.

It might seem that we are ready to discuss the onset of the political and industrial revolutions that transformed Europe and North America in the late eighteenth and early nineteenth centuries. But, to borrow a caution from James Clifford, not so fast. How was it that those seventeenth-century thinkers from Kepler to Descartes, Hobbes, Boyle and Spinoza, came to feel able to challenge and reject the Ancient authorities? What authorized their definition of themselves as Modern? In the leading learned journal of the time, the *Journal des Savants*, one writer made it clear why ancient authority could no longer be relied upon in the matter of optics:

> Because once the new world had been discovered, one had to make new Geographical Maps, and now there have even been found a number of secrets to perfect vision, about which the Ancients were ignorant; it was necessary to make a new Optics which included all that we had currently discovered in this science. M. Descartes had begun to work on this subject and has already shown following his principles one of three ways in which Optics are composed.
>
> (Anon., 1667: 113–14)

At first sight this explanation makes perfect sense. The opening of geographic space required new physical maps that in turn challenged what Fredric Jameson calls "cognitive mapping," the sense of how we as individuals make sense of our location in the world. Yet there is a problem. If the Americas were encountered in 1492, why did it take nearly two hundred years for this encounter to produce an effect in Europe? And more importantly still, if the experience of encounter was so decisive, shouldn't it be considered in its own right, both in terms of the Strangers and the Natives?

References

Anon. (1667), *Journal des Savants*.

Bosse, Abraham (1648), *Manière Universelle de Mr Desargues pour pratiquer la Perspective*, Paris.

Braudel, Fernand (1976), *The Mediterranean*, New York: Harper and Row.

Crary, Jonathan (1990), *Techniques of the Observer: On Vision and Modernity in the Nineteenth Century*, Cambridge, MA: MIT Press.

Damisch, Hubert (1994), *The Origin of Perspective*, trans. John Goodman, Cambridge, MA: MIT Press.

Descartes, René (1988), *Selected Philosophical Writings*, ed. J. Cottingham, R. Stoothoff and D. Murdoch, Cambridge: Cambridge University Press.

Duro, Paul (1997), *The Academy and the Limits of Painting in Seventeeth-Century France*, New York: Cambridge University Press.

Gilchrist, Alan, (1996), "Editorial," *Perception*, vol. 25, http://www.perceptionweb.com/perc1096/editorial.html, accessed 10/4/06.

Greenstein, Jack (1997), "On Alberti's 'Sign': Vision and Composition in Quattrocento Painting," *The Art Bulletin*, vol. 79 no. 4, pp. 669–98.

Hobbes, Thomas ([1651] 1947), *Leviathan*, London: JM Dent.

Howard, Ian P. (1996), "Alhazen's neglected discoveries of visual phenomena," *Perception*, vol. 25 no. 10, pp. 1203–17.

Huret, Grégoire (1670), *Optique de Portraiture et Peinture*, Paris.

Jenks, Christopher (1995), *Visual Culture*, London: Routledge.

Kemp, Martin (1990), *The Science of Art: Optical Themes in Western Art from Brunelleschi to Seurat*, New Haven, CT: Yale University Press.

Latour, Bruno (1993), *We Have Never Been Modern*, Cambridge, MA: Harvard University Press.

Lindberg, David C. (1976), *Theories of Vision from Al-Kindi to Kepler*, Chicago, IL: University of Chicago Press.

Metz, Christian (1982), *Psychoanalysis and Cinema: The Imaginary Signifier*, London: Macmillan.

Mirzoeff, Nicholas (1990), "Pictorial Sign and Social Order: L'Académie Royale de Peinture et Sculpture, 1639–1752," PhD Diss., University of Warwick.

Niceron (1638), *La Perspective Curieuse*, Paris.

Pader, Hilaire (1649), "Discours sur le sujet de cette Traduction," in his *Traicté de la Proportion Naturelle et Artificielle des choses par Jean Paul Lomazzo*, Toulouse.

Plato (1991), *Plato's Republic*, trans. Allan Bloom, New York: Basic Books.

Porta, Giovanni B. della (1650), *La Magie Naturelle*, trans. Lazare Meysonnier, Lyons.

Sabra, A.I. (1982), *Theories of Light from Descartes to Newton*, Cambridge: Cambridge University Press.

Shapin, Steven and Simon Schaffer (1985), *Leviathan and the Air-Pump: Hobbes, Boyle, and the Experimental Life*, Princeton, NJ: Princeton University Press.

Smith, A. Mark (2001), *Alhacen's Theory of Visual Perception. A Critical Edition, with English Translation and Commentary of the First Three Books of Alhacen's* De Aspectibus, Philadelphia, PA: American Philosophical Society.

Spinoza, Baruch (2000), *Ethics*, trans. and ed. G.H.R. Parkinson, Oxford and New York: Oxford University Press.

White, John (1967), *The Birth and Rebirth of Pictorial Space*, London: Faber.

CULTURE AS TRANSCULTURE

Culture is never a pure object but always the hybrid product of networks. Or to be brief, all culture is transculture. Transculture was a term coined by the Cuban anthropologist Fernando Ortiz, writing in 1947 about the formation of Cuba's plantation culture of sugar and tobacco. What he called "transculture" implies not

> merely acquiring another culture, which is what the English word *acculturation* really implies, but the process also necessarily involves the loss or uprooting of a previous culture, which could be defined as deculturation. In addition, it carries the idea of the consequent creation of new cultural phenomena, which could be called neo-culturation.
>
> (Ortiz, [1947] 1995: 103)

For the conditions of white settlement were such in the Caribbean islands that the aboriginal peoples were "destroyed," although if they were presumed gone, they were not forgotten. On Caribbean islands like Cuba, "all its classes, races, and cultures, coming in by will or by force, have all been exogenous and have all been torn from their places of origin, suffering from the shock of this first uprooting and a harsh transplanting" (Ortiz, [1947] 1995: 100). Once there, people underwent the second shock of transculturation, involving a certain acculturation to prevailing conditions, which, together with the loss of "previous culture" created neo-culturation. Ortiz left his provocative idea somewhat undeveloped, discouraged by the lack of response from anthropologists of his time. It was revived by theorists and historians of hybridity in the 1990s to great effect.

For our purposes, two additions should be made. First, transculturation does

not stop after one iteration. Rather as soon as the new cultural conditions are formed, they are themselves immediately subject to transculturation. If there is a certain myth of "original" and singular cultures lurking in Ortiz's concept of transculture, it can be set aside from the genealogical point of view that asserts that all cultures are transcultures and have always been so in known history. That is to say, the repetition of transculturation means that there is no singular transculture, that all transculture is plural. Second, whereas Ortiz considered his transculture to be a product of the local situation in the Caribbean, we would want to insist on it as a feature of networked globalization in general. In this sense the patterns of deculturation and neo-culturation form circuits that are in constant use. Transcultures can be imagined using the Caribbean poet Edouard Glissant's figure of the archipelago, a series of connected islands. The virtue of the archipelago is that a series of very different entities can be connected and a variety of different journeys can be imagined across it. In this sense, the archipelago is a network but one in which making links and routes was by no means simple or obvious.

The importance of transcultures lies not so much in the process of cultural development as in the critique of the concept of a singular or original culture. Of course, the more that processes of globalization advance, the more we have seen such assertions, almost always contradicted at once by events. For example, while many commentators insist on distinguishing "European" values from those of a monolithic Islam, even a country as small as Belgium within Europe was hopelessly divided in 2008 between French and Flemish speakers. By the same token, while British Labour Prime Minister Gordon Brown was insisting on the importance of the United Kingdom and a standardized citizenship test, his own party leader in Scotland was demanding a referendum on independence. For as Antonio Benítez-Rojo has commented, transculture should be understood as "a questioning of the concept of 'unity' and a dismantling, or rather unmasking, of the mechanism we know as the 'binary opposition'" (Benítez-Rojo, 1996: 154). Rather than continue to work within the modernist oppositions between culture and either art or civilization, transculture offers a way to analyze the hybrid, globalized market system in which we live. Its emphasis on change should remind us that no system, however permanent it may seem, lasts forever.

The contemporary Cuban artist José Bedia, who has worked in Cuba, Mexico and the United States has described how this understanding has affected his work:

> The process – transcultural to call it something – which is currently produced in the heart of many autochthonous cultures, I try to produce it in me in a similar yet inverted manner. I am a man with a "Western" background who, by means of a voluntary and premeditated system, strives for a rapprochement with these cultures and moreover experiences their cultures in an equally transcultural way.
>
> (Mesquita, 1993: 9)

José Bedia, *The Little Revenge From the Periphery* (1993). Courtesy of the George Adams Gallery

That is to say, Bedia actively attempts to deculturate his "western" self in favor of a reinvention of indigeneity. The results are saved from theoretical pomposity because Bedia's work also makes great use of humor. In his piece *The Little Revenge From the Periphery* (1993), a track carrying airplanes and faces runs around a central print bearing the title in English. Bedia recognizes the central importance of air travel in mapping those parts of the world taken to constitute "the global" but within the circle the focus is on past time. A print showing the nineteenth-century classification of races places a Native American, an African, an Asian and an ape in orbit around the figure of a white male. The little revenge of the title derives from the fact that the white figure is filled with arrows and a stone ax, tools that deliberately evoke the tension between the presumed modernity of the center and its antonym, the primitive periphery. Bedia recognizes that racialized categories of identity continue to place non-white people in the "past" in relation to the global EuroAmerican. His strategy is at once to undermine such assumptions with humor and to create a new map of cultures in space and time that does not revolve around the white male.

Transculture might be seen as the dominant experience of the periphery over the past several centuries that has now returned to sender, offering a new sense of culture itself as, to quote Benítez-Rojo, that which "has no beginning or end and is always in transformation, since it is always looking for a way to signify

what it cannot manage to signify" (Benítez-Rojo, 1996: 20). Writing on Bedia's art, Ivo Mesquita describes how transculture's work "resembles that of a traveler who, traversing different landscapes, describes routes, points out passages, establishes landmarks, fixes the boundaries of a specific territory" (Mesquita, 1993: 19). Such a description inevitably recalls the colonial travel narratives of the nineteenth century that presented colonized territories as blank spaces awaiting the arrival of Europeans to become places. Yet by consistently exposing that history and asking how the visuality of the present can be distinguished from that of the past, visual culture can play its part in redefining culture as a constantly changing, permeable and forward-looking experience of transculture, rather than as a clearly definable inheritance from the past.

If transculture was in a sense inescapable in the Atlantic world formed by slavery, other more complex forms of transidentification are possible. One mode of thinking the self through the visual encounter with the other is the ethical means of identification theorized by the Franco-Jewish philosopher Emmanuel Levinas as the ethical obligation to the Other that results from the "face-to-face" encounter at the heart of transculture. Placing the Biblical injunction not to kill at the heart of his philosophy, Levinas argues that I cannot privilege my own culture in this encounter but must defer and accept my responsibility to the Other (Levinas, 1990: 8). This ethical moment can, of course, be refused, unlike the involuntary shocks of transculture. It has been all too possible to insist that violence towards the Other was necessary, justified or for the greater good, such as that of religious conversion. Levinas insisted that even as one looks, that "look calls me into question" (Derrida, 1999: 3), a question that can be deferred but that eventually returns to demand its answer.

References

Benítez-Rojo, Antonio (1996), *The Repeating Island: The Caribbean and the Postmodern Perspective*, Durham, NC: Duke University Press.

Derrida, Jacques (1999), *Adieu: Farewell to Emmanuel Levinas*, Stanford, CA: Stanford University Press.

Levinas, Emmanuel (1990), *Difficult Freedom: Essays on Judaism*, trans. Seàn Hand, London: Athlone Press.

Mesquita, Ivo (1993), *Cartographies*, Winnipeg: Winnipeg Art Gallery.

Ortiz, Fernando ([1947] 1995), *Cuban Counterpoint: Tobacco and Sugar*, trans. Harriet de Onís, Durham, NC and London: Duke University Press.

"1492"

Expulsions, Expropriations, Encounters

I N THE MOST widespread theory of visual representation, based on the theories of the psychoanalyst Jacques Lacan, vision is subject to the law of the gaze. The gaze subjugates the viewing subject and object alike to itself because it is, according to Lacan, "outside" the person looking. The gaze is that sense one has of being looked at even when you cannot physically see the person or machine doing the looking. Even more, it is the sense of being watched that constrains social action. This restraint might prevent a person from littering when unobserved, at a micro level, but it might also deter people from acting against injustice for fear of police retribution. Visual representation, especially in its official forms, has historically enacted this grammar of domination, whether of monarch over subjects, colonizer over colonized, or men over women, among many possible examples. It follows that the encounter with the other and its transformative effect on the self is the visual moment that matters to visual culture, not the optical and geometric effects of sight and perspective. What follows and results from that encounter is the substance of the field. The encounter, whether real, commodified, mediated or virtual is the "primal scene" of visual culture, that is to say its founding moment, its first trauma and the cause of first deception, thereby forming the optical unconscious. If the encounters of "1492" displaced the European view of the world as being centered on Europe, the expulsions of the same year forged the cult of homogenous Same in the face of the Other. The encounter was even more disastrous for those encountered, whether in Africa or the Americas, losses that demand to be addressed even today.

The many 1492s

Indeed, to begin at the beginning, the date "1492" has multiple meanings in different contexts. For most Americans, it evokes the arrival of Christopher Columbus in the

Americas at the behest of Ferdinand and Isabella, king and queen of Aragon and Castille respectively, now modern Spain. The same Spanish monarchs were responsible for the other remembered events of 1492. As part of their project to reunify Spain, Ferdinand and Isabella forcibly expelled the Jews and the Moors, the first by force of law, the second by force of arms. For many years, the idea of 1492 as the first encounter was celebrated, at least by its predominantly European beneficiaries. However, in his recent history of the cultural impact of 1492, the Australian cultural critic John Docker has called these events a "world-historical disaster" (2001: 26). In recent decades, the traditional Western statement that Columbus "discovered" America has finally been modified by the realization that there were of course people there already. In the past 30 years, it has become clear to the settler majority in the North that the Americas have a far longer and more complex history of settlement than they had previously understood. Cultivation, urban settlement, and even James Joyce's sarcastic marker of the progress offered by imperial conquest, indoor plumbing, long preceded the arrival of European settlers in the Americas. As this is now the stuff of grade-school curricula, it is worth remembering that as recently as 1965, the leading British historian Hugh Trevor-Roper, later Lord Dacre, could uncontroversially observe that the "chief function in history" of indigenous peoples the world over "is to show the present an image of the past from which by history it has escaped" (Mann, 2005: 14). Trevor-Roper presented the indigenous as an image, a picture that could be studied by the descendants of European colonizers as a means of appreciating their own superiority.

The difference between the image presented by the indigenous and the European is registered as "history," suggesting that there was no meaningful history in most of the world until the Europeans arrived but also that history is in itself the means by which difference is understood. In this view, the indigenous present an image of the past in the observable present, allowing the historian the opportunity that is usually denied by definition to experience the past directly. Further, a people "without" history cannot have an encounter with those that do until and unless they are willing to concede epistemological superiority to history as told in Europe. Local knowledges and histories must be replaced by History, a single story of the success of one world-view. The historian Dipesh Chakrabarty (1999) has argued that all History as traditionally practiced is therefore European History by definition and that another form has to be found to accommodate different views. One instance of the contradictions produced by this system can be seen in the persistent description of visual arts produced in Africa, Asia, Latin America and Oceania as "non-Western," as if that somehow unites the very different cultures in question. By the same token, artists from these regions producing work today are described and marketed as "contemporary," rather than (say) African, artists.

If we were to "provincialize Europe," as Chakrabarty has suggested, it would be necessary to show that the shock of the new, usually assumed to be the effect of encounter, was interfaced with what anthropologist James Clifford has called the "Squanto effect." He was referring to the Pilgrim Fathers meeting, on first landing

in America, a Patuxet Indian from the Wampanoag Confederation, known as Squantom but actually named Tisquantum who had himself just returned from London. Tisquantum had not traveled voluntarily. He had been taken to Spain by Captain Hunt, deputy to the Captain John Smith of Pocahontas fame, to be sold into slavery. Rescued by friars, Tisquantum made his way to London, where he entered the service of John Slany, a shipbuilder, who displayed him as a curiosity, an early version of the freak show. He then persuaded Slany to allow him to return to America on one of his vessels. When he arrived to speak with the English colonists, he was acting as an envoy of the *sachem* (leader) Massasoit, who hoped that the foreigners could help him in his struggles with the Narangassett (Mann, 2005: 48–61). The effect at work here is complex: first, shock that subalterns also moved around the early Atlantic world, whether voluntarily or not; and then the shock of recognition that comes from identifying aspects of one's own culture in the other. In the case of Tisquantum, the point of identification was his knowledge of English that permitted vital communications between the Pilgrims and the Wampanoag that ensured the survival of the former and the decimation by European diseases of the latter. Tisquantum himself died of one such disease in 1675, following the great epidemic of 1616 (probably hepatitis) that killed an estimated 90 percent of the population of coastal New England and the 1633 smallpox epidemic that followed. In other words, cultures were never isolated islands, developing by themselves, but were always interfaced with effects that could be deadly.

(Long) after al-Andalus

In January 1492, Ferdinand and Isabella completed the "reconquest" of Spain by agreeing terms for the surrender of the city of Granada, reversing the conquest of Spain by the Moors – Arabs and Berbers from North Africa – in the eighth century CE. The transformation of Spain into a single monarchy with one intolerant dominant religion created a "1492" of the mind, a quest for purity and sameness that has been long remembered. In an interview with the *Guardian* newspaper (August 12, 2000), the Spanish novelist Juan Goytisolo recently remarked "I discovered that the Franco dictatorship was the result of a long tradition that began in the middle ages," meaning the expulsions of 1492. That is to say, modern fascisms in which the state controls all aspects of social life are genealogically descended from the culture of purity (*limpieza*) that triumphed in 1492. Goytisolo has campaigned to have the hybridity of Spanish language and culture recognized, pointing out the influence of Arabic on Spanish, such as the iconic *olé*, derived from *Allah*. More provocatively, he draws attention to the likelihood that many Spanish writers of the Classical period, including Miguel Cervantes, author of *Don Quixote*, were "new Christians," or forcibly converted Jews. Ironically, even the name *España* originally meant the zone of the Iberian peninsula occupied by the Moors (Anidjar, 2002: 91). In the visual arts, the cross-cultural *mudejar* style of architecture drawing on Islamic influence continued to be practiced by those Muslims who remained in Spain after

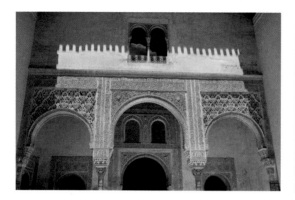

Figure 2.1 Alhambra Palace, Granada, Spain (built mainly between 1238–1358). Courtesy of The Art Archive/Manuel Cohen

Figure 2.2 El Transito synagogue, Toledo, Spain (built by Simon Levi, 1366). Courtesy of The Art Archive

1492. Such buildings as El Transito synagogue in Toledo had been built in this ornamental, decorative style before the reconquest but even Queen Isabella and her courtiers patronized buildings using *mudejar* features. It can also be seen in many Spanish colonial buildings in the Americas, not to mention the Islamicized features of much American synagogue architecture.

The Muslim caliphate saw what many have seen as a "golden age" of Jewish culture (Menocal, 2002), with accomplishments ranging from philosophy to poetry, led by such figures as Moses Maimonides (1135–1204), a legendary interpreter of the Torah. By 1492, Jews had lived in the Iberian Peninsula for over a millennium. Although Jews were limited in rights, as *dhimmis*, or "people under protection" they were able to live far more freely than in Christian Europe. The Muslims established what they came to call al-Andalus, at first a unified state but later a series of competing smaller states that were gradually defeated by Christian forces. Al-Andalus was almost from the inception a space under threat whose cultural expressions can seem strikingly modern as a result. Following the invasion of the Almoravids from Morocco and the destruction of Granada in 1090, the poet Moses ibn Ezra, who wrote in Arabic and Hebrew, lamented: "Tears flow from my eyes, as I seek to overcome my grief over my loneliness in my native land . . . I am like a resident alien therein, and I see no man about me of my family and kind" (Anidjar, 2002: 58). This sense of being a stranger even as you are at "home" was later to be a hallmark of modernism in the writings of Kafka and the paintings of De Chirico and the Surrealists. Medieval Jewish scholars in al-Andalus created a corpus of mystical writings known as Kabbalah, such as the *Zohar* (*Splendor*), whose readings of the Biblical texts and commentaries in the Talmud anticipated the deconstructive close readings of our own time.

Indeed, for the Italian philosopher Giorgio Agamben, the separation of language from its real world referent (the object that a word refers to or that an image depicts)

that began in texts like the *Zohar* culminated in the modern "society of the spectacle" (Anidjar, 2002: 88). For Agamben, language was the original Common that has been inverted by capitalism into the spectacle, a world where exchange value rules absolutely. Yet the very fact that the spectacle expropriates the common good means that it "still contains something like a positive possibility – and it is our task to use this possibility against it" (Agamben, 2000: 83). In this view, the spectacle and its means of opposition both emerged from the "end" of al-Andalus, a process without end. These moments and monuments in which different cultural traditions came together in a synthesis that left both of their origins visible was known as the *conviviencia*, or living together, that has again come to seem like a more desirable way of living than the current climate of global civil war. Indeed, the histories of 1492 have played a part in these conflicts. In a moment observed by Docker, one explanation of September 11 came in the form of a slogan quoted by an al-Qaeda supporter: "Remember al-Andalus." That is to say, remember the expulsion of Muslims from Spain in 1492.

"1492" did not inaugurate the arrival of History in the Americas. Others had come from Europe before, such as the Vikings who made settlements in Greenland and Canada, while fishing had been taking place off Newfoundland for some time, perhaps even centuries. Nonetheless, Christopher Columbus's arrival was of more moment because it led to a systematic project of settlement and colonial exploitation of the hemisphere. The connection between 1492 and the future was tellingly evoked by the anthropologist Claude Lévi-Strauss describing the encounter between Europeans and indigenous Americans: "Never had humanity experienced such a harrowing test, and it never will experience such another, unless, some day, we discover some other globe inhabited by thinking beings" (1976: 89). In almost all fictional and cinematic imaginings of such future encounters, the non-human beings attempt to kill or colonize the humans, a replay of 1492 in reverse. For Europeans immediately categorized the peoples of the "New World" as fundamentally different. When Columbus arrived in Cuba in 1492, he believed he had reached Cipango, or Japan, in whose provinces, he thought, "the people are born with tails." Soon afterwards, he received confirmation that "far from there, there were one-eyed men, and others with snouts of dogs who ate men, and that as soon as one was taken they cut his throat and drank his blood and cut off his genitals" (Greenblatt, 1991: 73–4). Here are the monsters of science-fiction already imagined and indeed a "monster" was understood in this period to mean a deformed human. From this first contact, a pattern was established whereby European travelers used the experience of natural wonders to confirm the existence of humanoid monsters, although they never saw them. The British explorer Sir Walter Raleigh reached Guiana in the 1590s, where he told of peoples "reported to have their eyes on their shoulders, and their mouths in the middle of their breasts." While Raleigh was aware that these accounts sounded like fairy tales, he asserted that "I have seen things as fantastic and prodigious as any of those" (Greenblatt, 1991: 21–2). Perhaps he had been smoking more than the tobacco that he helped make fashionable at the English court.

the better" (Dussel, 1995: 64). In this Platonic dialectic, the Amerindian was the former and the European the latter of all these pairings. Nonetheless it all depended on the unchallengeable assumption that the European was better than the American, who was understood as a *homunculus*, or half-man. It was a new world where the people were not equal to the Spanish but inherently servile, just as Aristotle had argued that slaves made noise but did not have language. However, the Indian was distinguished by being fit to obey rather than as a radically distinct species. On the other side of the debate, Bartolomé de las Casas made the simple claim: "All the nations of the world are men, and there is only one definition of all and each of them, which is that they are rational." The debate at Valladolid inaugurated half a millennium of tortured debates over this simple proposition: are all people to be considered human beings?

The idol and the fetish

One point Las Casas did agree with Sepúlveda: the Indians were idolators but he argued that at least they had not become Jews or Muslims. As Indians were "outside the Church . . . it is not the business of the Church to punish worshippers of idols . . . because the unbelief of the Jews and Saracens is much more damnable and serious than the unbelief of idolators" (Ishtay, 1997: 73). Both sides at Valladolid were, then, agreed that conquest was justified because the indigenous people were idolators, worshippers of images, rather than of the abstract God of monotheism. The idol is one of the three forms of visual imagery formed by colonial encounter, as analyzed by W.J.T. Mitchell (2005: 188–96), together with the fetish and the totem. In this classification, the idol demands your attention and merits your respect and worship. It expects forms of offerings or sacrifice. However, no one considers themselves to be an idolater. Rather it is an accusation leveled against you by another, whether Moses confronting the Israelites worshipping the Golden Calf, the Spanish conquistadors condemning the indigenous Americans, or today's accusations of idolatry in renewed global religious conflicts. The idolatry attributed to the indigenous Americans generated a colonial culture of suspicion, articulated by the Franciscan Bernardino de Sahagún in 1578: "It is necessary to know how these people formerly practised idolatry in order to preach against it or even to recognize it. Because of our ignorance, they now practice idolatry in front of us without our understanding it" (Dussel, 1995: 70). In other words, to destroy the idol, you had to know as much as possible about it.

Colonizing America was an attack on the image as idol, waged with a newly suspicious gaze, intent on rooting out heresy behind the mask of conformity. The task was doubly difficult because, as Sahagún put it, "All the things we discussed they gave to me by means of *paintings*, for that was the writing they had used" (Mignolo, 1994: 188). It was as if the native was an image, and indeed images have often been treated as objects of colonial dominion and contempt in Western discourse and practice. Across the Spanish colonies, indigenous art and texts were burned in *auto-da-fé*

ceremonies, as if the images themselves were heretics in need of salvation. Unlike the modern viewer who might ask, following Mitchell, "what does the picture want?," the Inquisition asked "what does the picture need to do to avoid heresy?" One of the most notorious instances of this questioning came in 1562, when the Franciscan Diego de Landa pursued vengeance against the Maya of Yucatan for, as he saw it, reverting to idolatry from Christianity. Widespread torture and extensive destruction of the sacred texts of the Maya was carried out at de Landa's behest. He then sat down to write a comprehensive history of the Maya from the very sources he had ordered destroyed, perhaps as a guide in case of future reversions or as a self-justification. Ironically, despite these suspicions, indigenous artists came to work for the Spanish within European forms to a very high level of accomplishment. The Spanish monarchy displayed portraits, now sadly lost, of leading colonial figures made by indigenous artists in 1571 alongside its Titians and El Grecos in Madrid.

In Shakespeare's 1611 play *The Tempest*, the encounter with the new world was both the scene of the action and a key subject of discussion. The play describes what happens to the Duke of Milan and his court after a great storm has shipwrecked them on an enchanted island. One of the magical aspects of the island seems to be its ability to be both in the Mediterranean, near North Africa, and in the Atlantic, near the Bahamas, at once. For its seventeenth-century audience, exoticism was on display in *The Tempest* and its exact location was not important. The play describes the fascination exerted over the London crowd by the sight of "one dead Indian." Within the play, the disabled native Caliban plots to overthrow the magician Prospero with the help of two of the shipwrecked sailors. On the unnamed island where the new and old worlds collided, Caliban served as a slave although his sorceress mother Sycorax had once been its ruler. When Prospero came to the island, he learned about its features from Caliban in exchange for literacy but by the time of the play, Caliban has been reduced to slavery and, as he says, "my profit on't, is that I learned how to curse." The Native was now slave to the Stranger. Caliban's offence against Prospero was to desire his daughter Miranda, a thought-crime for which he is consistently punished. Even in slavery, Caliban threatens his lord that he would have populated the island with mestizo children if he had had the chance. The primary fear engendered by Atlantic world colonization was that encounter would lead to mixing, hybridity and miscegenation, all of which nonetheless happened apace. Caliban was represented as what Sepúlveda called a *homunculus*, a half-man, but despite his reduced state, he can claim "Freedom high day!" For all his mythical background, Caliban seems more contemporary than the magician Prospero and has been celebrated as such in much post-colonial art and literature, ranging from Aimé Césaire's rewriting of the play in the context of African decolonization as *Une Tempête* (1969), to the Native American artist Jimmy Durham's piece *Caliban's Mask* (1992), to critical reworkings such as Michelle Cliff's well-known essay "Caliban's Daughter" (Goldberg, 2004). Caliban's experience of encounter resonates in the decolonized world in a way that the lordly domination of Prospero does not.

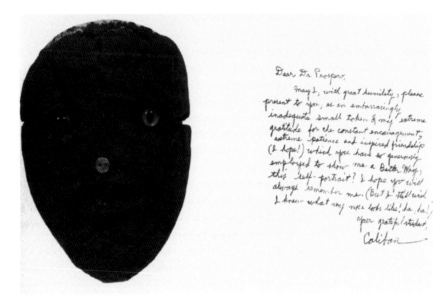

Figure 2.3 Jimmy Durham, *Untitled (Caliban's Mask)* (1992). Glass eyes, button, PVC, glue

A few years after *The Tempest* was first performed, Sir Francis Bacon called in 1620 for the overturning of four categories of "idols of the mind," showing that, on the one hand, Europeans could be idolators and, on the other, that he believed Englishmen were not, unlike Southern and Catholic Europeans (Mitchell, 2005: 48–9). At the end of the nineteenth century, Frederick Nietzsche would announce a new "twilight of the idols" for a different form of colonial modernity. It seems that, like the specter, the idol returns, wanted or not. In the seventeenth century, the newly dominant category of visual form generated by the Atlantic world encounter was that of the fetish. As William Pietz and others have shown (Pietz, 1985, 1987, 1988), the term fetishism was a production of the colonial trade with Africa, in which the word derives from the Portuguese meaning simply "made thing." The fetish was an inanimate object, sometimes a found object but usually one that had been worked into a given form. In the view of the colonizer or trader, the native person invested this object with a belief that it was alive and could act in the human world. Fetishes were asked to perform services for the fetishist and could be rewarded or punished accordingly. Colonial and slave trading produced these "things," which were not always seen as the threat represented by the idol so much as a necessary sign of difference and inferiority. At the heart of this sense of inferiority was the amazement of the European trader that African slave-traders would accept their cheap goods in exchange for human beings, not recognizing that the people concerned were prisoners of war or other low status individuals. Nor were the complexities of the relationship between spirit world and human existence in African religions even dimly understood.

However, unlike the idol, which is always a mark of the other, the fetish crosses boundaries. That is to say, "our" religion is never idolatry, only "theirs." But fetishism has not remained the property of the other in that way. When the enslaved made use of "magic" on plantations, it caused fear and repression. Slave-owners attempted to demonstrate that their "magic" was more powerful than that called on by their workers. (In Chapter 5, this conflict of rival fetishisms is explored in detail in the case of the Belgian Congo in the late nineteenth century.) At the same time, the emergent capitalist world created by global trade relied on commodity fetishism to generate its desire for goods. The commodity fetish is the belief that things mediate and give value to the relations between people, rather than direct human exchange. Thus a successful person might indicate their status by the acquisition of certain watches, clothes and other details of difference from ordinary people, as chronicled by novelists from Balzac to Scott Fitzgerald, and now by a panoply of television and print media coverage. In a final twist, Freud observed that in many cases, male sexual desire is stimulated by an object, such as furs or lingerie, that he called "fetishism" in extension of the earlier theory. So the "surplus value" produced by the idol, requiring devotion and sacrifice, was transferred to the fetish, producing desire that was at once a desire to consume and a sexual desire (Mitchell, 2005: 176). This transfer was never complete, never quite as precise as this formula suggests and always divided from within and without the capitalist market. This transition of mental space from absolute distinction to gradated and comparative difference is the emergence of the contemporary in which we still live.

1492 revisited

Indeed, recent representations of encounter suggest that old attitudes die hard, as one would perhaps expect. In 1992, the quincentennial of Columbus's encounter with the Americas seemed to mark a grand cultural anniversary. However, the insistent opposition of indigenous groups to the idea of celebrating their genocide (whether intentional or not), combined with the weakness of the projects created, turned the moment around. For example, Ridley Scott's historical drama *1492: The Conquest of Paradise* (1992) wanted to build on the success of his science-fiction classic *Alien* (1979). Throughout *Alien* heavy hints were dropped that the film was referring to colonialism, such as naming the spaceship *Nostromo* after a novel by Joseph Conrad. Scott even used *Alien*'s star Sigourney Weaver to play Queen Isabella of Castile. Columbus was played by Gérard Depardieu, the French art cinema star first introduced to American audiences as a penniless green card seeker in the 1990 film of the same name. But, like so much of the Quincentennial "Celebration," the film flopped (Shohat and Stam, 1994: 60–6). Columbus's greatness no longer appeared secure in the face of hostile criticism from Indian and Latino/a groups. The parallel with *Alien* shows that the colonial metaphor is better dealt with cinematically in "space," than in "time." That is to say, colonial anxieties can be worked out if imaginatively displaced off the planet, whereas the historical film is always likely to

Figure 2.4 A still from *1492: The Conquest of Paradise* (dir. Ridley Scott, 1992). Courtesy of Due West-Legend-Cyrk/The Kobal Collection

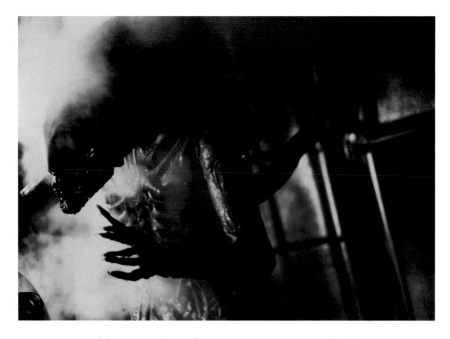

Figure 2.5 A still from *Alien* (dir. Ridley Scott, 1979). Courtesy of 20th Century Fox/The Kobal Collection

raise controversy. Like many science-fiction films, *Alien* was able to play a clever double game with its audience's emotions. The film carefully established and normalized its *mise-en-scène* before introducing its alien so that it came to seem appropriate in context, a process that might seem unnecessarily slow to twenty-first-century viewers. In the 1960s, filmmakers allowed audiences some 20 seconds to recognize an image, whereas their 2007 counterparts set aside just two (Hayles, 2007: 191). This recognition persuades audiences to accept the illusion, not because the monsters are real but because they are both like other fictional monsters and other filmed images. *Alien* clearly wanted its audience to dislike and fear the monster with its machine-like relentless appetite for killing combined with the very animal-like dripping jaws it used for its slaughter. At the same time, the audience is encouraged to feel a more rational dislike for The Company, which used an android crew member in its effort to ensure that the alien would survive, rather than its own crew. Colonial enterprise is depicted as being as ruthless and unpleasant as the alien, allowing for a viewing pleasure that combined horror-style violence, the uncanny aspect of the ghost story represented by the "invisibility" of the alien, and a political message that seemed to combine anti-imperialism with a "strong woman" lead character. If we think through the colonial parallel, however, the alien must represent the indigenous people, depicted here in familiar stereotypes of animal violence. At the same time, the dripping jaws of the creature are an almost parodic evocation of the male fear of castration, known to Freud as *vagina dentata*, the vagina with teeth (Creed, 1990). The suggestion that the alien evokes certain stereotypes of women and indigenous peoples is not meant to score points off the film makers as much as to indicate how when even sophisticated people turn to imagining what would be terrifying, it is hard to avoid the relics of the long colonial past.

Hollywood keeps returning to the subject of encounter in the hopes of getting it right and allaying settler guilt. Terence Malick's 2005 film *The New World* makes it clear from its opening sequence that the viewpoint is always going to be that of the arriving Europeans. After a brief and mysterious scene featuring an indigenous woman, who will turn out to be Pocahontas, the titles show a European ship crossing a graphic composed of period maps and prints but no native work. When we move back into cinema, three ships are seen sailing up river to the sound of uplifting music. The sight of a classic British actor, Christopher Plummer, training a telescope on the land reassures the audience that this is Quality Cinema. A rustling, silent, mystified view from the woods of the arriving technological marvel that is the European ship at once sets the tone. The natives are so close to the earth that they are Nature, while the Europeans are the corruption of Culture, coming to disrupt the Garden of Eden. Yet the viewpoint literally and metaphorically still belongs to the Europeans, as the natives peer from behind trees at the ships, while the captain surveys the land with his telescope and his maps. As a guilt-ridden version of the 1492 plot, *The New World* literally did not know what to say for itself, reducing dialog to a minimum that was often close to parody. The film centered on the "romance" between Pocahontas, a teenager whose real name was Matoaka, and Captain John

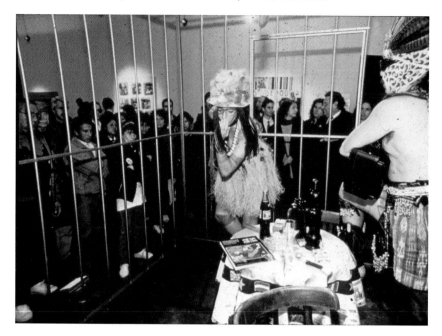

Figure 2.6 Coco Fusco and Guillermo Gómez-Peña, *Two Undiscovered Amerindians Visit Buenos Aires* (1992). Courtesy of Coco Fusco

Smith that had already been better told by the Disney animation *Pocahontas* (1995), which is not to say that it is a praiseworthy effort. Smith's overblown account of his life was better suited to cartoons. Although both films did take care to include sequences showing maize being cultivated by the Powhatans, *Pocahontas* did so before becoming involved with the contact narrative, while *The New World* waited until the violent conflict has been established. In science-fiction, the audience can consistently identify with the "humans" over the "aliens," but in the colonial context the moral rectitude now appears to belong to "them" – that is to say, the indigenous peoples who experienced the violence of colonial conquest. But the target audience is still the EuroAmerican, required here to disavow themselves in order to enjoy the film.

When the performance artists Coco Fusco and Guillermo Gómez-Peña devised their 1992 performance piece entitled *Two Undiscovered Amerindians*, it was their intention to explore these forms of disavowal by means of satire. Their goal was to evoke colonial attitudes to indigenous peoples by presenting themselves as the representatives of a hitherto unknown people, the Guatinauis. By performing in a cage in "traditional" costume but with a variety of self-evidently modern props, like a television, books and a computer, Fusco and Peña intended

> to create a satirical commentary on Western concepts of the exotic, primitive Other; yet, we had to confront two unexpected realities in the course of developing this piece: 1) a substantial portion of the public

believed that our fictional identities were real ones; and 2) a substantial number of intellectuals, artists and cultural bureaucrats sought to deflect attention from the substance of our experiment to the "moral implications" of our dissimulation.

(Fusco, 1995: 37)

Rather than provide an opportunity for reflection on the colonial past, *Two Undiscovered Amerindians* became a means for sections of the audience to demonstrate how effectively they had internalized the colonial role.

Audience reactions to Fusco and Peña's performance ranged from anger at the imprisonment of helpless aborigines to taunting and touching in explicitly sexual ways. Curators and critics responded by attacking the performers for their inauthenticity, as if it would somehow have been more appropriate to use "real" Amerindians in this context. On the other hand, the director of Native American programs for the Smithsonian Museum in Washington DC was troubled to see that audiences responded in exactly the same way to the satirical performance as they did to her carefully constructed events that were designed to be as "authentic" as possible. Fusco concluded "the cage became a blank screen onto which the audience projected their fantasies of who and what we are" (Fusco, 1995: 47). This attitude is what Octave Mannoni called the Prospero complex, alluding to Prospero's domination of Caliban in *The Tempest*. Mannoni asserts that Western identity is now predicated on being able to claim such dominance of the Other. At the same time, one might ask whether the performance invited this dark vision of unworked-through colonial supremacy. The only ways to engage with the performers provided to the audience necessarily produced a "colonial" attitude. The "correct" response was perhaps limited to a knowing smile from the back of the room.

The all but impossible viewing of *Two Undiscovered Amerindians* suggests that the force of the encounters of "1492" is unresolved. It is noticeable that science fiction, a genre that deals with the encounter by displacement, has receded from cinema and television since the end of the 1990s. The once-dominant *Star Trek* series finally came to an end with the uninspired *Enterprise TV* series (2001–5) actually being cancelled by the cable network UPN. Perhaps it is now time to deal with encounters neither in the past nor the future but the present. One such moment came in an episode of the HBO series *The Sopranos* (1999–2007) that dealt with a New Jersey mafia "family" and the actual families it involved. Led by Tony Soprano (James Gandolfini), a man proud of his Italian heritage and given to listing Columbus as one of his heroes, the mobsters intervene to break up a protest against Columbus Day (episode 42, "Christopher"). For the gang captain Silvio (Steven van Zandt) it's clear that Columbus Day is "a day of Italian pride," a sentiment shared by all, despite one objection that Columbus was from the North of Italy and so not really one of them, that is to say, Sicilian and Southern Italians. But when the New Jersey Council of Indian Affairs holds its protest, carrying signs declaring Columbus to be a mass murderer and slave trader, Silvio himself is to be found gambling – in a casino on a

reservation. For the largely ignored legal existence of Indian land as sovereign nations has come into play in recent years as a space of exception within the territorial boundaries of the United States, allowing gambling and the purchase of tax-free items like cigarettes. In the present, this episode suggests, cultural heritage is less important than the opportunity to make (and gamble) a few dollars in the United States.

Sorry day

As an academic based in North America, I have always been moved by the cere-monies at the start of events in Australia or Aotearoa New Zealand that recognize the indigenous presence. I am aware that these symbolic moments leave much of substance to be done and that, like all rituals, they have become routine for locals. However, with the election of a Labour government in Australia in 2008, the Prime Minister Kevin Rudd offered a televised Apology to the Aboriginal and Torres Strait Islander peoples of Australia. In recent years, debates over whether the settler population had acted violently towards the Aboriginals in the nineteenth century had caused what became known as the History Wars. Sharp debate also surrounded the practice of moving Aboriginal children away from their birth families, beginning in the nineteenth century and still going as recently as 1969, in order to have them raised by European families or acculturated to European lifestyles in state-run institutions (Lindqvist, 2007). It was hoped that these actions would end the cultural presence of indigenous peoples altogether. Rudd offered a series of direct apologies to these children and their families, known collectively as the Stolen Generation, as well as a more nuanced reflection on "past mistreatment" of all Aboriginal peoples. He further committed Parliament to a "future based on mutual respect, mutual resolve and mutual responsibility." The speech was watched across Australia, often in public settings on large screens, and around the world via YouTube and other file-sharing networks. In the wake of the many encounters since "1492," such moments of apology seem a necessary, if not sufficient, step to enabling a different future.

References

Agamben, Giorgio (2000), *Means Without End: Notes on Politics*, trans. Vincenzo Binetti and Cesare Casarino, Minneapolis: University of Minnesota Press.
Anidjar, Gil (2002), *"Our Place in al-Andalus": Kabbalah, Philosophy, Literature in Arab Jewish Letters*, Stanford, CA: Stanford University Press.
Casid, Jill (2005), *Sowing Empire: Landscape and Colonization*, Minneapolis: University of Minnesota Press.
Chakrabarty, Dipesh (1999), *Provincializing Europe*, Princeton, NJ: Princeton University Press.
Creed, Barbara (1990), *"Alien and the Monstrous Feminine,"* in *Alien Zone*, ed. Annette Kuhn, London: Verso.
Docker, John (2001), *1492: The Poetics of Diaspora*, New York: Continuum.

Dussel, Enrique (1995), *The Invention of the Americas: Eclipse of "the Other" and the Myth of Modernity of "the Other" and the Myth of Modernity*, trans. Michael D. Barber, New York: Continuum.

Fusco, Coco (1995), *English is Broken Here: Notes on Cultural Fusion in the Americas*, New York: New Press.

Goldberg, Jonathan (2004), *The Tempest in the Caribbean*, Durham, NC and London: Duke University Press.

Greenblatt, Stephen (1991), *Marvelous Possessions: The Wonder of the New World*, Chicago, IL: University of Chicago Press.

Hayles, N. Katherine (2007), "Hyper and Deep Attention: The Generational Divide in Cognitive Modes," *Profession 2007*, New York: Modern Language Association.

Ishtay, Madeleine R. (ed.) (1997), *The Human Rights Reader: Major Political Writings, Essays, Speeches, and Documents From the Bible to the Present*, London and New York: Routledge.

Lévi-Strauss, Claude (1976), *Tristes Tropiques*, London: Penguin.

Lindqvist, Sven (2007), *Terra Nullius: A Journey Through No One's Land*, New York: New Press.

Mann, Charles C. (2005), *1491: New Revelations of the Americas Before Columbus*, New York: Knopf.

Menocal, María Rosa (2002), *The Ornament of the World: How Muslims, Jews, and Christians Created a Culture of Tolerance in Medieval Spain*, Boston: Back Bay Books.

Mignolo, Walter D. (1994), *The Darker Side of the Renaissance: Literacy, Territoriality, and Colonization*, Ann Arbor, MI: University of Michigan Press.

Mitchell, W.J.T. (1994), *Landscape and Power*, Chicago, IL: University of Chicago Press.

—— (2005), *What do Pictures Want? The Lives and Loves of Images*, Chicago, IL and London: University of Chicago Press.

Mudimbe, V.Y. (1988), *The Invention of Africa: Gnosis, Philosophy and the Order of Knowledge*, Bloomington, IN: Indiana University Press.

Pietz, William (1985), "The Problem of the Fetish, I," *Res*, vol. 9, pp. 5–17.

—— (1987), "The Problem of the Fetish, II," *Res*, vol. 13, pp. 23–45.

—— (1988), "The Problem of the Fetish, III," *Res*, vol. 16, pp. 105–23.

Quilley, Geoff and Kay Dian Kriz (2003), *An Economy of Colour: Visual Culture and the Atlantic World, 1660–1830*, Manchester: Manchester University Press.

Schildkrout, Enid (1993), *African Reflections: Art from North-Eastern Zaire*, New York: American Museum of Natural History.

Shohat, Ella and Robert Stam (1994), *Unthinking Eurocentrism: Multiculturalism and the Media*, London: Routledge.

Takaki, Ronald (1993), *A Different Mirror: A History of Multicultural America*, Boston: Little, Brown.

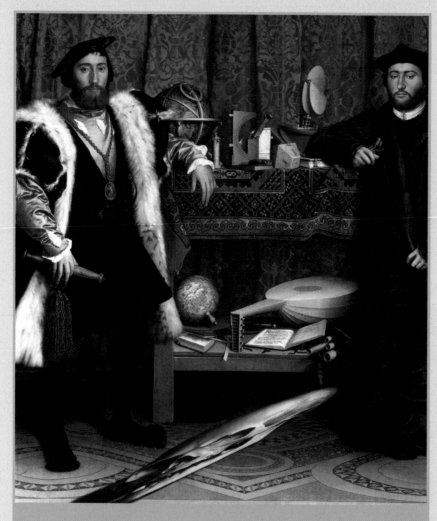

Hans Holbein the Younger (1497/9–1543), *The Ambassadors*. Courtesy of the National Gallery, London

THE AMBASSADORS

Slavery and the Gaze

For over half a century Hans Holbein's 1533 painting of two French ambassadors to the court of King Henry VIII of England (London: National Gallery) has been central to all discussions of mediated looking, the gaze and visual representation. Here it is taken to show that the formation of the gaze was indissociably intertwined with the creation of Atlantic slavery. The gaze is then necessarily "Western," often but not exclusively male, and certainly "white," although it was the very experience of deploying the gaze in the world that slavery built that formed a sense of being "white." That is to say, the gaze has not been a permanent institution of "Western" culture and it did not emerge simply as a form of visual representation. Rather what we understand to be the domination of the gaze was a product of the particular form taken by colonial and slave-owning domination. It interfaces the domain of the eye in assessing space and form with that of the gaze that looks at the subject from outside in a field that is given coherence by the presence of divinity as light and as ineffable invisibility.

The Ambassadors shows two men of wealth, Jean de Dinteville and Georges de Selve, surrounded by the trappings of their material comfort and the knowledge that enabled it. Dinteville was acting as an ambassador for the French king François I (1494–1547) and his visitor de Selve was a diplomat-bishop. For all their standing, they were relatively young, aged 29 and 25 respectively. There are repeated contradictions and displacements to be discerned in the represented material objects in the painting but, before we can think of them, our attention is driven away by means of a curious tubular shape cutting across the picture space. Seen from an acute angle, this shape "resolves" into an anamorphotic drawing of a skull. In anamorphotic drawings, the vanishing point used in perspective is placed on an extreme angle to the picture plane, producing a highly distorted image that can only be properly seen by physically moving

oneself to the intended vanishing point. From this angle, the main subject of *The Ambassadors* becomes far less visible and the viewer is confronted with a reminder of mortality that is in tension with the material wealth of the ambassadors. The painting is a form of riposte to its own subjects, reminding them that they too shall die, the one form of equality recognized by the hierarchical societies of the time.

Above and beyond this metaphorical meaning, the skull image was famously cited by psychoanalyst Jacques Lacan in his theory of the gaze, so central to contemporary film and visual culture analysis. Lacan looked at the anamorphosis of the skull and decided that "Holbein makes visible for us here something that is simply the subject as annihilated . . . in the form that is, strictly speaking, the imaged embodiment of the *minus phi* of castration, which for us, centers the whole organization of the desires" (1981: 88).[1] That is to say, the skull is the "gaze as such," it annihilates its object, here the French ambassadors, and the picture functions as a doubled representation of "the gaze as such" and as a "trap for the gaze" of the viewer. Lacan further understood the painting as an example of Alexander Kojève's famous lectures on Hegel's master–slave dialectic, rendered in visual terms. According to Kojève, Hegel showed that, although the master had power over the slave, he was dependent on the work done by the slave that would ultimately empower the slave to overthrow his subjection. As Martin Jay has put it, "[t]he lesson Lacan had absorbed in Kojève's lecture hall: true reciprocity is only an illusion" (1993: 364). The gaze, the visual form of the master, which is outside the subject, exerts mastery over the eye that wants to claim the ability to perceive "seeingness [*voyure*]." Whereas the Cartesian subject takes its "seeingness" as a token of its overcoming of any split in that subject, Lacan posits the gaze as constituting the subject through lack. That is to say, if Descartes took the transformation of sight into vision by the judgment as evidence of the existence of a self-sufficient subject, Lacan saw that as being only half of the process by which we experience visuality. The other half is outside us and looks at us from the place of death, which for psychoanalysis is equivalent to castration, itself represented by blindness.

As Lacan's key example of the gaze, *The Ambassadors* was reproduced on the cover of the French edition of his seminar, *The Four Fundamental Concepts of Psychoanalysis*. This usage has led to *The Ambassadors* being widely taught and discussed as an example of gaze theory, independent of its historical and cultural location. It is a painting that has probably been discussed in every visual culture, film theory and art history methodology class for the past quarter-century. In all this discussion, what there is to see with the eye in the rest of the canvas has been oddly overlooked. Holbein created a counterpoint between the destruction of the subject and the primitive accumulation of wealth enabled by African gold and the African slave trade. Its spectacular depiction of the gaze-as-anamorphosis was placed in counterpoint between the eternal and the temporal; or to put it another way, the divine and the secular; or yet again, between the

unapprehendable and the visible. Measurement and division are centrally part of the work of the painting, even as that work is presented as ultimately futile. On the shelves behind the figures are a variety of scientific instruments of the time, dominated by a centrally placed globe with its face turned so as to show the map of Africa and the facing land-mass of Brazil (Foister et al., 1997: 30–43). Place names on the African continent such as "Senega" can be read and major rivers were clearly marked and identified. The globe also shows the dividing line established by the Pope at the Treaty of Tordesillas in 1494 dividing Spain and Portugal's imperial domains (Foister et al., 1997: 39). The sundial on the shelves is set to tell the time in North Africa, while the celestial globe has a latitude set for Italy or Spain (Foister et al., 1997: 34–7). While Africa is centrally placed on the terrestial globe, the viewer is not expected to draw the conclusion that it is morally or cosmologically central to human affairs but that it is central to the vanity of human desire. For sixteenth-century Africa was a key location in the emergent global gold market that literally and metaphorically marked the emergence of a new form of wealth that would come to be capital, leading the west coast of Africa near the city of Axim to become known as the Gold Coast. It was of course also the first stop in the triangular slave trade from which point historians estimate that between 136,000 and 151,000 enslaved Africans were taken to Portugal and its Atlantic islands in the period 1441 to 1505 alone. By 1550, enslaved Africans were 10 percent of Lisbon's population, or 9,500 people (Blackburn, 1997: 112–13). Nearly 30 years after the first enslaved Africans landed in Hispaniola, Africa stood in *The Ambassadors* for the source of worldly wealth and vanity undercut by the inevitability of death.

Yet this network remains obscured by the dominant force of the anamorphotic skull, or the gaze. It is as if the gaze drags the attention of the viewer away from the uncanny network of African reference so that the subject sees its lack as mortality but not its human other. Thus the Western gaze has been alert to its own metaphorical slavery but was for centuries unable to see the actually existing chattel slavery on which its prosperity depended. Nonetheless that otherness is plainly there, suggesting that there is a difference between what is seen and what is understood, a difference that would be central to modern European thought and commerce. Visible on the lower shelf in Holbein's painting is a handbook for merchants, open to a page dealing with mathematical division and in fact beginning with the word "divide." This painted book is best read when standing off to the right in the viewing position from which the skull "resolves." Next to it in space but best read from the left-hand side was a Lutheran hymnbook, again open and legible (Foister et al., 1997: 40). By representing the reformed religion as music, Holbein reminded his viewers of Protestant iconoclasm, which he had himself witnessed in Basel. Here Protestantism and the money form of value were literally adjacent but at odds. In forcing the viewer to adjust position to best perceive his work, Holbein was emphasizing his concern with the interaction of the divides produced by commercial expansion and those of the emerging

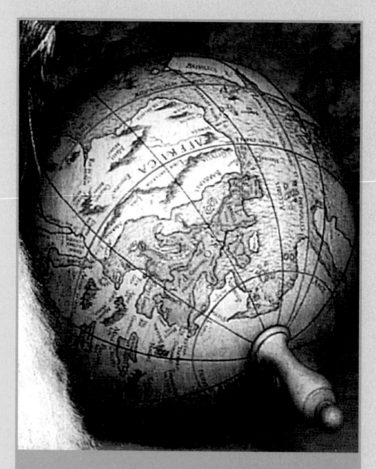

Hans Holbein the Younger, Detail of the globe in *The Ambassadors*.
Courtesy of the National Gallery, London

religious split between Protestant and Catholic. The device of the skull stands as a surrogate for all these concerns as desire, bringing with it the threat of castration, blindness and death.

Holbein visualized a new division of the sensible that was coming into being in his lifetime with acute insight, even as he was constrained to the discursive practices of resemblance that were the then indispensable ground for thought. For despite all the intensity of visible detail and reference in *The Ambassadors*, meaning seems displaced, divided and in a sense lost. Lacan's solution was to make the painting be about division, the permanent split in the subject: "In this matter of the visible, everything is a trap . . . There is not a single one of the divisions, a single one of the double sides that the function of vision presents that is not manifested to us as a labyrinth" (1981: 93). What is overlooked here is how the destructive domination sought by the gaze was itself represented by Holbein as in a dialectic with the division of the senses, space, time and labor in actually existing slavery.

Note

1 See Jay (1993), 329–80.

References

Blackburn, Robin (1997), *The Making of New World Slavery: From the Baroque to the Modern 1492–1800*, New York: Verso.

Foister, Susan, Ashok Roy and Martin Wyld (1997), *Holbein's Ambassadors: Making and Meaning*, London: National Gallery Publications.

Jay, Martin (1993), *Downcast Eyes: The Denigration of Vision in Twentieth-Century French Thought*, Berkeley and Los Angeles: University of California Press.

Lacan, Jacques (1981), *The Four Fundamental Concepts of Pyschoanalysis*, ed. Jacques-Alain Miller, trans. Alan Sheridan, New York: Norton.

SLAVERY, MODERNITY AND VISUAL CULTURE

THE FIRST ENCOUNTERS that we looked at in the last chapter were at once succeeded by expansion into the Americas to settle, mine and plant. The repeated epidemics caused by the introduction of exogenous viruses into the Americas reduced the native population to below a level where it could sustain the forced labor required to develop these new enterprises. The Atlantic triangle was formed by the forcible expatriation of Africans to the Americas by European slave-traders in order to sustain the colonial labor force. The enslaved were set to work in the plantation system, cultivating cash-crops like sugar cane, coffee and indigo. Those products were taken back to Europe by traders to complete the triangle, setting in motion the perpetual circulation that is characteristic of capitalism. This circulating network of bodies, goods and ideas created modern capitalist society in the "West." There is no modernity without slavery, even if slavery has also existed in other times and in different modes of production. Slavery operated behind a certain invisibility, as far as its European beneficiaries were concerned, that allowed abolitionists to challenge the system with simple but highly effective forms of visual propaganda. Those enslaved had already introduced their own visual forms to the Atlantic world, notably the circle created by African-influenced performance and the crossroads, the place of intersection and challenge. These counter-images refused slavery's efforts to reduce meaning and control difference, inflecting the new "objec-tive" medium of photography in the Americas with its dramas of race and power. Such connotations linger in present-day visuality, emerging from time to time as a disruptive and scandalous presence that is supposed to have been laid to rest.

The sense that slavery is over or should be forgotten leaves out of consideration its formative role in shaping modernity, especially Western capitalism, whose moment is far from complete. As the Caribbean historian and politician Eric Williams argued in his classic 1944 account *Capitalism and Slavery*, the forces that

drove modern capitalism into being were those set in motion by slavery. The examples that follow are taken from his text. In 1718, the British economist William Wood declared that the slave trade was "the spring and parent whence the others flow." The one small sugar island of Barbados, 166 square miles in extent, produced more revenue for Britain than New England, New York and Pennsylvania combined. There were vast profits to be made for elite families like the Beckfords of Fonthill and the Buckinghams. The famous residence of the British monarchy in London, Buckingham Palace, was one product of this spectacular wealth, ostentatiously given by the Duke of Buckingham to the monarchy as if to express his superiority. The planter Christopher Codrington of Barbados gave his library to All Souls College of Oxford University, marking his claim to be a man of culture as well as cultivation. Thus the eighteenth-century French abolitionist, the abbé Raynal saw that slavery "may be considered as the principal cause of the rapid motion which now agitates the universe." The sudden shift from feudalism to modernity was and is characterized above all by speed of circulation, rather than depending solely on a type of production process, just as our own era of globalization is characterized by speed of travel and communications, whether electronic or actual.

By today's standards, agriculturally based colonial capitalism was a slow process indeed but it allowed for the generation of profit that was extraordinary at the time. The "Great Gang," as the enslaved who worked in the fields were known, formed what the Caribbean historian C.L.R. James called the first modern proletariat, that is to say, a working class (1968). By the same token, the highly technical and co-ordinated processes involved in sugar production, entirely reliant on the labor of the enslaved, were the first "factories" in both the modern sense and in eighteenth-century terminology. The Cuban film *L'Ultima Cena* (1976) contains an evocative representation of these modern production techniques, leading to a revolt that is depicted as a precursor to the Cuban Revolution of 1959. By the same token, James argued that the revolution in Saint-Domingue (modern Haiti) of 1791 was the first modern proletarian revolution. According to Adam Smith, the eighteenth-century theorist of capitalism, labor was the basis of wealth. With the Great Gang concentrating labor as never before, he noted: "The profits of a sugar plantation in any of our West Indian colonies are generally much greater than those of any other cultivation that is known either in Europe or America." The process of profit-making began with the enslaved themselves. In 1710, an African person could be bought for £3 and then sold for £15, a dramatic multiple. In the 1730s, the margin had narrowed somewhat as a person was bought for £12 and sold for £25. Such rate of profit encouraged the notorious packing of slave ships with people that in turn led to a horrifying mortality rate on the infamous "Middle Passage" from Africa to the Americas. In 1771, 195 ships went to Africa from Britain shipping 47,146 people. In addition, 70 American and West Indian ships took another 57,000. Revenues amounted to £1.5 million for the people plus £500,000 for gold, mahogany and ivory. A ship named the *Lively* sailed from Liverpool in 1737 carrying cargo worth £1,307 and returned with £3,080 in cash plus a cargo of cotton and sugar. Note that

the goods exchanged for people in Africa were not wholly worthless, as is often said, but represented a significant investment. The three-fold return experienced by ships like the *Lively* was the origin of British naval power as one Liverpool slave trader acknowledged: "whenever it is abolished, the naval importance of this kingdom is abolished with it." Slave ships needed to be fast, secure and capable of taking hard use. However, there was one Liverpool shipmaker named William Rathbone who refused to make slave ships. He deserves to be remembered for showing that it was possible to refuse to be involved with slavery.

By 1798, the British Prime Minister William Pitt assessed revenues from the West Indies as £4 million, compared to the rest of the British empire producing just £1 million. When Marx claimed in 1846 that slavery was the root of modern industry it was simply common sense for most people:

> Direct slavery is as much the pivot of our industrialism today as machinery, credit, etc. Without slavery, no cotton; without cotton, no modern industry. Slavery has given value to the colonies, the colonies have created worldwide trade; world trade is the necessary condition of large scale machine industry.
>
> (Lewis, 1983: 95)

If the first famous example of capitalist production was what William Blake called the "dark, satanic mills" of England, the cotton woven in those mills had been cultivated by American slaves. Further, the rather meager diet of the new factory workers, usually displaced from the land into the growing cities, increasingly relied on colonial products, such as sugar, tea and tobacco, to stay alive and have the energy required for long hours of work. In Van Gogh's *Potato Eaters*, a depiction of nineteenth-century peasant life, the entire scene was dependent on colonial products. The peasants cultivate and eat the American potato, while they drink coffee perhaps grown in the Dutch East Indies and illuminate their meal with a lamp burning sperm whale oil. Far from being timeless workers on the land in the style of painters such as Jean-François Millet, Van Gogh's peasants were resolutely modern, living in the modernity that slavery made.

For the most part, slavery itself was invisible to Western eyes, or at least kept as far out of sight as possible, rendering slave economies peculiarly vulnerable to visual propaganda. To take one significant example, in Joseph Vernet's (1714–89) extensive series of French port paintings, commissioned by the monarchy in the 1750s, the vital contribution of enslaved African labor to the French economy was reduced to a single figure. These large-scale (typically 165 × 265 cm) panoramic views teem with detail that requires careful and extensive viewing to absorb. In all his canvases of the fifteen leading ports of France, I can see only one African at work. He is placed in the center foreground of Vernet's *Third View of Toulon* (1756). Even here his presence is displaced by comparison with the group of white prisoners condemned to the galleys at extreme right. While the African works freely by

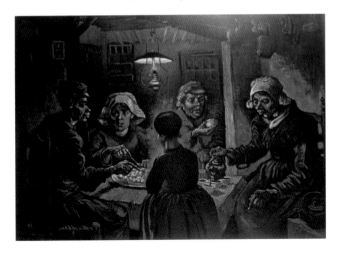

Figure 3.1
Vincent Van Gogh,
The Potato Eaters
(1884). Courtesy
Van Gogh
Museum,
Amsterdam/The
Bridgeman Art
Library

himself, and indeed under French law he would have been "free" while in France, the galley slaves are weighed down with heavy chains and under the supervision of a soldier. It seems likely that the African was not enslaved but was simply depicted as a reference to Toulon's proximity to North Africa. In the background, a long row of covered vessels can be seen that served as accommodation for the galley slaves. In short, white coerced labor finds a stronger visual presence than the Atlantic slave trade on which France's modern prosperity was based.

In British abolition campaigns of the period, this invisibility and erasure was countered by the abstract representation of the enslaved as the idea of slavery. In 1787 the potter Josiah Wedgwood, noted for the quality of his work as well as for the originality of his processes, created a medallion for the Society for Effecting the Abolition of the Slave Trade. It was made from the jaspera process that Wedgwood

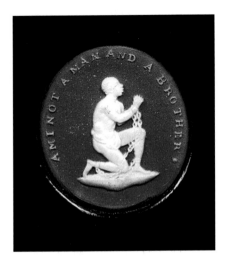

Figure 3.2 Josiah Wedgwood, *Am I Not A Man And A Brother?* (c. 1787). Enamel medallion, American Philosophical Society Museum, Philadelphia

saw as being suitable for "Cabinet pictures, or ornamenting Cabinets, Book-Cases, Writing-Tables &c, " (Bermingham, 2000: 153), placing its market as that of the intellectual. The motif depicted a kneeling African man in chains, raising his hands in supplication, beneath the motto "Am I Not A Man And A Brother?" As Mary Guyatt has argued: "the silhouette-like effect heightened the slave's shadow-like existence and depersonalized him," a strategy that nonetheless proved very effective (2000: 99). Indeed, Wedgwood's design was so successful that the medallion became a fashion item, appearing on snuffboxes, as bracelets and even as an ornament for hair (Honour, 1989: 62–3). This success gave force to Wedgwood's argument in a catalog of the same year that:

> Nothing can contribute more effectually to diffuse a good taste through the arts, then the power of multiplying copies of fine things, in materials fit to be applied for ornaments; by which means the public eye is instructed, good and bad works are nicely discriminated, and all the arts receive improvement.
>
> (Bermingham, 2000: 153)

The repeated shadow figure came to be an effective tool of abolition campaigns.

In the famous engraving, *Description of a Slave Ship* (1789), British abolitionists found a means of representing slavery that challenged the codes by which slavery was made acceptable (Finley, 1999). The engraving, in the words of Marcus Wood, "represented in cross-section, front-view and side-view, and in a series of overviews of both slave decks, the manner in which slaves could legally be packed onto the Liverpool slaver the *Brookes*" (2000: 17). The still-horrifying image shows people packed into every available space, with no room to stand or sit. Each figure is represented in an abstract manner, equal in height and size. The *Description* placed abstract representations of African bodies in an apparently precise naval architectural plan that is "perhaps best understood as a memorial to a disaster, not as a represen-tation of whatever happened" (Wood, 2000: 32). The *Description* claimed to show only how the ship was used in general rather than on a specific occasion, symbolically enacting what the leading anti-slavery campaigner Thomas Clarkson elsewhere described as the desire to enable the viewer to "comprehend the whole of [slavery] in a single view" (Wood, 2000: 4). It was consistently difficult to obtain such a view, as slavery was designed to prevent it.

The Atlantic triangle brought the two other forms of Atlantic visual culture to the Americas: the circle and the crossroads. The arts of the Atlantic world were created from the erasures, overlaps and intersections of these three competing figures. The cultural studies theorist Stuart Hall has called a culture a "distinctive repertoire of practices," exemplified by the performances of the enslaved. Performed in a circle, the "ring shout" was a key performative form for the rememorizing of African culture in diaspora (Stuckey, 1988: 3–98). Performers gathered in a circle, where, to the accompaniment of songs and drums, dance and ritual performance

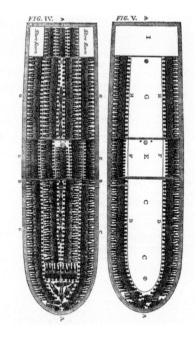

Figure 3.3
Description of a Slave Ship (1789)

were carried out. Just as nineteenth-century European proletarians challenged their own status by reading in the only time available to them, the night, so were these performances enacted at night. Slave-owners constantly wondered at the way in which the enslaved would use all their allotted rest in dancing and other perfor-mance. While they saw it as indicative of Africans' supposed lack of restraint, this reclaiming of the one available time given to the enslaved was a striking affirmation of culture as a means of sustaining identity in the most challenging circumstances. Combining African languages with perspective-resistant circles, diaspora perfor-mances of this kind resisted the means by which colonizers sought to dominate the lived environment of the plantation. Performances today commemorate the dead of the Middle Passage with a ring shout memorial ceremony. Nor were such perfor-mances in the period of slavery limited to outdoors gatherings. In Le Cap, the principal city on Saint-Domingue, there was a theater seating 1,500 people built in the 1760s that featured performers of African as well as European descent.

Often these actors were people of so-called mixed race who had obtained their freedom and were highly visible as evidence that the strict division between "black" and "white" on which slavery rested was frequently crossed in practice, whether voluntarily or not. Not for nothing was the crossroads a key location in popular African and European culture alike. In Europe, the crossroads was a powerful magical location, where murderers and other evil figures were buried to prevent their returning after death to haunt the living. London's notorious site of execution Tyburn Tree, now Marble Arch, was situated at an old crossroads. In Yorubaland

(Nigeria), the god Exu, a powerful trickster figure, presides over the crossroads. If the circle was a form to preserve cultural memory, the crossroads was the place of cultural fusion and intersection. Perhaps the most striking visual embodiments of the Atlantic crossroads are the altars and other objects created by the syncretic religions of the Caribbean that use African and European elements in synthesis. In present-day Haiti, the practice of Vodou involves performative ceremonies in which the spirits such as Baron Samédi or Erzuli descend to earth and "ride" one of their adepts. The possessed person embodies the spirit regardless of apparent clashes of gender or personality. That is to say, a woman could perform the sexually avaricious (male) Baron Samédi and so on.

The figure of the horse-rider became a visual crossroads in the Atlantic world. The first painter to emerge from enslavement in the Caribbean was José Campeche y Jordán (1751–1809), the son of a formerly enslaved African who had purchased his own freedom on the island of Puerto Rico. Campeche's mother was from the Canary Islands, a colony in the Western Atlantic near the coast of Africa, where Spanish sugar cultivation had first been practiced. Truly a child of the Atlantic world, Campeche worked for the colonial government, the church and for local people of means. His work is noticable for a series of finely observed portraits of women at leisure, including one of a *Woman on Horseback* (1785). The picture shows a woman dressed in the remarkably elaborate style associated with the court of Louis XVI of France prior to the revolution. Puerto Rico was gaining in importance in the period

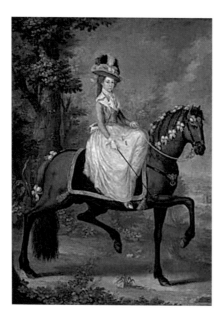 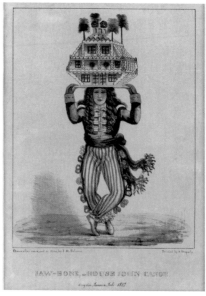

Figure 3.4 José Campeche, *Woman on Horseback* (1785). Museo de Ponce, Puerto Rico

Figure 3.5 Isaac Belisario, *Jonkonu* (1836). Courtesy of the National Library of Jamaica

and extensive sugar plantations, with their accompanying wealth creation and enslaved population, had been developed. The horse has its mane and tail braided with ribbons, matching the drama of its rider's hat. The painting has the air of being created in a studio as if against a backdrop. Is there a double meaning hidden in the painting, an allusion to the "riding" of the spirits in Atlantic world religions that were certainly known in Puerto Rico? Like all syncretic religions during active slavery, such meaning can only be alluded to rather than made explicit. In the language of criticism, one would say that a possible African reading is connoted rather than denoted. That is to say, while nothing can be seen that is simply "African," whatever that would mean, a possibility of seeing that meaning nonetheless exists, if the viewer perceives the connotation. In a print from Jamaica made just before the emancipation of the enslaved, the Jewish artist Isaac Belisario (the first known Jamaican-born artist) depicted a carnival character called *Jonkonu*, or John Canoe, whose immensely elaborate house-shaped hat clearly parodied the Rococo fashions of the slave-owners. If such parody could be shown directly with emancipation at hand, it would seem reasonable to suggest that such double meanings had been in circulation for some time.

In other Caribbean visual images from the period, such allusions can be seen more clearly. For example in the best-known print of Toussaint Louverture, leader of the revolution in Saint-Domingue (1791–1804), he is seen on horseback. Toussaint's pose at once suggests a mastery of the animal that above all others was associated

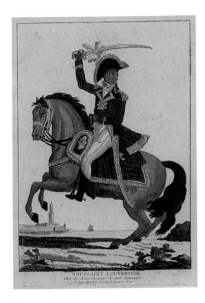

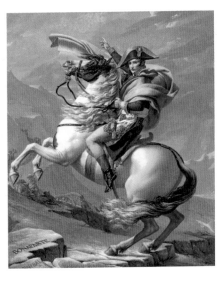

Figure 3.6 *Toussaint Louverture*. From a group of engravings done in post-Revolutionary France (c. 1802)

Figure 3.7 Jacques-Louis David, *Napoleon Crossing the Alps at the Saint-Bernard Pass* (1800). Courtesy of Musee Nat. du Chateau de Malmaison/Lauros/Giraudon/The Bridgeman Art Library

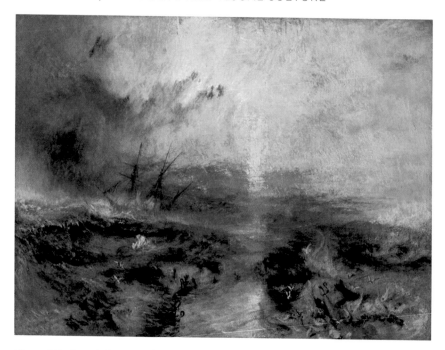

Figure 3.8 Joseph Turner, *The Slave Ship* (1840). Courtesy of the Museum of Fine Arts, Boston

with European settlement of the Americas that he as a former slave was not supposed to possess. The print shows by connotation and denotation alike his ability to "ride" the spirit, referring to the Vodou associations of the revolution, which began in 1791 with a Vodou ceremony led by the *oungan* (priest) Boukman, still remembered in Haitian art and religion today. At the same time, the image of Toussaint also makes iconographic reference to the Neo-Classical painter Jacques-Louis David's portrait of *Napoleon at the Saint-Bernard Pass* (1799). Both riders master their rearing steeds, both wear the military uniform of the French Revolution and have sufficient control to do all this with one hand. Nor have such motifs been forgotten. Jean-Michel Basquiat, the New York graffiti artist of Haitian descent, represented a scene of riding the spirits in his evocative painting *Riding With Death* (1988) that the African-American critic bell hooks has interpreted in terms of the Vodou spirits. At the same time, the painting is clearly visually influenced by Leonardo da Vinci's *Allegorical Composition*, and the street style of graffiti "tagging" from 1980s New York (Mirzoeff, 1995: 185). Basquiat's work collides intersection into intersection, refusing to limit itself to a single meaning.

Such undecidable alternance between denotation and connotation was consciously attached to slavery. In his ground-breaking analysis of the black Atlantic, Paul Gilroy called attention to Joseph Turner's 1840 painting, *The Slave Ship*, and its reception. This stunning canvas depicted one of slavery's most notorious scenes (1993: 13–14).

Slavers Throwing Overboard the Dead and Dying, Typhon Coming On, to give the painting its full title, depicted the notorious voyage of the slave ship *Zong* in 1781, whose captain ordered 132 Africans to be thrown overboard during a storm, thereby at once lightening the ship and enabling its owners to file an insurance claim for lost "cargo" (Baucom, 2005). The painting shows a moment just after the weighted-down prisoners have been thrown into the sea and just before they finally sank. Chains, hands, arms and one leg are visible in wake of the ship, leading to the bottom right corner. In his commentary, the Victorian critic John Ruskin asserted that there was no point of identification with these bodies: "we are not allowed to tumble into it, and gasp for breath as we go down." Recent accounts of the painting have also insisted on this border policing, arguing that there is no spectatorial position within the painting (Baucom, 2005: 292). In fact there are three. One can look from the point of view of those about to drown, not yet dead, who can still see through the water. Second, there is the viewpoint of the sea creatures, both the fish and the creature on the far right. Finally, there is the place marked by the pillar of light, the place of the angel of history. This light cannot be the sun unless it represents the passing of divine time, which would be in dialectical contradiction with the instant of human time that is seen in the water. History, the commodification of people, the actuarial rendering of that property and the doubled visualities resonate across this painting to the outrage of Turner's contemporaries.

In that same year, 1839, the processes now known as photography were finally perfected after many years of effort (Batchen, 1997). Far from being an unmediated depiction of exterior reality, or denotation, photography was from the first inflected by the connotations of race and slavery. If photography turns time into an object, slavery turned a person into an object. While William Henry Fox Talbot (1800–77), the legendary pioneer of British photography, was a Reform Member of Parliament in 1832 and voted for the emancipation of the enslaved in the British Empire, his photographs contained no allusions to the issue. In the Americas, where slavery was still in force when photography came into being, matters were necessarily different. Unlike painting, photography rendered slavery visible. The French artist Hercules Florence (1801–78) was the first man to use the term "photography" in 1833 in Campinas, now part of São Paolo, Brazil, a district of slave-maintained coffee plantations. According to his own account, in "1832, on August 15, while strolling on my verandah an idea came to me that perhaps it is possible to capture images in a *camera obscura* by means of a substance which changes color through the action of light. . . . I captured a negative view of the jailhouse" (Kossoy, 1977: 16). His verandah would have given a view of a world created and sustained by slavery and the jail would have housed runaways and otherwise disobedient slaves. In Brazil, slaves were often punished in the jailhouse, making it a central part of the plantation system. In the United States, the best-known early experimenter with photographic processes was Samuel B. Morse, the painter and later inventor of the famous code that bears his name. Morse experimented with silver nitrate in New Haven, probably in 1821, but once he succeeded in generating what we would now call a negative

Figure 3.9
Hercule Florence,
Sketch from Brazil
(1833)

image, he abandoned his researches. Morse was also a convinced advocate of slavery, based on his constantly reasserted opinion that it was no sin but rather "a social condition ordained from the beginning of the world for the wisest purposes, benevolent and disciplinary by Divine Wisdom" ([1914] 1973: 331). There was, then, no contradiction between being modern and being pro-slavery.

So by the time that the *New Yorker* magazine ran the story of Talbot and Daguerre's discoveries on April 13, 1839, it was no surprise to see that the specter of slavery was prominent:

> Wonderful wonder of wonders!! Steel engravers, copper engravers, and etchers, drink up your aquafortis and die! There is an end of your black art – "Othello's occupation is no more." The real black art of true magic arises and cries avaunt. All nature shall paint herself.
>
> (Foresta and Wood, 1995: 223)

The black arts of engraving and etching (in part a pun on black and white images) no longer had enough power to resist the "true black art" of photography. This magical transformation is explicitly racialized with the quotation taken from Shakespeare's drama of the African soldier Othello at the very moment when he discovers Desdemona's apparent infidelity in the form of the infamous handkerchief, proffered to him by Iago, and declares "Othello's occupation's gone" – the *New Yorker* writer misquoted. In the play, Othello follows his lament with a demand that Iago

provide "the ocular proof" that so many private investigators would later offer suspicious spouses in the form of photographs. This quotation from Shakespeare suggested far more than a simple transposition of reproductive technologies from engraving to photography. It set in play an ambiguous range of dangerous ideas from the foundational Western drama of cross-ethnic relationships to emancipation, performance, betrayal and deception. The reference to Othello had a specific connotation in New York of the period. The role was famously performed by the African-American actor and Abolitionist Ira Aldridge, who had begun his career in New York's African Theater. Moving to Britain in 1825, he made his debut as Othello in 1833, where he was identified as a "native of Senegal." A subsequent burlesque on this performance in Liverpool claimed to feature as Othello an actor "formerly an Independent Nigger from the Republic of Haiti" (MacDonald, 1994: 231). For non-slave audiences in the decade of emancipation in the British Empire, seeing a black actor in the role of Othello was a visible reminder of the diverse society that was being created. The subject matter of *Othello* was also read as a warning to white spectators concerning the imminent prospect of miscegenation that was endemic to slavery but always denied. As if to confirm this suspicion, an 1832 performance of the play in New York was followed by Thomas "Daddy" Rice jumping "Jim Crow," the minstrel character he popularized that came to be synonymous with segregation in the United States. Aldridge himself performed a version of Jim Crow from 1840 onwards.

American photography was characterized in its first 30 years by the peculiar longevity of daguerreotypy, the single-plate process devised by Daguerre. By the 1851 Crystal Palace exhibition in London, American daguerreotypes were held to be the best examples on display. One then obscure example of daguerreotypy has now come to take a prominent role in the history of African Americans and enslavement. In 1850, the Swiss scientist Louis Agassiz (1807–73), well-known for his theory of the Ice Age, employed a daguerreotypist named J.T. Zealy to take a series of plates of enslaved Africans in South Carolina. These were forgotten for over a century until their accidental rediscovery in 1975 led them to become some of the best-known images of slavery. As Brian Wallis (1995) has shown, Agassiz was engaged in attempting to find evidence for his controversial thesis of polygenesis, that is to say, the idea of entirely separate human races. He had photographs taken of what he took to be the dominant African racial groups, such as a man called Renty who was taken to depict the Congo. By Congo, slavers meant a vast area incorporating modern Congo, Angola and the Congo Republic that contained a wide array of language and cultural groups. In many of the photographs, such as those of Drana, Delia, Fassena and Renty, Agassiz's desire to see the half-naked body is fulfilled but the clothes worn by the enslaved men and women are still visible. In the cases of Drana and Delia, we can see that the women were wearing quite elaborate print dresses. The half-on, half-off dresses highlight the absurdity of the project and, taken together with the apparent "refusal to engage with the camera or its operator," noted by Wallis, contribute to the failure of the daguerreotypes to

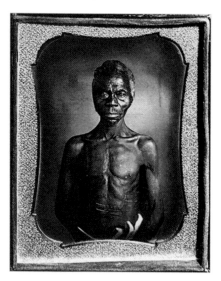

Figure 3.10 J.T. Zealy, *Renty Congo* (1850). Courtesy of the Peabody Library, Harvard University

signify what Agassiz had hoped to show. That is to say, these images fail to perform race in a satisfactory manner, meaning a visual depiction of inferiority, which perhaps contributed to their being forgotten. As a series, they constitute an attempt to call a mode of identification into being that was, for the time being, unsuccessful. Perhaps the most important aspect of the photographs was the refusal of the enslaved to perform as racialized human property.

To gain a sense of why Agassiz's images failed to perform, it is necessary to look at other deployments of enslavement in American daguerreotypes. In the account of her life in and out of slavery, Louisa Picquet detailed an exchange of photographs across the Mason-Dixon line. By 1859, the formerly enslaved Picquet had reached freedom in Cincinnati and was able to locate her mother Elizabeth Ramsey in Texas. In a dictated letter of March 8, 1859, Ramsey requested that: "I want you to hav your ambrotipe taken also your children and send them to me" (Picquet, [1861] 1988: 31).[1] The ambrotype was a cheap form of photographic reproduction, invented in 1855, and Ramsey's request shows that enslavement did not keep African Americans in ignorance of new technical developments. A.C. Horton, her owner, did later send a more expensive daguerreotype, as part of his bid to sell Ramsey to Picquet for $1,000, a not unusual price at the time – Picquet herself had sold for $1,500 (Picquet, [1861] 1988: 17). Describing the photograph, the abolitionist Mattison reported: "mother and son . . . are set forth in their best possible gear, to impress us in the North with the superior condition of the slave over the free colored people." This reading ironically seems to evacuate the people from the image. It is not hard to imagine Elizabeth Ramsey wanting to impress her daughter, who had requested the image, even as Horton was trying to justify his price. At the same time, of course, the photograph was in itself a bill of sale. In this sense it extends Allan Sekula's argument that the photograph was a form of currency, whose

In the world of enslavement, visual recognition was phantasmagorical. In Lewis Clark's narrative of his escape from slavery, he described his predicament on needing to find a place to spend the night before he could reach Ohio. To travel at night would excite suspicion. To sleep in the open risked detection by dogs and arrest as a thief if not as a runaway. So he decided to stay at a tavern:

> After seeing my pony disposed of, I looked into the bar-room and saw some persons that I thought were from my part of the country, and would know me. I shrank back with horror. What to do I did not know. I looked across the street and saw a silversmith. A thought of a pair of spectacles, to hide my face, struck me. I went across the way and began to barter for a pair of double-eyed green spectacles. When I got them on they blind-folded *me*, if they did not others. Every thing seemed right up in my eyes. Some people buy spectacles to see out of; I bought mine to keep from being seen.
>
> (Clark, 1999: 621)

The simple disguise was enough to prevent him from being recognized precisely because it covered his eyes, perhaps the one feature that might have identified the light-skinned Clark as being of African descent in the racially charged plantation state.

Precisely because the enslaved were denied the status of visual subjects, any visual agency on their part could be effective in evading capture. In a general sense, learning to read was for Frederick Douglass and many others the means to escape "mental darkness" and to achieve freedom even within slavery (Douglass, 1999: 553). As slavery became more controversial, proponents and abolitionists even debated its effects on sight itself. In 1856, the British popular science writer Joseph Turley published a volume called *The Language of the Eye* that fused seventeenth-century notions of the expressive body with Victorian morality. In Turley's view, "the eye gives the promptest and securest indication of mental motion." A key example was the effects of enslavement: "Look on the nations under slavery; how dull, sullen, dissatisfied is the expression of the eye, as though rapture and real temperament were put back for want of exercise of independence" (Flint, 2000: 26). Freedom is, then, understood to be indispensable for the proper exercise of vision. However, for the plantation owner, the opposite was the case, so that James Hammond, a well-known proponent of slavery in the United States, asserted that the senses of the slave were "dull" (Tadman, 1996: 213). Just before the Civil War a New Orleans-based doctor went so far as to claim that "the inner canthus of the negro's eye is anatomically constructed like that of the orang-outang, and not like that of the white man" (Smith, 2006: 44). Again, one slave narrative of the period asserted the opposite, claiming that "the two senses of seeing and hearing in the slave are made doubly acute by the very prohibition of knowledge" (Smith, 2006: 31). At stake here was the question posed repeatedly from the Valladolid debate of 1555 to Wedgwood's

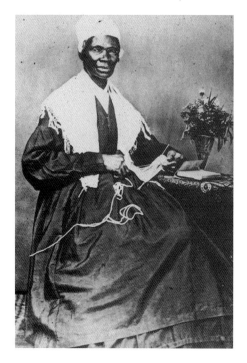

Figure 3.12 Photograph of Sojourner Truth

in crowds to his room; all classes, white and black, bond and free" (Willis, 2000: 4–5). So while there is no doubt that African Americans, free and enslaved, both took and commissioned daguerreotypes, the meanings of the resulting images were subject to dispute. Perhaps in order to resolve such ambiguities, Ball created a remarkable 600 yard panorama that presented a visual history of enslavement from Africa to Alabama. According to Willis, "operated by rotating the canvas between two poles as in a scroll, the panoramas told stories in picture form," looking forward to the cinema (2000: 7). At the same time, the daguerreotype was in itself a form of emancipation. For those condemned to the natal alienation of slavery, simply maintaining a record of one's family was a challenging and liberating act. But there were other views at the time. Writing in the immediate aftermath of the Fugitive Slave Law (1850), which made it legal for Southern slave-owners to recapture escaped slaves in the North, Augustus Washington, an African-American daguerreo-typist working in Hartford, Connecticut, wrote to the abolitionist newspaper, *The New York Tribune*, in 1851 that: "Strange as it may appear, whatever may be a colored man's natural capacity and literary attainments, I believe that, as soon as he leaves the academic halls to mingle in the only society he can find in the United States, unless he be a minister or a lecturer, he must and will retrograde" (Johnson, 1996: 269). Washington was as good as his word: he emigrated to Liberia in 1853, where he took a series of portraits of local leaders, his only known images of African Americans (Shumard, 2000).

Downs) standing on either side of a "black" child, Isaac White (Collins, 1985). The children are smartly dressed, carefully disposing their hands so as not to create a blur for the camera. Behind them stand three adults, whose dark skin and servants' clothing leaves no apparent doubt as to their African-American origins. Wilson Chinn, standing on the left, had several letters branded into his forehead as a mark of being chattel. As he was branded in a place that could not be concealed, he may very well have been an apprehended runaway. No such visible marks appear on the four white children in the front row. The selling point and scandal of the photograph was precisely the fact that all the children, by virtue of their status as former slaves, were African American. The very whiteness of the children's skin was the sign that they had no place in slavery. Slavery was to be abolished, then, not only because it was violent and inherently immoral, but also because the "wrong" kind of people were being enslaved. The older enslaved people shown in these photographs were all dark-skinned, whereas dark-skinned children only appeared as a minority, and many photographs showed just the light-skinned children. These compositions were designed to tell a story of rampant miscegenation by the Southern planters, creating an emergent generation of slaves that was more white than not. Reinforced by abolitionist newspapers and slave narratives, these photographs present slavery as a scandal of miscegenation, rape and violence, without needing to address the fundamental issues of owning people as property or distinguishing people into distinct races.

These images can be contrasted with the *cartes-de-visite* sold by the abolitionist Sojourner Truth to fund her activities (Painter, 1996). In these carefully posed images, Truth sought to counter the ambivalence of earlier abolitionist photography with a series of well-chosen signs. Dressed in respectable middle-class attire, Truth posed as if caught in the middle of knitting. Her gender-appropriate activity and dress allowed her to signify her engagement with ideas and learning, shown by her glasses and the open book. The caption that she provided for the cards showed her awareness of the ambivalences of photography: "I sell the shadow to support the substance." Here the emancipated woman makes her image the object of financial exchange in place of the substance, her whole person, which had once been for sale. It indexes freedom rather than question whether we see race. Her re-commodification of her "shadow" was justified by its substantive use in campaigning for the abolition of the ownership of people. Following the antebellum use of daguerreotypy as a means of documenting African-American freedom, Truth's use of photography shows that another "shadow archive" was possible. By insisting on her control over the financial process, Truth further asserted a freedom to dispose of her own image that the "emancipated slaves" did not possess. Truth made her shadow claim the substance of freedom, even beyond her person.

Historian Deborah Willis has identified 50 African-American daguerreotypists who emerged before the Civil War (and no doubt more await identification). One of these was James Presley Ball, a committed abolitionist, who came to Richmond, Virginia, in 1846, where according to a contemporary account: "Virginians rushed

value was based on "the archive as an encyclopedic repository of exchangeable images" (Sekula, 1986: 352). What was exchangeable in this instance was Elizabeth Ramsey herself. Surviving photographs attest to this usage. In one image, produced as a carte-de-visite around 1860, an African-American woman stands barefoot and with an utterly blank expression, wearing the number 251 to identify her as an inventory lot (Duggan, 1996: 29).

Abolitionists circulated a photograph known as *The Scourged Back* (1863) that depicted a half-naked African man, whose horribly scarred back is turned to the camera. It was intended to highlight the evils of enforced labor and human bondage, made visible as the scars of whipping(s) inflicted by a cruel slave-owner. In the plantation world-view, *The Scourged Back* was simply evidence of a crime committed and properly punished. The wider point to be drawn, in this view, was the irrepressible malfeasance of Africans, who, therefore, could only be controlled by force (Greenberg, 1996: 15). In two key sets of photographs from the moment of abolition these tensions became fully visible. After Union forces took New Orleans in 1863, schools were established for African-American children, often for the first time. As funds to support the project were low, a series of photographs, such as M.H. Kimball's *Emancipated Slaves* (1863), were created for sale. In an oval frame, two rows of people face the camera directly. In front are five children, four seeming to be "white" (namely Charles Taylor, Augusta Broujey, Rebecca Huger and Rosina

Figure 3.11 M.H. Kimball, *Carte-de-Visite of Emancipated Slaves Brought from Louisiana by Colonel George H. Hanks* (1863). The New York Historical Society

medallion: were the enslaved and colonized human or not? Abolition affirmed that all were human but did not sufficiently challenge the internal distinction to the human that came to be known as "race." Indeed, abolitionists often argued that because Africans were a weaker "race," slavery was immoral on the grounds that it took advantage of the inferior. Absolute distinction, whether between monarch and subject or slave-owner and enslaved, was now replaced with gradated distinctions centered around the idea of the "norm" and the "normal." The rise of the disciplinary society was the direct corollary and descendant of the abolition of slavery.

Coda: slavery and psychogeography

No issue seems to enrage certain people of European descent more than the suggestion that the consequences of slavery still persist. At the level of economics and politics, such as the debate over reparations for slavery in the United States, such discussions are often conducted in quantifiable terms. At the level of affect or emotion, it seems harder to set these connotations aside. Take the Tate Gallery, now known as Tate Britain, the home of the most substantial collection of Turner paintings in the world – except for *The Slave Ship*, which, with a degree of appropriateness, is in America, Boston to be precise. The gallery now houses a state-owned collection of British art, concentrating on painting, from 1500 to the present. The presence of diaspora peoples (other than the Anglo-Saxons, of course) intrudes only in special exhibitions. For example, a 2007 photography show called *How We Are Now* showed the back of a man's head who appeared to be black but otherwise offered the familiar Britain of heritage, rural beauty and observational detail, with counterpoints from a council estate and a young white man throwing up in the street. The building in which these works are housed was constructed on the site of the former Millbank Prison, designed by the Utilitarian philosopher Jeremy Bentham, from where many were deported to Australia and other locations. The current building was paid for by Henry Tate (1819–99), the sugar magnate, who made a fortune from his 1872 patented method to make sugar cubes. As the Tate website discreetly tries to suggest by means of a timeline, he was not directly engaged in plantation and his sugar manufacturing process postdated British slavery. On the other hand, the modernity in which Britain came to play so great a part was figured and shaped by the circulation of capital that plantation slavery set in motion. Tate Britain can be seen as a thought-exercise in association, connection and causality. The radical Situationist movement of the late 1950s and 1960s called such linkages of physical location with private and public meaning "psychogeography" (Debord, 2006: 283).

This multi-dimensional imaginary has been depicted by the contemporary African American artist Kara Walker (b. 1969) in her controversial cut-outs, animations and drawings. Her work represents the obscenity of slavery in its sexual violence and corporal excess, seen only in silhouette form, made from black paper or vinyl. The scenes refuse to resolve into simple narratives, although Walker often uses titles

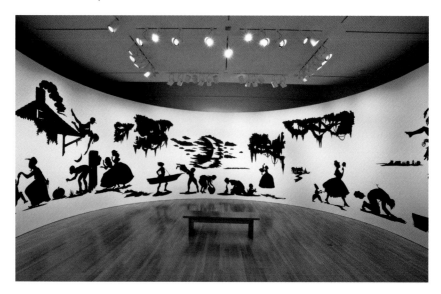

Figure 3.13 Kara Walker, *Slavery! Slavery! Presenting a GRAND and LIFELIKE Panoramic Journey into Picturesque Southern Slavery* (1997) or *Life at Ol' Virginny's Hole* (Sketches from Plantation Life). "See the Peculiar Institution as never before! All cut from black paper by the able hand of Kara Elizabeth Walker, an Emancipated Negress and leader in her Cause". Cut paper on wall, 12×85 ft (3.7×25.9m). Installation view at The Hammer Museum, LA, 2008. Image courtesy of Sikkema Jenkins & Co

for her pieces that seem to be parodies of nineteenth-century slave narratives, such as *Slavery! Slavery! Presenting a GRAND and LIFELIKE Panoramic Journey into Picturesque Southern Slavery* (1997). By using the white walls of the gallery space as the space in which these scenes are situated, Walker calls our attention to the normally "invisible" space that has been called the "white cube," referring both to the minimalist aesthetics of the art gallery and its racialized practice. The space is circular, evoking what she terms a "cyclorama," a form of nineteenth-century moving-image projection device that preceded cinema and was popular across the Anglophone colonial world from Australia to the Virgin Islands. At first, the dramatic bodies catch our attention, like that of a woman extruding fluid from her mouth, breast, armpit and vagina. A child hatches from an egg, another has two sets of legs. Then we notice details, such as the paper chains that rise in three dimensions from the wall, breaking the illusion of projection. Walker sees herself as a blank space onto which the dramas of race are projected and literally stand out. She visualizes the contradictory time and space of the American present, still split across the color line. By way of confirmation of the importance of her project, it was discovered that New York city schools were more segregated in 2007 than they were before the *Brown vs. Board of Education* Supreme Court decision of 1954. At the entrance to her 2007 mid-career retrospective at the Whitney Museum of American Art in New York, Walker posted a letter (reproduced here as she wrote it with spelling "mistakes"):

Dear you hypocritical fucking Twerp,

I hope that the time we spent in the Quarters with my family sleeping
neerby quietly ignoring what you proceeded to do to me – what, rather
I proceeded to do to you – ws worthwhile for you, that you got the
stimulation you so needed, Because now That I'm Free of that poison
you call Life, that stringy, sour white strand you called Sacred and me
savior, that peculiar institution we engaged in because there was no
other foreseeable alternative, I am LOST.

 Before when there was a before, an upon a time, I was a blank space
defined in contrast to your POSITIVE, concrete avowal. now a blank
space in the void.

Note

1 The "illiterate" style of the letter is possibly an interpolation of Mattison's as the narrative
 suggests that both mother and daughter could not write so the letter must have been
 dictated.

References

Batchen, Geoffrey (1997), *Burning With Desire: The Conception of Photography*, Cambridge,
 MA and London: MIT Press.

Baucom, Ian (2005), *Specters of the Atlantic: Finance Capital, Slavery, and The Philosophy of
 History*, Durham, NC and London: Duke University Press.

Bermingham, Ann (2000), *Learning to Draw: Studies in the Cultural History of a Polite and Useful
 Art*, New Haven, CT: Yale University Press.

Clark, Lewis (1999), "Narrative of Lewis Clark" (1845), rpr. in Taylor (1999).

Collins, Kathleen (1985), "Portraits of Slave Children," *History of Photography*, vol. 9 no. 3,
 pp. 187–207.

Debord, Guy (2006), *Oeuvres*, Paris: Gallimard.

Douglass, Frederick (1999), "Narrative of the Life of Frederick Douglass," rpr. in Taylor
 (1999).

Duggan, Ellen (1996), *Picturing the South: 1860 to the Present*, Atlanta, GA: High Museum
 of Art.

Finley, Cheryl (1999), "Committed to Memory: The Slave-Ship Icon in the Black Atlantic
 Imagination," *Chicago Art Journal*, vol. 9, pp. 2–21.

Flint, Kate (2000), *The Victorians and the Visual Imagination*, Cambridge and New York:
 Cambridge University Press.

Foresta, Merry and John Wood (1995), *Secrets of the Dark Chamber: The Art of the American
 Daguerreotype*, Washington, DC: National Museum of American Art, Smithsonian
 Institution Press.

Gilroy, Paul (1993), *The Black Atlantic Modernity and Double Consciousness*, Cambridge, MA:
 Harvard University Press.

Greenberg, Kenneth S. (1996), *Honor and Slavery*, Princeton, NJ: Princeton University
 Press.

Guyatt, Mary (2000), "The Wedgwood Slave Medallion: Values in Eighteenth-century Design," *Journal of Design History*, vol. 13 no. 2, pp. 93–105.

Honour, Hugh (1989), *The Image of the Black in Western Art*, vol. IV part 1 "Slaves and Liberators," Cambridge, MA and London: Harvard University Press.

James, C.L.R. (1968), *The Black Jacobins*, 2nd edn, London: Allison & Busby.

Johnson, Carol (1996), "*Faces of Freedom*: Portraits from the American Colonization Society Collection," *The Daguerreian Annual*, p. 269.

Kossoy, Boris (1977), "Hercules Florence, Pioneer of Photography in Brazil," *Image*, vol. 20 no. 1, pp. 12–21.

Lewis, Gordon K. (1983), *Main Currents in Caribbean Thought: The Historical Evolution of Caribbean Society in its Ideological Aspects, 1492–1900*, Baltimore, MD: Johns Hopkins University Press.

MacDonald, Joyce Green (1994), "Acting Black: *Othello*, *Othello* Burlesques and the Performance of Blackness," *Theatre Journal*, vol. 46, pp. 231–49.

Mirzoeff, Nicholas (1995), *Bodyscape: Art, Modernity and the Ideal Figure*, London and New York: Routledge.

Morse, Edward Lind (ed.) ([1914] 1973), *Samuel F.B. Morse: Letters and Journals*, New York: Da Capo Press.

Painter, Nell (1996), *Sojourner Truth: A Life, A Symbol*, New York: W.W. Norton.

Picquet, Louisa ([1861] 1988), *The Octoroon: or Inside Views of Southern Domestic Life* by H. Mattison, reprinted in *Collected Black Women's Narratives*, New York and Oxford: Oxford University Press.

Schaaf, Larry J. (ed.) (1994) "David Brewster to Talbot, 12 February 1839," in *Selected Correspondence of William Henry Fox Talbot 1823–1874*, London: Science Museum and National Museum of Photography, Film and Television, p. 18.

Sekula, Allan (1986), "The Body and the Archive," *October*, vol. 39, pp. 3–64.

Shumard, Ann M. (2000), *A Durable Memento: Portraits by Augustus Washington, African American Daguerreotypist*, Washington, DC: National Portrait Gallery, Smithsonian Institution.

Stuckey, Sterling (1988), *Slave Culture: Nationalist Theory and the Foundations of Black America*, New York: Oxford University Press.

Smith, Mark M. (2006), *How Race is Made: Slavery, Segregation, and the Senses*, Chapel Hill, NC: University of North Carolina Press.

Tadman, Michael (1996), *Speculators and Slaves: Masters, Traders and Slaves in the Old South*, 2nd edn, Madison, WI: University of Wisconsin Press.

Taylor, Yuval (ed.) (1999), *I was Born A Slave: An Anthology of Classic Slave Narratives*, vol. 1 1772–1849, Chicago, IL: Lawrence Hill Books.

Wallis, Brian (1995), "Black Bodies, White Science: Louis Agassiz's Slave Daguerreotypes," *American Art*, vol. 9 no. 2, pp. 39–61.

Williams, Eric (1944), *Capitalism and Slavery*, New York: Capricorn.

Willis, Deborah (2000), *Reflections in Black: A History of Black Photographers 1840 to the Present*, New York and London: W.W. Norton.

Wood, Marcus (2000), *Blind Memory: Visual Representations of Slavery in England and America, 1780–1865*, New York: Routledge.

specters and phantasmagorias of emancipation. Carlyle imagined the eye of history sweeping across what he called "clear visuality," "visualizing" what could not be seen by the minor actors of history themselves (Carlyle, [1841] 1993). Visuality was, then, the clear picture of history available to the Hero as it happens and the historian in retrospect. It was not visible to the ordinary person whose simple observation of events did not constitute visuality. Consequently, Carlyle's new language of visuality was explicitly opposed to the Benthamite theory of reform that has come to be epitomized in the visual technology of the Panopticon. Carlyle's concern was to provide a history and theory for his conservative mode of anti-emancipation, resistant to what he later called "Bethamee [sic] constitutions," Chartism and the emancipation of the enslaved. In their place, Carlyle offered only one thing: "the right to be led." This was an aristocracy of heroes, those who led because they deserved to do so and were not challenged by the weaker mass of people. Such theories were developed in the twentieth century to disastrous ends and Carlyle was an influence on Mussolini's fascism and Hitler's Nazism. It is said that the last book Hitler had with him in the bunker in 1945 was Carlyle's history of Frederick the Great.

Nonetheless, throughout the nineteenth and early twentieth centuries, intellectuals and artists struggled with and against Carlyle. Oscar Wilde knew long passages of Carlyle by heart and bought his writing desk for his own use. It is curious to think of Wilde's paradoxical dramas of sexuality and society being written on the same surface that produced Carlyle's broadsides. In the United States, Carlyle's ideas were widely disseminated, especially by his friend and admirer Ralph Waldo Emerson, whose own book *Representative Men* gave an American twist to the idea of the Hero. As a student at Fisk and Harvard, the African-American scholar and activist W.E.B. Du Bois was much influenced by Carlyle. Following Emerson's definition of the "Representative," Du Bois held that "an aristocracy of talent and character" was to perform a necessary action on behalf of their fellows: "The Negro race, like all races, is going to be saved by its exceptional men" (1986: 847, 842). On the other hand, the Italian Marxist Antonio Gramsci, so influential in cultural studies, rejected the two poles of what he called bourgeois history that he saw as being embodied in Carlyle and the Social Darwinist Herbert Spencer (Gramsci, 2000: 37). He turned instead to a revised version of Marxism, just as Du Bois would come to do in the crisis of the 1930s. These histories of visuality need to inform our own usage of the term in a period where once again leaders are claiming to be heroes, seeing what we cannot, and demanding our adherence to their vision.

References

Carlyle, Thomas ([1837] 1989), *The French Revolution*, ed. K.J. Fielding, Oxford and New York: Oxford University Press.

—— ([1841] 1993), *The Norman and Charlotte Strouse Edition of the Writings of*

Cultural Studies. It would be particularly appropriate for visuality, as Raymond Williams devoted a section of his classic *Culture and Society* (1958) to Carlyle. Thinking of vision in terms of subcultures is a provocative idea that would suggest an examination of vision and visuality as what Paul Gilroy, himself following Williams, called in a different context "structures of feeling, producing, communicating and remembering" (1993: 3). In fact, Jay proposed a scheme, which he acknowledged to be provisional, opposing Renaissance and Baroque ways of seeing, with the "Renaissance" being subdivided into "perspectival" and "descriptive" modes. Using similar language, Jonathan Crary introduced his now familiar theory of the collapse of the *camera obscura* as a model of vision in terms of a discontinuity within "a dominant Western speculative or scopic tradition of vision" (1988: 29).

Thomas Carlyle coined both "visuality" and the verb "visualizing" in a series of writings between 1837 and 1841 designed to create a spiritual antidote to modernity that was nonetheless strongly supportive of imperialism. The terms followed from his sense of his work as embodying the "eye of history" ([1837] 1989: 8). By this he did not mean the objectivity promoted both by modern historians and his own contemporaries like Leopold von Ranke. Like his otherwise opposed contemporary Macaulay, he refused the technical apparatus of historical research such as archives or even libraries, seeing them as the product of "Mr Dryasdust" (Carlyle, 1843). History was far more than the accumulation of facts and historians themselves were often questionable for Carlyle because they presented events as "*successive,* while the things done were often *simultaneous*" (Schoch, 1999: 29). To capture this simultaneous quality, Carlyle wanted to convey an "Idea of the whole" (Rigney, 1996: 344), which he rendered by means of what he called "a succession of vivid pictures" (Schoch, 1999: 38). These pictures were, it might be said, History paintings that had long been celebrated for their ability to sustain a narrative within a single frame. Visuality, then, ordered and narrated the chaotic events of modern life in intelligible, visualized fashion.

Carlyle's pictorial history was reacting to what he called "the loud-roaring Loom of Time with all its French Revolutions, Jewish Revelations" (Carlyle, [1837] 1989: ix), linking the French Revolution to its emancipation of French Jews. This sense of modernity as mechanized chaos was deeply antithetical to his beliefs in a patriarchal Tradition but he nonetheless recognized that he must respond to it. Political revolution and emancipated revelation were so intertwined as to weave "the deranged condition of our affairs" (Carlyle, 1855: 2), thereby suggesting that Enlightenment had in fact ushered in an age of unreason, rather than exert its claim to enact rationality. In counterpoint to this spectral reality of everyday people, with their eternal tendency to amalgamate as Revolution, Carlyle constructed a visualized form of history, dominated by heroes. In his lectures *On Heroes,* Carlyle argued that only the Hero had the vision to see history as it happened, a viewpoint that was obscured for the ordinary person by the

that came to have considerable resonance in the period. Indeed, in this era of Christian-inspired imperial ventures, his ideas do not sound altogether unfamiliar today. For many key figures in emancipatory movements of the period, Carlyle's vision of the Hero had to be stood on its head, as Marx did to Hegel, in order to create a sense of possibility. These strategies can be seen as part of the modern production of the visual subject, a person who is both the agent of sight (regardless of biological ability to see) and the object of discourses of visuality. In many instances, the claim to visual subjectivity was part of a general claim to majoritarian status within Western nations for those like women, the enslaved and their free descendants, and people of alternative sexualities. The centrality of Carlyle's discourse of visualized heroism to Anglophone imperial culture was such that any claim to such subjectivity had to pass by visuality. Here lies the contradictory source of the resonance of "visuality" as a keyword for visual culture, as both a mode of representing imperial culture and a means of resisting it by means of reverse appropriation.

The introduction to Foster's 1988 volume continues to be widely cited as it has been one of the few efforts to define the term (Rose, 2003), so his formulas are still of importance. In the opening paragraph, Foster proposed that: "Although vision suggests sight as a physical operation, and visuality as a social fact, the two are not opposed as nature to culture" (1988: ix). Now that the critical work of Judith Butler and others has so effectively reduced the nature/culture divide, it is all the more apparent that in dealing with vision and visuality: "the difference between the terms signals a difference within the visual . . . a difference, many differences, among how we see, how we are able, allowed, or made to see, and how we see this seeing or the unseen therein" (Foster, 1988: ix). These differences are, however, seen as being regulated by each "scopic regime" into "one essential vision." *Vision and Visuality* sought to disrupt this homogenizing process by discussing the physiology of vision and its psychic import, and to "socialize this vision" and its production of subjectivity. By placing this individual visuality into tension with "its own production as intersubjectivity," one would arrive at an understanding of the "dialectic of the gaze." The project in general sought to "historicize modern vision," a history that needed to be defined, determined and questioned. This was an ambitious project indeed, and its continued importance is clear. Yet, as the slippage over the nature/culture divide shows, the critical apparatus used to support it often elides conceptual difficulties.

Martin Jay adopted the notion that a given "scopic regime" was hegemonic in a particular period of time from the film theorist Christian Metz (Jay, 1988: 3; Metz, 1982: 61). Against what he saw as a dominant tradition of Cartesian perspective, Jay argued that Western modernity should be "understood as a contested terrain, rather than as a harmoniously integrated complex of visual theories and practices" (1988: 4). He called these competitive visualities "visual subcultures," borrowing a term from the Birmingham Center for Contemporary

VISUALITY

Visual culture gained one of its signature ideas from Hal Foster's (1988) edited collection *Vision and Visuality*, now 21 years old. Taking the two terms of the title to refer to the physical processes of sight and the "social fact" of visuality respectively, Foster nonetheless argued that they could not be simply distinguished. Rather he proposed a dialectical interface between the two that could rework then widespread models of a single dominant or bourgeois culture. To do so, the various contributors used tools from poststructuralism, psychoanalysis, art history and history, generating an ambitious project for the situation of vision and visuality within Western modernity. One of the few stones left unturned was the key term visuality itself. Far from being a poststructuralist term of art, visuality together with other related terms like visualize was in fact coined by the complex and controversial Scottish historian Thomas Carlyle (1795–1881) in 1840. Although Foster's account did acknowledge the importance of historical predecessors like Panofsky (Foster, 1988: xiv), it is hardly surprising that Carlyle did not feature in the discussion at that time. As one typical description by a leading Carlyle critic ran: "Carlyle's unequivocally antidemocratic spirit, stylistic self-indulgence, shameless racism and deeply felt sexism have dropped him almost absolutely from favor at the moment" (Levine, 1997: 45).

In recent years, however, nineteenth-century studies have reconfigured both their sense of the period in general and of Carlyle in particular. Rather than concentrating on the critique of a dominant bourgeoisie, studies of the period now emphasize its complexity, with debates over the status of key terms such as representation, all understood in relation to imperialism (Hall, 2002). Carlyle has emerged in this context as a key figure. Opposed to Chartism, panopticism and all the emancipatory movements that stemmed from the French Revolution, Carlyle imagined a moral imperialism led by great men in a visualized narrative

Thomas Carlyle: On Heroes, Hero-Worship and the Heroic in History, notes and introduction by Michael K. Goldberg, text established by Michael K. Goldberg, Joel J. Brattin and Mark Engel, Berkeley and Los Angeles: University of California Press.

—— (1843), *Past and Present*, London.

—— (1855), "Model Prisons," pub. March 1850 rpr. in *Latter-Day Pamphlets*, London: Chapman and Hall.

Crary, Jonathan (1988) "Modernizing Vision," in Foster (1988).

—— (1991), *Techniques of the Observer*, Cambridge, MA: MIT Press.

Du Bois, W.E.B. (1986), *Du Bois: Writings*, New York: The Library of America.

Foster, Hal (ed.) (1988), *Vision and Visuality*, Seattle, WA: Bay Press.

Gilroy, Paul (1993), *The Black Atlantic: Modernity and Double-Consciousness*, Cambridge, MA: Harvard University Press.

Gramsci, Antonio (2000), *The Antonio Gramsci Reader*, ed. Davic Forgacs, New York: New York University Press.

Hall, Catherine (2002), *Civilizing Subjects: Metropole and Colony in the English Imagination, 1830–1867*, Chicago, IL: University of Chicago Press.

Jay, Martin (1988), "Scopic Regimes of Modernity," in Foster (1988).

Levine, George (1997), "Carlyle, Descartes and Objectivity," *Raritan*, vol. 17, pp. 45–58.

Metz, Christian (1982), *The Imaginary Signifier: Psychoanalysis and the Cinema*, Bloomington, IN: Indiana University Press.

Rigney, Ann (1996), "The Untenanted Places of the Past: Thomas Carlyle and the Varieties of Historical Ignorance," *History and Theory*, vol. 35 no. 3, pp. 338–57.

Rose, Gillian (2003), *Visual Methodologies: An Introduction to the Interpretation of Visual Methods*, London: Sage.

Schoch, Richard W. (1999), "'We Do Nothing But Enact History': Thomas Carlyle Stages the Past," *Nineteenth-Century Literature*, vol. 54 no. 1, pp. 27–52.

Williams, Raymond (1958), *Culture and Society, 1780–1950*, New York: Columbia University Press.

PANOPTIC MODERNITY

BEGINNING IN THE late eighteenth century, a striking change came over systems of social organization and classification in Europe. Where nations had once publicly executed and tortured criminals, they now imprisoned them or executed corporal punishment out of sight. In the monarchical system, a crime was understood as an attack on the monarch that had to be rectified by a punishment meted out to the body of the condemned. The sufferings of torture were understood both as an expiation of the crime and as a means of restoring the king's imagined body, that is to say the state of majesty, to its proper state. The worst tortures, such as the extended dismembering of Damiens in 1757 were therefore reserved for those who literally attacked the King in person. In 1894 when Captain Alfred Dreyfus was falsely convicted of spying for Germany, he was sentenced to penal servitude and was publicly cashiered. That is to say, where Damiens had undergone the most extreme sufferings of the flesh, culminating in his being pulled apart by horses, Dreyfus suffered the public humiliation of the soul in which his marks of military rank were cut off, his sword broken and his fellow soldiers turned their backs on him in front of a crowd of 20,000 people. The point here is not that Dreyfus's punishment was lesser than that of Damiens. Indeed, the Dreyfus Affair was one of the key developments in the rise of modern anti-semitism whose consequences became clear in Nazi Germany. Rather it indicates that whereas the monarch had punished the physical body, the state punished and corrected the "soul," a phenomenon that was called into being by the processes of discipline using the language of religion.

Accompanying and interacting with the change in regimes of punishment to codes of discipline was the emergence of the concept of the "norm." As theorized by Jacques Quételet in 1844, the norm provided a means to rank and organize apparently random phenomena, such as height and weight. By means of statistical analysis, it could be demonstrated that in a given category, such characteristics tended to

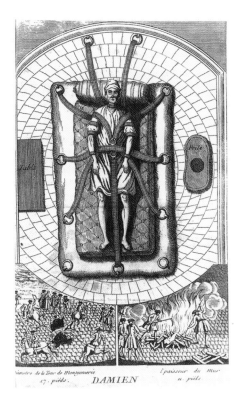

Figure 4.1 Damiens being broken on the wheel during the French Revolution (c. 1757)

group in what has become known as a "bell curve." That is to say, if the data are plotted on a graph, the resulting curve looks like the outline of a bell, rising from the leading edge to a flattened peak and dropping down again. Those areas of the curve at and close to the peak represented the greatest number of cases and would be defined as the "norm." It is important to recognize that the process of defining a norm relied on determining what lies outside it. So "transgressive" behavior or categories of being are not only predicted by the normative but required by it in order to delineate the norm. The statistical process of analyzing the norm was transferred to the human sciences as the binary category of the normal and the pathological. A given state thus has two variants, one normal, the other pathological or diseased. Thus whereas it had been once possible to describe someone as being, for example, one-third deaf, by the middle of the nineteenth century a person was either hearing, and thus normal, or deaf and thus pathological. The usages of the normal have often been very beneficial in medical care and social analysis. However, they have also lent themselves to defining certain categories of people as altogether pathological, a definition that has in extreme cases lent to their physical extermination.

Following the research of French philosopher Michel Foucault, one can call this transformation the emergence of "bio-power," a power over life itself. Bio-power had two predominant forms in modern society. First, it sought to train and discipline

the individual body. For example, a person became a soldier through the practice of drills, a ritual that has been enshrined in many movies as the making of formerly weak people into strong soldiers. In Foucault's analysis, the goal was the production of "docile bodies." A docile body could work on the new mechanized production lines in factories without causing injury to itself or others, adapt to the social environment of the new cities and create new behaviors suitable for life in crowds and other public spaces. The second goal of bio-power was the maximum extension of life by means of health provisions, retirement and other welfare systems. A trained workforce was worth preserving at the instrumental level and such rewards provided an incentive for people to participate in the new structures of work. At the abstract level, power did not just repress people. In Foucault's view, power flows in networks, like electricity, and can be used in different ways, even by the apparently powerless. A significant part of his research was devoted to recovering the traces of those designated insane or otherwise deviant by the system of disciplinarity and using their histories as key evidence for how society as a whole was organized.

Foucault's key illustration of this radical shift was the Panopticon devised in 1791 by Jeremy Bentham, an English philosopher. The Panopticon – literally, the place where everything is seen – was Bentham's device for a model prison. He called the Panopticon "an inspection house" for the reformation of morals, whether of prisoners, workers or prostitutes, by means of constant surveillance that the inmates could not perceive, a system summed up by Foucault in the aphorism "visibility is a trap" (1977: 200). The Panopticon proper would have consisted of an outer ring of cells, supervised from a central control tower, constructed so that each prisoner could see neither his fellows nor the supervisors in the tower but was fully visible to anyone watching from the tower. The guards could thus see the prisoners without being seen themselves. Rather than control prisoners with expensive fortifications and numerous guards as was traditionally the case, they could now be managed from one central point. The vanishing point that organized perspective had now become a point of social control. Bentham imagined it as being constructed from the then new architectural materials of iron and glass, which he called "a glass bee-hive." A proper Panopticon would thus have looked more like the Crystal Palace built for the International Exhibition in 1851, or the Paris Arcades, than the forbidding structures actually built in the period. It was also technically difficult in the period to achieve the permanent visibility so central to the project. Bentham at first proposed that the prisoners would in effect be back-lit by large glass windows, while lamps backed by reflectors would generate visibility at night. When the then governor of prisons heard of the scheme, he simply pointed out, "They will all get out." Later Bentham proposed using gaslight, an idea far ahead of its time, as was his scheme for listening tubes in each cell (Semple, 1993: 116–21). So although the principle of surveillance was central to nineteenth-century prisons, schools, military barracks and factories alike, it is true to say that no real Panopticon was ever built. The closest approximation was a prison for recalcitrant deported convicts erected in Port Arthur, Tasmania.

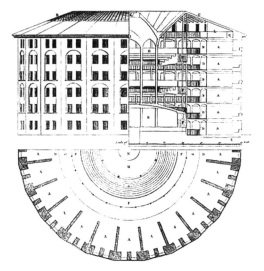

Figure 4.2 Panopticon. Blueprint by Jeremy Bentham (1791)

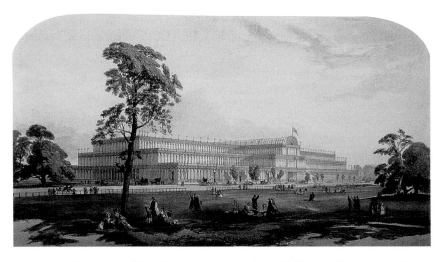

Figure 4.3 The Crystal Palace from the northeast from Dickinson's *Comprehensive Pictures of the Great Exhibition of 1851* (1854)

The Panopticon sought to control prisoners and keep discipline through a system of visibility:

> And, in order to be exercised this power had to be given the instrument of permanent, exhaustive, omnipresent surveillance, capable of making all visible as long as it could itself remain invisible. It had to be a faceless gaze that transformed the whole social body into a field of perception.
>
> (Foucault, 1977: 214)

The disciplinary society differed from early modern visibility in that it ceased to matter exactly who was watching so long as individuals continued to be visible. Whereas the Hall of Mirrors at Louis XIV's Palace of Versailles displayed the body politic itself – that is to say, the symbolic power of the King as manifested in his individual person – in the Panopticon it did not matter who was looking. Bentham specified that while the system was devised so that the prison governor could supervise the inmates, anyone could be substituted, even servants or children, because the prisoners could not see who was looking. They knew only that they were being watched. Perspective ordered the visual field and created a place from which to see. The Panopticon created a social system around that possibility of seeing others. The key to this visualized system was that those who felt themselves to be observed could be controlled.

The disciplinary system was in effect the fusion of the colonial system of surveillance of the enslaved and colonized with the new classifications created by the norm and its predication of a binary opposition between the normal and the pathological. Foucault suggested that the disciplinary system could first be observed in the Jesuit colonies in Paraguay "in which existence was regulated at every turn" (Foucault, [1967] 2002: 235). This surveillance was carried out directly, whether by the Jesuit priests in their colonies or the aptly named overseer on the plantation. It was reinforced and made viable by the ever-present threat of extreme physical violence used in slavery and colonization alike. The Panopticon was intended to reduce the need for such punishment of the body. It did so by prompting the prisoner (the soldier, the factory worker, or the child) to discipline themselves, that is to say, to subject themselves to a series of norms. Bentham explicitly derived his project from from a Russian system adopted or created by his brother for a factory in St Petersburg. It was intended to be the solution for the mass overcrowding of British prisons that was in fact solved by the deportation of prisoners to Australia, where the First Fleet anchored in 1788. In short, the Panopticon was the creature of the globalization of its day.

Foucault derived from the Panopticon the principle of power itself: "Power has its principle not so much in a person as in a certain concerted distribution of bodies, surfaces, lights, gazes. . . . The Panopticon is a marvelous machine which, whatever use one may wish to put it to, produces homogenous effects of power" (Foucault, 1977: 201). If the distribution of lights, gazes and surfaces within the Panopticon were changed, then it would have disrupted the principle of power. The power of visuality was in fact far from homogenous. Bentham knew what lurked within his panopticon papers: "it is like opening a drawer where devils are locked up – it is breaking into a haunted house" (Semple, 1993: 16). He even came to realize that solitary confinement, a key part of his original plan, was in fact its undoing as a system of visibility: "in a state of solitude, infantine superstitions, ghosts and spectres, recur to the imagination" (Semple, 1993: 132). In short, the marvelous machine was out of order. The prisoner could neither be perfectly visible nor be constantly aware of disciplinary surveillance. Consequently, they were not disciplined, but simply punished: they became ghosts.

Discipline and color

The discipline established by the panoptical system with its structure of norms extended as far as color, the presumed opposite of perspective and other geometric systems of ordering space. Color presents an interesting complementary case to that of perspective, rather than a radical contrast. Throughout the early modern period, color was an alternative method of pictorial construction to the geometric perspective system. Obviously, color perception is a crucial part of human eyesight. Unlike perspective, it has been possible to describe color in exact scientific terms as a property of light, but the perception of color varies from person to person, even before the vexed questions of taste and color symbolism can be addressed. As a consequence, artists, scientists and visual technicians have sought various ways to render the depiction of color without the possibility of variation or dispute. In this way, the representational aspect of the visual image could be balanced with the resemblance provided by accurate depiction of color. However, color's seemingly infinite variations of hue, tint and shade provide stubborn resistance to such classification. Artists and scientists have devised an apparently endless array of color charts, triangles and wheels that were the analog to the perspectivists' geometric diagrams. No one was ready to go into the picture space unaided.

No effective system could be devised for standardizing the construction of picture space by color. Artistic uses of color very soon differed from the scientific understanding of the subject. Painters from the seventeenth century onwards have held that all colors can be created using three primary colors, namely blue, red and yellow. However, in his famous *Opticks* (1704), Isaac Newton showed that light was composed of seven prismatic colors: red, orange, yellow, green, blue, indigo and violet. By the mid-nineteenth century the German scientist and philosopher Hermann von Helmholtz (1821–94) was able to show that there was a fundamental difference between additive and subtractive means of making color. Colored light relies on adding light together, based on the primary colors red, green and blue. Paint and other forms of pigment absorb certain forms of light from the spectrum in order to generate the perception of a specific color, and thus used blue, red and yellow as primaries (Kemp, 1990: 262). Helmholtz's explanation has since been shown to be flawed but at the time it helped explain why artists and scientists had differed over the very composition of color for 150 years.

The normalization of vision around the perception of color can be illustrated with the case of color blindness. It was not until the first half of the nineteenth century that ophthalmologists first discovered the existence of color blindness and then devised tests to diagnose the condition. The British scientist John Dalton had recognized his own inability to perceive red in the 1790s, naming the condition "Daltonism." After Charles Darwin's *The Origin of Species* (1859) had given wide currency to the notion of evolution, intellectuals began to play with the idea that color vision had evolved in humanity within historical time, rather than in the mists of prehistory. This is an excellent example of the misuse of evolution to explain differences within one species, namely the human species, rather than relative

patterns of development between species. In order to explain this discrepancy, scientists postulated that the human species was in fact composed of different races who were biologically different from each other. It must be emphasized that despite a century of scientific endeavor to identify these differences, no definable biological difference between humans has been found. Indeed, genetic science has clearly shown that all humans share the same gene pool. Nonetheless, social Darwinism – as this application of evolution to humans was called – has flourished for over a century as a means to seek rational explanations for the irrationality of racial prejudice. So far reaching were these efforts in the nineteenth century that intellectuals claimed to have identified historical differences in color perception amongst the different "races."

Anthropologists combined old antisemitic and racist prejudices with the new "science" of race to provide a racial origin for color-blindness. In 1877, the German philologist Hans Magnus conducted a study of color in the work of the ancient Greek poet Homer. He found a very restricted number of Homeric terms for color, most of which appeared to distinguish light from dark more than they did particular tints. He concluded that Greeks of the period had in fact seen in black and white and that the color sense was a recent and developing aspect of human evolution that would soon permit humans to perceive the ultra-violet elements of the spectrum. Magnus developed this argument to explain color-blindness in hereditary terms:

> Beginning from the opinion that, in the most distant periods of human evolution, the functional capacity of the retina was restricted to detecting manifestations of light, . . . we are inclined to believe that cases of complete congenital color-blindness must be considered a type of atavism.
>
> (Magnus, 1878: 108)

Recognizing the importance of color to manufacturing, Magnus developed a practical color chart in order to educate the industrial working classes in the names and range of color.

These ideas were given dramatic support by the British prime minister and noted classical scholar, William Gladstone. Gladstone conducted his own study of ten books of the *Odyssey* and found only "thirty-one cases in nearly five thousand lines, where Homer can be said to introduce the element or the idea of color; or about once in a hundred and sixty lines" (Gladstone, 1877: 383). For the Victorians, Homer's prestige was so great that this oversight could not be attributed to mere indifference to color or simple failure of description, it had to indicate a profound truth. Gladstone therefore concluded that the Greeks' perception of color was like a photograph, that is to say black and white. His empirical evidence came from the colonies: "Perhaps one of the most significant relics of the older state of things is to be found in the preference, known to the manufacturing world, of the uncivilized races for strong, and what is called in the spontaneous poetry of trading phrases,

loud colour" (Gladstone, 1877: 367). That is to say, if color vision evolved gradually, it was only natural that the least evolved preferred strong, intense colors that were easy to distinguish.

As these remarks from one of the most distinguished Liberal prime ministers of the century show, almost all Europeans casually assumed their superiority to other "races," such as Africans, Asians or Jews, who demonstrated that inferiority by their vulgar taste for loud colors. This prejudice often continues to be expressed against Mexican immigrants to the United States, Indians in Great Britain and Jewish communities everywhere. Soon racial "science" advanced the belief that, because of their presumed intermarriage since Biblical times, Jews were especially prone to color-blindness as an atavistic throwback to early human history. Africans and other colonized peoples were already perceived as being "stuck" at this early stage of development, as evidenced by Western military and technological superiority. The peculiar combination of literary and political authority, mingled with the empirical "truths" of colonialism and anthropology that gave rise to the notion of the evolution of the color sense was simply too embedded in nineteenth-century common-sense to be challenged. The result was that the disciplinary system of vision that had been instituted in the early nineteenth century became racialized around the issue of color. By adding the "scientific" dimension of race to the fugitive trace of color, it became possible to restore a dimension of presumed objectivity to the subjective perception of color that color-blindness had been revealed to be far from universal.

Around the time that Gladstone published his article on Homer, a fatal railway accident in Sweden was attributed to the color-blindness of the train driver. The Swedish physiologist Fithiof Holmgren (1831–97) established that 13 of the 266 workers on his local railway line were color-blind and set about devising a standardized test. For if safety depended upon the ability to distinguish between a red and green railway signal, whether by light or flag, it was important that an employee could register that difference. In this example, we see the double-edged nature of modern discipline. It is clearly in the interests of all passengers and railway employees that signal staff be able to distinguish between the lights and flags. It became imperative to devise a test. Using the actual flags was held to be too simple because the subject had too good a chance of passing by luck. Holmgren devised a wool test in which the subject was presented with a random collection of strands of wool and asked to select those that matched another single strand, dyed pale green. According to an account published in *Nature*, "when confusing colours have been selected, or when an unnatural slowness and hesitation have been shown in selecting, the examinee must be regarded as either completely or incompletely colour-blind" (Brudenell Carter, 1890: 60). For the employee, a failed test meant dismissal. It was claimed that 4 percent of the "civilized" suffered from color-blindness, a point emphasized by claims that it was especially prevalent among Jews and less noticeable in the schoolboys of Eton, Britain's foremost private school. Both Holmgren's test and Magnus's color chart were introduced into the United States by Dr. Benjamin Joy Jeffries (1833–1915), who campaigned for their widespread

adoption. In less than a century, vision had become subdivided into a series of differentiated categories of color perception, centering around a norm, which were established by testing, trained by education, subjected to racialization and calculated by statistics.

Light over color

Nineteenth-century avant-garde art, such as that of the Impressionists, is usually thought of as being far removed from such prejudices. Yet their assertion of the domination of color and then light in art often made explicit or implicit use of such racialized imagery. Later nineteenth-century artists sought to control color by again subjecting it to racial theory and ultimately by concentrating solely on light. Through this focus on light, the Impressionists and later modern artists sought to control reality itself. The pro-Impressionist critic Edmond Duranty asserted that light in itself "reflects both the ensemble of all the [color] rays and the color of the vault that covers the earth. Now, for the first time, painters have understood and reproduced, or tried to reproduce, these phenomena" (Broude, 1991: 126). What was at stake was the normalizing control of vision and visual representation through a seemingly exact system of knowledge that might overcome the ambiguities of representation.

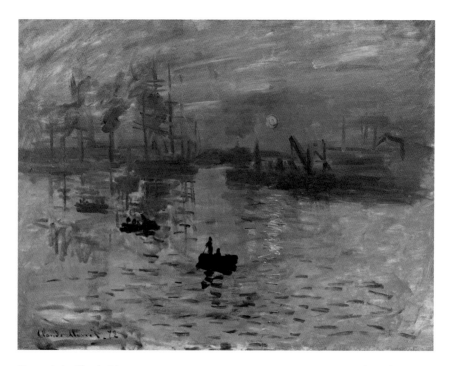

Figure 4.4 Claude Monet, *Impression: Sunrise, Le Havre* (1872). Courtesy of Musée Marmottan, Paris/Giraudon/The Bridgeman Art Library

A few years later another Impressionist supporter, the poet and art critic Jules Laforgue, gave these ideas an explicitly racialized context, mixing them with his understanding of Darwin in his famous 1883 essay on Impressionism:

> The Impressionist eye is, in short, the most advanced eye in human evolution, the one which until now has grasped and rendered the most complicated combinations of nuances known . . . [E]verything is obtained by a thousand little dancing strokes in every direction like straws of color – each struggling for survival in the overall impression. No longer an isolated melody, the whole thing is a symphony, which is living and changing, like the "forest voices" of Wagner, all struggling for existence in the great voice of the forest – like the Unconscious, the law of the world, which is the great melodic voice resulting from the symphony of consciousnesses of races and individuals. Such is the principle of the *plein air* Impressionist school. And the eye of the master will be the one capable of distinguishing and recording the most sensitive gradations and decompositions, and that on a simple flat canvas.
>
> (Nochlin, 1966: 17)

Laforgue's endorsement of the Modernist aesthetic of flatness has ensured his place in the critical canon, but his belief that Impressionism was the product of a Darwinian struggle for cultural existence dominates the essay. His references to the Teutonic forest clearly identified the Impressionists as Northern, or Aryan. For he was less concerned with the means of representation than the internal effect caused by the painting, which was above all perceptible to the "eye of the master," that is to say, the master race.

Two years later, the avant-garde theorist Félix Bracquemond separated color from light altogether, noting that a drawing specialist used color without understanding the effects of reflections and complementary color, with the result that such work looked like an Oriental carpet. As we have seen, this remark was not a compliment but an assertion that the artist had a primitive understanding of color and thus of visual representation itself. The colorist did not in fact rely on the constantly changing range of color but on light: "art isolates color and makes an image from it by using the intensities of light [*clarté*], which are relatively stable and always verifiable in their proportions" (Bracquemond, 1885: 47). Light disciplines color. By extension and implication, the Northern "race" disciplines the Southern. In both cases, the Western perception is that the evasive element was controlled by a more powerful force.

This insistence on the primacy of light over color entailed some surprising conclusions. It is unexpected to hear Vincent Van Gogh argue that the rules of color contradict traditional notions of artistic genius:

> The *laws* of the colors are unutterably beautiful, just because they are *not accidental*. In the same way that people nowadays no longer believe

in a God who capriciously and despotically flies from one thing to another, but begin to feel more respect and admiration for, and faith in nature – in the same way and for the same reasons, I think that in art, the old fashioned idea of innate genius, inspiration etc., I do not say must be put aside, but thoroughly reconsidered, verified – and greatly modified.

(Gage, 1993: 205)

Ironically, Van Gogh has now become the archetype of the modern artistic genius, evidenced above all by his vivid use of color. By the late nineteenth century, color seemed to have been as thoroughly subdued as the colonies in Africa and Asia that it was held to represent. When Henri Matisse developed his stunning palette of colors in works like *Blue Nude – Souvenir of Biskra* (1907) that directly evoked Western travel to Africa, he was direct enough to say that, far from being a radical gesture, he saw his art as being like "an armchair for the tired businessman."

White

In order to understand how this disciplining of color operated in specific cases, let us consider the apparently simple case of the color white. Understanding the meanings of this one color in the nineteenth century renders the familiar distinction between complex texts and simple visual materials questionable at best. White takes us to the purported origin of Western art, and its highest known form, Greek and Roman sculpture. In the nineteenth century, the beauty of these sculptures was held to be epitomized by their pure white marble. The ancient Greeks themselves colored their statues with bright primary-color paint, a fact known to classical scholars since the 1770s. Recent recreations have shown that classical statues were painted with blood flowing from wounds, complex costume patterns, detailed hairstyles and so

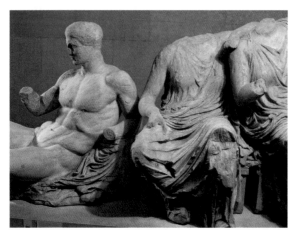

Figure 4.5 The Elgin Marbles: east pediment of the Parthenon. © The British Museum

on in ways that eyes trained by unadorned stone forms find gaudy or even tasteless. In the nineteenth century, by contrast, Greek statues were held to be white because whiteness conveyed the exquisite taste of the Greeks as well as their "Aryan" racial origins, and served as evidence of their monochrome vision (described above). So strong was this belief that the British Museum had the Elgin Marbles, sculptures from the Parthenon in Athens, vigorously scrubbed in the 1930s because they appeared insufficiently white (see Figure 4.5). So much for the argument that the British are the best placed to preserve the sculptures from future damage!

Whiteness came to convey an intense physical beauty in itself. In Oscar Wilde's novel, *The Portrait of Dorian Gray* (1892), the aesthete and aristocrat Lord Henry Wotton compares Gray to a Classical sculpture:

> "He was a marvellous type, too, this lad . . . ; or could be fashioned into a marvellous type at any rate. Grace was his, and the white purity of boyhood and beauty, such as old Greek marbles kept for us. There was nothing that one could not do with him."
>
> (Jenkyns, 1980: 141)

Two seemingly contradictory forces run through this passage. On the one hand, whiteness expresses the ideal racial type, as made explicit by the Victorian painter Frederick Lord Leighton: "In the Art of the Periclean Age we find a new ideal of balanced form, wholly Aryan and of which the only parallel I know is sometimes found in the women of another Aryan race," that is to say, the Germans (Jenkyns, 1980: 145).

On the other hand, there was unsurprisingly more than a hint of homoeroticism in Wilde's own writing. He was making a by-then familiar connection between Greek sculpture, whiteness and the homoerotic. His Victorian contemporary Walter Pater, who similarly praised the "white light" of Greek sculpture, traced the homoeroticism it engendered back to the writing of J.J. Winckelmann. Winckelmann's eighteenth-century investigations into ancient sculpture – especially his *History of Ancient Art* (1764) – are usually considered the first works of modern art history. Furthermore, at the time he was writing "for many worldly Europeans 'Rome,' as well as 'Greek art,' already signified sexual freedom and available boys" (Davis, 1998: 146), in the same way that Christopher Street or San Francisco's Castro district have gay resonances today. Winckelmann did not make this connection explicit but he stressed the importance for the art historian of understanding male beauty: "I have noticed that those who fix their attention only on the beauties of women, and who are only feebly affected by those of our own sex do not in any way possess the sentiment of beauty to the degree necessary to constitute a real connoisseur" (Winckelmann, 1786: 244). Pater elucidated such careful statements as meaning

> that his affinity with Hellenism was not merely intellectual, that the subtler threads of temperament were inwoven in it, is proved by his

romantic, fervent friendships with young men. . . . These friendships, bringing him in contact with the pride of human form, and staining his thoughts with its bloom, perfected his reconciliation with the spirit of Greek sculpture.

(Jenkyns, 1980: 150)

By the late nineteenth century it was a commonplace that the whiteness of Greek sculpture was a mark of its aesthetic quality. In turn for both Pater and Wilde, the Oxford aesthetes, those able to appreciate these qualities of whiteness found both a justification for and a reflection of same-sex desire.

How could the same color give rise to notions of racial supremacy and of what was then becoming known as homosexuality, "the love that dare not speak its name," to quote Lord Alfred Douglas's famous poem of the period? As Eve Kosofsky Sedgwick has argued, the rediscovery of ancient Greece created

for the nineteenth century a prestigious, historically underfurnished imaginative space in which relations to and among human bodies might be newly a subject of utopian speculation. Synecdochically represented as it tended to be by statues of nude young men, the Victorian cult of Greece gently, unpointedly, and unexclusively positioned male flesh and muscle as the indicative instances of "the" body.

(Sedgwick, 1990: 136)

This new imaginative space allowed unusual connections to be made through the male body. It had been a long-standing justification of the European colonization of America that it would prevent the sodomy of the indigenous peoples. As early as 1519, a few years after the first contact, the Spanish conquistador Cortés reported home: "They are all sodomites" (Goldberg, 1992: 193). This blanket description served to mark the absolute difference between the Europeans and the indigenous peoples. Yet at the same time, Europeans forcibly sodomized those they defeated as a mark of absolute domination. Anthropologist Richard Trexler has shown that the Spanish army transferred its own system of discipline via forced sodomy to the Amerindians (Trexler, 1995). Domination and difference came to be signified as sodomy, or at least as sexual relations between men.

Skeptics may wonder if these paradoxical and multiple interpretations of white were really seen by nineteenth-century audiences. It is of course impossible to know whether every spectator had these sentiments but they were certainly noticable at the time. In his 1851 novel *Moby Dick*, the American novelist Herman Melville recounted an epic saga in which Captain Ahab leads his crew to disaster in his obsessive pursuit of the white whale known as Moby Dick. Melville saw white as the color of holiness and beauty but speculated at length as to why it also induced what he termed "a certain nameless terror . . . [I]n many natural objects, whiteness refiningly enhances beauty, as if imparting some special virtue of its own, as in

marbles, japonicas and pearls." The white beauty of marble leads directly to a discussion of the imperial quality of the color, which "applies to the human race itself, giving the white man ideal mastership over every dusky tribe." As he digresses on other aspects of the fear induced by white, Melville names the Peruvian capital Lima as

> the strangest, saddest city thou can'st see. For Lima has taken the white veil; and there is a higher horror in this whiteness of her woe. Old as Pizarro, this whiteness keeps her ruins for ever new; admits not the cheerful greenness of complete decay; spreads over her broken ramparts the rigid pallor of an apoplexy that fixes its own distortions.

The journey within whiteness from sculpture to race theory and the Spanish conquest of Latin America outlined above was also taken by Melville. Melville saw whiteness as terror and beauty at once, oscillating from one meaning to the next, but all symbolized by this color, "a colorless, all-color of atheism from which we shrink" (Melville, [1851] 1988: 188–95). In similar fashion, Sigmund Freud's concept of the "uncanny," or *umheimlich*, the sense of being haunted or otherwise displaced from feeling at home, came to mean its apparent opposite, the sense of being at home, *heimlich*. It was in part that internal instability within the categories that discipline wanted to keep distinct that led to its radical acceleration in the late nineteenth and early twentieth centuries.

1895: global panopticism

The normative aspect of the disciplinary society came fully into effect in a period of a few years in the late nineteenth century. Modernity was reconfigured from the zone implied by the norm into a social application of the sharp distinction between the normal and the pathological. A series of radical new distinctions in disability education, race and sexuality remade modern Europe in colonialism's image. One of the great achievements of the French Revolution was the establishment of an Institute for the Deaf in 1791 that taught students in sign language. One former student turned instructor named Laurent Clerc came to the United States, where he helped establish Gallaudet College (now Gallaudet University), where instruction was also in sign. However, the hearing educators of the deaf came to see sign language as a visible symptom of the pathology of deafness that prevented the deaf from integrating into hearing society. Further, it was argued, sign could be an impediment to factory workers by using their hands for communication rather than labor. At an international conference held in Milan in 1800, sign language was banned from deaf education, a ruling that persisted until the 1970s. Deaf children were forced to sit on their hands in class and would be struck on the hands if they attempted to sign. This movement, known as "oralism," successfully downgraded the visual language of sign by means of comparison with the "primitive savage" and

monkeys. If missionaries, settlers and explorers were using gestures to communicate in the colonies, it could not be a "normal" form of civilized language. Such gestures are of course simple pantomime, whereas sign language proper has its own abstract vocabulary and spatial grammar. The normal body would communicate only by sound. Such newly archival and indexical binary difference could be found across imperial modernity. In 1895, Oscar Wilde was convicted in London of "gross indecency," meaning homosexuality, and sentenced to two years' hard labor, leading to his death in 1898. As Foucault has shown, the "homosexual" was a newly classified "species" in the period, distinguished in all aspects from the "heterosexual" that it called into being (1978: 43). Whereas an animal species might be characterized anatomically, the "homosexual" represented what Foucault called "an interior androgyny, a hermaphrodism of the soul," changing the homosexual act, punished on the body, into a homosexual "soul," classified and ordered by discipline. By the same token, the Dreyfus Affair mobilized different sectors of French society around the question of the nature of the "Jew": for those supporting the Army, Jews were inherently cosmopolitan, and therefore potential traitors, whereas the Dreyfusards, as his supporters came to be known, argued from the basis of evidence that he was innocent. Both positions were modern. The Impressionist painter Camille Pissarro was as ardently convinced of Dreyfus's innocence, as his fellow artist Edgar Degas was of his guilt.

In June 1892, Homer Plessey defied the recently passed segregation laws of Louisiana and took a seat in a "white" car on an East Louisiana Railroad train. Plessey was a so-called Creole of Color, meaning that he was descended from Spanish or French settlers as well as African diaspora forced migrants, whose family had been in the region since before the Louisiana Purchase. Although himself light-skinned (if one must use such descriptors), Plessey was now classified as "black" by virtue of Louisiana's "one drop" law, meaning that a person with any African descent was now "black." Here the "norm" had rigidified into a binary exclusion. Plessey's conviction was upheld by the United States Supreme Court in 1896, giving segregation a legal basis that persisted until overturned by the combined impact of *Brown v. The Board of Education* in 1954 and the Civil Rights Act of 1965. In his classic *Souls of Black Folk*, published in 1903, the African-American activist and historian W.E.B. Du Bois described the African American as having what he called a "double-consciousness": "one ever feels his twoness, an American, a Negro" ([1903] 2000: 2). This twoness was a specific product of the moment in which Du Bois was writing, when African-American difference was being enshrined as absolute, a visible form of difference that could be archived and indexed.

This realignment of legal, medical, religious and ethnic categorization was complemented by the new world order of imperialism. In 1898, the Spanish-American war ended 400 years of Spanish presence in the Americas and gave hegemony of the hemisphere to the United States, as well as the territories of Cuba, the Philippines and Puerto Rico. The war had a distinctly contemporary feel. The three-year guerrilla war in the Philippines sparked significant opposition in the US, led by such

figures as Mark Twain and William James. It is as a consequence of this conflict that the US Navy has an outpost at Guantánamo Bay, Cuba, that has been of such significance as a prison and interrogation center since 2001. Indeed, one of the first concentration camps was established on Cuba during the Spanish-American war, with a similar establishment being set up by the British in South Africa. Both were foreshadowed by the convict lease-labor camps in the United States, in which private enterprise undertook labor-intensive tasks using predominantly African-American convict labor for very low cost. These camps were the dialectical other to the reforming Panopticon. Neither the concentration camp nor the convict labor camp had any concern to reform their detainees. The object was in the first case simply to sequester people felt to be dangerous and in the second to generate low-cost labor. As activist and philosopher Angela Y. Davis has emphasized, the passage of Black Codes in the South after the repression of Reconstruction criminalized certain behaviors ranging from theft to being "wanton in conduct or speech," or "all other idle and disorderly persons" (1998: 76). While such catch-all categories had been included in nineteenth-century Vagrancy Acts, they were now directed at only one group of people. In combination with the new forms of labor such as share-cropping, the Black Codes and convict leasing placed the formerly enslaved under a new disciplinary system of "quasi-total control" (1998: 78). Homer Plessey became the visible symbol of that system, one that certainly aspired to seeing all activity but only for the benefit of the rulers, not the ruled. The United States's realignment took place in a time that placed no less than 85 percent of the world's surface under one form or another of imperial domination by 1914. It was also the period of the invention of cinema, with the screening of the Lumière brothers' first films in December 1895. These "views," as they called them, were shot on precisely 17 meters of film that was projected on their cinematograph device. The famous *Arrival of a Train in La Ciotat* was held to have caused people to flee the room in panic,

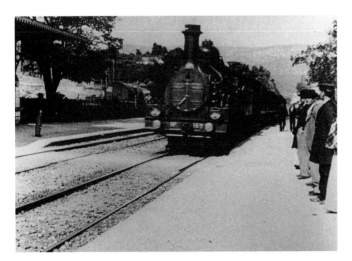

Figure 4.6 Lumière brothers, *Arrivée d'un train (à la Ciotat) (Arrival of a Train in La Ciotat)* (1895). 35mm print, black and white, silent, approx. 45 seconds. Courtesy of The Kobal Collection

a story now much disputed. Some attribute it to a clever publicity ploy, others suggest that the film recalled a well-known recent train crash, and still others say that the film had not yet been made. The fact that the story was believed for so long shows that modernity has come to be understood as cinematic and that it is a perceptual shock to the senses.

Perhaps our understanding of the *Arrival of a Train* changes again in light of Homer Plessey's attempt to desegregate the Louisiana train system? Amongst their many "views," the Lumières also filmed a now less-celebrated short called *Nègres dansant dans la rue* (Blacks dancing in the street) in London in 1896, featuring "blacked-up" minstrels, as one of their "comic" films. Moving images came to represent current events for the first time during the Spanish-American war by the New York based fledgling film company Vitagraph. It was formed by two classic Atlantic world characters, Albert E. Smith, an actor descended from a long line of sailors, and the marine painter Jim Blackton. The two abandoned a failing vaudeville company for a motion picture enterprise after seeing a demonstration of Edison's kinetoscope in 1895. Although Vitagraph did well at first, it was again on the verge of failure when the Spanish-American war of 1898 provided them with an opportunity. After a success with a simple film of marching soldiers, Blackton and Smith claimed to join Roosevelt's Rough Riders in Cuba and released a film that purported to show the US troops in action along with a faked film of the *Battle of Santiago Bay* of 1898 that destroyed the Spanish Caribbean fleet. The success of these films and Smith's later footage of the Boer War launched a company that lasted until its purchase by Warner Brothers in 1925. Film historians have suggested that the outburst of shorts depicting the war introduced the concept of narrative into moving pictures, turning the "view" into a structured story that could become cinema (Musser, 1990: 225). However, as Amy Kaplan has rightly emphasized, "spectacles of foreign warfare become stories only in relation to the domestic sphere" (1999: 1070), where "domestic" refers both to the household and the sense of "domestic" politics in contrast to foreign policy. The classifications and visualizations of race were the medium that enabled that link to be made. In 1900 Vitagraph pioneered some animation shorts based on Blackton's "Chalk Talk" variety act (Smith, [1952] (1985): 29). First the names "Cohen" and "Coon" were written on a blackboard. Then each name was turned into a stereotypical racist cartoon. While such early animated shorts were long dismissed as curiosities, they are now receiving renewed critical attention as forerunners to digital cinema both on the large screen and in formats like Quicktime. In a certain sense, *Cohen and Coon* is sadly familiar material, even though the specific piece may well be obscure now.

The normative binary oppositions of the imperial disciplinary perspective created by the world empires of the late nineteenth and early twentieth centuries set the boundaries for what could and could not be seen. That is to say, race, whether as the African or the "Jew," set one axis of the imperial world-view, while the binary opposition of sex and gender set the other. Along this axis, male was opposed, and therefore attracted to, female, categories that were now taken to be norms. When

French feminist Simone de Beauvoir set out her ground-breaking theory of *The Second Sex* in 1949, she argued that "woman has been defined as the Other" (1953: lx). It was axiomatic for her that this Otherness was "precisely like the 'equal but separate' formula of the Jim Crow laws aimed at the North American Negroes" (1953: liii). De Beauvoir understood that maintaining separate and subordinate modalities of gender, and hence sexuality, required maintaining similar modalities of race and colonial hierarchy. The following chapters will therefore use these categories of race, gender and sexuality to trouble the notions of culture, sexual difference, the West and the digital that were central to the construction of Western modernities.

References

Bracquemond, Félix (1885), *Du Dessin et de la Couleur*, Paris: G. Charpentier.

Broude, Norma (1991), *Impressionism: A Feminist Reading*, New York: Rizzoli.

Brudenell Carter, R. (1890), "Colour-vision and colour blindness," *Nature*, vol. 42 no. 1072.

Davis, Angela Y. (1998), *The Angela Y. Davis Reader*, ed. Joy James, Oxford: Blackwell.

De Beauvoir, Simone (1953), *The Second Sex*, trans. H.M. Parshley, New York: Everyman.

Du Bois, W.E.B. ([1903] 2000), *The Souls of Black Folk*, London and New York: Penguin.

Foucault, Michel ([1967] (2002), "Of Other Spaces," in *The Visual Culture Reader*, ed. Nicholas Mirzoeff, New York: Routledge.

—— (1977), *Discipline and Punish: The Birth of the Prison*, trans. Alan Sheridan, London and New York: Penguin.

—— (1978), *The History of Sexuality: Volume One*, New York: Vintage.

Gage, John (1993), *Colour and Culture: Practice and Meaning from Antiquity to Abstraction*, London: Thames and Hudson.

Gladstone, William E. (1877), "The Colour Sense," *The Nineteenth Century*, vol. 1, September.

Goldberg, Jonathan (1992), *Sodometries: Renaissance Texts, Modern Sexualities*, Baltimore, MD: Johns Hopkins University Press.

Jenkyns, Richard (1980), *The Victorians and Ancient Greece*, Cambridge, MA: Harvard University Press.

Kaplan, Amy (1999), "The Birth of an Empire," *PMLA*, vol. 114 no. 5, pp. 1068–79.

Kemp, Martin (1990), *The Science of Art: Optical Themes in Western Art from Brunelleschi to Seurat*, New Haven, CT and London: Yale University Press.

Magnus, Hans (1878), *Histoire de l'évolution du sens des couleurs*, trans. Jules Soury, Paris: C. Reinwald.

Melville, Hermann ([1851] 1988), *Moby Dick*, Evanston and Chicago, IL: Northwestern University Press and the Newberry Library.

Musser, Charles (1990), *The Emergence of Cinema: The American Screen to 1907*, New York: Scribner's.

Nochlin, Linda (ed.) (1966), *Impressionism and Post-Impressionism 1874–1904: Sources and Documents*, Englewood Cliffs, NJ: Prentice-Hall.

Sedgwick, Eve Kosofsky (1990), *The Epistemology of the Closet*, Berkeley: University of California Press.

Semple, Janet (1993), *Bentham's Prison: A Study of the Panopticon Penitentiary*, Oxford: Clarendon Press.

Smith, Albert E. with Phil A. Koury ([1952] 1985), *Two Reels and a Crank*, New York and London: Garland.

Trexler, Richard J. (1995), *Sex and Conquest: Gendered Violence, Political Order and the European Conquest of the Americas*, Ithaca, NY: Cornell University Press.

Winckelmann, Johann (1786), *Receuil de différentes pieces sur les Arts*, Paris.

MODERNITY

There was no single experience that could be called the modernity of visual culture. Rather it was an interface of lived experience, the expansion of capital and its tendency to become an image under conditions of intense accumulation, and the resulting mass circulation of images. All these modes of modernity were experienced in different forms depending on historical and cultural circumstances. In a sense, the very all-embracing sense claimed by the idea of modernity expresses what it wanted to be: a way of describing and understanding the modern world. That world was inherently confusing, as Marx and Engels famously described it in *The Communist Manifesto* ([1848] 1948): "All that is solid melts into air, all that is holy is profaned." The force behind this transformation was the world-shattering growth of capital. Modernity is the experience of constant transformation, of things not staying the same, of endless invocations of the new and the different, all in the service of renewing capital. In Marx's classic analysis, capital is the abstracted form of the value people find inherent in objects. This value can be expressed in two ways: as a use-value, meaning the value that a coat has when I wear it in cold weather; or as exchange value, meaning the value that the coat has when I sell it or swap it for something else. The exchange is based on the amount of human labor it took to create the object. As that can be hard to measure, value has taken an abstract form that we call money.

Marx understood modernity to be formed when people no longer exchanged things directly according to need but in search of more money. An invested sum of money could be used to make coats that, when sold, return a higher quantity of money than the original investment. This "magical" difference comes from the difference in the amount paid to those who work producing the coats and what the employer can sell them for and it is therefore known as surplus value.

If money continued to circulate in this fashion, growing in quantity by means of extracting surplus value, it became capital. Whereas an individual may only buy and sell according to need, "the circulation of money as capital is an end in itself, for the valorization of value takes place only within this constantly renewed movement. The movement of capital is therefore limitless" (Marx, [1867] 1977: 253). The next characteristic of modernity, then, is circulation: the endless circulation of goods, money, ideas and to a greater or lesser extent, people. This change was so clear to Marx because it was far from new: "World trade and the world market date from the sixteenth century, and from then on the modern history of capital starts to unfold" ([1867] 1977: 247). That is to say, while there was certainly capital before the sixteenth century, with the expansion of Europe and the beginnings of colonialism and the slave trade, the modern history of capital took a decisive turn at that time.

As capital came to shape the world in its own image, people experienced the world very differently. Marx describes how commodities – those things that are bought and sold – claim the human labor that has formed them as their own inherent characteristics. In trying to explain how it is that manufactured "sensuous things" become "social," or beyond the sensible, Marx drew a parallel with eyesight. He recalls that what we experience as "the objective form of a thing outside the eye" is really no more than the stimulus of the optic nerve. Although light does enter the eye in a material form, the value of the commodity has no connection to its physical properties or the labor that went into making it. For those beyond subsistence level, commodities are desired for often irrational reasons – think of the last pair of shoes you bought: did you actually need footwear or did you want those shoes? Objects come to express our desires, our personality, our sexuality, our religion and so on. As Marx put it, "the definite social relation between men themselves . . . assumes here, for them, the fantastic form of a relation between things" ([1867] 1977: 165). Rather than people relating directly to each other, relations are mediated by commodities, not just relations with others but even the understanding of the self. This "commodity fetishism," as Marx famously called it, attributes life to things, even though we know they do not have it. So when a middle-aged man like myself purchases a sports-car, almost everyone can make the analysis "mid-life crisis" without difficulty. But that does not stop people from buying or wanting the cars. In short, commodity culture decenters people from their own experience and makes them mediate it through objects.

In part because of this decentering, modernity was lived and experienced in and through the body as a crisis of time and space. When Copernicus proved that the earth moved around the sun in 1543, his discovery undermined the idea that humanity was central to all creation. Although Copernicus placed the center of the universe near the sun, it no longer revolved around humans, who were revealed as a small part of an infinitely large system. In 1752, the British state moved from the inaccurate Roman, or Julian, calendar to the Gregorian calendar

that equated more precisely with the rotation of the earth around the sun, requiring only one "leap" day every four years to stay synchronized with the earth's orbit around the sun. In order to catch up, the date had to be moved forward eleven days, prompting a widespread protest movement with the slogan "Give us back our eleven days." At the beginning of the nineteenth century, time was registered on clocks according to the specificities of each locality. With the development of railways and other mass communications, standardized time zones and national time were adopted, creating many local anomalies on the borders of, say, Eastern and Central Time in the United States. During the revolutions of 1848, rebels took to shooting the clocks, expressing their sense that standardized time was a form of social control. The historian of science Peter Galison has recently suggested that such alterations in the depiction of time were in part what prompted Einstein's theory of relativity, which, as it were, generalized decentralization. In a relative universe, there is no center, only places from which to observe.

The space in which people lived changed drastically and often incomprehensibly. Modern cities radically changed the lived environment in the nineteenth century, just as enclosures and clearances created a new form of countryside. The creation of the modern city of Paris by Baron Haussmann in the 1860s has become the epitome of this process. Haussmann drove wide, straight and lengthy

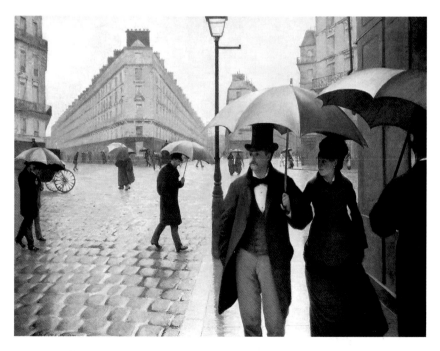

Gustave Caillebotte, *Paris Street; Rainy Day* (1877). Courtesy of the Art Institute of Chicago

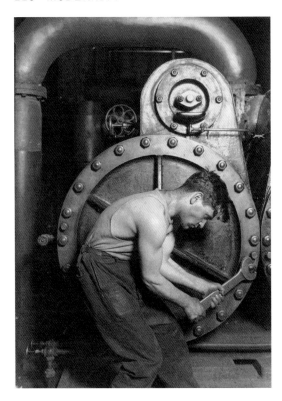

Lewis Hine, *Powerhouse Mechanic* (1921)

boulevards (one of which now bears his name) through the winding and narrow streets of old Paris in the center of the city. In so doing, he at once destroyed many working-class districts of the city, provided the means to move troops efficiently into the city in the event of an insurrection, and created the cityscape that was to be celebrated by the Impressionists. With the development of the global museum circuit, it is safe to say that some exhibition is celebrating this version of modernity on a daily basis. In the twentieth century, the modern city became New York, with construction driving upwards in the form of the sky-scraper that has become the global symbol of the modern city, as any visitor to Shanghai, Taiwan or Singapore can attest. Just as Marx emphasized that the accelerated pace of change in Europe during the course of the nineteenth-century Industrial Revolution relied on a much longer process of capital accumulation, so did these transformations of modern space follow from the long history of European overseas expansion. In this history, certain nations came to constitute themselves as representing the modern in relation to other nations and peoples that they conquered or colonized. The spatial and temporal crisis of modernity caused the world to be experienced as a picture, first as a still and then as a moving image. The German philosopher Martin Heidegger – no Marxist, it should be said – renamed modernity the "age of the world picture." He clarified that

> a world picture . . . does not mean a picture of the world but the
> world conceived and grasped as a picture . . . The world picture does
> not change from an earlier medieval one into a modern one, but
> rather the fact that the world becomes picture at all is what dis-
> tinguishes the essence of the modern age.
>
> (Heidegger, 1977: 130)

That is to say, it was not the ability to make pictures with greater and greater
ease that created the age of the world picture but rather a need to render the
experience of being in the world as a picture. The long experience of modernity,
in this view, has been one in which its displacing and decentering permanent
circulation could only be understood as a picture. Even the human sensorium
has reacted and continues to react to the new urban conditions and the ubiquity
of visual media. In his meditation on the impact of film, the German critic Walter
Benjamin argued in the 1930s that in features such as the close-up and slow-
motion "a different nature opens itself to the camera than opens to the naked
eye – if only because an unconsciously penetrated space is substituted for a space
consciously explored by man" (Benjamin, 1968: 236). It is clear that the camera
can reveal features that cannot be seen by the unaided eye and alters our under-
standing of the exterior world. We may not be able to see a horse's legs while
it is galloping but thanks to Eadweard Muybridge's 1872 photographs, we know
that centuries of equine painting in which their legs are depicted as pointing
backwards and forwards are in error. Now exploration, which was once the phys-
ical discovery of hitherto unknown geographical space, had become the charting

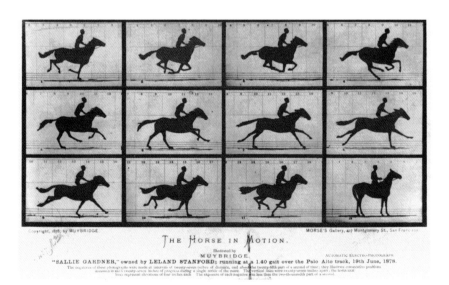

Eadweard Muybridge, *Horse Galloping* (1872)

of perceptual and pictorial space. Benjamin concluded that we have developed an "optical unconscious," analogous to the unconscious mind mapped by Freud, a means of negotiating experience in the age of the world-picture. In short, modernity in visual culture was the process by which the optical unconscious was produced, experienced and identified as a space for personal identification, social organization and commodification.

References

Benjamin, Walter (1968), *Illuminations,* trans. Harry Zorn, New York: Schocken.

Heidegger, Martin (1977), "The Question Concerning Technology," trans. William Lovitt, in *Basic Writings,* New York: Harper and Row.

Marx, Karl ([1867] 1977), *Capital,* trans. Ben Fowkes, London: Penguin.

Marx, Karl and Friedrich Engels ([1848] 1948), *The Communist Manifesto,* Moscow: International Publishers.

PHOTOGRAPHY AND DEATH

All photographs are *memento mori*. To take a photograph is to participate in another person (or thing's) mortality, vulnerabliity, mutability. Precisely by slicing this moment and freezing it, all photographs testify to time's relentless melt.

Susan Sontag (1973: 15)

In his meditation on photography, Roland Barthes described it as "*the impossible science of the unique being*" (1981: 71). By this he meant that photography seeks to record with the highest degree of realism the individuality of its subject, but that this sense of an individual is exactly what cannot be photographed. At the same time, photography is distinct from other media because it shows that something was definitely there when the shutter was opened. What the object photographed is to be called and what judgment we make of that is up to the viewer, but the fact that something was present to be photographed cannot be denied. As a result, photography is a past-tense medium. It says "that *was* there" not what *is* there. It emphasizes the distance between the viewer of the photograph and the time in which the photograph was taken. In a secular society the photograph is Death's point of entry into everyday life, or as Barthes puts it: "With the Photograph, we enter into *flat death*" (1981: 92). The past that the photograph presents cannot be recaptured and emphasizes the "imperious sign of my future death" (1981: 97). The same can be said of cinema. For the silent film director Jean Cocteau, the camera "filmed death at work" (Burgin, 1996: 85).

In Barthes's analysis, the specificity of time and place sought by early photographers was attainable only insofar as it evokes a response in the viewer. Barthes named this response the *punctum*, the point, contrasting it to the *studium*, or

general knowledge that is available to every viewer. He seems to offer two versions of the *punctum*. One is the casual, everyday notion of irrational preference for a particular detail in a photograph. It may be that this detail calls to mind something similar in the viewer's own experience or simply that it appeals for an unknown reason, as Barthes specifies that what can be named or described in a photograph belongs to the *studium*. At the *punctum*, we are dealing with that ineffable difference in pose that causes us to select one portrait photograph over another or to say that a photograph does or does not "look like" its subject. A photograph looks like its subject by definition: what we refer to is that "impossible science" of resemblance to character, personality or ego.

On the other hand, there is also the sense in which the *punctum* is a wound. In this instance, the photograph evokes something very powerful and unbidden in the viewer. Barthes found this *punctum* in a photograph of his mother taken when she was a little girl. In this photograph, which he discovers after her death, it seems to him that he discovers his mother "as she was": "this photograph collected all the possible predicates from which my mother's being was constituted" (1981: 70). No photographer could set out to create an image with such multiple meanings. They are brought to the image by the viewer for whom the *punctum* creates the means to connect memory with the subconscious drives for pleasure and death. The most important and yet most unknowable singularity of photography is this power to open a *punctum* to the realm of the dead. At the same time, it opened the possibility of a play with death and a certain survival after death that had not previously been open. In 1840, the photographic pioneer Hippolyte Bayard, convinced that Daguerre and Talbot had unfairly claimed all the credit for the new process at his expense, produced the first such image, *Self-Portrait As A Drowned Man*. It showed the photographer sitting, head slumped, as if dead. His tanned face and hands were cited as evidence that the corpse was already beginning to decay in the caption that accompanied the photograph, yet the very existence of the photograph attested to the capacities of its maker. Less than a year after the first public display of photographs, it was possible to parody and play with the medium in this way. Like digital media after it, photography had been anticipated for so long that by the time it became a material fact, all its possibilities had already been thought through.

Photography came into being at a time of profound social change in attitudes to the dead and to death. It thus participated in a new means of configuring death at the same time as it offered an everyday reminder of death. The experience of mass industrial society led to a desacralization of death and its experience from a public religious ceremony in the early modern period into the private, medicalized case history of modernity. Joseph Roach (1996) has shown that Christian burial was transformed in the period that Foucault has called the emergence of the disciplinary society (1750–1840). While the dead had previously been buried in the church itself or close at hand in the churchyard, the modern period saw the construction of "cities of the dead," the vast cemeteries

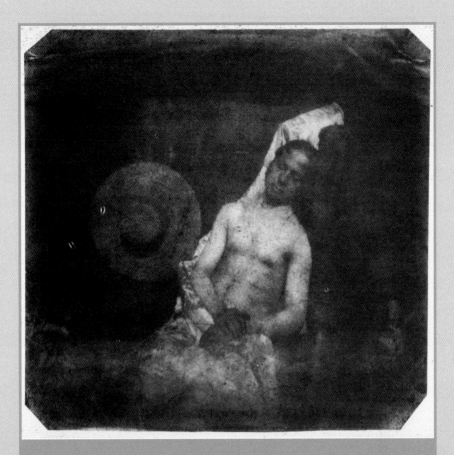

Hippolyte Bayard, *Self-Portrait As A Drowned Man* (1840)

placed on the outskirts of the new cities to keep a dividing line between the living and the dead. By the 1860s the Goncourt brothers, conservative French art critics, observed that

> as societies advance or believe themselves to advance, to the degree that there is civilization and progress, so the cult of the dead, the respect for the dead, diminishes. The dead person is no longer revered as a living being who has entered into the unknown, consecrated to the formidable *"je ne sais quoi"* of that which is beyond life. In modern societies, the dead person is simply a zero, a non-value.
>
> (Nochlin, 1971: 60)

In a society in which the preservation of life was the highest state objective, death had to be kept away in an imperative that would later be summarized by the poet Dylan Thomas: "Do not go gentle into that good night./ Rage, rage, against the passing of the light."

Photography defined the new border between life and death as a capturing of light that paradoxically survived death even as it reminded the viewer of it. It is even common for Catholic gravestones to feature a photograph of the deceased. In place of the traditional wax death mask or deathbed engraving, photography came to be the prime means of capturing the image of the departed. Due to its lower cost, it opened remembrance to a wider strand of society than ever before. In this way, death became not just a metaphorical means of understanding the power of photography, but one of its privileged subjects. The celebrated early French photographer Nadar claimed a coup in 1861 with his photographs of the Paris catacombs. By devising a means of artificial lighting, he showed something that could not previously be reproduced while at the same time claiming the kingdom of the dead for photography.

In the early twentieth century, Eugène Atget (1857–1927) set out to record Old Paris, the Paris that the renovations of the nineteenth century had brought to the verge of disappearance, or death. Atget became sufficiently well-known for these images that both French museums and Surrealist artists like Man Ray bought his work. He called them documents, implying that their interpretation and use would be left to others. Thus his photograph of the wall of the Père-Lachaise cemetery in Paris known as *Le Mur des Fédérés*, where the last fighters of the 1871 Paris Commune had been summarily shot by government troops, contains no judgment. A viewer might see the wall as the Left traditionally did as the site of a massacre, or as the Right understood it, as the ending of a criminal insurgency. Or it might simply record a place where a contested historical event occurred. Atget aspired to the egalitarianism of death itself. For example, in his series depicting traditional Parisian restaurants, ghostly figures can often be seen behind the glass of the door. His photograph of *Au Tambour, 63 quai de la Tournelle* (1908) allows us to see two men standing in the doorway of the restaurant as well as the reflection of the banks of the Seine and Atget's photographic apparatus. The old and the new literally merge on the screen of the photographic surface. Not surprisingly, these images fascinated Walter Benjamin, who famously appreciated:

> the incomparable significance of Atget who, around 1900, took photographs of deserted Paris streets. It has quite justly been said of him that he photographed them like scenes of a crime. The scene of a crime too, is deserted; it is photographed for the purpose of establishing evidence. With Atget, photographs become standard evidence for historical occurrences and acquire a hidden political significance. They demand a specific kind of approach; free-floating contemplation is not appropriate to them.
>
> (Benjamin, 1968: 226)

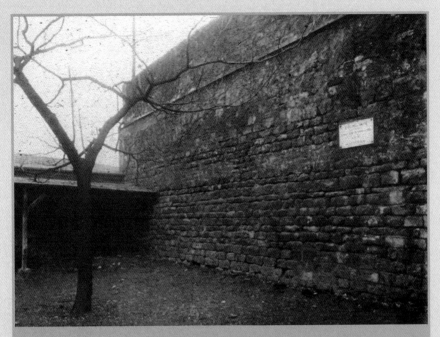

Eugene Atget, *Mur des Fédérés* (1871)

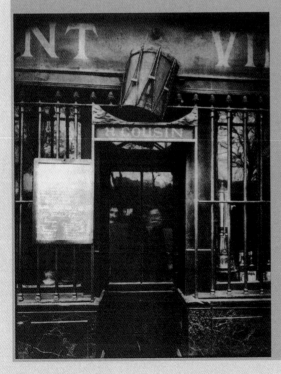

Eugene Atget, *Au Tambour, 63 quai de la Tournelle* (1908). © The Museum of Modern Art, New York

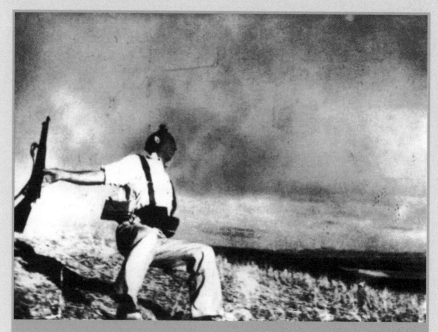

Robert Capa, *Near Cerro Muriano (Córdoba front) September 5, 1936.* Courtesy of George Eastman House

Robert Capa, *Indochina, May 25, 1954.* Vietnamese troops advancing between Namdinh and Thaibinh. This is the last picture taken by Robert Capa with his Nikon camera before he stepped on a landmine and died at 14.55. Robert Capa © 2001 by Cornell Capa. Courtesy of Magnum Photos

Atget's work demanded a specific kind of attention to its subject matter that could be generalized as the depiction of time past for the purposes of evidence. As such, it inevitably and insistently evoked the presence of death in the visual field.

Modern photography was consistently haunted by these themes. Around 1910, a photographer of the Mexican revolution took a picture of a man standing at ease in his shirtsleeves, foot poised on a rock, smoking a cigarette. His cool gaze makes him an icon for guerrilla chic, until one reads the accompanying caption and discovers that he is about to be shot. The cigarette becomes the last cigarette, the quaintly decaying wall becomes a wall ravaged by the repeated shock of the firing squad and the photograph acquires an intense vividness that seems to attest to the preciousness of life even in its last moments. Look at the famous Robert Capa photograph, *Near Cerro Muriano (Córdoba front) September 5, 1936*. It simply shows a Republican soldier in the Spanish Civil War at the moment in which he has been shot. His rifle is still in his hand as his knees give way and he falls back. The image has an intense power that is enhanced by the absence of any other significant detail in the frame. But very soon, questions were asked. It seemed that there had been no action on the Córdoba front that day and that the photograph must therefore be a fake. The fact that Republicans were certainly being killed daily in the struggle against Fascism was not felt to absolve Capa. Photography had become too central to modern life for such equivocations to be accepted. Intriguingly, it was announced in 1996 that a historian had discovered that there was one death that day on the Republican side. The victim's sister was still alive and claimed Capa's photo did indeed show her brother. At 60 years' distance who can say if her memory was accurate? What kind of truth about death do we expect from the photograph? In one of those ironies that can cause you to pause in everyday life and become aware of a certain sense of mortality, Capa's own life ended in similar circumstances. On May 25, 1954, Capa was accompanying some soldiers through a field in Vietnam at Nam Dinh, just south of Hanoi. He had taken 11 photographs on his last roll of film, the last of which shows the soldiers walking casually ahead of him. He jumped up onto a bank to their right for a better angle, where he stepped on a landmine and was killed instantly. At least Capa's death is memorialized and his last picture has become an icon. Who will remember Namir Noor-Eldeen, a Reuters photographer killed in Iraq in July 2007 by fire from a US helicopter, one of 32 photojournalists to have died in that conflict as of July 2008?

References

Barthes, Roland (1981), *Camera Lucida: Reflections on Photography*, New York: Noonday.

Benjamin, Walter (1968), *Illuminations*, New York: Schocken.

Burgin, Victor (1996), *In/Different Spaces: Place and Memory in Visual Culture*, Berkeley: University of California Press.

Nochlin, Linda (1971), *Realism*, London: Penguin.
Roach, Joseph (1996), *Cities of the Dead: Circum-Atlantic Performance*, New York: Columbia University Press.
Sontag, Susan (1973), *On Photography*, New York: Farrar, Straus and Giroux.

IMPERIAL TRANSCULTURES

From Kongo to Congo

O N A HOT summer day in 1920, the poet Langston Hughes was on a train to Mexico. At sunset outside St. Louis, the train crossed over the Mississippi and Hughes set to thinking about the importance of rivers in African-American history: "Then I began to think about other rivers in our past – the Congo, and the Niger, and the Nile in Africa – and the thought came to me 'I've known rivers.'" Within 15 minutes, he wrote perhaps his most famous poem on the back of an envelope:

> I've known rivers:
> I've known rivers ancient as the world and older than the flow of
> human blood in human veins.
> My soul has grown deep like the rivers.
> I bathed in the Euphrates when dawns were young.
> I built my hut near the Congo and it lulled me to sleep.
>
> <div align="right">(Hughes, 1993: 55)</div>

The view from a moving train was a central visual experience in the formation of modernism, opening the possibility that modernity itself could be envisioned as a moving image. Hughes places this vision in a different context from the standard modernist linear narrative – of forward-moving history. His diasporic modernism replaces the linear evolution model with the river; it replaces a single flow of time with what Achille Mbembe has called "entanglement," the complex interactions of pasts, presents and imagined futures (2002: 12).

Inventing the heart of darkness

For Hughes and many anthropologists, novelists and historians of his time, one spot was of particular importance – the Congo. Far from being the mythical origin of the primitive, the Congo has in fact been a key site of transculture since the fifteenth century. While the Congo was one of the sites of Hughes's diasporic memory from the past, European slavers and colonizers had transformed the Central African Kongo civilization of the Bakongo people into the Congo, the degree zero of modern space-time. For anthropologists and eugenicists alike, the Congo was the most primitive place in Africa, itself the Dark Continent left behind by progress. As such, the Congo served as the anchor or base for the evolutionist ladder that led up to the West. As the heart of "darkest Africa," the Congo was supposed to epitomize the binary distinction between the civilized West and its primitive Other. The Congo became notorious to Westerners after Henry Morton Stanley (of "Dr Livingstone, I presume" fame) published a famous account of his journey from East Africa to the Atlantic coast down the Congo river, entitled *Through the Dark Continent* (1878). Stanley then helped the Belgian monarchy establish a vast colony, centered entirely around the river itself.

Far from being an irrelevant locale on the periphery of cultural history, Kongo was integral to the unfolding history of modernity. For it was and is a dramatic example of the power of transculturation to create and destroy at once. Its peculiar reputation as the very origin of the primitive made it a key site for the constitution of Western notions of modernity that are always in tension with the primitive and primitivism. Several factors make the Congo a place of particular interest for visual culture. The Congo was a key point in what has been called the Black Atlantic, first created by the Atlantic triangle of slavery, but now understood by scholars of the African diaspora as "a means to reexamine the problems of nationality, location, identity, and historical memory" (Gilroy, 1993: 16). As Hughes's poem recalls, a high percentage of those Africans taken in slavery from the sixteenth to the nineteenth centuries were from Kongo. As a result, Kongo practices were often recreated in the Americas by the enslaved, contributing many words like "jazz" to the English language and playing a central part in the syncretic religions currently practiced across the Caribbean and the Americas. Second, the Congo was the birthplace of American Studies, the home of cultural studies in the American academy. For it was in the Congo that Perry Miller, who would go on to found the discipline of American Studies, experienced what he called an epiphany while unloading oil drums from a tanker. In "the jungle of central Africa" he suddenly saw "the pressing necessity for expounding my America to the twentieth century" (Kaplan and Pease, 1993: 3). What Miller saw as the emptiness of Africa offered a blank slate against which he was able to see clearly his vision of America. The evolutionist ladder created in the nineteenth century to account for the superiority of Western civilization ironically prepared the ground for the success of cultural studies whose avowed aim is to contest such reactionary beliefs. Third, the Congo

was the site both of some of the most egregious colonial violence and the most principled resistance to colonialism by both Africans and Europeans. This history, pursued in this chapter and the next, makes the Congo a key point for the definition of the colonial project, which created a new everyday reality both in the colonies and in the colonizing nations. With the achievement of indepedence in the 1960s, a new round of transculturation was set in motion that continues to be played out with the overthrow of Mobuto Sese Seko's Zaire and Laurent Kabila's reinstituted Democratic Republic of Congo in 1997. The focus on the Congo in this and subsequent chapters is not, however, intended to suggest that only the Congo – rather than, say, Latin America or East Asia – is representative of the transculturation of modernity but that it was one important site of that process. I concentrate upon it here to emphasize that Africa also has had its part to play in globalizing modernity from the earliest contact between Europeans and Africans despite its continuing characterization as the "Dark Continent," amply in evidence in Western media coverage of Africa.

As European political economy turned from slavery to colonialism, it reoriented its own history in a remarkable rewriting of historical and popular memory. In a few decades, Europeans seemed wilfully to forget all that they had learned about Africa since the fifteenth century – in Ortiz's terms, they decultured Kongo in order to acculturate themselves and Africans to the new entity they had created named the Congo. This loss of knowledge involved turning what had been a place into empty space so that it was suitable for the civilizing mission of colonialism. Amnesia as a political strategy was directly advocated by the philosopher Ernest Renan, whose racial theories were central to the consolidation of the French Third Republic (1870–1940). In an 1882 lecture entitled "What is a Nation?," Renan baldly asserted that: "Forgetting, I would even go so far as to say historical error, is a crucial factor in the creation of a nation" (Renan, 1990: 11). The creation of the imperial nations of the late nineteenth century involved forgetting the Africa of the Atlantic slavery period and reinventing it as an untouched wilderness. Maps from the early modern period show detailed knowledge of African geography and place names, while eighteenth-century published collections of voyages offered the reader a wide range of information about the major African peoples. In the mid-nineteenth century, Europeans placed this knowledge aside, and created in its place the myth of the Dark Continent, a wild place whose customs were both unknown and barbaric. For Captain Camille Coquilhat, one of Stanley's deputies and later District Commissioner of Balanga in the so-called Congo Free State, commercial progress was far easier to achieve in the Congo than civilization:

> The people of Upper Congo, given over to cannibalism, human sacrifice, judgments by poison, fetishism, wars of plunder, slavery, polygamy, polyandry and deprived of all unity in government, science, writing, and medicine, are less advanced in civilization than the Celts were several centuries before Christ. All of a sudden, without any transition,

they saw appear on their savage waterway European steamships of the nineteenth century. In industry, the blacks can be advanced more quickly. But in moral order, progress will not advance with precipitation.

(Coquilhat, 1888: 483)

It was the task of the Europeans to assist the "infant" Africans to the maturity that had taken two millennia in the West. In this new cultural geography, Africa now had to be remapped by anthropologists, explorers and photographers whose combined efforts at describing African primitivism would re-enter European modernism with Pablo Picasso's use of motifs derived from Dan sculpture in his famous Cubist painting *Les Demoiselles d'Avignon* (1905).

Nineteenth-century maps of the Congo showed a squared white space, traversed only by the complicated flow of the Congo and its tributaries. For Europeans, the Congo had become simply a series of stops along the waterway. It may have been the sight of such charts that prompted the novelist Joseph Conrad to undertake his journey to the Congo, the last of what he called "the blank spaces on the earth," which he later fictionalized in his famous novella *Heart of Darkness* (1899). Photographers like the Belgian Emile Torday devoted thousands of exposures to the impossible task of recording and representing the Congo river, which defied photography due to its sheer size. The river itself was intensely alien to Europeans, as in this typical and widely quoted assessment by Count Pourtalès in 1888:

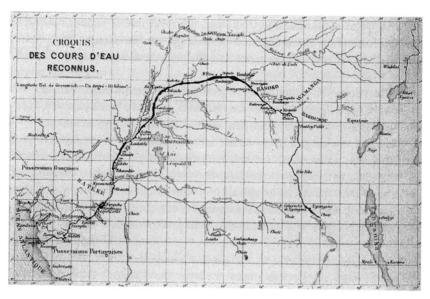

Figure 5.1 Camille Coquilhat, "Map of the Congo River," from *Sur Le Haut Congo* (Paris, 1888)

Figure 5.2 Herbert Lang, *Flocks of Birds on the Congo River* (c. 1910). American Museum of Natural History

> A leaden atmosphere envelopes you, rendered even more oppressive by the heat, which engulfed the sunshade of our little steamer. In the river, two or three rocky islands without any vegetation except the trunks of one or two dead trees, thrusting a naked branch towards the sky, as if tortured by suffering and despair. On the bank are monstrous crocodiles, and occasionally, in the shade of a rock, the silhouette of a huddled and immobile Negro, looking at our boat without making any movement as if petrified. Over all of this is spread something of that indefinable and mysterious thing that characterizes Africa. The European is not accustomed to see an immense river without shipping and with no habitation on its banks. Here, there is nothing except the noise of eddies produced by a current of such power that our boat, in certain places, seemed unable to advance. . . . However, this lugubrious spectacle, this silence, this immobility in creation are surprisingly severe and grandiose.
>
> (Coquilhat, 1888: 35)

For Europeans accustomed to the modern spectacle of circulation, whether of goods, people or traffic, the Congo river was perceived as a spectacle of primitivism that was almost impossible to visualize.

While the Congo river defined the Congo for Europeans, Kongo peoples saw water as the dividing line between this world and the world of spirits and the dead. The Kongo world-view could not have been more different from European beliefs in linear evolution and progress. It was encapsulated in what has been called the cosmogram, a cross of two intersecting lines within a circle forming four quarters representing "an ideal balancing of the vitality of the world of the living with the visionariness of the world of the dead" (Thompson, 1983: 106). The top half of the cosmogram represented the world of the living and the bottom that of the dead. Life was envisaged as a circle in which the individual passed from the land of the living to that of the dead and back again, while the community as a whole was constantly engaged with the spirits of the dead. In between was the water of the river and the sea. Just as Hughes was later to see the river as a site for diasporic

memory, Kongo peoples saw it as a place of complex connection between the past and the present. Europeans were convinced that the elimination of such beliefs was an essential step in converting Kongo primitivism into the modern, urban civilization of the Congo in which the river would come to serve as a waterway for the transportation of goods and the central avenue of settlement.

Figures like Stanley and Conrad who traveled in Congo around the turn of the twentieth century liked to portray themselves as the first Europeans to have set foot in the region, venturing into wholly unknown territory. When the Belgian Musée du Congo (now known as the Musée royale de l'Afrique Centrale) began to publish its holdings in 1902, the first volume was prefaced with the simple statement: "Twenty-five years ago, the Congo was unknown" (Notes, 1902: 1). In fact, Portuguese navigators first reached Kongo in 1483, initiating two centuries of conversion efforts by Catholic missionaries. The Kongo king Afonso I Mvemba Nzinga (1456–1542) not only learnt Portuguese but compiled erudite commentaries on religious texts and sent some of his relatives to Portugal, where one of his sons became a bishop. Nonetheless, the slave traders were raiding his country, as he protested to the King of Portugal in 1526: "Each day the traders are kidnapping our people – children of this country, sons of our nobles and vassals, even people of our own family. This corruption and depravity are so widespread that our land is entirely depopulated." Atlantic slavery destroyed the political structures in Kongo and erased the memory of the earlier crosscultural encounters.

Hundreds of thousands of Kongo people were forcibly expatriated into slavery and many more died as a consequence of the slavers' activities. The centralized monarchy gave way to a system of matrilineal clans, whose chiefs rose and fell according to their relationship with the slavers. Unsurprisingly, Christianity

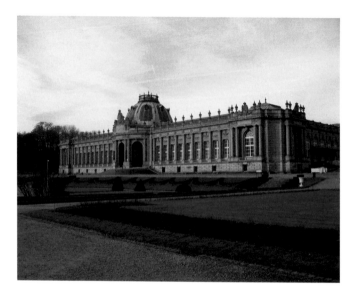

Figure 5.3
Musée Royale
de l'Afrique
Centrale,
Tervuren,
Belgium

"declined to the point of disappearance until Protestant missionaries began to arrive in the 1870s" but trade links continued even after the end of the slave trade (MacGaffey, 1993: 31). While anthropologists later assumed that Africans "evolved" from tribes to kingdoms, the reverse was in fact true – Europeans destroyed the kingdom of Kongo and created the Congo tribes as part of their divide-and-rule policy. As historian Wyatt MacGaffey has emphasized: "In Kongo, an area where one would expect to find tribes, if such things existed, we find instead a constant flux of identities" (1995: 1035). The process of deculturation here took the most violent form imaginable, forcing the peoples of Kongo to acculturate to new political realities and create new cultural practices from religion to art and medicine. While Europeans sought to invent the home of "primitive culture" in the Congo, everyday objects, African sculpture and European photography alike attest that the region continued to develop in transcultural fashion. Even in what Europeans saw as the very origin of the primitive, they created a record that often contradicts their own texts. The objects created by Kongo people were, in the Western sense, both realistic and abstract. They both resisted the colonizers and accommodated them. Their influence reaches back to the Christianized Kongo of the fifteenth century and forward to modern Paris (see Chapter 6).

The colonial venture into the Congo began in earnest after the Berlin Conference of 1885 had assigned the region to Belgium's King Leopold II. By this arbitrary act of division, Europeans reinvented Africa as a mirror of their own balance of power. For all the countries involved, imperial success in Africa became a key measure of national standing and influence. It is in this sense that the contemporary African philosopher V.Y. Mudimbe (1988) has suggested that the very idea of Africa is Western, for only the Europeans could have had the notion of sitting down at a table to divide up an entire continent amongst themselves. The Congo Free State, as it was ironically enough known, was created from a vast region of Central Africa equivalent in size to the entirety of Western Europe. It was all but a personal fiefdom of the Belgian monarch, who was at a stroke of the pen able to transform his country into a major colonial power. By 1895, the disorderly colony was nonetheless on the verge of bankruptcy, when the discovery of rubber transformed it into one of the most profitable of all colonial ventures.

The dramatic European commercial expansion into the Congo made it possible for anthropological and natural history expeditions to reach the interior with ease. Anthropologists were fascinated by the so-called "pygmies," or Mbuti peoples of the forest regions, while naturalists hoped for dramatic discoveries. In 1901 Sir Harry Johnston fulfilled this ambition when he became the first European to see the hitherto unknown okapi. Subsequently, all the major natural history museums mounted expeditions to the region in order to obtain their own specimens and perhaps to discover other unknown species. However, the violent excesses of the Belgian authorities in extracting the maximum profit from the Congo were such that they caused a scandal even in the high noon of imperialism. Even travel and natural history accounts of the region took positions for and against the colonial

regime until the publication of a report by the British consul Roger Casement in 1904 finally made the violence and arbitrary exercise of authority in the Congo an international matter of concern. Joseph Conrad wrote to Casement congratulating him on his report, noting that "it is an extraordinary thing that the conscience of Europe which seventy years ago has put down the slave trade on humanitarian grounds tolerates the Congo state today. It is as if the moral clock had been put back" (Pakenham, 1991: 656). Thus, the Anglo-Polish writer pointed out to the Anglo-Irish diplomat the exercise in (trans)cultural amnesia that the British themselves were content to ignore.

The result of this combination of anthropology, natural history and political scandal was a remarkable quantity of photographs, travel narratives and appropriation of African art and material culture that present the historian with an unusually rich range of materials with which to analyze the colonial Congo. Further, the almost entirely textual nature of the European re-invention of the Congo in the 1870s gave way to a visual representation of the heart of darkness. This revisualization was primarily enabled by the advances in dry-plate photography in the 1880s that enabled amateur photographers to take pictures even while on long trips. It sought to deny the excesses of colonialism and to instead represent it as a civilizing mission. What Conrad called the "threshold of invisibility" was the subject of innumerable visual representations as the first rung of the cultural ladder built by European science that led upwards to Western Europe. Photography was a key tool in visualizing colonial possessions and demonstrating Western superiority over the colonized. As the Europeans consolidated their hold on Africa, there followed a seemingly endless supply of "adventurers" and "explorers," who nearly all felt the need to publish an account of their journey. In these writings resistance to colonialism becomes rewritten as savagery.

European travelers consistently congratulated themselves on surviving the rigors of what Adolphus Friedrich, Duke of Mecklenberg, called "this dark corner of the world" (Friedrich, 1913: 3). In fact, the colonial regime had long since facilitated travel for well-to-do Europeans and created what might be seen as a virtual Congo for visitors to experience, photograph and retell back home. For example, Friedrich records his visit to a theatrical company, a race-course and a regatta in the course of one day. These recreations of European civility allowed European visitors to ports like Mombasa to retain some sense of being at "home," while acculturating to Africa. From there, the journey always led to the interior. In the Congo, the Belgian authorities laid down railway lines and operated river steamers, allowing the visitor to reach the "bush" quickly. Albert Lloyd, a British missionary, photographed the arrival of one such steamer at Avakubi, intending to show the remoteness of the place. One actually sees a large crowd of Africans calmly awaiting the steamer, bringing goods and offering services such as portering (Figure 5.4). No European carried his own baggage but instead had Africans carry large loads of 50 to 60 pounds a person, ensuring that British and German explorers traveled in sufficient comfort that they could dispute the appropriate point in their meal to drink the port (indeed

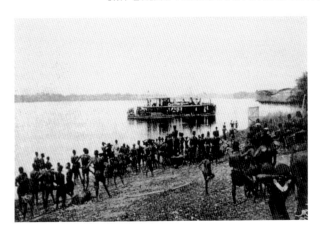

Figure 5.4 Albert
Lloyd, "Arrival of the
Steamer," from *In
Dwarf Land and
Cannibal Country*
(London, 1899)

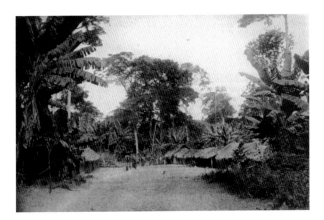

Figure 5.5 Adolphus
Frederick, "A Station
Village in the Congo,"
from *In the Heart of
Africa* (London, 1910)

the prodigious quantity of alcohol consumed can be seen from the fact that during
a supplies crisis at Leopoldville, officials had to restrict each European to half a bottle
of port a day). The government maintained a network of paths and resthouses spaced
out every 10 to 20 miles, allowing an expedition to proceed at a gentle but satisfac-
tory pace (see Figure 5.5). They also created obvious opportunities for photography
that few passed up. Friedrich illustrated his account with a photograph entitled "A
Glade in the Virgin Forest" to demonstrate his courage in taking on the African
elements (see Figure 5.6). Instead, the photograph clearly shows a well-beaten path
heading directly through the scrub. These paths were sufficiently well-maintained
that one Marguerite Roby was able to ride her bicycle through much of the Congo
in 1911 (see Figure 5.7). The work involved was performed by the Congolese to
meet the taxation demands levied on them by the Belgians, realized either with
colonial products such as ivory and rubber or with unpaid labor. The local people
were also responsible for supplying the resthouses with food and water. This govern-
ment care of the European traveler was well rewarded, as most travel accounts

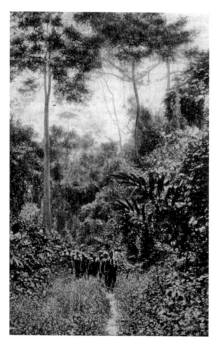

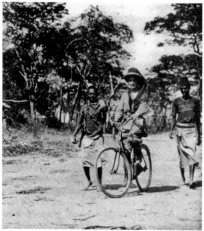

Figure 5.6 Adolphus Frederick, "A Glade in the Virgin Forest," from *In the Heart of Africa* (London, 1910)

Figure 5.7 Marguerite Roby, "Leaving Elizabethville," from *My Adventures in the Congo* (London, 1911)

supported the government against the reformers. The photographs in such books were taken as key evidence of the authenticity of the traveler's account. While they no doubt did record what European visitors had experienced, that experience had been carefully prepared for them by the colonial administration.

For most European travelers, African resistance was only encountered symbolically as resistance to photography. Their books are filled with pictures of Africans permitting themselves to be photographed, often because they had no choice, but withholding consent by refusing to strike a pose or smile. For Europeans, this lack of cooperation was explained as a superstitious fear of cameras, rather than as an acknowledgment that Western military technology was in a position to enforce consent. In one typical account published in 1892, M. French-Sheldon, the self-styled "Bebe Bwana" asserted simply that

> the natives' horror of being photographed makes it most difficult to obtain satisfactory portraits of them. Once, and only once, with their knowledge I held up my camera before a group of natives employing the photographer's fiction to attract their attention, "Look here and you will see a bird fly out." The result justified the deception. Their

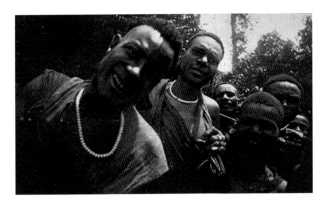

Figure 5.8
M. French-Sheldon,
"Untitled," from her
*Sultan to Sultan:
Adventures in East
Africa* (Boston, 1892)

good-natured, laughing physiognomies depict anything but brutality
or savagery.

(French-Sheldon, 1892: 414)

French-Sheldon's self-confidence in her superiority was such that she completely
failed to see the mockery on the faces of her subjects, who were fully aware of what
she was doing. These stories were repeated so often that they have become part of
the Western myth of its own technical, hence moral, superiority. What they forget
is that such fears originated in Europe. The French novelist Honoré de Balzac, whose
own work concentrated on describing modern society, at first refused to be
photographed. The photographer Nadar recalled that Balzac

concluded that every time someone had his photograph taken, one of
the spectral layers was removed from the body and transferred to the
photograph. Repeated exposures entailed the unavoidable loss of
subsequent ghostly layers, that is, of the very essence of life.

Nonetheless, he was later able to persuade Balzac to be photographed in dramatically
Romantic style, as photography quickly became naturalized and normalized as part
of Western society. The gap between Balzac's fear of the camera and the later
attribution of that fear to Africans was precisely that in which Europeans forgot one
version of Africa and invented another.

Anthropologists were not much more perspicacious when it came to describing
human society in Kongo. Friedrich documented what he described as "A Cannibal
from the Border Mountains of Congo State." The proof that this man was a cannibal
lies in his sharpened teeth that he conveniently bared for the camera. This decorative
tradition led many Mbuti people to be falsely described as cannibals. One such man
named Ota Benga was actually displayed as an exhibit at the Bronx Zoo in New York
City in 1906. Cannibalism has long been used to justify colonization. The British
accused the Irish of being cannibals in the seventeenth century, for example, while

Indian Hindus thought Christians were cannibals when they proclaimed the Eucharist to be the body of Christ. Cannibalism, understood as the routine eating of human flesh, has been nothing more than an enabling ideology to justify European expansion. For colonists could claim that the formerly prevalent practice of anthropophagy had died out as soon as their regime took control, thus taking credit for eliminating something that had not existed in the first place. While some anthropologists still maintain that cannibalism was practiced by some peoples, such as the Anasazi people in what is now the Southwest US, there seems no incontrovertible evidence of this to outweigh the centuries of prejudice. It may be possible that symbolic consumption of specific body parts took place in warfare. The Christian Crusaders were among those thought to have participated in such cannibalism.

Nor could any human equivalent of the okapi be found, a suitably exotic variant on the European definition of the human to satisfy their sense of physical superiority. The best that could be done was to identify the Mbuti people as the "Pygmies," a people supposedly notable for their shortness and reclusive behavior. One English writer, A.F.R. Wollaston, who accompanied the British Natural History Museum expedition to the Kongo region in 1905–6 moved directly from his discussion of the okapi to the Pygmies: "who can climb trees like a squirrel and can pass through the thickest jungle without disturbing a twig. . . . The first Pygmy that I met greeted me with a shout of 'Bonzoo, Bwana (sir)'; he had been for a time in a Congo post, and 'Bonzoo' was his version of 'Bon jour'" (Wollaston, 1908: 153). In a typically surreal moment of colonialism, an Englishman thus criticized an Mbuti for his French pronunciation in the Congo rainforest, while blithely insisting that this person was also an example of Darkest Africa. In 1853 a group of Mbuti dressed in European clothing even went on a tour of Britain, where they played piano to show how "civilized" they could be (Fusco, 1995: 43). The more that Europeans tried to insist on the profound difference of Africans, the more they seem to provide evidence of the transcultural and hybrid world created by colonialism.

One of the longest missions to the region was that of the American Museum of Natural History, led by Herbert Lang and James Chapin from 1909–15 (Mirzoeff,

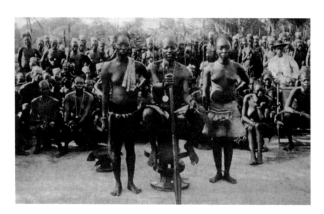

Figure 5.9
Herbert Lang, *Danga: A Prominent Mangbetu Chief* (1910–14).
American Museum of Natural History

1995: 135–61). In over 10,000 photographs, Lang obsessively documented both natural and human sights of interest, taking especial care to record the way of life of the Mangbetu people. Despite his extended fieldwork, Lang reproduced images not of the "authentic" Mangbetu way of life but of the colonial order imposed by the Belgians, and Mangbetu attempts to negotiate with this power. In one photograph, Lang showed "Danga, a prominent Mangbetu chief" seated in front of a large crowd, whom we may suppose to be Danga's subjects (see Figure 5.9). As Lang noted in his caption, Danga is wearing his brass insignia of office, given to him by the Belgians, "of which he is inordinately proud." As well he might be, for the Belgian badge was Danga's only connection to power. The Northeastern region of the Congo had actively resisted Belgian control until an army of over 15,000 African troops, commanded by Belgian soldiers, had suppressed dissent in 1895. Even then, outbreaks of rebellion persisted well after 1900. The Belgians installed their former soldiers, recruited elsewhere in the Congo, as chiefs of the subjugated rebels. Danga was most probably not even Mangbetu, let alone a "chief." Here Lang recorded nothing more than the colonial attempt to create a manageable "tribal" order in what they called the Congo from ruins of the vast Kongo kingdom. Furthermore, despite Lang's attempt to record only authentic local culture, a man wearing a Western white linen suit topped with a felt hat can be seen on the right-hand side of the picture.

In one case, the transformation of colonial text into image that is typical of the visual culture of colonialism in this period took concrete form. When Lang arrived in the Mangbetu region, he expected to see a great hall that he had read about in Schweinfurth's book *In the Heart of Africa* (1874). By this time, no such hall existed if indeed it ever had. Once the local chief Okondo realized that Lang was upset by this disruption of his vision of the colonial order, he set about rectifying matters. He had a hall built, 9 meters high by 55 meters long and 27 meters wide. As Lang himself noted, "five hundred men worked at the structure, of course with continual interruptions for dancing and drinking" (Schildkrout, 1993: 65). One can only

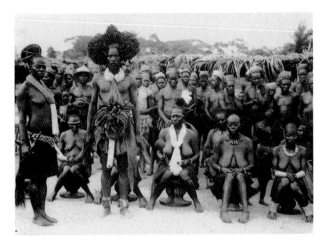

Figure 5.10 Herbert Lang, *Chief Okondo in Dancing Costume* (1910). American Museum of Natural History

imagine how amusing the Mangbetu must have found re-imagining this structure on the basis of Lang's description. At the same time, it was worth their undoubted exertions and cost to build this hall if by so doing they could avert the violence of the colonizers. Needless to say, when the building was finished Lang photographed it. The photograph is a powerful testament to a particular version of what Homi Bhabha has called the mimicry of the colonial order (Bhabha, 1994: 85–92). In this case, the Mangbetu were mimicking the colonizers' ideas of how "natives" ought to live, right down to the local architecture. Once one becomes aware that Lang's photographs do not show what they purport to represent, it becomes difficult to place trust in any of them. When we see, for example, "Chief Okondo in dancing costume" (Figure 5.10), is this really a dancing costume used by Mangbetu, or a suitably exotic masquerade dreamt up to satisfy a colonial whim? Given that Okondo seems to have worn his Belgian army uniform for day-to-day clothing, his dancing costume seems all the more stylized to meet a colonial need.

Okondo's strategy was not unusual in the upside-down world of colonial empires. In neighboring Cameroon, King Njoya of Bamum had found himself under considerable pressure from the German colonial authorities to donate his beaded throne to their anthropological museum. Njoya agreed to make an identical copy of his throne for the German but when a delegation arrived to collect it, the copy had not been finished. Njoya simply gave them the throne he had been using and kept the copy for himself. He later donated copies of the throne to British and French colonial officials, making five copies in all. From the Western perspective, only the German example is the "real" throne and the others are simply inauthentic copies. But as Michael Rowlands explains,

> in Bamum aesthetic terms there was no single original work to be copied but rather a number of equal alternatives. Any one of them could be desacralized as a gift or resacralized as a state throne. There was no reason to privilege one of them in particular although none of them should have been sold. The creation of an authentic original to suit European sensibilities was achieved by Njoya's gift, transforming ritual object into artwork.
>
> (Rowlands, 1995: 15)

Leaders like Njoya and Okondo helped Europeans invent Africa in the way they envisaged it, as an untouched primitive dark continent with a native culture on the verge of extinction that had to be preserved in the only suitable location, a Western museum. This strategy of acculturating colonialism provided a space for Africans and Europeans to coexist in the uneasy alternating cold and hot wars of colonial settlement. For Europeans, the visual documentation of Africa was central to their transculturation of the continent into a land fit for colonization. Africans aided this process as an alternative preferable to the kind of violence that led to an international outcry over conditions in the Congo from 1897 onwards.

Resistance through ritual

Resistance to colonial rule also took more direct forms, especially in regions remote from the main military centers. Many accounts record attacks on Europeans throughout the "scramble for Africa" period that were always presented as rank treachery but seem to testify better to colonial gullibility or naiveté. Friedrich recorded one such incident in which the Sultan of the Massalits attacked a party led by one Captain Fiegenschuh at a peace conference in 1910:

> The Sultan rode to meet Captain Fiegenschuh, accompanied by hundreds of his warriors, as is customary in a friendly reception. The too-confiding Captain took this as a sign of peaceable intentions, never suspecting treachery. The Massalits hurled themselves upon the astonished Frenchmen, whose weapons were not even loaded, and cut them to pieces.
>
> (Friedrich, 1913: 48)

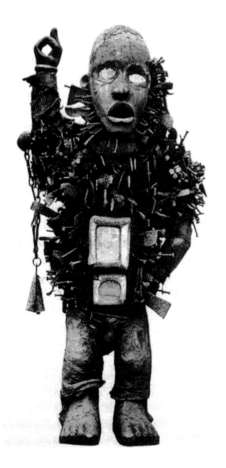

Figure 5.11 Anon., *Nkisi Power Figure* (c. 1900), Tervuren, Musée Royale de l'Afrique Centrale

In the more policed areas of the region such direct action was not possible. Resistance instead came to center on a remarkable type of object, the Kongo *minkisi* (singular *nkisi*). *Minkisi* were power objects that, when called upon by a skilled operator, the *nganga*, would intervene on behalf of the supplicant against his or her enemies or evil spirits. Europeans characterized these and other African religious objects as "fetishes," by which they meant inanimate objects that have powers of their own. Wyatt MacGaffey exhorts us to "remember that 'fetish' is an entirely European term, a measure of persistent European failure to understand Africa" (1993: 32). These extraordinarily complex figures defy the usual descriptive categories for they were the result of the transculture process, creating a striking new cultural form. The skill with which they were made and the visual power they present obviously qualifies them to be considered as art, but the practical and religious uses to which they were put also implies that were ritual objects and a part of everyday life.

Nails were driven into the figure as an injunction for it to carry out the mission that the client was seeking to accomplish. When activated by the appropriate medicine and rituals, the *nkisi* was able to invoke the powers of the dead against hostile forces, whether illness, spirits or individuals, and to interact with the forces of nature. It is clear from the great numbers of *minkisi* made in the colonial period and the care with which the colonizers sought to destroy or remove them that both Africans and Europeans thought these power figures were an effective part of the resistance to colonialism:

> *minkisi* were important components of African resistance. The destruc-
> tion of these objects was also justified as part of the eradiction of
> "heathen" religions and the missionary effort to spread the "civilizing"
> influence of Christianity. Missionaries burned *minkisi* or carried them
> off as evidence of paganism destroyed; military commanders captured
> them because they constituted elements of an opposing political
> force.
>
> (MacGaffey, 1993: 33)

The Belgians understood that removing the *minkisi* was a necessary military action, as the curators of Belgium's Congo Museum in Tervuren explained:

> Generally intelligent, the fetish operators pursue anyone who crosses
> their designs with an inveterate hatred. The Europeans are the particular
> object of their hostility. If our compatriots relentlessly pursue them to
> prevent their misdeeds, for their part, the fetishists return in hate and
> perfidy all the damage done to their illicit industry. Many rebellions,
> crimes against Europeans, and outrages against authority are due to this
> hostility.
>
> (Notes, 1902: 169)

In this text, anthropology quickly becomes identical to colonial authority. Anthropologists and colonial officials alike pursued the *minkisi* because they represented a new mode of everyday life for Africans under colonial rule. Furthermore, they could not deny that some *ngangas* did have a "real mysterious power" that was directly opposed to colonial rule. The very existence of the *minkisi* allowed Africans to imagine themselves as subjects within the colonial system rather than merely its servants or objects.

The care with which these missions to eliminate the *minkisi* were carried out means that there are significant numbers of *minkisi* in European and now North American museums. The collector Arnold Ridyard explained, "the Portuguese and French governments are taking these Fetishes away by force as they stop the trade of the country" (MacGaffey, 1993: 42). He was referring to the worry that the *minkisi* were enabling Kongo peoples to resist producing rubber, ivory and the other colonial products sought by the Belgians. An especially frequent figure in such colonial collections is the *nkisi Kozo*, representing a double-headed dog (see Figure 5.12). As dogs were key to the hunt, Kozo was an especially powerful *nkisi*. Furthermore, he has two heads to represent the Kongo belief in the ability of dogs to see both the land of living and that of the dead, metaphorically understood as the village and the forest. This doubled vision of Kongo was unavailable to the colonizers and represents a way of looking back at the colonial gaze represented by the photograph. It was not simply a stereoscopic vision but a way of seeing that was more than ordinarily human, able to see forwards and backwards at once. The *minkisi* were not relics of archaic religions but a means of organizing resistance to colonial culture and creating an alternative means of representing reality for the colonized. It was not for nothing that the Belgians named them an "industry," for it was a productive and organized social structure that enabled the colonized to think of themselves as subjects and not merely embodied labor.

It was common for *minkisi* to have pieces of European cloth fixed to them, indicating the target for the spirits, or even be equipped with a gun to help the struggle against the colonizers (MacGaffey, 1993: 98–100). Some carved figures

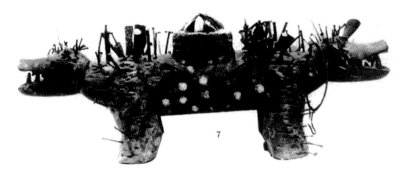

Figure 5.12 Anon., *Nkisi Kozo* (c. 1900), Tervuren, Musée Royale de l'Afrique Centrale

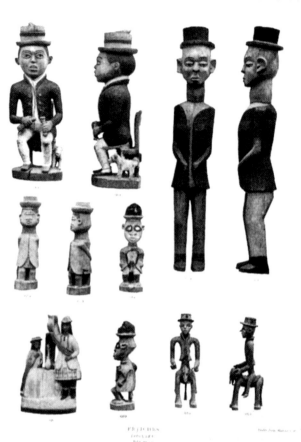

Figure 5.13
Unknown Kongo
artists, *European
Figures* (c. 1900),
Tervuren, Musée
Royale de l'Afrique
Centrale

are known that represented either Africans dressed in European clothing or Europeans (Notes, 1902: pl. LIII). The difficulty we now have in classifying these particular figures is a good indication of the limitations of the taxonomic gaze. A sculpture of a man wearing European clothing pouring a drink from a bottle into a glass is a good example. For the curators of the Congo Museum, it was clear that the clothing was European, as was the man himself, while the dog was Congolese (Notes, 1902: 293). These judgments are hard to support from the visual evidence. The man's hair seems to be a stylized representation of African hair but none of his features conform to Western stereotypes of the African. He may of course be of both European and African descent. His clothes are Western in style but a curious fusion of what looks like an eighteenth-century jacket with modern trousers and shoes, the whole topped off with a remarkable hat that has aspects of the top hat but with unusual decoration. The museum curators discovered traces of what they termed "magic substances" in the hat of this and other similar hybrid figurines. Just

as the top hat was a symbol of authority for European men, often replaced by the pith helmet in Africa, so too was the hat a location of power in these Kongo figurines. At this distance, we should not be drawn into the game of trying to determine their "real" ethnic type. Rather this figure attests to the transcultural complexities of the colonial Congo.

For the *minkisi* are not what they might at first appear. To Western eyes, these objects may seem almost uniquely "African," wholly drawn from another culture than that of the Euro-American tradition. Indeed, an *nkisi* figure served as the frontispiece for the catalog of the controversial *Primitivism in 20th Century Art* exhibition at New York's Museum of Modern Art (1984), presumably because it was seen as a dramatic example of the exotic primitivism that was held to influence modern artists with its authentic power. However, not only do the *minkisi* derive their meaning and function from the interaction with colonizers of the Scramble period, but their distinctive style may owe something to a much earlier contact with Europeans. Even the Belgian authorities recognized that "incontestably there are notions of obscure European provenance in the fetishist ideas of several Congo peoples" (Notes, 1902: 147). Anthony Shelton has suggested that the use of nails to invoke certain *minkisi* may derive from the Christian imagery of the fifteenth century: "The origins [of the *minkisi*] . . . remain enigmatic, but it is probable, though historically unproven, that they emerged from a synthesis of Christian and Kongo beliefs." An especially close parallel can be seen in the fact that "images of the pierced body resulting from the martyrdom of saints or the crucifixion of Christ have dominated Christian iconography" (Shelton, 1995: 20). Christian images had been retained by Kongo chiefs, despite the decline in Christian beliefs, as the cross could easily be assimilated as a cosmogram. The striking confluence between medieval Christian iconography and the *minkisi* figures suggests that the pierced body image was acculturated in Kongo during the Christian period, deculturated as Christian observance diminished and given neocultural form in the *minkisi*. In short, despite the century-old attempt to classify the Congo as the remotest point on the ladder of cultural evolution from the European heights, Kongo and Western peoples have in fact been engaging in transcultural exchange for half a millennium, creating a distinct form of modernity. The experience of dislocation and fragmentation associated with postmodernism in the West has in fact long been anticipated in the so-called periphery.

References

Bhabha, Homi (1994), *The Location of Culture*, London: Routledge.

Coquilhat, Camille (1888), *Sur Le Haut Congo*, Paris: J. Lebègue.

French-Sheldon, M. (1892), *Sultan to Sultan: Adventures among the Masai and other Tribes of East Africa*, Boston, MA: Arena.

Friedrich, Adolphus (1913), *From the Congo to the Niger and the Nile*, London: Duckworth.

Fusco, Coco (1995), *English is Broken Here: Notes on Cultural Fusion in the Americas*, New York: New Press.

Gilroy, Paul (1993), *The Black Atlantic: Modernity and Double-Consciousness*, Cambridge, MA: Harvard University Press.

Hughes, Langston (1993), *The Big Sea: An Autobiography*, New York: Hill and Wang.

Kaplan, Amy and Donald E. Pease (eds) (1993), *Cultures of United States Imperialism*, Durham, NC: Duke University Press.

MacGaffey, Wyatt (1993), *Astonishment and Power*, Washington, DC: National Museum of African Art.

—— (1995), "Kongo Identity, 1483–1993," *South Atlantic Quarterly*, vol. 94 no. 4, pp. 1025–37.

Mbembe, Achille (2002), *On the Postcolony*, Berkeley: University of California Press.

Mirzoeff, Nicholas (1995), *Bodyscape: Art, Modernity and the Ideal Figure*, London: Routledge.

Mudimbe, V.Y. (1988), *The Invention of Africa: Gnosis, Philosophy and the Order of Knowledge*, Bloomington, IN: Indiana University Press.

Notes (1902), *Notes Analytiques Sur les Collections Ethnographiques du Musée du Congo*, Brussels: Annales du Musée du Congo.

Pakenham, Thomas (1991), *The Scramble for Africa*, New York: Random House.

Renan, Ernst (1990), "What is a Nation?," in Homi Bhabha (ed.), *Nation and Narration*, London: Routledge.

Rowlands, Michael (1995), "Njoya's Throne," in *The Impossible Science of Being: Dialogues between Anthropology and Photography*, ed. Christopher Pinney et al., London: Photographers' Gallery.

Schildkrout, Enid (1993), *African Reflections: Art from North-Eastern Zaire*, New York: American Museum of Natural History.

Shelton, Antony (1995), "The Chameleon Body: Power, Mutilation and Sexuality," in *Fetishism: Visualizing Power and Desire*, London: South Bank Centre.

Thompson, Robert Farris (1983), *Flash of the Spirit: African and Afro-American Art and Philosophy*, New York: Random House.

Wollaston, A.F.R. (1908), *From Ruwenzori to the Congo*, London: John Murray.

RACE

The means of distinguishing humans into separate categories known as "races" has a long and undistinguished history. Let it be noted at once that a clear scientific consensus exists that there are no biological grounds to distinguish human beings into separate "races" (hence the quotation marks which I will assume from now on). Genetic research has shown that even at the level of DNA there are no fundamental differences between people, although it is possible to classify people by ethnicity. If a particular group has certain characteristics, whether visible or not, that can be detected, while marking no broad difference among humanity as a whole. But the social practices of slavery, segregation and racism have nonetheless made race a social fact in the United States. The divisions made by race became more rather than less acute after the abolition of slavery. Under slavery, while being in some part of African descent was a historical factor in being enslaved, the primary relationship was one of property. Slave-owners defended their property rights and made instrumental use of the "inferiority" of the enslaved. Abolitionists countered that because of coerced sexual relations on the plantations, there was increasingly little visible distinction between the enslaved and the free. Paradoxically, then, the failure of slavery as an American institution was in part due to its inability to maintain visibly distinct characteristics between the enslaved and free population.

However, modern racism determined that any "mixing" of the presumed stable races was not to be allowed, forgetting in one fell swoop centuries of forced and free intermarriage and sexual relations between different ethnicities. Laws passed in the late nineteenth century instituted a segregation so rigid that a person with 1/32 African ancestry was classified as "black." Known collo- quially as the "one drop of blood" rule, this division created separate facilities for education, health, labor and indeed all categories of the modern disciplinary

society. In 1903 W.E.B. Du Bois described the experience of the African American as having what he called a "double-consciousness": "one ever feels his twoness, an American, a Negro" ([1903] 2000: 2). This "twoness" was made into a social fact by the existence of what Du Bois called the "color line," an invisible but powerfully significant division of the sensible. By presuming that race was an immutable fact and that races should not mix, United States law and social practice forced people into one of only two distinguishing categories, "white" or "colored."

How were the many people of diverse heritage to be classified under such rules? It can be argued that race is a pragmatic form of the indexical sign. The theory of indexicality was taken from the work of the American philosopher Charles Sanders Peirce (1839–1914). In his theory of the sign, an indexical sign was one that bore a real relation to its object. According to Peirce,

> An *index* is a sign which would, at once, lose the character which makes it a sign if its object were removed, but would not lose that character if there were no interpretant. Such, for example, is a piece of mould with a bullet-hole in it as a sign of a shot; for without the shot there would have been no hole; but there is a hole there, whether anybody has the sense to attribute it to a shot or not.
>
> (Bal and Bryson, 1991: 189)

The index thus puts the interpreter in a significant place because only by making the appropriate series of deductions can the hole be shown to be a bullet hole in particular. Race thus exists and visual signs make it visible. Racialized theory itself has been intensely ambivalent about the place of the skin or other physical features in determining race. Numerous accounts argue that these signs may be important but what matters is the internal quality of difference that may be as effectively concealed as revealed by the external appearance. Caught between the desire to state the obvious as its argument – that race is what is visibly different – and the impossibility of sustaining such a position in the face of the always already mixed population of the United States, race flickers in and out of sight, frustrating efforts to refute it by refusing a stable definition. Race has thus tended to be defined in ways that we can call pragmatic, referring at once to the work of American philosopher William James ([1907] 2000) and the sense that race "works" or does work within American society. Pragmatism refused to allow technical or theoretical difficulties, such as an effective means of actually distinguishing humans into distinct races, stand in the way of the practical necessity of doing so. Thus current federal regulations allow for five categories of racial identity plus "other." In this sense, the act of racial distinction created race, just as, in William James's famous example, the act of crying produces the sensation of grief.

Mixing was seen in strikingly literal terms that would inevitably leave a visual

mark. In his novel *The Mulatto* (1881), the anti-slavery Brazilian writer Aluíso Azevedo continued to subscribe to this belief in the visibility of miscegenation. His hero Dr. Raimundo José da Silva, a blue-eyed light-skinned man, seeks the hand of Ana Rosa but is refused because it transpires that he was the son of a slave woman:

> [Raimundo] stopped in front of the mirror and studied himself closely, attempting to discover in his pale face some thing, some sign, that might give away his Negro blood. He looked carefully, pushing back the hair at his temples, pulling the skin taut on his cheeks, examining his nostrils, and inspecting his teeth. He ended up slamming the mirror down on the dresser, possessed by an immense cavernous melancholy.
>
> (Azevedo, [1881] 1990: 211)

Needless to say, Raimundo dies and his intended recovers to marry an appropriate suitor. The visible mark of race indicates that the bearer is not a full member of society, defined as "white," and is hence not entitled to contract marriages or have children. To put it in psychoanalytic terms, the mulatto cannot possess the gaze/phallus any more than can women. His racial Otherness excludes him from the ranks of patriarchy, especially the key transactions of marriage and childbirth. He is fit only to die or be sold.

If biology did not always provide secure arguments against miscegenation, morality could always be relied upon to fill the gap. In 1860, the Southern sociologist Henry Hughes proclaimed that: "Impurity of races is against the law of nature. Mulattoes are monsters. The law of nature is the law of God. The same law which forbids consanginous amalgamation forbids ethnical amalgamation. Both are incestuous. Amalgamation is incest" (Rogers, 1994: 166). Hughes conceded that sexual reproduction between races was biologically possible but asserted that it was as morally intolerable as incest. The parallel seems odd. Incest is forbidden because of the closeness of the potential partners, while race theory argued that Africans and Europeans were fundamentally different races. If the law of incest was really to be applied in conjunction with the dictates of race science, then miscegenation ought to have been the rule not the exception. Such arguments indicate that it is often futile to attempt to tease out the logic of race, based as it is on fundamentally irrational premises. Nonetheless it was not until 1967 that the state of Virginia legally permitted marriage across the color line, with the dilemma featuring that year in the Oscar-nominated film *Guess Who's Coming to Dinner?*, starring Sidney Poitier, Spencer Tracy and Katherine Hepburn. This "issue" film posed a dilemma for white liberal parents when their daughter Joanna wants to marry the impossibly perfect Dr. Prentice (Poitier). Seen today, there is no real tension as the highly qualified doctor with impeccable manners seeks the consent of his fiancée's parents.

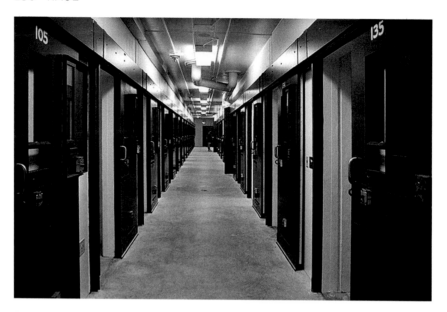

Supermax prison

It might be concluded that such sexualized panics about race have been largely although not entirely superceded. However, the other intent of the Black Laws passed during segregation was to criminalize the African-American population in a discriminatory fashion. The new penitentiaries provided a cheap labor force for the post-Reconstruction South under the convict lease schemes, in which an employer could hire those convicted for negligible rates of pay, creating the now-infamous chain gang as one of its most visible forms. While the chain gang is mostly gone, the prison population of the United States has grown ever larger and more unequally marked by racialized distinction. A report published by the respected Pew Charitable Trust in 2008 concluded that 1 percent of the adult population of the United States was in prison, making the US incarceration rate the highest in the world, reaching 2,319,258 in 2007. This population is disproportionately African-American to the extent that one African-American man in nine between the ages of 20 and 24 is now in prison (Pew, 2008: 3). In the last 20 years, the amount spent on state higher education has risen by a modest 21 percent, while corrections budgets have increased by 127 percent (Pew, 2008: 15).

Angela Y. Davis, activist and scholar, has called the resulting situation "the prison industrial complex," playing off President Eisenhower's famous description of the "military industrial complex." The prison industrial complex is composed first of the technologies and built environment required to sustain so large a prison population. With state and national governments being unable to keep pace, a substantial global corrections industry has emerged, used above

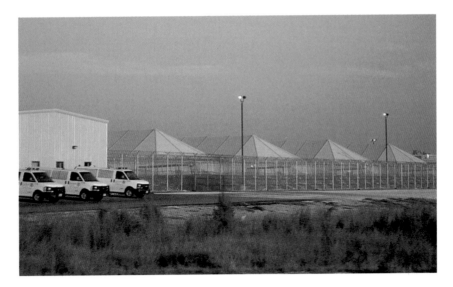

Asylum seeker detention center

all in the detention of asylum seekers, migrants and refugees. The prisoners themselves serve as subjects for medical testing, as call center operators and as minimal cost labor. In Davis's view, it is necessary to call for the abolition of prison. By this she intends to challenge us to rethink a one size fits all solution to the false dyad of crime and punishment and instead to adopt a networked solution to modern governance: "demilitarization of schools, revitalization of education at all levels, a health system that provides free physical and mental care to all, and a justice system based on reparation and reconciliation, rather than retribution and vengeance" (2003: 107). Understood in the historical framework set out in this book, Davis's call is for the end to the panoptic tech- nology of the single disciplinary institution based on surveillance being used to control schools, prisons, the health care system and the military.

Perhaps the greatest single obstacle to that program is the reaction experi- enced by the Caribbean psychiatrist Frantz Fanon when he visited France in the 1950s. A child cried out to its mother "Look! A negro . . . mother, I'm fright- ened." The simple presence of a person visibly of African descent led to an association with imminent crime. Fanon linked this association to popular entertainment, such as cartoons and films, to which we should now add the endless repertoire of crime-based television drama. In short, the visualized code of skin color now associates darker skin with crime. This provides for a deniable practice of racialized distinction. When a white man was mugged in the once diverse neighborhood of downtown Cleveland, Ohio, on New Year's Eve 2007, Dick Feagler addressed the other white residents in the *Cleveland Plain Dealer*: "So move. But do it like we all have – like the whole three-county area

has – don't call it racism. Call it reality." This editorializing is perhaps more revealing than it intended to be: race, understood as crime, is not to be understood as indicating a prejudice but an objective observation of exterior reality, pragmatically defined as requiring *de facto* economic segregation. Perhaps not altogether surprisingly, in the Ohio Democratic primary election in March 2008, Hillary Clinton handily defeated the African-American Barack Obama.

References

Azevedo, Aluíso ([1881] 1990), *The Mulatto*, London: Associated University Presses.

Bal, Mieke and Norman Bryson (1991), "Semiotics and Art History," *The Art Bulletin* vol. 73, no. 2, pp. 174–208.

Davis, Angela Y. (2003), *Are Prisons Obsolete?*, Boston: Open Media.

Du Bois, W.E.B. ([1903] 2000), *The Souls of Black Folk*, London and New York: Penguin.

James, William ([1907] 2000), "What Pragmatism Means," rpr. in *Pragmatism and Other Writings*, London and New York: Penguin.

Pew (2008), "One in One Hundred: Behind Bars In America," available from http://www.pewcenteronthestates.org/news_room_detail.aspx?id=35912, accessed 7/21/08.

Rogers, David Lawrence (1994), "The Irony of Idealism: William Faulkner and the South's Construction of the Mulatto," in *The Discourse of Slavery: Aphra Behn to Toni Morrison*, ed. Carl Plasa and Betty J. Ring, New York: Routledge.

SEXUALITY DISRUPTS

Measuring the Silences

S EXUALITY DISRUPTS. If culture is often presented as a discrete object, a seamless web of social relations, sexuality is the loose end that undoes the garment. The coexistence of culture with power necessarily evokes the modern preoccupation with gender, sexuality and "race." Rather than seeing sexuality as a means of constituting identity, it can instead now be described, in Kobena Mercer's phrase, "as that which constantly worries and troubles anything as supposedly fixed as an identity" (Mercer, 1996: 119). Although the biological difference between men and women might appear "obvious," there have been and continue to be sharp changes in the way the human reproductive system is believed to operate. These changes in the interpretation of biological sex have extended repercussions. In the first instance, they challenge the assumption that sex is natural, while gender is a social construction. The modern logic of sex, gender and sexuality – that biological sex predicates gender, which in turn dictates the choice of the opposite gender as a sexual partner – turns out to be a castle built on sand. However, taking sex to be a cultural category poses as many questions as it answers. Early modern Western medicine had interpreted classical theories of reproduction to generate a one-sex model of the human species. In this view, the sexual organs were essentially the same in men and women, only inverted so that what was inside the woman was outside the man. Yet in Thomas Lacquer's account "[b]y around 1800, writers of all sorts were determined to base what they insisted were fundamental differences between the male and female sexes, and thus between men and women, on discoverable biological distinctions" (Lacquer, 1990: 5). The evident biological inaccuracies in the ancient account led to a total transformation, not only of biological interpretations of physiology, but of the social roles accorded to each gender, as stated baldly by the French biologist Isidore Geoffroy Sainte-Hilaire in 1836:

The laws of all nations admit, among the members of the society they rule, two great classes of individuals based on the difference of the sexes. On one of these classes are imposed duties of which the other is exempt, but also accorded rights of which the other is deprived.

(Epstein, 1990: 128)

This shift to what Lacquer calls a "biology of incommensurability" had profound implications for sexual practice as well as classification. Early modern society held that unless they experienced orgasm, in the words of one popular text, "the fair sex [would] neither desire nuptial embraces, nor have pleasure in them, nor conceive by them" (Lacquer, 1990: 3). Here the last is perhaps the most important: if it was believed that female orgasm was an indispensable condition to conception, then no man could afford to ignore it. Nineteenth-century medicine observed that female pleasure was not in fact essential to reproduction and the disciplinary society was free to regulate feminine sexuality as being deviant if it centered on clitoral rather than vaginal pleasure. The production of a "biology of incommensurability" was both challenged by and dependent on the question of miscegenation, where discourses of race and sexuality literally engender reality. The highly charged term miscegenation refers to the "mixing" of different "races" in sexual reproduction, leading to the generation of a new hybrid. The linguistic difficulties one encounters in trying to refer to this subject without using racialized terminology are indicative of the persistence of racialized notions in Western everyday life. In the colonial period, the Spanish devised an extremely complicated vocabulary for designating such offspring, measured by degrees of white, black and Indian ancestry. Some of these terms have survived into current usage, such as mulatto/a, the child of one white and one African parent. A mestizo/a was originally the offspring of an Indian with a mulatto/a but the term has come to apply to the web of cross-cultural ancestry that has generated the contemporary populations of the Caribbean and Latin America. As this language has its origin in theories of racial purity, these issues remain extremely charged. In Mexico, this dynamic was symbolized by Malinche, or Malineli Tenepatl (c.1505–c.1529) the indigenous woman, now thought to have been Nahua, who became an interpreter for Hernán Cortés. She had been enslaved to the Maya who in turn gave her to Cortés by whom she later had a son. Her gain in personal power has to be offset against the damage done by her work to her own people that led her to be long portrayed as a traitor, until her recent adoption as a symbol by Chicana lesbian feminists (Goldberg, 1992: 204).

Ironically, the simple fact that people of different ethnicities can and do have children with each other, even though it has consistently been either denied or termed morally wrong, gives the lie to the notion of distinct human races. This mixture of affirmation and denial is typical of the fetishistic gaze. Fetishism allowed Western men to disavow what must have been the direct experience of their senses in the long history of miscegenation in Africa, the slave plantations of the Americas, and the Caribbean. Yet, as we shall see, it should also not be forgotten that

homosexuality is one possible outcome of the visual experience that leads to fetishism. It is hard to find rational historical explanations for such an overde-termined area as racial categorization of humans. For example, in colonial Jamaica, the British operated a relatively relaxed regime under which anyone who was three generations or more from entirely African ancestry was to be considered white. Yet Edward Long, a passionate British defender of slavery in the eighteenth-century Caribbean, could insist that mulattos were infertile with each other. Following the doctrine of the naturalist Buffon who held that like could only breed with like, he argued that mulattos "bear no resemblance to anything fixed, and consequently cannot produce anything resembling themselves, because all that is requisite in this production is a certain degree of conformity between the form of the body and the genital organs" (Long, 1774, vol. II: 335). In other words, the genitalia of the mulatto/a were inevitably deformed due to their mixed origin. Working from this fantastical theory, Long then sought to prove that "the White and the Negro had not one common origin." This was of course his initial premise, which served to justify slavery and colonialism. It had to be upheld even in the face of daily evidence to the contrary.

Scientists sought to confirm these stories with dissections and examinations of the female genitalia, looking for a visible difference that would confirm the deviancy of the African woman. A woman whom we know only as Saartjie or Sarah Baartman, the so-called Hottentot Venus, became the "missing link." In 1810, Baartman was brought to London from South Africa where she had grown up as one of the Khoikhoi or Khoisan peoples. She was exhibited onstage at the Egyptian Hall of the period, a key London venue for the display of new visual phenomena, later to be the site for both the exhibition of Theodore Géricault's *Raft of the Medusa* in 1824 and the first British commercial film showing in 1896. Early nineteenth-century visitors were above all fascinated by what they saw as her pronounced buttocks that they took as the sign of African deviance. The shape of her buttocks was diagnosed as a medical condition named steatopygia, rendering her body the site of a symptom. However a surgical dissection of her genitalia by the French biologist Georges Cuvier after her death at the age of 26 in 1815 found these to be the true site of deviance, available to the medical gaze but not the casual glance (Fausto-Sterling, 1995). Like the contemporary person of indeterminate gender, Baartman was held to have an unusually large clitoris, the sign of her supposed sexual lasciviousness. Cuvier claimed "her external genitalia reminded [one of] those of the orang-outang." As a testament to their key importance as a sign of deviance, Baartman's genitalia were preserved by the Musée de l'Homme in Paris, where they were even on display not long ago. Nelson Mandela submitted a request for the return of Baartman's remains in 1994 that was not acted upon until 2002. The French concern was that the case might be used to claim the return of other cultural property, so the case was designated as "scientific." It might seem bizarre that one example could serve as the means to classify such an enormous group of people as African women – but such extrapolation was entirely typical of nineteenth-century anthropology. Race,

sexuality and gender were inextricably linked in a classificatory system that insisted that these categories be visible on Baartman's body, which was seen as that of a specimen rather than an individual. Baartman's genitalia became a fetish testifying to the existence of a fundamental racial and gender difference that was known at some level to be false but was nonetheless dogmatically defended. She thus established a typology for modern visual classification – the fetishism of the gaze – accounting for the continued fascination with her case from Steampunk novelist Paul Di Filippo to playwright Suzan-Lori Parks and artists such as Frida High Tesfagiorgis in the United States, Ike Udé in Britain and Penny Siopis in South Africa.

Baartman's tragic history also testifies to the anxiety felt in the nineteenth century to sustain and justify the incommensurability of genders, limited to male and female, in "normal" and "pathological" forms. In the new two-sex system, it was obviously of the greatest importance that men and women form clearly distinguishable categories. Lesbians and gay men, masculine women and feminine men, transvestites, and persons of indeterminate sex challenged the absolute nature of the binary opposition. It was therefore no coincidence that an intense investigation of all these people began in the mid-nineteenth century. Although people of intersex – so-called hermaphrodites – have been recognized since antiquity, this period saw a determined social and medical effort to eliminate all such ambiguity. One remarkable case was that of Herculine Barbin who was raised as a girl in convent schools. However, once she began a romantic liaison with another woman, she was determined to be legally male in 1860. After a few years living in Paris during which time s/he wrote an autobiography, s/he committed suicide in 1868. This text was rediscovered and published by Michel Foucault in 1978, and has been the subject of a remarkable number of competing interpretations, seeming to confirm Barbin's gloomy anticipation of her death:

> When that day comes a few doctors will make a little stir around my corpse; they will shatter all the extinct mechanisms of its impulses, will draw new information from it, will analyze all the mysterious sufferings that were heaped up on a single human being; O princes of science, enlightened chemists . . . analyze then if that is possible, all the sorrows that have burned and devoured this heart down to its last fibers.
>
> (Barbin, 1980: 103)

Barbin asserted that the policy of making the absolute division between the sexes visible and open to medical analysis was doomed to failure.

A famous painting of the period unexpectedly seems to bear out her case. In 1875 the American painter Thomas Eakins depicted a well-known surgeon called Samuel D. Gross at work in Philadelphia (see Figure 6.1). Known as *The Gross Clinic*, the canvas shows Gross directing an operation while lecturing to students studying his methods. At first sight the painting is a display of the heroic mastery of modern medicine over the weaknesses of the human body. It depicts a treatment for

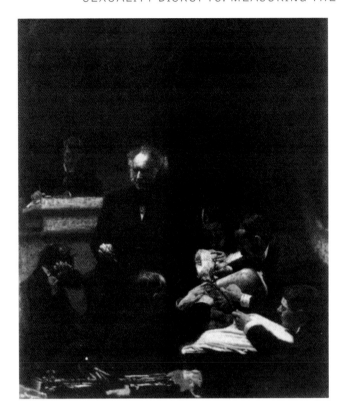

Figure 6.1
Thomas Eakins
(1844–1916), *The
Gross Clinic* (1875)
(oil on canvas).
Courtesy of
Jefferson College,
Philadelphia, PA,
USA/The
Bridgeman Art
Library

osteomyelitis, or infection of the bone, a condition that is now manageable with antibiotics but was life-threatening in Gross's day. The painting was found objectionable on grounds of its graphic content and was rejected from the Philadelphia Centennial Exposition in 1876 but has since become one of the classics of American painting. Eakins was himself well-informed about modern medicine, having studied with Gross himself and at the École de Medicine in Paris (Johns, 1983: 48–68). It is then all the more surprising that there is no way of determining whether the patient is male or female. As Marcia Pointon argues, this "indeterminate gender is part of the condition in which this figure functions in the image as a fetish" (Pointon, 1990: 50). The fetish here is the modern belief that the human body is absolutely legible and subject to one of two primary classifications by sex. Yet at the very heart of his homage to modern medicine, Eakins, like the fetishist, admits to ambiguity even as he denies it. For all his attempts to be as realistic as possible, the artist opens up an ambiguity that undercuts one of the most fundamental notions of the real in the period.

Nor could this ambivalence be more inappropriate than in a portrait of Dr. Gross. In 1849 he had operated to castrate a child "regarded as a girl" who was found to have testicles. In an article on this procedure, Gross commented:

A defective organization of the external genitals is one of the most dreadful misfortunes that can possibly befall any human being. There is nothing that exerts so baneful an influence over his moral and social feelings, which carries with it such a sense of self-abasement and mental degradation, . . . as the conviction of such an individual that he is forever debarred from the joys and pleasures of married life, an outcast from society, hated and despised, and reviled and persecuted by the world.

(Epstein, 1990: 121)

Such intensity of feeling created a (male) gender identity for Gross's patient in Eakins's painting for the alternative would have been to question the realistic mode of representation itself. Despite the lack of visual evidence, the fetishistic gaze was able to "see" gender in the patient where it was in fact ambiguous. The very creation of a standardized notion of the human implies the elision of many individual cases in order to sustain the overarching categories. In her historical survey of attitudes to people of indeterminate gender, Julia Epstein concluded:

Gender is a historically and culturally relative category, and medical science has recognized the enormous plasticity of both sexuality and gender. Anatomical markers are not always determining. While medicine recognizes the flexibility of the continuum along which sexual differentiation occurs, that recognition has not resulted, as one might have postulated, in a necessary juridical accommodation of those who occupy minority spaces (which are, ironically, its midpoints) on the continuum.

(Epstein, 1990: 128)

Thus the clarity of the classificatory principle overrides the existence of specific real people.

In the mid-nineteenth century, racial and sexual classifications were a key subject for artists in the Americas, still grappling with the existence of slavery, which was gradually being abolished. One celebrated work was a play called *The Octoroon* (1859), adapted from Mayne Reid's novel *The Quadroon* by the Irish playwright Dion Boucicault. Boucicault had lived in New Orleans during the 1850s, where he would have observed women who were a quarter (quadroon) or one-eighth (octoroon) African being sold as "Fancy Girls" for five to ten times the price of a field hand. One such woman, Louisa Picquet, recalled being sold in Mobile for $1,500, a substantial sum in the period (Picquet, 1988: 17). The reason for this high price was the sexual frisson generated by such women in white men who found exciting what performance studies historian Joseph Roach calls "the duality of the subject – white and black, child and woman, angel and wench" (Roach, 1992: 180). Here the fetishistic (male) gaze could have it both ways with the liminal woman. It became

commonplace to refer to such women as tragic, caught between two worlds. In Boucicault's play, an Englishman named George Peyton finds himself the heir to a Louisiana plantation. On arrival in the South, he falls in love with the octoroon of the title named Zoe. When he proposes marriage to her, she tells him to look at her hands: "Do you see the nails of a bluish tinge?" This mark is also apparent in her eyes and hair: "That is the ineffaceable curse of Cain. Of the blood that feeds my heart, one drop in eight is black – bright red as the rest may be, that one drop poisons all the flood" (Boucicault, 1987: 154). Inevitably Zoe dies at the curtain, whereupon her eyes mysteriously change color and lose the "stain" of Africanness.

After the abolition of slavery, the possibilities for white men to have coerced relationships with black women diminished in the United States, although they certainly did not disappear, especially in the world of commercial sex. However, in the new African colonies it was almost universal practice for European men to maintain African women as concubines. As ever, European writers claimed to be shocked when they encountered them. Here, for example, is the British naturalist Wollaston describing the situation in the Congo:

> Almost every European official supports a black mistress. The right or wrong of it need not be discussed here, but the conspicuous position which the women occupy is quite inexcusable. It is not an uncommon thing to see a group of these women walking about a post shrieking and laughing, and carrying on bantering conversations with the Europeans whose houses they pass; or, very likely, the Europeans will come out and joke with them *coram populo* [in view of the people]. . . . It is impossible that natives, when they see women of their own race being treated openly and wantonly with familiarity, should feel any great degree of respect for their European masters, and when that is the case, discipline and obedience to authority are quickly lost.
>
> (Wollaston, 1908: 182)

It seems that like Conrad's fictional character Kurtz, most colonial officials went "native" in at least this regard. What Wollaston objected to was not the sexual relationships in themselves but the breakdown of respect between Africans and Europeans that they caused. Furthermore, this scandal was fully visible to the Africans, challenging the colonial fantasy that the European was "monarch-of-all-I-survey," to use Mary-Louise Pratt's phrase.

The African women involved were thus in a curious position. On the one hand, they were forced to have sexual relations with the colonial officials but as a result they acquired a form of authority. As Jenny Sharpe has argued in the case of the Caribbean, "slave women used their relationships with free men to challenge their masters' right of ownership." In so doing, they gained what Harriet Jacobs called in her *Incidents in the Life of a Slave Girl* (1861) "something akin to freedom" (Sharpe, 1996: 32, 46). The choices available to these women were, of course, anything but

free. At this point, we find ourselves at the intersection of one of the most enduring myths of colonialism and one of the most difficult problems for postcolonial studies. Colonialism's myth was that the African woman was so sexually lascivious that she would even have relations with primates. The obsession with Baartmann and other African women stemmed from what Robert Young has called "an ambivalent driving desire at the heart of racialism: a compulsive libidinal attraction, disavowed by an equal insistence on repulsion" (Young, 1995: 149). This connection became so well-established that when Sigmund Freud was forced to admit his ignorance of female sexuality, he described it as the "dark continent." Africa as a whole had come to symbolize the mysterious forces of female sexuality for European men.

One way to counter this myth has been to try to find out what the women themselves thought of their lives but this has proved difficult, due to the problematic nature of sources. An important historiographical debate on this topic has centered around the experience of *sati*, the practice whereby Hindu women immolated themselves on their husbands' funeral pyres. In 1829 the British authorities banned *sati*, thus allowing them to present themselves as the defenders of Indian women. Gayatri Spivak summarized the debates on *sati* as a discussion between men:

> The abolition of this rite by the British has generally been understood as as case of "White men saving brown women from brown men." White women – from the nineteenth-century British Missionary Registers to Mary Daly – have not produced an alternative understanding. Against this is the Indian nativist argument, a parody of the nostalgia for lost origins: "The women actually wanted to die."
>
> (Spivak, 1994: 93)

The obvious alternative would be to try and understand the motives of the women involved, but Spivak at first denied that the texts available, whether by British or Indian men, allowed the women to be heard and concluded simply "the subaltern cannot speak." While other scholars sought to mitigate the absoluteness of this pronouncement, the extreme difficulty of retrieving women's experience under colonialism remained, a direct result of their triple oppression by race, class and gender. In reconsidering her project in 1999, Spivak emphasized the ways in which Freudian analysis sought to make the woman speak as a scapegoat and reiterated that "our efforts to give the subaltern a voice in history will be doubly open to the dangers run by Freud's discourse." She suggests that part of the means by which one would negotiate such dangers is by "*measuring* silences," an evocative and suggestive phrase (Spivak, 1999: 284).

One way to begin measuring such silences can be to try not just to hear the subaltern woman but to see her. While the evidence for *sati* comes mostly from written texts, it is visual material that supplies what knowledge we have of the Kongo women who became the "mistresses" of the Europeans. For amongst the piles of ethnographic and landscape photographs of the Congo are to be found many

photographs of African women, which often had rather coy titles or included small children in the shot. It seems that without being able to say so, many European men wanted souvenirs of the women they became attached to and the children they had by them. Here we see the women as the colonizers wanted to see them. At the same time, we can see the mixture of self-presentation, adornment and resistance created by Kongo women to win "something akin to freedom." Given the widespread European ignorance of African languages, these encounters were unlikely to have been centered around language, whether written or spoken. They were primarily visual and perhaps also physical encounters in which African women presented themselves in ways that both allowed Europeans to take them for sexually promiscuous "natives" and gave the women themselves a persona that might offer some escape from the harshness of colonial life.

Take Albert Lloyd's 1899 photograph "Bishop Tucker and Pygmy Lady" (see Figure 6.2). It shows Tucker clad in requisite colonial gear, complete with pith helmet, standing in front of his tent. On his right is a young Mbuti (Pygmy) woman and he has his arm around a small child on his left. Given that Lloyd titled his book *In Dwarf Land and Cannibal Country*, it was unusual for him to refer to any African as a "lady." Certainly there is some unpleasant sarcasm here, but its source may well be the unease felt by the traveler at this transgressive relationship. Were Tucker and the Mbuti woman the father and mother of the child? Are they both his children? The facts of this case are now unknowable, presenting a silence as to whether what appears visually as a family group, carefully posed in front of Tucker's tent to suggest

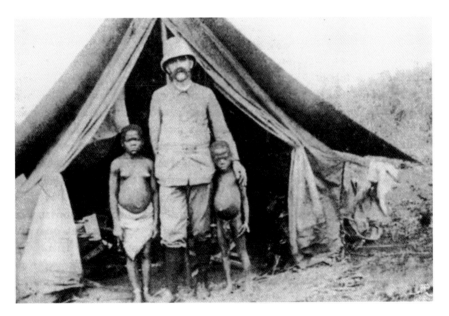

Figure 6.2 Albert Lloyd, "Bishop Tucker and Pygmy Lady," from *In Dwarf Land and Cannibal Country* (London, 1899)

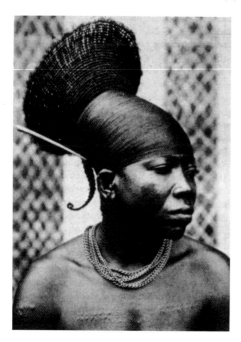

Figure 6.3 Herbert Lang, *A "Parisienne" of the Mangbetu Tribe* (1910–14). American Museum of Natural History

a curious version of Victorian domesticity, actually is so. The paternity displayed was either imperial dominance or an actual relation – it may well have been that the missionary did not perceive a substantial difference between the two states. By contrast, Herbert Lang, who was both anthropologist and reporter, frequently photographed a woman he titled *A "Parisienne" of the Mangbetu Tribe* during his five-year stay in the Mangbetu region of the Congo in 1910–15 (see Figure 6.3). The term "Parisienne" refers in part to the striking raffia headdress worn by the woman, as if to suggest she is dressed fashionably. But, as Lang must have known, this headdress was not a coquettish fashion item but a signifier of social rank, to be worn only by the élite. "Parisienne" would have also suggested to Western readers a woman whose sexuality was so marked as to be almost deviant. The Mangbetu woman colluded in Lang's fantasy, at least to the extent of being photographed in this mode of dress. At the same time, her image resists this characterization because the woman's pose and bearing give her an unmistakeable dignity and pride, despite her subaltern status in relation to the photographer. It is through this self-presentation and demonstration of the ambivalence of the colonial subject that the silences of Kongo women can be measured, despite the fact that we do not even know their names.

If these pictures do not seem legible in the literary or semiotic sense, it is because these women were deliberately trying to be unproductive. Both slave-owners and colonial administrators alike were constantly complaining that their charges were lazy and work-shy. Marx cited what he called "an utterly delightful cry of outrage"

from a Jamaican plantation owner in 1857 that the "free blacks . . . regard loafing (indulgence and idleness) as the real luxury good" (Gilroy, 1991: 153). With hindsight, it is easy to see how such slow-going was an indirect form of resistance to the force of slavery and colonialism. This type of resistance always ran the risk of violent reprisals from overseers and managers. Kongo women managed to be unproductive in ways that the Europeans could not punish so easily. Gossip and chatter, as noted by Wollaston, is by definition unproductive in the economic sense but can often be the "site of defiance or resistance" (Rogoff, 1996: 59). The elaborate headdresses and bodypainting that led Lang to think of Mangbetu women as Parisiennes were very time-consuming activities but ones that Europeans considered appropriate for women and thus had to permit. For Europeans avid to deny the reality of cross-cultural relationships, even the children that they fathered with African women were unproductive. They could not be acknowledged as legitimate children but nor could they be treated as badly as "real" Africans. Unproductive is not the same as meaningless. By being unproductive, these women created an image that was fascinating to Europeans precisely because they could not define it. This visual culture of self-presentation and adornment constituted a mode of everyday resistance to colonial power that was necessarily "weak" but nonetheless effective.

Queering the gaze: Roger Casement's eyes

At this point I need to stop the narrative and ask myself: how can I see this scene? Whose eyes am I looking through? In the case of the Congo, the answer is clear: Roger Casement's eyes supplement Langston Hughes's look to allow the late twentieth-century gaze to focus on the Congo. Casement was the British consul to the Congo Free State whose 1904 report to Foreign Secretary Sir Edward Grey led to international action to reform the Congo. His report dispelled years of dissembling by Belgian officials and European travelers and has remained the "authentic" way for historians to look at the Congo. It is as if we have placed his eye into the opening of the *camera obscura*, as recommended by Descartes, in order to see colonial reality. Yet Casement's gaze needs to be understood not as the measuring of some objective reality but as a politics of queering the colonial gaze. Like Hughes, Casement was gay in a culture that had just determined the "homosexual" to be a distinct but inferior species, legislating the incommensurability of what was now seen to be an all-determining "essence" of sexuality, rather than any given transgressive act. As Foucault famously argued: "The sodomite had been a temporary aberration; the homosexual was now a species" (Foucault, 1978: 43). The Labouchère Amendment to the Criminal Law Amendment Act of 1885 made all sexual contact between men a criminal offence in Britain (Weeks, 1989: 102). The statute held gay men to be marked with "the hallmark of a specialised and extraordinary class as much as if they had carried on their bodies some physical peculiarities" (Weeks, 1989: 100). It was under this provision that Oscar Wilde was convicted and sentenced to a two-year jail term with hard labor in 1895.

In his 1903 diary, Casement seemed to accept the diagnosis while rejecting the cure. He noted the suicide of the soldier Sir Hector MacDonald, accused of being a homosexual: "The most distressing case this surely of its kind and one that may awake the national mind to saner methods of curing a terrible disease than by criminal legislation" (Girodias and Singleton-Gates, 1959: 123). Casement further transgressed the sexual norm by having relations with African men on a regular basis. His diaries, the basis of his later report, occasionally record attractive or well-endowed men alongside the atrocities with no sense of incongruity. In another moment of colonial surrealism, Joseph Conrad and Roger Casement met in the Congo in 1897, where the writer observed the diplomat depart into the forest with only one Loanda man for company with a "touch of the Conquistador in him. . . . A few months later it so happened that I saw him come out again, a little leaner, a little browner, with his sticks, dogs and Loanda boy [sic], and quietly serene as though he had been for a walk in the park" (Girodias and Singleton-Gates, 1959: 93). Casement's sexual experience thus takes place offstage, literally obscene. The same-sex cross-cultural encounter that could not be named nonetheless appeared to Conrad to have left its physical mark on Casement, as predicted by medical science, producing a darker skin and more effete body.

While Casement retained his colonial privilege, this relationship appears markedly less forced than was usual in colonial society. Indeed, that constituted the real scandal of Casement's later life, for while many Europeans went to Africa to have same-sex relations, they would usually do so with male prostitutes or coercively. Any degree of consent from the African man was to give him a degree of equality unthinkable in the colonial sexual order. Unsurprisingly, Conrad adds of Casement as if he were Kurtz: "He could tell you things! Things I have tried to forget, things I never did know." But when Casement was later on trial for his life, due to his involvement with the Irish Republican cause, Conrad would not intercede on his behalf, as if his transgression made it impossible to speak for him, or even of him. At the same time, Casement's experience challenges the idea that Europeans introduced homosexuality to Africa. Ifi Amadiume's work on gender in Nnobi society shows that woman-to-woman marriages were common in precolonial society, loosening ties of gender to biological sex so that a woman could be the "husband" of a family. However, she argues that any suggestion of lesbianism would be "shocking and offensive to Nnobi women" (Amadiume, 1987: 7), motivated only by the "wishes and fantasies" of the interpreter. In truth we cannot be sure either way. Yet many have jumped to her standard claiming that Amadiume's work proves the historical heterosexuality of Africans. Sometimes the protesting may be too much, as in Frantz Fanon's assertion that there was no homosexuality in Martinique, even though some men dressed and lived as women. As Gaurav Desai says, "at least in some African contexts, it was not *homosexuality* that was inherited from the West but rather a more regulatory *homophobia*" (Desai, 1997: 128).

Casement was aware that he saw things differently from his European colleagues, as he wrote to his friend Alice Green:

I knew the Foreign Office would not understand the thing, for I realized that I was looking at this tragedy with the eyes of another race of people once hunted themselves, whose hearts were based on affection as the root principle of contact with their fellow men, and whose estimate of life was not something to be appraised at its market price.

(Casement et al., 2003: vi)

He has been taken to refer to the Irish here but his words might equally apply to gay men, whom British law certainly held to be from "another race of people." One can compare Conrad's description of Casement as a Conquistador to Freud's famous letter to his friend Wilhelm Fliess in 1900, in which he too claimed the Conquistador's gaze for psychoanalysis. The difference is in the affect of the two descriptions. Freud saw himself uncritically as opening up a new intellectual continent for knowledge (a metaphor later adopted by the philosopher Louis Althusser), while Conrad adopts the British view that held the Spanish to be cruel and immoral colonists in order to confirm Casement's queerness. Casement refused both categories to claim a subaltern point of view, a mixture of his Irish background and gay sexuality.

Indeed, when Casement himself was sentenced to death for his support of the Irish republican movement in 1916, the legal adviser to the Home Office resisted appeals for clemency on the grounds that "of later years he seems to have completed the full cycle of sexual degeneracy and from a pervert has become an invert – a woman, or a pathic, who derives his satisfaction from attracting men and inducing them to use him" (Girodias and Singleton-Gates, 1959: 27). That is to say, Casement was alleged to have shifted his tastes from penetrating men – perversion – to the inversion of being penetrated by other men and thus becoming in effect a woman. It is noticeable that the new science of sexuality had already become part of the legal apparatus of colonial rule. In this view, Casement's look at the colonial scene was in a sense almost the same as that of the Congo women – but not quite. Unable to claim his own sexuality, he instead "outed" the Congo Free State. Casement's look was multiply displaced: for the British but not of them, from the point of view of subalterns but not of them either. Such displacement is the effect of the queering of the gaze, that which Lee Edelman describes as: "the undoing of the logic of positionality effected by the sodomitical spectacle" (Edelman, 1991: 103). To re-examine the colonial Congo requires exactly such a displaced and displacing vision.

Rather than see sexuality as identity, forming a neat unit, "queer" turns towards what Eve Kosofsky Sedgwick has called: "the open mesh of possibilities, gaps, overlaps, dissonances, and resonances, lapses and excesses of meaning when the constituent elements of anyone's gender, of anyone's sexuality aren't made (or *can't* be made) to signify monolithically" (Sedgwick, 1993: 18). That is not to say that the issues we have discussed so far are "really" about homosexuality but that considering how same-sex and non-heteronormative sexualities might fit into the intellectual picture changes the entire approach. The queer viewpoint does not

create a "true" point of view but the very exclusion of queer identity from the normative discourses of sexuality reveals the contradictions and faultlines in those discourses. From this perspective, sexual and gender identity are seen to overlap with race, ethnicity and nationality in ways that question how identity itself, a very privileged term in recent scholarship, should be conceived. If, as Judith Butler puts it, gender is a

> normative institution which seeks to regulate those expressions of sexuality that contest the normative boundaries of gender, then gender is one of the normative means by which the regulation of sexuality takes place. The threat of homosexuality thus takes the form of a threat to established masculinity or established femininity.
>
> (Butler, 1994: 24)

In short, any corporal identity that falls outside the established parameters for personal identity will encounter disciplinary force, the same disciplinary force that produces heterosexual men and women. In the phallocentric system, there are no outlaws, only deviants.

This displaced queer vision produced what Michael Taussig has called a "cool realism," using Marshall McLuhan's terminology, in Casement's account of the region as opposed to the fevered hallucinations of accounts like that of Joseph Conrad. At the end of *Heart of Darkness*, Marlow has to tell Kurtz's Intended of his death. Here the Victorian myth of the woman as angel by the hearth was threatened by her Other, the "primitive" sexualized African woman by whom Kurtz had had children. Equally present was the homoerotic relationship between Marlow and Kurtz, the love that dare not speak its name. Marlow seems to hear the room echo with Kurtz's famous phrase "The horror! The horror!" He restores order at the expense of the truth by telling the Intended that Kurtz's last words were her name. "I knew it!" she exclaims. The horrors of modernity were constantly displaced into a phantasmic, hence sexualized, colonial order that produced the unquestionable knowledge of the fetishist. Alan Sinfield has argued that queer culture can be thought of as a diaspora (Sinfield, 1996). Using the Congo experience, I should like to suggest that the formula can also be reversed so that diaspora can be thought of as queer sexuality. That is not to say that Africans were in some sense deviant but that the European sense of order depended on a normative heterosexuality that was always already racialized. The Congo river was a place where the boundaries between subject and object seemed to dissolve into identities that we once called postmodern but we can now see to have been modern all along. That seeing is not a matter of Cartesian observation but of viewing from the "perverse angle" (Sedgwick) with the "parallax vision" (Mayne) of "(be)hindsight" (Edelman) that once seemed the marginal viewpoint but increasingly seems the only available place from which to look at the colonial spectacle that came home to the colonizing nations in the era of decolonization.

References

Amadiume, Ife (1987), *Male Daughters, Female Husbands: Gender and Sex in an African Society*, London: Zed Press.

Barbin, Herculine (1980), *Herculine Barbin: Being the Recently Discovered Memoirs of a Nineteenth-Century French Hermaphrodite*, New York: Pantheon.

Boucicault, Dion (1987), *Selected Plays*, Gerrards Cross: Colin Smythe.

Butler, Judith (1994), "Against Proper Objects," *differences*, vol. 6 nos. 2–3, pp. 1–26.

Casement, Roger, Séamas Ó Síocháin and Michael O'Sullivan (2003), *The Eyes of Another Race: Roger Casement's Congo Report and 1903 Diary*, Dublin: University College Dublin Press.

Desai, Gaurav (1997), "Out In Africa," in *Genders 25, Sex Positives: The Cultural Politics of Dissident Sexualities*, ed. Thomas Foster et al., New York: New York University Press.

Edelman, Lee (1991), "Seeing Things: Representation, the Scene of Surveillance and the Spectacle of Gay Male Sex," in *Inside/Out: Lesbian Theories, Gay Theories*, ed. Diana Fuss, New York: Routledge.

Epstein, Julia (1990), "Either/Or–Neither/Both: Sexual Ambiguity and the Ideology of Gender," *Genders*, vol. 7, pp. 99–143.

Fausto-Sterling, Anne (1995), "Gender, Race and Nation. The Comparative Anatomy of 'Hottentot' Women in Europe, 1815–17," in *Deviant Bodies*, ed. J. Terry and J. Urla, Bloomington, IN: Indiana University Press.

Foucault, Michel (1978), *A History of Sexuality, Vol. 1*, trans. Alan Sheridan, New York: Vintage.

Gilroy, Paul (1991), *"There Ain't No Black in the Union Jack": The Cultural Politics of Race and Nation*, Chicago, IL: Chicago University Press.

Girodias, Maurice and Peter Singleton-Gates (1959), *The Black Diaries: An Account of Roger Casement's Life and Times*, New York: Grove Press.

Goldberg, Jonathan (1992), *Sodometries: Renaissance Texts, Modern Sexualities*, Baltimore, MD: Johns Hopkins University Press.

Johns, Elizabeth (1983), *Thomas Eakins: The Heroism of Modern Life*, Princeton, NJ: Princeton University Press.

Lacquer, Thomas (1990), *Making Sex*, Cambridge, MA: Harvard University Press.

Long, Edward (1774), *A History of Jamaica*, London.

Mayne, Judith (1993), *Cinema and Spectatorship*, New York: Routledge.

Mercer, Kobena (1996), "Decolonization and Disappointment: Reading Fanon's Sexual Politics," in *The Fact of Blackness: Frantz Fanon and Visual Representation*, ed. Alan Read, Seattle, WA: Bay Press.

Picquet, Louisa (1988), "The Octoroon," in *Collected Black Women's Narratives*, ed. Anthony G. Barthelemy, New York: Oxford University Press.

Pointon, Marcia (1990), *Naked Authority: The Body in Western Painting 1830–1908*, Cambridge: Cambridge University Press.

Roach, Joseph R. (1992), "Slave Spectacles and Tragic Octoroons: A Cultural Genealogy of Antebellum Performance," *Theatre Survey*, vol. 33 no. 2, pp. 167–87.

Rogoff, Irit (1996), "Gossip as Testimony: A Postmodern Signature," in *Generations and Geographies in the Visual Arts: Feminist Readings*, ed. Griselda Pollock, London: Routledge.

Sedgwick, Eve Kosofsky (1993), *Tendencies*, Durham, NC: Duke University Press.

Sharpe, Jenny (1996), "'Something Akin To Freedom': The Case of Mary Prince," *differences*, vol. 8 no. 1, pp. 31–56.

Sinfield, Alan (1996), "Diaspora and Hybridity: Queer Identities and the Ethnicity Model," *Textual Practice*, vol. 10 no. 2, pp. 271–93.

Spivak, Gayatri (1994), "Can the Subaltern Speak?," in *Colonial Discourse and Post-Colonial Theory*, ed. Patrick Williams and Laura Crishman, New York: Columbia University Press.

—— (1999), *A Critique of Postcolonial Reason*, Cambridge, MA: Harvard University Press.

Weeks, Jeffrey (1989), *Sex, Police and Society: The Regulation of Sexuality Since 1800*, London: Longman.

Wollaston, A.F.R. (1908), *From Ruwenzori to the Congo*, London: John Murray.

Young, Robert (1995), *Colonial Desire: Hybridity in Theory, Culture and Race*, London: Routledge.

THE FETISH AND THE GAZE

Perhaps no single concept was more influential in the formation of the current state of visual culture, film studies, art history and media studies than Jacques Lacan's theory of the gaze and its reception in 1970s film theory (see also the discussion of *The Ambassadors* earlier in this volume). In the latter guise, the gaze became "the male gaze," an idea that has since found its way into popular culture. Lacan presented his work as a return to the theories of Sigmund Freud, which he claimed had been misinterpreted by the psychoanalytic profession. Perhaps this gesture of returning to the origins of psychoanalysis has obscured the historical dimensions of the gaze. The gaze is not what it was – and that's a good thing. Pursuing this approach would be to engage with what Hortense Spillers has called "psychoanalytics, a project that would think through aspects of a psychoanalytic culture criticism and how one might go about determining its shape and style" (2002: 382). That is to say, these ideas are designed for cultural analysis not for use in therapeutic practice.

For the practices of this book, I am going to make some declarative statements about the gaze to cut through the complexities; they will no doubt seem horribly simple-minded to some. First: *all looking is fetishist.* It is a curious fact that the most important psychoanalytic theories of looking, namely fetishism and the gaze, rely on the viewer's misrecognition of what he or she sees (especially he). Both Freud's theory of fetishism and Lacan's account of the mirror stage take as their origin the primal male moment of recognition of difference instantiated by the female genitalia not possessing the phallus. Perhaps it was no coincidence that Lacan owned Gustave Courbet's scandalous oil painting of the female body centered on the genitalia, entitled *The Origin of the World*, as if in testament to the centrality of this visual experience. In his 1927 essay on "Fetishism," Sigmund Freud sought to account for the fact that numerous men could only

achieve sexual gratification via a specific material object that he called the fetish object, such as fur or velvet. By using the colonial term "fetish," created by Europeans to (mis)describe African ritual objects such as the *minkisi* described in Chapter 5, Freud immediately created an overlap between race and sexuality. In Freud's view, the fetish is always a penis-substitute: "To put it plainly: the fetish is the substitute for the woman's (mother's) phallus which the little boy once believed in and does not wish to forego." In this view, the little boy had believed that his mother possessed a phallus just as he did, until at some point he became aware that her genitals were different from his in that she lacked a penis.

There is now a threat: "if a woman can be castrated then his own penis is in danger." There is a leap here – the child sees difference and is presumed to deduce a violent creation of lack and then to project that possibility onto himself. In Freud's view, the boy is both aware of what he has seen and denies it: "He retains this belief but he also gives it up." The fetishist displaces his belief in the female phallus onto the fetish object, "possibly the last impression received before the uncanny traumatic one." The female sex is "uncanny," referring to Freud's earlier analysis of this double-edged term that in German (*Heimlich*) means both "homelike" and "unhomelike/uncanny" at once, meaning that it cannot be seen entirely as what it is. That moment of uncertainty is followed and surpassed by the traumatic realization of the lack of the penis. While relatively few men become clinical fetishists, this trauma is, according to Freud, universal:

> Probably no male human being is spared the terrifying shock of threatened castration at the sight of the female genitals. We cannot explain why it is that some of them become homosexual in consequence of this experience, others ward it off by creating a fetish and the great majority overcome it.
>
> (Freud, [1927] 1959)

There are, then, three possible outcomes from the moment of (mis)recognition: heterosexuality, homosexuality or fetishism, but Freud had nothing to say here as to how each of these outcomes is decided.

Fetishistic viewing is not limited to the neurotic fetishist but is a critical part of everyday visual consumption. The disavowal of the fetishist is not absolute. As phrased by Octave Mannoni, it is better expressed as "I know . . . but nonetheless" [*Je sais . . . mais quand même*]. For the fetishistic gaze, reality exists but with the viewer's desire superimposed. It is in this way that we casually accept film and photography as "realistic," while being fully aware of their conventionality. For example, an accepted index of good acting is now taken to be a willingness for an attractive actor to play someone ugly, or an able-bodied person to play a person with disabilities. Here the viewer actively "toggles" between

their watching of the particular role and their recollection of the "real" star, who is of course in turn a carefully constructed image produced by stylists, publicists and designers. A key part of everyday looking consists in this ability to keep two incompatible approaches in play at once. In Lacan's reconceptualization of Freudian analysis, looking has become the gaze, taking a still more central position in the formation of gender identity. The gaze is not just a look or a glance. It is a means of constituting the identity of the gazer by distinguishing her or him from that which is gazed at. At the same time, the gaze makes us aware that we may be looked at, so that this awareness becomes a part of identity in itself. In Jean-Paul Sartre's example, one may look through a keyhole without any awareness of self, but if footsteps are heard in the hall: "I see *myself* because *somebody* sees me."

Sartre's existential theory involving a Self and an Other was internalized in Freudian terms by Lacan: "the gaze is outside, I am looked at, that is to say, I am a picture." Lacan placed the gaze at the center of the formation of the ego in his famed mirror stage. In the mirror stage, the infant learns to distinguish between itself and the (mother's) image by becoming aware of sexual difference. As a result the subject is split, as Carole-Anne Tyler explains:

> The subject can never reconcile the split between itself and its mirror imago, the eye which sees and the eye which is seen, the I who speaks and the I who is spoken, the subject of desire and the subject of demand, who must pass through the defiles of the Other's signifiers.
>
> (Tyler, 1994: 218)

When I see myself in the mirror, I can never see the Ideal of the Imaginary but only the Symbolic "I." The Anglophone homophone of "eye" and "I" has been extensively remarked on as indicating the centrality of the visual process to identity formation in Lacan's theory. The infant becomes able to visualize its body as being separate from that of the mother because it becomes aware of the mother's desire for something else. This something is lacking in both mother and child. Lacan calls it the Name of the Father, insisting that it is a linguistic and legal function rather than the real father – who may be absent or otherwise implicated in the child's primary identification – that is meant. Thus, the gaze brings into being that which says "I" and names itself, the subject or self, as either male or female.

These subjects – the gaze and the subject of representation – exist only in relation to each other and combine to form the image/screen, or what is perceived. In this split field of vision, the phallus comes to represent that which divides and orders the field of signification, or the gaze. *In the gaze, the phallus is the fetish.* For Lacan the phallus is a phantasm that the penis comes to represent "because it is the most tangible element in the real of sexual copulation, and also the most symbolic." As Lacan himself pointed out, the penis itself becomes a fetish in this

conveniently circular argument, in which the penis is the phallus because of its apparent capacity to be all things at once. At the same time, whereas Freud's fetishism centered on the sight of the female sex, the gaze itself is the phallus, re-engendering the process of looking.

In a now celebrated essay published in *Screen* magazine in 1975 theorizing visual experience in Lacanian terms, film critic Laura Mulvey argued that the gaze should therefore be understood as male (Mulvey, 1989). The essay analyzed the operations of visual pleasure in classic Hollywood cinema, arguing that the "paradox of phallocentrism . . . is that it depends on the image of the castrated woman to give order and meaning to its world." It is the woman's lack of the phallus, or symbolic castration, that initiates the formation of the ego and a signifying system that nonetheless excludes women. While the male hero initiates action, "women are simultaneously looked at and displayed, with their appearance coded for strong visual and erotic impact so that they can be said to connote *to-be-looked-at-ness.*" That is to say, what the (male) gaze looks at when it looks are women, as in Alfred Hitchcock's classic *Rear Window* (1954). Nonetheless, female characters still evoked the specter of castration that needed to be controlled. The woman may be punished in the film to overcome the threat in a sadistic form of voyeurism, or it may be disavowed by fetishism. Just as Mulvey sees castration anxiety as being at the heart of cinematic pleasure, Freud regarded fetishism as clear proof of his theory that men are haunted by the fear of castration, while women are marked by their lack of the phallus. Both formations derive from early visual experience that causes the infant to adopt a specific view of what she or he has seen, whether of denial, assimilation or displacement.

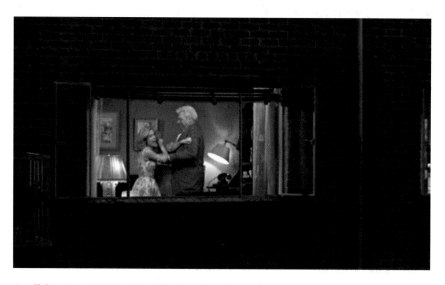

A still from *Rear Window* (dir. Alfred Hitchcock, 1954)

Fetishism led Freud to conclude that even when a "very important part of reality had been denied by the ego," the result was not necessarily psychosis but merely everyday neurosis. From a psychoanalytic standpoint, reality is in the eye of the beholder.

Perhaps the most striking aspect of theories of fetishism and the gaze as systems of analysis is the way in which women are systematically excluded. Both Freud and his French disciple Lacan agreed that there was no such thing as female fetishism (Apter, 1991: 103), for the entire psychic mechanism revolved around the real penis and the fear of castration. As part of becoming a "woman" in the Freudian scheme was abandoning the infant desire to possess the phallus or to be the phallic mother in favor of a passive femininity, marked by the switch from clitoral to vaginal sexuality, there was no corresponding system for women. In the Lacanian system, woman is similarly defined by lack, by her inability to possess the phallus, inevitably excluding her from the signifying system. Feminists have taken this elision of women to indicate that the psychoanalytic binary opposition between male and female was in fact no more than a recasting of sex as being always and already masculine. In this view, there is no such thing as the female sex because the entire system is devised around and for men. For Luce Irigaray, this system posited a "sex which is not one," that is to say, in psychoanalysis there is no woman. Irigaray declares:

> Female sexuality has always been theorized within masculine parameters. Thus the opposition between "virile" clitoral activity/ "feminine" vaginal passivity which Freud – and many others – claims are alternative behaviors or steps in the process of becoming a sexually normal woman, seems prescribed more by the practice of masculine sexuality than by anything else.
>
> (Irigaray, 1985: 99)

It can be fairly said that 1970s feminism changed the way we look and certainly there would be no such thing as visual culture studies without it.

However looking back on her 1975 essay in 1989, Mulvey herself now felt that:

> The polarisation only allows an "either/or." As the two terms (masculine/feminine, voyeuristic/exhibitionist, active/passive) remain dependent on each other for meaning, their only possible movement is inversion. They cannot be shifted easily into a new phase or new significance. There can be no space in between or outside such a pairing.
>
> (Mulvey, 1989: 162)

For example, visual culture scholar Carol Mavor has defined a form of feminine desire that is not simply a surrogate of masculinity. In her analysis of

photography, Mavor (1999) has argued for a feminine "reduplicative desire," epitomized by the endlessly reproducible photograph. This desire is not single or singular but is enacted in its making of duplicates. By the same token, while not wanting to define female sexuality as a form of perversion, Mavor identifies female fetishism as a form of collecting, perhaps especially the collecting of photographs. These collections are stored in drawers and boxes, rather than framed and displayed, a form of secrecy that is essential to the structures of fetishism and fetishistic looking. For the desire here is not just to see the photo-graph once but to look at it repeatedly in order to reproduce desire. Mavor's

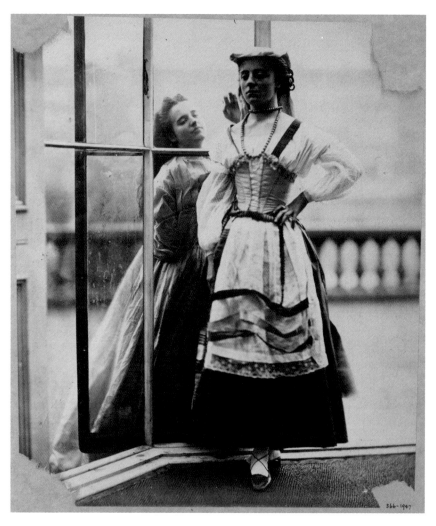

Clementina, Lady Hawarden, *Study from Life* (c. 1864) © Victoria and Albert Museum, London

theory was inspired by the Victorian photographer Lady Hawarden but it clearly has much to say to the era of digital imaging with its apparently endless modes of duplication.

Indeed, if the gaze was formed in relation to the early modern technology of the mirror, it would be surprising if the many new forms of visual technology of the past century and a half had not entailed some changes in visual desiring. One of the most important exclusions from the Freudian binary was the possibility of same-sex or gender-radical desires that by their nature seek to disrupt the heteronormative pattern of identity. That is to say, the medicalization of sexuality in the nineteenth century took desire to be "normal" when it was for "the" other sex, a pattern that Freud and Lacan projected onto the gaze. As Judith Halberstam has shown in her analysis of Kimberley Pierce's 1999 film *Boys Don't Cry*, it is now possible to represent a "trans" gaze, that is to say, a way of looking consistent with Brandon Teena's identity as a transman (2005: 86–8). This possibility has arisen both because of lesbian, gay, queer, trans-gender and genderqueer activism and scholarship, and because it has become clear that there is no such thing as "the" body that can be neatly divided into two sexes, genders and so on. As Donna Haraway was perhaps the first to point out, the body is increasingly interfaced with the machine and with the animal. As we become less impressed by human differences with animals, we are increasingly dependent on machines for our sensory input. That is to say, *machines are (re)making vision*. In dialogue with Halberstam's work, I think it is now (past) time for a transient, transnational, transgendered way of seeing that visual culture should seek to define, describe and deconstruct with the transverse (or sideways) look or glance – not a gaze, there have been enough gazes already.

References

Apter, Emily (1991), *Feminizing the Fetish: Psychoanalysis and Narrative Obsession in Turn-of-the-Century France*, Ithaca, NY: Cornell University Press.

Freud, Sigmund ([1927] 1959), "Fetishism," *Sigmund Freud: Collected Papers*, Vol. V, New York: Basic Books.

Halberstam, Judith (2005), *In a Queer Time and Place: Transgender Bodies, Subcultural Lives*, New York: New York University Press.

Irigaray, Luce (1985), *This Sex Which Is Not One*, Ithaca, NY: Cornell University Press.

Mavor, Carol (1999), *Becoming: The Photographs of Clementina, Viscountess Hawarden*, Durham, NC: Duke University Press.

Mulvey, Laura (1989), *Visual and Other Pleasures*, Bloomington, IN: Indiana University Press.

Spillers, Hortense (2002), *Black, White and In Color: Essays on American Literature and Culture*, Chicago, IL and London: University of Chicago Press.

Tyler, Carole-Anne (1994), "Passing: Narcissism, Identity and Difference," *differences*, vol. 6 no. 2/3, pp. 212–48.

INVENTING THE WEST

THE FORMATION OF a normative individual, the white man (always presumed to be straight), was represented as a visible type and placed at the head of a ranking of humanity in seven racialized categories. This visible hierarchy was further implemented as the necessary dominance of the "West" over the "East" that supported first imperialism and later the Cold War. The "West" became an imperial Hero for the imperial age, taking on the burden of representing authority in a way that no single individual could continue to do in the age of global power. While the division of space into the civilized and the barbarian dates back to antiquity, the imperial period rendered that division into an obligation on the civilized to conquer and transform the barbarian spaces of the world. Civilization was understood as a spatial and hierarchizing term, separating and dividing the sensible between the West and its others. This distinction was able to serve again during the Cold War (1945–89) between the United States and the Soviet Union (USSR) and their allies that was acted out in representational form. This chapter looks at alternating representations of the "West" and its "Eastern" other as a structure of opposition between otherness and intimacy in art, popular culture and film, beginning with the colonial deployment of color in art from Romanticism to Abstract Expressionism; via the opposition between mass culture and high art in the period either side of World War II; to the cinematic genre of the Western from *High Noon* (1952) to *There Will Be Blood* (2007).

In his classic study *Orientalism* (1978), the scholar Edward Said argued that certain groups of people in Europe had been defining themselves as the "West" in relation to the "East," or Orient, since the Ancient Greeks. For the Greeks, their enemies such as the Persians were barbarians, a word that was meant to evoke the sound of non-Greek language to Greek ears as "bar-bar." In plays such as Aeschylus' *The Persians* (472 BCE), the East was represented as despotic, cruel and sexually deviant,

figures that indeed persist to the present. Yet the distinction at work here was between Greek and barbarian, whereas the modern opposition has been between the West and the Orient. As Said demonstrated, the "Orient" is not a place or region but a set of ideas that were applied to widely ranging and distinct locations that have changed over time. In the nineteenth century, it was common for the South of Italy and Spain to be regarded as the "Orient," places that are very much now seen as being in the "West." While the "Orient" suggests places to the East of Europe, many representations of the Orient were taken from North Africa, while the Victorian explorer Richard Burton defined what he called "the Sotadic zone" that stretched across the globe from Southern Europe to the Middle East, Asia and the South Pacific. If each representation of the "Orient" claimed to define a universal binary relationship, there were in fact many such competing representations at any one time, known collectively as Orientalism. Orientalism as an aesthetic and colonialism as a way of life remain intensely desirable goals for "Europeans" even today, as evidenced by the successful revival of the luxury "Orient Express" train service (http://www.orient-express.com/web/vsoe/vsoe_a2a_home.jsp), offering "romance, adventure and travel" to well-heeled passengers.

Said adapted Marx's comment about the French peasantry as the key to Orientalism: "They cannot represent themselves, they must be represented." That is to say, if the Orientals were too primitive or deviant to represent themselves, then that task would have to be undertaken by people in the West who became

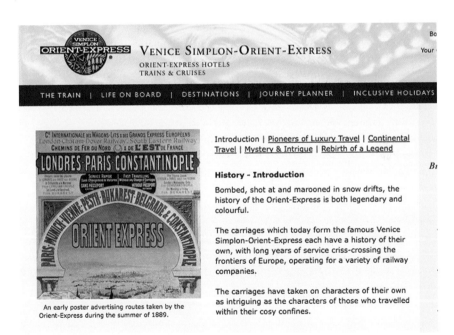

Figure 7.1 The Orient Express webpage

known as Orientalists. Orientalism, then, is a Western means of arranging knowledge that, while it claims to be an investigation of the Other, the Oriental, is in fact also a mapping of the Western by means of negative differentiation: that is to say, whatever the Orient is, the West is not, and vice versa. As this outline suggests, the structure of Orientalist representation created a good deal of ambiguity and ambivalence. As a system of representation, Orientalism moved from space to race and sexuality in a constant series of displacements. Antonio Negri and Michael Hardt have forcefully argued that nineteenth-century imperialism gave history the appearance of being dialectical – that is to say, as shaped by a clash of opposites that would be resolved into a new synthesis of both sides. "Reality," they write, "is not dialectical. Colonialism is" (Hardt and Negri, 2000: 128). By this they mean that it was the goal of colonial practice to turn the encounter between two peoples into a dialectic of the colonizer as the Self and the colonized as the Other. The Other is in every way the opposite to the Self, justifying the power of colonialism as a civilizing mission. But, they continue, "precisely because the difference of the Other is absolute, it can be inverted in a second moment as the foundation of Self . . . What first appears strange, foreign, and distant thus turns out to be very close and intimate." What is known as identity, whether of the colonizer or colonized, was produced in the dialectical tension between otherness and intimacy.

Mickey Mouse and popular culture

The level of economic globalization in 1913, as measured by foreign direct investment, reached a peak that was not reattained until 1997. This global imperial economy was shattered by the disaster of World War I (1914–18) and the subsequent collapse of the Austro-Hungarian, Ottoman and Russian Empires. In Europe, the devastation of the war and the often problematic terms of the peace, combined with economic recession, led to the rise of fascism in Italy and Nazism in Germany. The West now seemed divided within itself, with questions of culture and civilization playing a central role. The Nazi leader Herman Goering notoriously remarked: "When I hear the word culture, I reach for my revolver." On the anti-fascist side, one of the many areas of disagreement was how to respond to this challenge. It is perhaps hard to imagine the German intellectual Walter Benjamin watching Mickey Mouse cartoons. Nonetheless, after seeing them in 1931, he claimed "in these films, mankind makes preparations to survive civilization." Benjamin meant that in his first incarnation as a trickster figure in films like *Steamboat Willie* (1928), Mickey suggested that it is possible to survive, even when the body no longer appears human in any way. In this way, Benjamin argued, "the public recognizes its own life" in cartoons (Benjamin, 1999: 545), suggesting how representation might move beyond the anthropomorphic and the mimetic, an issue that has all the more powerfully returned in our own era of digital manipulation. These early animations were not "realistic" but created an image that foregrounded their own artificiality and machine-made quality.

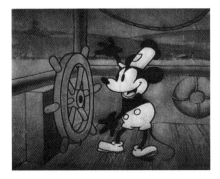

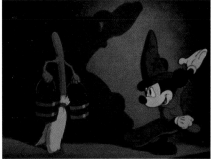

Figure 7.2a A still of Mickey Mouse
from Disney film *Steamboat Willie* (1928)

Figure 7.2b A still of Mickey Mouse from
Disney film *Fantasia* (1940, re-released 2000)

These cartoons and the popular comedies of Charlie Chaplin were a key influence on Benjamin's thoughts about art and popular culture, which culminated in his famous 1936 essay "The Work of Art in the Age of its Technological Reproducibility" (Benjamin, 2002).[1] In this essay, Benjamin developed his ideas as a theory of film. He argued that film sought "to establish equilibrium between human beings and the apparatus." That is to say, in the dehumanizing machine-world created by industrial capitalism, film was both a product of that world and the means by which people could come to terms with it. The closed-in environment of the modern city that Benjamin termed a "prison-world" was opened up by means of cinematic techniques like close-up and slow-motion into a "space for play" [*Spielraum*].[2] Close-up expands space, while slow-motion expands time, in ways that cannot be seen by the naked eye. For Benjamin, then, the camera reveals what we know must be there but could not otherwise perceive, such as the precise motions used during walking that had been made visible by Eadweard Muybridge's stop motion photographs in the late nineteenth century. Benjamin saw this as opening into new modes of visuality, tapping into an "optical unconscious," a counterpart to the "instinctual unconscious" explored in psychoanalysis by means of language (2002: 117). Moreover, film conveys the very "stereotypes, transformations and catastrophes" that haunt the unconscious mind, leading Benjamin to suggest that the individual imagination had a counterpoint in the collective vision of cinema:

> The ancient truth expressed by Heraclitus, that those who are awake have a world in common while each sleeper has a world of his own, has been invalidated by film – and less by depicting the dream world itself than by creating figures of collective dream, such as the globe-encircling Mickey Mouse.
>
> (2002: 118)

Benjamin felt that the "collective laughter" produced by such grotesque figures could immunize the audience against the mass psychosis of fascism, even as he recognized

that Mickey Mouse himself was quickly being recuperated by capitalism. In short, Benjamin was prepared to allow popular culture of the least "cultivated" – albeit the most technologically advanced – variety to serve the critical political purpose of his time, the fight against fascism and the defense of culture.

The American critic Clement Greenberg, in his virtually contemporaneous essay "Avant-Garde and Kitsch" (1939) took a diametrically opposed view. For Greenberg, art was the polar opposite of mass-produced "kitsch," or popular visual culture, the latter exemplified by the covers produced by Norman Rockwell for the *Saturday Evening Post*. Ironically, Rockwell has been the subject of his own New York museum retrospective in recent years, rendering Greenberg's distinction moot. In the period, by posing this opposition, Greenberg defended avant-garde art as the site of the survival of elite cultural values, threatened on all sides by the forces of capitalism and commodification. Both essays were written in the face of the rise of Nazism and of the prospect of a second world war. Both adopted a position that was Marxist, but not of any orthodox variety. Both started from the presumption that the mass reproduction of images had emerged with the rise of industrialism at precisely the time when Marx was formulating his theory of capitalism. Thus, the new means of capitalist production was also notable for its generation of technologies of reproduction that had far-reaching social and cultural effects. For Greenberg, the most crucial side effect of the rise of industrial capitalism was the creation of an avant-garde. In order to survive, art had to consider solely its own conditions of (re)production so that artists came to "derive their chief inspiration from the medium they work in" (1939: 23). Art now concentrated on the "imitation of imitat*ing*" (1939: 24, Greenberg's emphasis), as opposed to mass-reproduced imagery which, for Greenberg, was homogeneous in its low-brow appeal and included a wide range of debased forms of kitsch: "popular, commercial art and literature with their chromeotypes, magazine covers, illustrations, ads, slick and pulp fiction, comics, Tin Pan Alley music, tap dancing, Hollywood movies, etc., etc." (1939: 25). Whereas Benjamin saw film as a revolutionary new medium, Greenberg thus viewed it as yet another manifestation of kitsch, consistent with his belief that "kitsch changes according to style but remains always the same" (1939: 25). Much the same had of course been said of the Orient and Greenberg would claim later that Abstract Expressionist painters had taken over the Oriental sense of color. Continuing these Orientalist arguments, Greenberg claimed that while the "peasant" looking at folk art and the "cultivated spectator" looking at Picasso share the same first impression, a second look gives the cultivated person the advantage of "the recognizable, the miraculous, and the sympathetic," qualities that are in fact "projected" into the painting by the viewer. Thus art represents "cause" while kitsch presents only an "effect" (1939: 27–8). If the avant-garde imitates the process of imitating, commenting in a critical way on the internal properties of art-making itself, kitsch only "imitates its effects" (1939: 28). While Greenberg was a partisan of avant-garde art, he nonetheless saw its separation from what he and Benjamin both called "the masses" as a symptom of the final decline of capitalism.

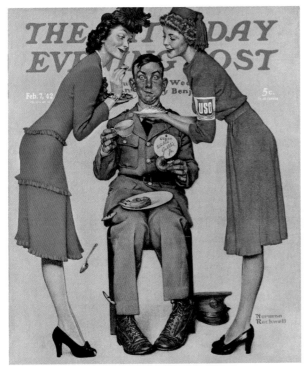

Benjamin, however, took the argument a step further. Like Greenberg he agreed that the development of technological means of reproduction, namely photography, had instigated the "art for art's sake" philosophy of the nineteenth century. As photography copied what was placed before the camera, art was freed from what Benjamin called "ritual," the cult of either religious or secular beauty so that it could now take on a new social function – that of politics. Benjamin argued that because photography distanced people from nature by substituting a mimetic reproduction for the "real," the popular attitude to art had also shifted: "The extremely backward attitude toward a Picasso painting changes into a highly progressive reaction to a Chaplin film" (2002: 116). Of course, Greenberg would not allow that the latter was even possible since he argued that kitsch products such as Chaplin's films were diametrically opposed to high art, with its redemptive value. Benjamin's theory of the optical unconscious expressed by film followed from his sense that "just as the entire mode of existence of human collectives changes over long historical periods, so too does their mode of perception" (2002: 104). In other words, Benjamin acknowledged something Greenberg did not even address – that which was "progressive" changed in relation to technological shifts, which in turn changed in complex relationship to society as a whole. Film allowed the mass, urban audience

created by industrial capitalism to experience a collective response to visual media
– a response that could not be evoked by paintings no matter how popular the exhi-
bition in which they were displayed. At the same time, Benjamin still privileged art
– particularly Dadaist works – as being the first to express the shock of modernity.

Benjamin and Greenberg were agreed that the primary enemy of all culture was
fascism. Greenberg, writing on the brink of war, saw little hope for outright resis-
tance: "Today we no longer look to socialism for a new culture – as inevitably one
will appear, once we do have socialism. Today we look to socialism *simply* for the
preservation of whatever living culture we have right now" (1939: 32). In this view,
socialism acted as a kind of museum for high culture as it retreated from the mass
political movements of the day. He drew only a limited distinction between Nazism,
Italian fascism and Soviet communism, because his version of art could have no
application for political propaganda. Again, Benjamin, after having been driven out
of Germany by the Nazi takeover because of his Jewish background, articulated more
subtle distinctions. He argued that fascist spectacle functioned to lure people into
feeling they were in charge of their country, even though the ownership of property
had not changed at all. The logical goal of such aesthetic spectacles as the Nuremberg
rallies or Mussolini's Roman parades was war, following the Italian Futurists' vision
that "war is beautiful" (Benjamin, 2002: 121). War thus provided the ultimate
gratification of the desire for art for art's sake. To this aestheticizing of politics,
Benjamin suggested that "Communism replies by politicizing art" (2002: 122).

At the end of World War II, everything appeared radically different. Even before
the war, Benjamin's colleague at the Institute for Social Research, Theodor Adorno,
had strongly criticized his endorsement of Disney cartoons. In the 1936 version of
his essay on the work of art, Benjamin cut his references to Disney in response to
Adorno's insistence that the mass response to these animations was in no way
progressive and could even prepare the way for fascism. And, just after Benjamin
had lauded Disney, the radical quality of the early cartoons gave way to the lush color
and domesticated story lines of the increasingly formulaic animated films put out
by the Disney machine, as became clear in the "Magician's Apprentice" section of
Fantasia (1940), which sees Mickey anticipate the glories of automated household
cleaning. During the war itself Adorno and his colleague Max Horkheimer, stunned
by the Holocaust and living in exile in the USA, wrote their classic *Dialectic of
Enlightenment* (1944). Here they proposed a theory of the "culture industry," which
they saw as dominating and impoverishing modern everyday life in every possible
way. In this view, "all mass culture is identical" and serves to deceive the masses
([1944] 1973: 24). As if to illustrate their thesis, Disney became increasingly
politicized during the Cold War, as numerous commentators have pointed out. By
the 1950s and 1960s, Donald Duck cartoons were being used, without any great
subtlety, to promote US interests in South-East Asia and Latin America (Dorfman
and Mattelart, 1975). By the time the skeptical postmodern French philosopher
Jean Baudrillard came to assess the United States via Southern California around
1975, he saw Disneyland as the epitome of the "desert of the real" that the

superpower had become. The function of Disneyland was simply "to conceal the fact that it is the 'real' country, of all 'real' America, which is Disneyland" (1984: 262). If the British Empire had offered its colonial subjects "civilization," the American hegemony provided mass culture to ultimately similar effect.

American art critics took a similar but reversed route in hailing, without irony, the "triumph of American painting" in the post-war decades (Sandler, 1976). That is to say, rather than condemning all American culture as kitsch, they praised new American art as the victorious form of high culture, just as the nation had prevailed in war. During the war, American artists expressed a globalized idealism. In a 1943 manifesto that was given wide publicity by the *New York Times* and other media, the artists Adolph Gottlieb, Barnett Newman and Mark Rothko declared that henceforth American art must work on a "truly global plane." This art was to be both "tragic and timeless. This is why we profess spiritual kinship with both primitives and archaic art" (Guilbaut, 1983: 76). Now the "Oriental" or primitive mind was subject to appropriation by the Western artist as the very mark of his (gender intended) advanced civilization. Needless to say, were a person designated as primitive to make a similar claim it would not have been heeded. The rise of Soviet domination in Eastern Europe produced a rightward drift in many intellectuals, resulting in an increased desire to remove high culture from the incursions of the political. By 1948, in an essay published in the now patriotic *Partisan Review*, Greenberg argued that "the main premises of Western art have at last migrated to the United States, along with the center of gravity of industrial production and political power" (Guilbaut, 1983: 172). The avant-garde stance against popular culture was now combined with a sense of American manifest destiny to create a package the US government was happy to support, albeit covertly. As scholars such as Serge Guilbaut have pointed out, while American senators thundered on about abstract art as communism, the CIA and other agencies were quietly supporting exhibitions, magazines and other outlets for the new American art as evidence of the freedom offered by the United States.

The Western

Nowhere was the dichotomy between Western "freedom" and its enemies more visible than in the Western, the cinematic genre depicting the expansion of the United States into the Western regions of the continent at the expense of Mexico and indigenous populations that visualized "manifest destiny." The Westerns of the 1930s had collapsed into the parodic Singing Cowboy format of Gene Autry and Roy Rogers movies, backed up by tales of heroic masculinity like *The Virginian* (1929). By 1952, Gary Cooper, star of *The Virginian*, was playing the lead in *High Noon* (1952) that culminated in the same obligatory shoot-out in the streets but in a much different context. Cooper played Will Kane, a marshal in the fictional town of Hadleyville that was depicted as just having emerged from the lawlessness of the Wild West to being a place where Northern investors were on the point of opening

Figure 7.4 A still from *High Noon* (dir. Fred Zinnemann, 1952)

factories. The film opens with Kane giving up his law enforcement position and getting married, when it is discovered that Frank Miller, a gunman he had convicted of murder, has been pardoned and is returning to town on the noon train for revenge. His Quaker wife Amy (Grace Kelly) and his friends urge Kane to leave and at first he does but turns back compelled by his sense of duty. None of the other men in the town will join with Kane and in the final shoot-out, it is only Amy's reluctant taking up of arms that gives him the chance to go one-on-one with Miller. After he (of course) is victorious, Kane throws his marshal's star in the dirt and leaves town, whereupon the film ends.

High Noon was written under a pseudonym by Carl Foreman, who had been placed on the Hollywood blacklist because he had refused to name his former associates in the Communist Party to the House UnAmerican Affairs Committee, chaired by the notorious Senator Eugene McCarthy. So at one level the film was a critique of Cold War panics about Communism in which Kane finds his erstwhile friends unwilling to support him against the threat of villains. If Kane is the one "real" man in the film, he is backed up by Amy and by Helen Ramirez, his former lover, played by the Mexican actress Katy Jurado. At the same time, *High Noon* also depicts the mythic "Western" values of self-reliance, determination and a refusal to compromise basic principles, even if corners have to be cut to accomplish the goal. As a drama, *High Noon* created tension by playing out its action in something close

to "real time": that is to say, elapsed time in the film corresponded to the actual passing of time. The decisive combat depends on the train being on time, leading one of the gang to check its punctuality repeatedly with the station master. A similar motif of the industrialized time of the modern cutting across the mythic West structured *3.10 To Yuma* (1957) in which rancher Dan Evans (Van Helfin) has to get the outlaw Ben Wade (Ben Ford) onto a train to take him to jail. This taut plot device was effective enough to get the film remade in 2007 with Russell Crowe and Christian Bale playing Wade and Evans.

By contrast the myth of the West as an epic place of discovery and contest was central to the work of director John Ford. In his 1956 classic *The Searchers*, the West is a seemingly limitless space that stretches from Northern snows to cactus-filled Spanish-speaking desert locations. Its opening sequences feature the return of Ethan Edwards (John Wayne) to his family's home. This well-appointed ranch is bizarrely situated in the heart of Ford's favorite location, Monument Valley, Utah, a desert featuring dramatic mesas. In a series of subtle hints, it is quickly established that Ethan fought for the Confederacy, whom he still supports, then went to Mexico to fight for the Emperor Maximilian, installed by the French to run Mexico as part of the empire of Louis Napoleon. After that effort collapsed, he robbed a Union bank and returned hoping to find Martha (Dorothy Jordan), his young love, only to discover that she has married his brother Aaron (Walter McCoy). Ethan is openly racist towards Martin Pawley (Jeffrey Hunter), whom he accuses of being a "half-breed." Martin defends himself by saying that he is only one-eighth Comanche (by coincidence precisely the faction of Native descent required by the Federal government to claim that ethnicity today). The search of the title involves Ethan and Martin joining forces to search for Debbie (Natalie Wood), taken in a Comanche raid on

Figure 7.5 A still from *The Searchers* (dir. John Ford, 1956)

the Edwards homestead, left unguarded thanks to a trick by the Comanche leader Chief Cicatrice, known as Scar (Henry Brandon). Ironically, although the Comanche did indeed actively contest European rule in the West, Monument Valley was one of the few places where they did not have a presence.

The pursuit of Scar takes Ethan and Martin from snowy plains to Spanish-speaking cactus-filled frontier towns in a five-year quest. In every location, Ethan is master of the local, speaking both Comanche and Spanish as required, and conversant with indigenous customs. Like the Orientalist, he is more expert than the native on local traditions. When Martin "marries" a Comanche woman named Look by mistake, Ethan finds the whole affair hilarious. Given that Ford indicated that his film was a "psychological epic," the name Look was not an accidental choice. Martin cannot bear her presence and tries everything to get her to leave. The Look of the native is unbearable to the colonizer, especially to those who know that they are not as different as they would like to believe. After he has finally succeeded, it later transpires that she has been killed by US soldiers, an act that Martin finds excessive but it does not deter him from later pursuing Laurie Jorgenson (Vera Miles). At the conclusion of their search, Ethan hunts down Debbie who by now identifies as Comanche. It seems that he is about to kill her when he sweeps her up into his arms and she "reverts" to whiteness, remembering her past life and family. For all its apparent liberalism (by the standards of the time), *The Searchers* saw human difference as innate rather than as being shaped by context and history.

It is interesting to note that it was in the immediate aftermath of the end of the Cold War that Clint Eastwood made *The Unforgiven* (1992), a film dedicated to debunking the very Western myths that Ford had tried so hard to visualize. Eastwood directed and played the lead William Munny, a former bandit and gunfighter tempted out of retirement to win a bounty of $1000. The twist is that the reward was posted by a group of prostitutes, angry that one of their co-workers had her face slashed with a knife because she laughed at the under-endowment of a client. The implicit connection between masculinity and violence in the Western was here made central to the narrative of the film. *The Unforgiven* was also notable for its brutally realistic depictions of violence. Unlike the classic "quick on the draw" denouement, Munny sneaks up on the evil sheriff Little Bob (Gene Hackman) while the latter is reloading his gun. To Little Bob's claim "I don't deserve this," Munny simply replies "Deserve's got nothing to do with it." The film gained added resonance because Eastwood himself was so well-known as the lead character in the so-called Spaghetti Westerns directed by Sergio Leone, such as *A Fistful of Dollars* (1965) and *For a Few Dollars More* (1965). Eastwood played "The Man With No Name," a mysterious man of few words whose violent devastation of his opponents was the main theme of the films.

The repudiation of the classic Western went hand-in-hand with the development of a new narrative of "one world" globalization. The Scottish artist Douglas Gordon literally sought to enact this narrative when he attempted to show *The Searchers* over the five-year period the film claimed to represent. In a piece known as *5 Year Drive*

Figure 7.6 A still from *Brokeback Mountain* (dir. Ang Lee, 2005)

By (1995), Gordon slowed the film down either to fit the length of an exhibition or ideally to match the five years of the cinematic narrative. In the latter case, each frame was on screen for sixteen minutes and only the most patient of watchers would have observed the scene change. By 1995, the cowboy epic seemed equally impossible to understand. Cinematically, this narrative peaked with the release of Ang Lee's 2005 revisionist view of the West in *Brokeback Mountain*. *Brokeback* made the homoerotic undertones always present in the homosocial life of the cowboy its explicit theme. The film described the relationship between Ennis del Mar (Heath Ledger) and Jack Twist (Jake Gyllenhall), from their first meeting on a sheep-herding assignment in 1963 to Jack's death in the "present" created by the film. The two men begin their sexual relationship on a cold night in the hills and pursue it, despite their marriages and separations, until Jack is murdered. The primary responses to the film in the US called it either an abomination (from the Christian right) or a hymn to universal love (from most mainstream media). As Judith Halberstam has pointed out, the homoerotics of the cowboy was a very badly kept secret, even in the period. Visually, she argues,

> *Brokeback Mountain*, with its wide angled views of the wide-open, rolling hills and its tight frames of suffocating domesticity, appeals to queer audiences and straight audiences alike because it maps the tragic narrative of thwarted manly love onto the imagined landscape of that most mythic of US sites – the West.
>
> (Halberstam, 2006)

Brokeback was in this sense a very conventional Western in that heroic masculinity found its proper counterpart in the dramatic landscape of the American West, rather

than in the constrained and feminized domestic interior. Cinematic cowboys, whether represented as straight or queer, have in common their love of the wild and their distrust of women.

Understood in this light, Paul Anderson's *There Will Be Blood* (2007) was a far more insightful critique of the invention of the West. Here the landscape is brutal and hostile to life, filling the screen with depictions of barren, stony hills in marked contrast to Ford's Monument Valley or Lee's Wyoming. In the first 14 minutes and 35 seconds of the film, no words are spoken as Daniel Plainview (Daniel Day-Lewis), whose very name expresses the visual emptiness of the scene, struggles to extract gold from a mine he has constructed himself. A long sequence of mining by hand and by explosives culminates with Plainview falling down the mine, shattering his leg. Even before he thinks of his condition, Plainview checks to see if the blast has exposed gold. The first verbal communication in the film comes in the form of a written communication in which an assayer calculates for Plainview the value of his gold. The film can be divided into three stages corresponding to the development of capitalism, beginning with what has been called "primitive accumulation," the creation of wealth by hoarding, in this case by Plainview's solo mining. Next we move on to production in which Plainview searches for oil and strikes a well at the cost of at least one miner's life. This violent death orphaned a young boy known as H.W. (Dillon Freasier) whom Plainview adopts, allowing him to pretend to be a "family man," as he puts it, without the inconvenience of actual marriage. In the longest segment of the film, set in 1911, Plainview drills for oil at a town called Little Boston in the California desert, a place so desolate it allows farming only for goats. His goal here was not just to find more oil but to build a pipeline to the sea, allowing him to move into the decisive stage of capitalism, namely circulation. In all stages of the film, speech is duplicitous. Plainview deceives everyone with his plans for oil and is engaged in verbal conflict by an evangelical preacher named Eli Sunday (Paul Dano), whose sermons had dominated the rural community before Plainview's arrival. In the many scenes of inglorious hand-to-hand conflict in the film, the loser often has his mouth covered or stuffed with some substance. When Eli demands money from Plainview, the oilman responds by slapping him into the ground and filling his mouth with oil, leading Eli to launch a similar attack on his own father Abel. In order to sustain this counterpoint, Anderson indulges in one key anachronism. When the well at Little Boston strikes oil, the resulting explosion deafens H.W., returning him to the silence of accumulation from which Plainview emerged. He is later sent to the California School for the Deaf in Berkeley, from which he returns signing fluently. However, deaf education in the United States at this point had shifted away from sign language to "oralism," a method that claimed to be able to teach the deaf to speak. In fact, as H.W. had acquired and used language before his deafening he might have been a suitable candidate for such methods, unlike those born deaf or pre-lingually deafened. Further, sign was held to be a vulgar and lower-class language that certainly would not have been taught to the child of an oil baron. Still less would there have been sign-language interpreters available, as

Figure 7.7 Stills from *There Will Be Blood* (dir. Paul Thomas Anderson, 2007)

depicted in the penultimate scene, which shows Plainview cruelly undercutting H.W.'s ambition to drill for oil himself by revealing his orphan status – or "a bastard in a basket," as he puts it. Even Anderson was not willing to show an America in which the Deaf were forced to speak to conform to a standard of the norm in which it was normal to speak, therefore all must speak. Ironically, so concerned were the elders of the American Deaf community about the disappearance of sign language that they raised some $5,000 by appeal in 1913 to film several sequences of signing by distinguished practitioners, all older men. Finally, argued George Veditz of the California School for the Deaf, there was a method to pass on signs "to future generations . . . through the use of *moving-picture films*" (Veditz, 2001: 85). Instead the Plainviews of the world prevailed, eliminating sign language from formal deaf education in the United States until the 1970s.

When Plainview clubs Eli to death in the concluding scene, set in 1927, his final line is "I'm finished." While many deplored the ending as a caricature, the point was precisely that the Plainview of the world had become dominant in the United States. Its cartoon-like violence had eliminated all opposition. The echo of Christ's final words on the cross, "It is finished" (John 19:30) is entirely intentional, only in

reverse. The melodramatic grand guignol style of the scene, reinforced by the period music that ends the film, also reminds the viewer that in 1927 *The Jazz Singer* would end silent cinema and open a new era of films. In the modern cinema, viewers have become so accustomed to the redemptive ending, in which even a film like *Rendition* (2007) about state-sponsored torture ends with the triumph of the free press in revealing the news, that the comic squalor in which *There Will Be Blood* fulfilled its own prophecy seemed unintelligible. It was the inexplicable nihilism of the Coen brothers' film *No Country for Old Men* (2007) that swept the Oscars that year for its depiction of a psychopathic hired killer Anton Chigurh (Javier Bardem) and his relentless pursuit of those he designates as his targets. The film begins and ends in the circulation of violence after a Texan policeman arrests Chigurh on a desolate highway with no explanation for how he comes to be there or why he is being arrested. Meanwhile Llewellyn Moss (Joss Brolin) a down-on-his-luck cowboy out hunting comes on the scene of a shoot-out between drug dealers where he discovers a suitcase full of cash. Once Chigurh has killed his way out of prison, the film consists of a duel between him and Moss for the money with the local sheriff Ed Tom Bell (Tommy Lee Jones) always a step behind. Sheriff Bell opens the film by musing about the changes since the "old days," soon comes to feel "outmatched" and ends in retirement, dreaming about horses. Chigurh, having killed all his opponents, gets into a car crash and ends as he began, limping down a road, albeit in the suburbs rather than the open country. *No Country* offered a conservative vision of a dangerous world in which unknown people are coming across the border, whether Mexicans or former Soviets turned killers, and the ineffectual liberal state is unprepared to do what it takes to stop them. Neither the good cowboys, like Sheriff Bell, echoing *High Noon*, or those living on the margin of the law, like Llewellyn Moss, echoing *The Searchers*, seem to know how to make sense of being Western in the new world.

If being the West has proved visually difficult in the framework created by the Cold War Western, Hollywood has found another formula ready to hand that seems to suit the new situation. As film historian Jack Shaheen describes, "from 1896 until today [Hollywood] filmmakers have collectively indicted all Arabs as Public Enemy #1 – brutal heartless, uncivilized fanatics and money-mad cultural 'others' bent on terrorizing civilized Westerners" (2003: 172.) While this image is recognizable to filmgoers since 2001, even in movies like *Syriana* and *Rendition* that criticize Western governments as well, Shaheen emphasizes that this pattern has remained constant in the over 900 films that he has researched featuring Arab characters over the century of film's existence. The best-known of the recent exceptions to this rule is *Three Kings* (1999), a satire of the first Gulf War in which Arabs appear as sympathetic characters that a Western audience might actively identify with. In the hundreds of films that depict Arabs as villains, a pattern has begun to emerge in which the United States Department of Defense (DOD) is actively involved: "more than fourteen feature films, all of which show Americans killing Arabs, credit the DOD for providing needed equipment, personnel and technical assistance" (Shaheen, 2003: 177). While the military have an obvious interest in promoting themselves, it is

worth asking why audiences have continued to respond to these and other stereo-types. Bertolt Brecht, who knew a few things about the tricks played in theaters, reports somewhere that when he found himself watching a Western, he ended up supporting the cowboys. Despite all his radical politics that would have led him to sympathize with the Indians, and his radical aesthetics that would have made him despise the heroic leader format, even Brecht was seduced by the idea of inventing the West.

Notes

1 This essay is better known under its first translated title "The Work of Art in the Age of Mechanical Reproduction." I am citing here the second version of the essay, before it was revised under the influence of Theodor Adorno.
2 I prefer to use the literal translation rather than the generic "field of action" offered in the Harvard translations.

References

Adorno, Theodor and Max Horkheimer ([1944] 1973), *Dialectic of Enlightenment*, trans. John Cumming, London: Allen Lane.
Baudrillard, Jean (1984), *Selected Writings*, ed. Mark Poster, London: Polity Press.
Benjamin, Walter (1999), *Walter Benjamin: Selected Writings Vol. 2 1927–35*, ed. Michael Jennings et al., Cambridge, MA: Harvard University Press.
—— (2002) "The Work of Art in the Age of its Technological Reproducibility," in *Walter Benjamin: Selected Writings Vol. 3 1935–38*, ed. Howard Eiland and Michael Jennings. Cambridge, MA: Harvard University Press.
Dorfman, Ariel and Armand Mattelart (1975), *How to Read Donald Duck: Imperialist Ideology in the Disney Comic*, New York: International General.
Frascina, Francis (ed.) (1985), *Pollock and After: The Critical Debate*, London: Harper and Row.
Greenberg, Clement (1939), "Avant-Garde and Kitsch," rpr. in Frascina (1985).
Guilbaut, Serge (1983), *How New York Stole the Idea of Modern Art: Abstract Expressionism, Freedom and the Cold War*, Chicago, IL: University of Chicago Press.
Halberstam, Judith (2006), "Re-Imagining the Terrain: The Queer Western," keynote address to the London Queer Film Festival 2006, unpublished, courtesy of the author.
Hardt, Michael and Antonio Negri (2000), *Empire*, Cambridge, MA and London: Harvard University Press.
Said, Edward (1978), *Orientalism*, London: Routledge & Kegan Paul.
Sandler, Irving (1976), *The Triumph of American Painting*, New York: Harper and Row.
Shaheen, Jack G. (2003), "Reel Bad Arabs: How Hollywood Vilifies a People," *Annals of the American Academy of Political and Social Science*, vol. 588 "Islam," pp. 171–93.
Veditz, George (2001), "The Preservation of the Sign Language," in Lois Bragg (ed.), *Deaf World: A Historical Reader and Primary Source Book*, New York: New York University Press.

EMPIRE AND THE STATE
OF EMERGENCY

Recent critical discussion of the direction now being taken by globalization has centered on two key ideas: empire and the state of emergency, or exception. Both can be traced back in the Western context to ancient Rome, whose empire continues to set the paradigm in which present-day empire might be judged and whose law is still the foundation of many legal codes. As modern empires grew, they came to compare themselves to Rome. In Edward Gibbon's monumental history of *The Decline and Fall of the Roman Empire* (1776–88), Rome's eventual fall, corrupted both by wealth and what Gibbon saw as the enfeebling influence of Christianity, overshadowed her achievements, changing the nature of the metaphor. Indeed, the artist and poet William Blake called himself the "prophet against Empire" in late eighteenth-century London, while the American painter Thomas Cole (1801–48) painted a famous series called *The Course of Empire* (1834–6) that visualized the inevitable decline of empires brought about by material decadence. However, as the modern empires grew, the prestige of Rome rose. In 1879, Thomas Carlyle's biographer and successor James Anthony Froude wrote a fulsome biography of Julius Caesar, the first Roman Emperor, proposing an imperial future for Britain under a single ruler rather than as a parliamentary democracy. Even more directly than Carlyle, Froude saw visuality as the world-view of imperialism, or perhaps more specifically, of the imagined Emperor. His model for this imperial dominion was India and indeed in 1877, Queen Victoria had officially been named Empress of India, following the crown assumption of direct sovereignty in 1858 after the so-called Indian Mutiny of 1857. Just as Carlyle's negative view of emancipation had gained official support as time went by, so too did Froude's authoritarian vision of empire come to seem prescient as European empires expanded across the globe.

Seen with the benefit of hindsight, Benito Mussolini, leader of the Italian Fascist party and self-styled *Duce* (leader) of Italy, who modeled his party on the Roman Empire and launched an imperial war in Ethiopia to bolster his claim, now appears in his own propaganda films to be a posturing clown. Nonetheless, he held power for 20 years. Mussolini's power rested on a visualized authority. In 1896, the psychologist Gustave Le Bon wrote an influential treatise on how to manage the modern mass crowd: "crowds being only capable of thinking in images are only to be impressed by images. It is only images that terrify or attract them and become motives of action." Writing before the development of mass audio-visual media, Le Bon's concept of images was as much mental as physical, relying on a sense of mysticism. Mussolini was deeply influenced by Le Bon and set out his policy as being "to dominate the masses as an artist." The Hero now forges the "masses" into a beautiful whole, taking as his template

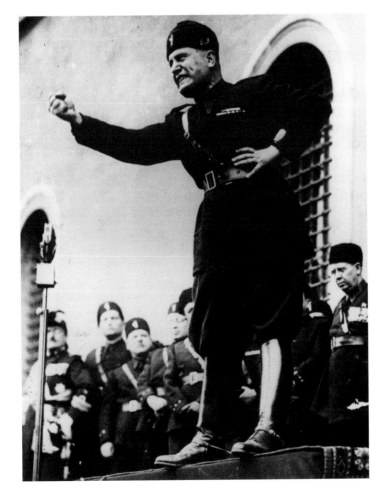

Benito Mussolini (c. 1934). Photo by Keystone/ Getty Images

the Roman Empire. In 1922, on the verge of power, Mussolini claimed: "Democracy has deprived people's lives of 'style.' Fascism brings back 'style' into people's lives: that is a line of conduct, that is the color, the strength, the picturesque, the unexpected, the mystical" (Falasca-Zamponi, 1997: 22–6). It was for this reason that Walter Benjamin famously argued that fascism aestheticized politics. Its strategy was to render the mass society into a single unit directed to a single goal under a single leader. In order to do that, an enemy was required to define who was and was not part of the nation. After years of saber-rattling Mussolini invaded Ethiopia in 1935 claiming, accurately, that: "The Empire cannot be done otherwise" (Falasca-Zamponi, 1997: 169). Hitler's contemporary Thousand Year Reich took the policy a step further by finding enemies within and without, personified above all by the "Jew."

This transformation of empire into dictatorship gave rise to a body of legal theory, seeking to justify the new regimes, that has been analyzed by the Italian philosopher Giorgio Agamben (2005). Agamben shows how modern dictatorship was based on the Roman theory of a "state of exception" in which authority was temporarily taken away from the Senate and given to a single leader in time of war or other crisis. The state of exception suspends the constitution in order to defend it. In its modern version, it became necessary to suspend democratic rights in order to defend such rights in a crisis. Reading the Nazi theorist Carl Schmitt, Agamben shows that the state of exception opposed the necessity to take decisions to the "norm" of standard practice, under the Roman law maxim "necessity has no law." By that phrase is meant that in its crisis, state authority is its own justification, taking whatever actions it needs to ensure its own survival. Agamben points out that the now notorious Article 28 of the Weimar Constitution, allowing the constitution to be suspended in an emergency, was used to validate the National Socialist (Nazi) regime. In a strict sense, the Third Reich was not a "dictatorship" but a "state of exception" allowed for under the constitution.

This insight prepares the way for Agamben's most challenging thesis. He argues that the "state of exception" is in fact a new model of government that has developed in frequency and extent since its codification into European law during the French Revolution to the point where it now threatens to become the "norm." Agamben shows that President Lincoln's strategies during the American Civil War, including the emancipation of the enslaved, were based on his assumption of exceptional powers (2005: 20–1). Far from being a point of detail, General Pervez Musharraf of Pakistan referred to Lincoln's actions in declaring his own state of emergency in November 2007. Speaking of Italy, one of the world's leading economic powers, Agamben points out "that the democratic principle of the separation of powers has today collapsed and that the executive power has in fact, at least partially, absorbed the legislative power" (2005: 18). Here he references the imperial premiership of Silvio Berlusconi, returned to power in 2008 to the accompaniment in certain places of fascist

salutes. It is clear, as Agamben notes, that the second Bush administration in the United States (2000–8) also claimed such extensive powers in order "to produce a situation in which the emergency becomes the rule" (2005: 22). That is to say, the Presidency under Bush claimed what it called the "full powers" of executive authority by virtue of its role as Commander-in-Chief of the armed forces in a permanent war against terror. In the current situation, Agamben argues, it is no longer possible to answer the question "what does it mean to act politically?," a question that for the same reason attains a new level of urgency.

This thesis can be contrasted with that of Michael Hardt and Antonio Negri, who have discerned a new form of empire emerging in the late twentieth century, using a different genealogy. Their vision of empire is of a

> decentered and deterritorializing apparatus of rule that progressively incorporates the entire global realm within its open, expanding frontiers. Empire manages hybrid identities, flexible hierarchies, and plural exchanges through modulating networks of command.
>
> (2000: xii)

Here the nation-state is in decline as transnational forces create a "deterritorialized" populace, one separated from a given place or location as a place of identification, whether by force or by choice. The difference in language from Agamben's indicates what one might call a prophetic vision, hoping to discern an emergent future in the chaos of the present. Indeed, while Hardt and Negri also see a parallel between their work and the Roman Empire, their assertion is that the new Empire is to the present as Christianity was to Rome. That is to say, Empire is a phenomenon produced within the old regime that is nonetheless radically distinct from it. Their language is in this sense reminiscent of Carlyle's Hero, only in this case the Hero is a collective entity known as the multitude. Here Hardt and Negri are recuperating the multitude, a term usually used by conservative writers with some contempt for the mass of people, to mean the new global formation caused by the new means of value production. In this view, "intellectual, immaterial, and communicative labor power" (Hardt and Negri, 2000: 21) or knowledge production, is the critical problem for the twenty-first century in the same way that industrial labor power was for the nineteenth and early twentieth centuries.

Their thesis countered the "end of history" theme so common in the 1990s with a sense of a very different future at hand. For writers like Francis Fukuyama, modern Western consumer society was the "end of history" once imagined by Hegel. From now on, it was argued, the only question was which brand to purchase. Whatever one thinks of the first decade of the third Christian millennium, it no longer seems likely that history is at an end. Nor, sadly, does the idea of a flexible, open network society seem imminent but it is (at time of writing) only seven years since Hardt and Negri's book was published. So while

Agamben's thesis seems more in tune with the global crisis of 2007, Hardt and Negri seemed to many to be articulating the form of globalization enacted up until September 11, 2001. It is surely too early to say which view is likely to become accepted.

References

Agamben, Giorgio (2005), *State of Exception*, Chicago, IL and London: University of Chicago Press.

Hardt, Michael and Antonio Negri (2000), *Empire*, Cambridge, MA and London: Harvard University Press.

Falasca-Zamponi, Simonetta (1997), *Fascist Spectacle: The Aesthetics of Power in Mussolini's Italy*, Berkeley and London: University of California Press.

Further reading

Agamben, Giorgio (1998), *Homo Sacer: Sovereign Power and Bare Life*, Stanford, CA: Stanford University Press.

DECOLONIZING VISIONS

W HEN I WAS AT school in the United Kingdom, maps were hung in class-rooms that still showed one quarter of the world colored red to indicate that it was a part of the British Empire. Even then, in the 1960s and 1970s, that was no longer the case but it shows that empires do not end when the last soldier has been withdrawn, the flag lowered and the retreating planes have taken off. The twentieth century was marked by a global resistance to colonial rule from Africa to Asia and ultimately the Soviet Union and the United States. There has been a good deal of debate as to the meaning of the term "postcolonial." Does it mean simply the time period after colonization, or a perspective on colonialism informed by anti-colonial politics, or the collapse of the binary West/East (or North/South, or Occident/ Orient) division of the world? The combination of violence, cultural rupture and cultural conflict that resulted produced a dynamic that played out across the dividing line that marked the end of formal colonial rule. In many cases, colonial rule was ended by active resistance, often involving military action as in Algeria, Cuba and Vietnam. In India, mass popular non-violent direct action led by Mahatma Gandhi was a direct contributor to the British withdrawal from what had always been considered the "jewel" in the crown of the empire. Sometimes guerrilla wars would lead to a sudden collapse in the imperial will to dominate, as in the end of the Portuguese empire in Mozambique and Angola. In all these struggles culture played a significant role precisely because the colonizers had claimed to be bringing "civilization" to those they ruled. For resistance groups and new postcolonial nations alike, forming a sense of national culture that was not a pastiche of colonial culture but could withstand accusations of primitivism was a central task.

Visualizing necropolitics: the Congo in *Life*

After World War II, African peoples began to demand and achieve independence from the European powers that had all been exhausted by six years of conflict. Africa at once became a chessboard in the complicated game that was Cold War geopolitics. Liberation wars were often intensely violent, complicated both by colonial powers refusing to accept the end of their authority, as seen in the French repression in Algeria, and by superpower involvement, such as the so-called civil war that devastated Angola. These histories have led Achille Mbembe to describe the rise of a "necropolitics," in which "the ultimate expression of sovereignty resides, to a large degree, in the power and capacity to dictate who may live and who must die" (2003: 11). Mbembe contrasts this new form with the "biopolitics," or concern over the extension and development of life, that dominated Western internal politics from the end of World War II to the collapse of the Soviet Union. While Western European nations were building welfare state provisions, such as compulsory vaccination schemes and universal pensions, decolonizing states were dominated by the control of the power to kill. One example of this process can be seen in the international representations of the decolonization of the Belgian Congo in 1960. The vast colony became the independent nation of Congo under the presidency of the radical Patrice Lumumba. His regime was soon challenged by rebel forces, sponsored by the US Central Intelligence Agency, leading to a desperate civil war with Cold War overtones. A series of reports in *Life* magazine from the key months of February, March and April 1961 show how the West continued to depict the Congo as the heart of primitivism, leading to a violence from within and without. There is a certain irony to the name *Life* itself, as the issue is one of the contrast between biopower, power over life, and necropolitics, power over death.

In February 1961, the civil war reached a turning point with the assassination of Lumumba, as *Life*'s lead story reported: "Anarchy, armed and uncompromising, ranged the land and ruled it. Four provincial Congolese armies fought among themselves, seemingly without knowing why. New-made nationalists reverted to tribesmen again and took the vengeance of old hates." In short, Lumumba had to die to prevent the war that had been created against him. The only innocents in this conflict were children, depicted as the "victims of the deepest tragedy of the Congo, they were the deathly [sic] harvest of an anarchy which called itself freedom" (*Life*, February 17, 1961). Such freedom cannot be allowed to those not responsible enough to wage war, the state's primary responsibility. Such reporting depicted the Congolese as simple primitives, dressed up as nationalists by "the Communists," whose child-like actions ended up hurting their own children most of all. One week later, the geopolitical implications of the Congo crisis made the front page as the "U.N.'s Gravest Hour." The reporting took on a hysterical edge as global protest against the murder of Lumumba reached the United Nations itself. Readers were reminded that Lumumba was a "communist pawn . . . [whose] fiery speeches against the colonial nations made him an international symbol of black men's anger at long

years of white exploitation." This anger was intended to resonate with American readers as an echo of the nascent civil rights movement. Two years later on the hundredth anniversary of emancipation in 1963, James Baldwin wrote "Black has become a beautiful color – not because it is loved but because it is feared." Although his solution to the crisis was Love, his title *The Fire Next Time* resonated more precisely with white fears.

Photographs in *Life* showed the response around the world to Lumumba's murder as a "spectacular, global onslaught," culminating with a demonstration at the United Nations. One shot of well-dressed Congolese in Paris protesting the assassination was captioned as an "anti-colonialist riot." Photographs showing African Americans taking the same protest to the United Nations were described as showing "U.S. Negro extremists" on the rampage, who "intended to foment black anger against the white race" (*Life*, February 24, 1961). Now the fear was that African nationalism could spread to African diaspora peoples in the West, especially the United States. Just as the Belgians had interpreted anticolonial activism as genocidal war against whites, so the *Life* photoessays presented the protests surrounding Lumumba's death as a global African–Communist conspiracy against white people. In short, decolonizing politics was always understood and responded to as necropolitics. It is important to note that another view of the Congo was possible. In the Ghanaian version of the multi-racial South African magazine *Drum*, a 1961 photograph by Christian Gbagbo showed the conquest of the Congo not by primitivism but by the West African music highlife. Gbagbo's picture showed Ghanaian soldiers from the United Nations' peacekeeping force and Congolese civilians mixing happily (Oguibe, 1996: 226). The dance hall was a modern structure, with plaster relief on the ceiling, electric light and amplification – a marked contrast with Western depictions of the primitivism of the Congo. No such representation of Congolese modernity ever appeared in *Life*.

The new African nations now formed the largest bloc at the United Nations, one that appeared to be lending its support to the Soviet Union. Western media depicted Africa as still in the thrall of superstition and therefore incapable of rational politics. Under a banner headline declaring " 'black' magic [to be] a vital force in new African nations," *Life* journalist Robert Coughlan pronounced in April 1961:

> what goes on in the African mind is an important matter – and we must realize that it may not be the product of logical reasoning or even of the operation of physical laws as they are understood in the West. Instead, it is fairly often the product of magical influences.

Alongside this text, as if to prove the point, the reader was confronted with a large, out of focus photograph of an *nkisi* figure captioned as "fetish figure used by African sorcerers who jab nails into it to put curse [sic] on their enemies." The threat that such "sorcerers" represented to whites in Africa was depicted in terms very similar to those used by the Belgians 60 years previously:

> Now and again . . . one of these messiahs decides he has received a
> divine appointment to drive the white men out of Africa. Some of the
> present antiwhite violence in the Congo is the legacy of such a sect, the
> Kitawala Society, which the Belgians tried to suppress years ago but
> which smoldered on in the jungle villages and helped nurture Congolese
> nationalism.

Coughlan attempted to bolster his argument with citations from Freud's *Totem and Taboo*, the famous anthropologist Sir James Frazer and *The Economist*. Nonetheless his piece claims that "near Patrice Lumumba's home territory," Congolese had recently "killed and partially eaten" 34 people. The reason for such outbreaks was that given for the original imposition of colonialism, except in reverse: "With the end of white colonialism, the laws that hemmed [magic] in are being weakened, either as a matter of policy on the part of the new governments, or by being slackly enforced, or both" (Coughlan, 1961). It is remarkable to see how quickly such sweeping judgments had been formed. Just as the Belgians had justified their colonial policy by their supposed ending of cannibalism and the spread of Christianity, now American intervention in the Congo was being justified on the same grounds. It was only evoked by implication: "A traditional method of exorcising the spirits has been to kill white hens; a more direct method can be left to the imagination." Such fears of African "magic" leading to attacks on whites, transposed onto the global scale of the Cold War, underpinned Western support for the long dictatorship of Joseph Mobutu, later known as Mobutu Sese Seko, in Congo. Ironically, Mobutu enacted an Africanizing policy, renaming the country Zaire and claiming to adopt a wide range of indigenous practices, while maintaining power principally because of his solid anti-Communism.

Reimagining Congo

In postcolonial visual culture, Congolese and African diaspora artists have sought to reclaim the Kongo visual tradition and use it to directly criticize Western culture. It is now the "Western tradition" that is finding itself subject to the disruptive and unpredictable forces of transculture. In a remarkable series of work, the African-American artist Renée Stout explored the *nkisi* figure as a resource for her own experience. She recalls seeing an *nkisi nkondi* figure in the Carnegie Museum in Pittsburgh at the age of ten:

> I saw a piece there that had all these nails in it. And when I first saw that
> one it was like I was drawn to it. I didn't really know why. . . . Even
> when I go home, I still go back to that piece and look at it each time,
> because I feel like I'm coming back with a little more knowledge each
> time.

> (Harris, 1993: 111)

Perhaps the most striking result of this fascination with the *nkisi* figure has been Stout's transformation of her own body into an *nkisi* in her sculpture *Fetish No. 2* (1988). Stout modeled the figure on her own body but gave it the attributes of an *nkisi* figure and a title that a Western ethnographic museum might bestow on such an object. By making the female body the source of power, Stout created a resonant image suggestive both of African-American feminism and the difficult lives of Kongo women under colonial rule and perhaps thereafter. This echo is given further force by the contents of the medicine compartment placed in the figure's stomach. Like some Kongo *minkisi*, the compartment is a box under glass containing an old photograph of a baby, an old stamp from Niger and some dried flowers. The baby's photograph recalls the hybrid children born in Kongo during the colonial period and their uncertain fate. The stamp evokes the African diaspora but also the European practice of sending postcards home depicting "native" life. The flowers and the medicine-filled bundles (*bilongo*) around her neck recall the practice of activating the power figure as a resistance to colonialism. For much of Western history, the black woman's body has evoked only the fears and desires of sexuality. Stout does not repress the sexuality of her figure but does not accent it. She concentrates instead on reclaiming her body as a source of power, using a Kongo practice that is well-suited to such resistance.

Similarly, the Congolese artist Trigo Piula used the *nkisi* figure to reverse the terms of the discussion on fetishism. In his 1988 painting *Ta Tele*, Piula visualized this strategy by depicting an African audience staring at an *nkisi* figure. Where the

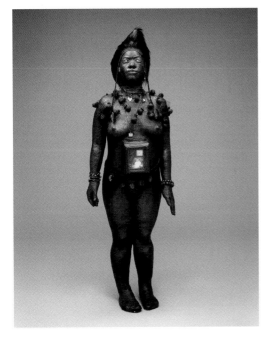

Figure 8.1 Renée Stout, *Fetish No. 2* (1988). Image courtesy of the artist and the Dallas Museum of Art. Collection of the Dallas Museum of Art

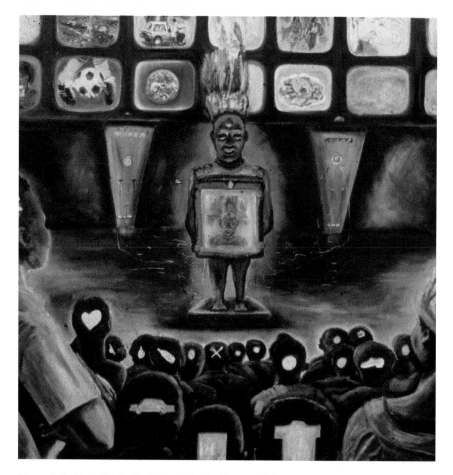

Figure 8.2 Trigo Piula, *Ta Tele* (1988). Collection of the artist

medicine compartment would ordinarily be, he placed a television screen, showing a duplicate image of the figure's head. Behind the power figure, a range of screens depict a chat show, a soccer match, a view of Paris featuring the Eiffel Tower, a beer commercial, a white couple kissing, a table laden with food and a view of the Earth from space. These sights create desires in the audience, visible as outlined objects in their heads, as if we can read their thoughts. Different individuals aspire to cars, a meal, love, clothing, a drink, while others keep the space blank, waiting for desire to arise. Piula's work suggests that the Western obsession with consumer goods is the real fetishism that has affected Africa, not some spurious religion. In the advertising-saturated global culture created by television, commodity fetishism holds a far greater sway than the users of Kongo power figures could ever have imagined.

Cheri Samba, the Congolese painter, made this return of the Western gaze by postcolonial Africans the center of much of his work. Samba began his career as an

urban artist in Kinshasa, painting murals and other forms of public art. His reputation became such that his work became sought after by Western dealers, and *Les Magiciens de la Terre* (The Magicians of the Earth) was featured in the 1989 Paris exhibition (Jewsiewicki, 1991: 130–51). As this title suggests, the curators continued to place African art under the heading of fetishism, or magic, rather than as contemporary art. Samba responded by making criticism of the West, especially Paris, a feature of his art. Many Central African people now live in Paris and it is the global center for recording *soukous* and other forms of popular African music. At the same time, the French government continues to regard sub-Saharan Africa as its sphere of influence and the racist National Front, campaigning on its slogan of "France for the French," made it into the run-off second round of the 2002 Presidential election. Samba replied to such hostility in his painting *Paris Est Propre* (1989). It shows a fantasy view of Paris at night, again centering on the Eiffel Tower, flanked by the Palais de Chaillot (Trocadéro), home of the Musée de l'Homme where Pablo Picasso was inspired to create his *Demoiselles d'Avignon* (1903), the founding

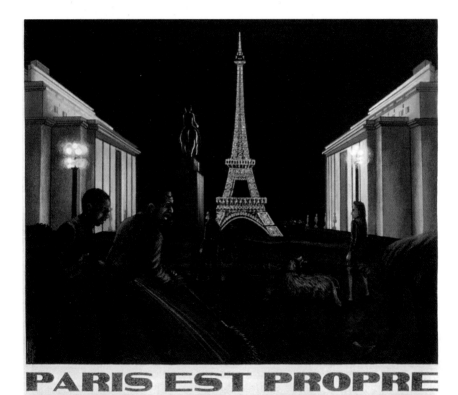

Figure 8.3 Cheri Samba, *Paris Est Propre* (1989). Courtesy Jack Shainman Gallery, New York

painting of Cubism, using African mask motifs. In the foreground of Samba's work, three African men work cleaning up litter and dog excrement. Middle-class Parisians had a craze for large dogs in the 1980s, both for protection from street crime and as a fashion accessory. Samba's text highlights the consequence: "Paris is clean [propre]. Thanks to us, the immigrants who don't like to see dogs' urine and droppings. Without us, this town would probably be a slagheap of droppings." The title has a double meaning as propre can mean clean or honest. The Parisians own dogs to protect them from crime, often allegedly perpetrated by African immigrants, yet it is these same immigrants who keep the city from being deluged by the animals' by-products. There are metaphorical meanings at work here as well. Paris is often referred to as the City of Light, emphasized in its brightly-lit buildings, while the Africans from the Dark Continent seem to be placed in the shadows. Samba's painting directly challenged these Western metaphors of divided space and culture to face the reality of an interconnected and interdependent global culture.

Another of Samba's works asks us to look at Paris as if from Kinshasa, reversing centuries of European inventions of Africa. *Souvenir d'un Africain* (An African's Recollection) shows a scene in a Paris metro station with two Europeans embracing in the foreground. The African of the title stands further down the platform. In contrast to the casual clothes of the Europeans, he is smartly dressed in the fashionable *sapeur* style adopted by many Congolese in Paris. His thoughts appear in the caption:

> Why don't these people in the Occident have any shame? Everywhere I go, it's always the same and it always ends like this. It never amounts to anything. What lousy aphrodisiac do they drink that helps them not to get excited?

African sexuality was of course the subject of intense European curiosity and experimentation throughout the colonial period. Now Samba reverses that gaze with results that may make Westerners feel uncomfortable. The sexual revolution of the 1960s, for all its faults, seems to many people to have made real gains in recognizing different forms of sexual identity, the public expression of affection and in moving towards more casual dress for all. The African in this painting sees all these developments as failures and, in a direct reference to so many travel and anthropological accounts, highlights what he sees as their lack of appropriate morality. Here Paris is far from *propre*. As the example of these artists shows, it is no longer a question of transculture operating only in the "periphery" of the formerly colonized nations but of its triangulating effect throughout the world.

Necropolitics: Rwanda

These effects were far from uniformly benign. The most notorious of these was the Rwandan genocide of 1994, in which some 500,000[1] people are believed to have died and whose consequences entailed the subsequent death of an estimated

3.8 million people in the Congo region. When the postcolonial state lost the ability to support its power economically due to globalization, it turned itself into what Mbembe has called a "war machine" (2003: 32). The Rwandan economy was radically undermined by the collapse in global coffee and tea prices in the late 1980s, generating a powerful sense that treachery must have been involved. In Rwanda, the convenient scapegoat of the Tutsi minority, long castigated as the agents of Belgian colonialism, was to hand. In this sense, without meaning to mitigate the horrendous violence in any way, the genocide was also a form of mediated representation. I do not mean that it was not real but that it was symbolic in form and practice. The genocide enacted the logic of the (post)colonial state as a representation of ethnic superiority. It took the "imagined community" of Rwanda to be synonymous with the image of the "Hutu" and acted upon that idea.

As is now well-known, Western race theory of the colonial period held that Hutu and Tutsi were different peoples by nature, representatives of the larger and equally distinct "Bantu" and "Nilotic" groups (Mamdani, 2001: 76–102). Certainly there was a class distinction between Tutsi and Hutu in pre-colonial Africa, but this distinction was made absolute and biological by the Belgian colonial authorities. When Hutu leaders called the genocide *umuganda*, or "communal work," this was not a cynical euphemism but an expression of the genocide's motivating logic (Mamdani, 2001: 194). On the radio station RTLM, the broadcaster Valerie Bemerki incited the extremist factions of the Hutu to kill their Tutsi neighbors: "Do not kill these *inyenzi* (cockroaches) with a bullet, cut them to pieces with a machete" (Swain, 1999: 14). The manual labor of the genocide was not a sign of Rwanda's primitivism but a symbolic act. The killing was presented throughout as "work" and machetes and firearms were described as "tools." This "work" was organized by state officials whom Rwandans were accustomed to seeing in positions of authority. Orders from the government were handed down the administrative chain to the communes, calling for "self-defense" against "accomplices" of the enemy. Those who carried out the work of killing were paid in cash, kind or in land taken from the victims. Wealthier killers were compensated with computers or televisions.

RTLM constantly exhorted its listeners to complete the "final war" against the Tutsi (Article 19, 1996: 112). The echo of the Holocaust in this remark in fact highlights the vital difference between the two events. The Nazis made every effort to keep their crimes secret and invisible, referring to those killed as *figuren*, puppets or drawings, rather than as people. In choosing this metaphor, Nazi ideology evinced a contempt for visual representation as being a subordinate or inferior form. The *untermensch*, the Jewish/queer/disabled or communist body, was an inferior copy of the perfect Aryan that consequently did not even deserve to exist. During the Shoah, the bodies were turned to ash, which was itself then dispersed. By contrast in Rwanda, events were clearly visible to all and the dead lay where they fell. The physicality of the body as a mediated object was emphasized by the acts of rape, torture and deliberately prolonged execution that characterized the genocide. In neighboring countries, such as the Democratic Republic of Congo, it was even

possible to watch the genocide live on television. Rather than being a secret art in which bodies were rendered into drawings, Rwandan genocide was performed as public work that had to be seen to have its proper effect. In this sense, the genocide was drawing a "world picture," or engaged in "world making," creating a world that was visibly different because it was ethnically the same (Mitchell, 2005: 93).[2] The "language of pure violence" that divided colonizer and colonized (Fanon, 2004: 4) had now been reprised within the boundaries of the postcolonial nation state. In the devastating assessment of Paul Kagame, the post-genocide president of Rwanda, "never again became wherever again." The implication is that the post-World War II settlement predicated on the 1948 Universal Declaration of Human Rights that in effect mandated independence for colonized countries and a global determination never to revisit the genocidal practices of Nazism has been set aside. Consequently, the Rwandan genocide was represented at the time as a natural disaster. For example, the Egyptian Bhoutros Bhoutros-Ghali, then Secretary-General of the United Nations, depicted Rwandans as a people "fallen into calamitous circumstances," as if it were all a terrible accident. For one Belgian history professor quoted in the *New York Times*, there was no moral lesson to be drawn: "This is not a story of good guys and bad guys but a story of bad guys. Period" (Strauss, 1998). Rwanda's own complexities were rendered invisible by unspoken comparison with the Holocaust and became mere misfortune.

It was thus imperative to the Rwandan Popular Front-led government to find a means to call attention to what had happened and to preserve its memory. A series of museums were created in former churches that had been sites of massacres. At these sites, the unburied or exhumed bones of the dead were left visible to make the genocide unavoidable. At Gikongoro, 170 kilometers southwest of Kigali where over 50,000 people were killed, the former Murambi school has been converted into a genocide memorial site. In 72 unadorned concrete rooms, the remains of over 27,000 Tutsi and moderate Hutu victims were on display, having been chemically treated with both traditional and modern preservatives (*Mail and Guardian*, May 1, 2000). The government created such bone memorials in over 50 churches, a serial monument that the Catholic Church – over 65 percent of Rwandans were Catholic in 1994 – has resisted, wanting instead to return the churches to liturgical functions. The Church hierarchy was finally forced to accept the museums in early 2000. In these "cities of the dead," the departed remain in all senses, for they are not segregated from the living, in the manner of the cemetery (Roach, 1996: 47–55), but have taken over key venues of civil society such as churches and schools. They are not gone in order not to be forgotten. The stronger sense is of a healing that will come only if that which has returned in the past no longer returns, namely racialized genocide. While the West stood by as the genocide was carried out, it was quick to rush in counsellors to help with presumed post-traumatic stress disorders in the aftermath of the actual killing. But, as Jody Ranck has pointed out, it makes no sense to refer to Rwanda as being post-traumatic (2000: 200–1). Post-traumatic stress is diagnosed as a normal reaction to abnormal events. The goal of

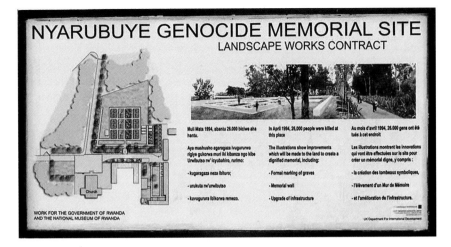

Figure 8.4 Nyarubuye Memorial Plan, National Museum of Rwanda.
www.museum. gov.rw/2_museums/kibungo/nyarubuye/pages/text_nyarubuye2.htm

the therapist is to "reintegrate" the sufferer into normality. In Rwanda, everyday experience constantly offers the possibility of the recurrence of genocide. Philip Gourevitch remarks that he found the memorial site at Nyarubuye "beautiful" (1999: 19). Any good postmodernist would have said "sublime." But perhaps the affect of the "postmodern" is itself no more than a ghost now. When the Ugandan historian and political theorist Mahmood Mamdani saw the memorial at Ntarama, he noted that: "[a] veteran of sites in the Luwero Triangle in Uganda like me felt a sense of déjà vu, even if the numbers of skulls and sacks were greater in quantity than I had ever seen at any one site" (1996: 18) Mamdani's thought amplifies Kagame's rewriting of "never again" into "wherever again" by recalling that genocide in the formerly colonized regions of the world has frequently been ignored since 1945. Rwanda's memorials offered a tremulous beginning to the rewiring of the postcolonial network. Oscillating between visibility and invisibility, the presence of the dead creates a *memento mori* for this era of globalization, recalling Holbein's *The Ambassadors*, where this book began (Chapter 1).

For Rwanda is both liberated and not. It is a carceral society whose prisons overflowed with an estimated 120,000 people awaiting trial on charges of genocide in the 1990s. These jails were an appropriate representation of a country in which the majority are in some sense guilty and yet cannot be held accountable. In early 2000, the Rwandan government decided that a formal Western-style justice system could never cope with the caseload. By way of supporting evidence, the International Criminal Tribunal for Rwanda has spent over $200 million in five years to secure a few convictions – some of them major players – and 38 accused suspects in custody. Rwanda has consequently re-instituted a "traditional dispute resolution mechanism" known as *gacaca* in a law passed in 2001. By allowing communities to resolve the

fate of those accused of lesser offenses – on a scale of relativity otherwise unimaginable – it is hoped that reconciliation will be promoted by involving the mass of the population in the process. At the same time, however, the Catholic Church is seeking to undermine the *gacaca* by creating its own *gacaca Christu* in which the *génocidaires* would confess their crimes in church and be forgiven (Prendergast and Smock, 1999). Despite this dubious diversion, *gacaca* has succeeded in catching the global imagination. In Raoul Peck's 2004 film for HBO depicting the genocide, *Sometimes in April*, the concluding scene shows a woman finding the courage to speak at a *gacaca* proceeding. After a long depiction of violence, this moment is one of hope for the future. It is indeed the case that women have formed one of the most effective post-genocidal organizations, *Mbwira Ndumva* (Speak, I'm Listening). The organization provides "a space where women can tell their stories," helps to provide housing and micro-credit and does so without regard to ethnicity (Ranck, 2000: 209). Yet the actual *gacaca* system has proved less effective in practice, as Alison des Forges of Human Rights Watch commented in April 2004: "it's not working and people are not participating because life is still so miserable. We're talking about a nation where 95 percent of the people are farmers, where it's hard to take a whole week off without pay to participate in the *gacaca*" (Human Rights Watch, 2004). It is still possible that this innovative structure will succeed but the refusals to allow alleged RPF criminal activities be tried by *gacaca* courts does not bode well.

Indeed, by 2004, South Africa's *Mail and Guardian* in effect accused the Rwandan government of playacting in its discussion of the skull memorials: "Keeping the skulls enables Rwanda to deflect criticism of its own failures . . . to ensure that the genocide issue remains a cornerstone of the government policy to hold the world hostage with these images and memory of the mass killings" ("Africa's press reflects on genocide lessons," BBC News, April 18, 2004). Such criticism would have been

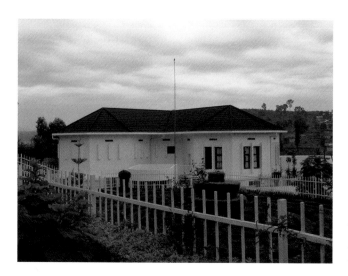

Figure 8.5
Kigali Genocide
Memorial,
Rwanda. Photo
by Khanjan
Mehta. Courtesy
of the artist

unthinkable in the early years of the RPF government, which created a model of Rwandan reconciliation dependent on the nation being a place within which difference can be interred. The question is now whether that policy was well-intentioned or merely a means to sustain another of Africa's one-party states. In contradiction with Kagame's earlier statement, Rwanda's government is now presenting a simplified and moralized view of the genocide as a replay of the Holocaust. At the tenth anniversary commemorations of the genocide in April 2004, a national memorial in Kigali was opened that plans to display photographs of the estimated 300,000 children who were killed in the genocide, while other memorial sites will also make use of photographs. The memorial is architecturally undistinguished, resembling nothing so much as one of the giant new suburban houses common in the United States.

The Aegis Trust decided to tell the story of the genocide in visual form, following the peculiar assertion that most Rwandans are illiterate (Dougherty, 2004), although the United Nations Development Program estimates that 70 percent of Rwandans over 15 are functionally literate. The memorial thus incarnates an assumption of African primitivism that suggests that the intended audience is in fact Western tourists. Its visual narrative is subtle and symbolic, using stained glass windows made by a Holocaust survivor and a single photograph to allude to the Tutsi role under the Belgians. The specificity of the Rwandan events is further displaced by a narrative of global genocides, from Armenia to the Balkans and of course the Holocaust. The physical remains central to the original massacre site memorials are mostly being removed and interred, while those that remain are placed behind dark glass. Here then the bodies are literally made invisible in favor of the presumed clarity of the photographic record, which photographers themselves have acknowledged offers no such thing. A preview of the new photographic memorial was shown, under the banner "Never Again." The Holocaust is now being, as it were, dragged over the Rwandan genocide in order to persuade Western audiences of its importance, even though it is better seen as evidence of the failure of memorialization inspired by the Holocaust. In so doing, the visible engagement with genocide becomes elided into the refusal of representation that surrounds the the Holocaust. The victims cease to be a presence and become *figuren*. Strikingly, the new memorial is funded by the Belgian Government ($1,060,000), the Swedish Government ($400,000) and the Clinton-Wasserman Foundation, USA ($250,000), and is being constructed by a British NGO (www.aegistrust.org). Now that the Rwandan genocide can be understood in terms dictated by the Holocaust, a number of Western films have been made of the events, including *Hotel Rwanda* (2004), starring Don Cheadle, and *Sometimes in April* (2004). While all this activity is taken as evidence that the global powers are now engaged with Rwanda, it might also be seen as a failure of representation that attempts to cover up the wider failure to engage with the questions of colonization, decolonization and globalization that led not only to Rwanda's genocide but to a world newly engaged in old divides but with no new solutions.

Visualizing the postcolonial

The immense challenge for artists, filmmakers, activists and scholars is, then, to resist the homogenizing tendency of the nation-state and its transformation into a war machine, while sustaining the possibility of difference and a different future. As Simon Njami has observed, for African artists, "pan-African theories of nationalism" have had to be replaced by "the fact that in one way or another they will always be foreigners" (Njami, 2005: 54–5). In that sense, an optimistic reading would say that they are simply the first to negotiate the complexities of being a foreigner at "home" that is the condition of globalization. The London-born Nigerian-British artist Yinka Shonibare (b. 1962) has powerfully visualized this "radical uncertainty" of the postcolonial condition, caused by the rise of necropolitics. Shonibare's work mixes photography, fabric design, fashion and sculptural installation (Oguibe, 2004: 32–40). Often he highlights the contradiction that the brightly colored and highly decorated fabrics called *ankara* in Yoruba and known in the West as "African" wax prints are not indigenous in origin but a legacy of colonial trade. The wax print style was originally based on Indonesian designs, printed in Holland and exported to West and Central Africa. The British later took the leading role in the trade. In much of his early work, Shonibare used these fabrics in unexpected circumstances, such as his piece *Cha Cha Cha* (1997), showing a pair of high-heeled women's shoes of a conventional kind, covered in wax print fabric and sealed into a glass showcase, as if always already a museum piece. As Manthia Diawara has commented, when we take Shonibare's work seriously "we're not black or white, Igbo or Nigerian, European or African. We are all of these at the same time and from time to time" (2004: 23).

In his installation *Scramble for Africa* (2003) 13 mannequins dressed in Victorian costume made from wax print fabrics sit round a long negotiating table with a map

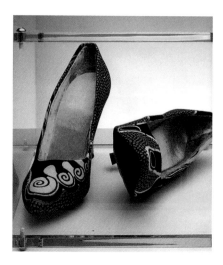

Figure 8.6a Yinka Shonibare, MBE, *Cha Cha Cha* (1997). Wax print cotton textile, velvet, leather, acrylic, metal. Acrylic box: 25.5 × 25.5 × 20cm, (10 × 10 × 8in). Plinth: 44.5 × 44.5 × 111.5cm, (17 ⅓ × 17 ½ × 44in). Courtesy the artist, Stephen Friedman Gallery (London) and James Cohan Gallery (New York) and Poju and Anita Zabludowicz

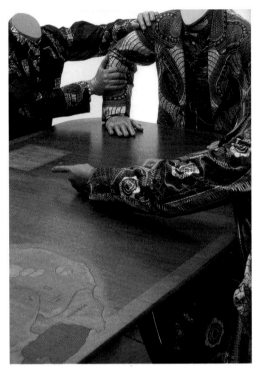

Figure 8.6b Yinka Shonibare, MBE, *Scramble for Africa* (2003). 14 figures, 14 chairs, table. Dutch wax printed cotton textile. Overall: 132 × 488 × 280cm, (52 × 192 × 110in). Commissioned by the Museum of African Art, New York. Courtesy the artist, Stephen Friedman Gallery (London) and James Cohan Gallery (New York)

of Africa inlaid into it. The figures gesture forcefully, perhaps angrily, but their emotional state is in question because they have no heads, satirizing the notion that the politicians at the Berlin conference could be described as "heads of state." By the same token, it prevents the viewer from using their racial identification skills to see if the figures are "really" African or not. In short, Shonibare's piece questions the authority that was claimed to make such decisions by making it seem ludicrous. In 2008, he was able to place this questioning at the heart of the old imperial capital of London, when his project *Nelson's Ship in a Bottle* occupied the fourth plinth in Trafalgar Square. Shonibare made a giant model of Nelson's flagship *HMS Victory* placed in a glass bottle, as hobbyists have done for generations, but with its sails made of his trademark wax prints purchased in Brixton Market, one of the most Afro-Caribbean districts of the city.

One version of the "parallax vision" that brings together race, class and sexuality in order to look towards the future, rather than resuscitate the past can be seen in the photography of Samuel Fosso (b. 1962). Fosso was born in Cameroon but lives and works in Bangui, the capital of the Central African Republic. He began work as a photographer's assistant at the age of 13 and began his remarkable series of self-portraits in 1976, which began to attract international attention from Mali to Paris and New York in the 1990s. He chose the backgrounds, costumes and accessories, sometimes adding captions with Letraset. In one shot he appears in white singlet

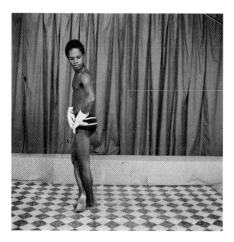

Figure 8.7 Samuel Fosso, *Untitled* (1977). Courtesy of JM Patras/Paris

and briefs, standing in front of a fabric curtain with a clothes-line hanging above his head. Around the curtain are festooned numerous examples of standard portrait photography. He looks away to his left, one foot posed on the other, seeming both assured and nervous at once. The photograph as a whole is disquieting. It is as if we see a film still from a movie whose plot we do not know. In other images he seems more assured. He stands in front of what seems to be a theatrical curtain, in a suitably dramatic pose, hands on hips and one foot arched above the other, showing the whiteness of his soles (Figure 8.7). He wears only swimming trunks, striped with white, giving a suggestive air to the image that is disrupted by the fact that he is wearing large gloves, a detail that pushes the photograph from cinematic realism towards the surreal. There is a rhythm between the black and white tiled floor and the alternating white and black skin and clothing. We rarely meet Fosso's gaze. In one shot he faces the camera directly, only for heart-shaped patches on his large sunglasses to obscure his eyes altogether. From reflections in the lenses we can deduce that he seems to be looking at an array of newspapers, magazines or photographs. Again, he wears a bright white shirt, open at the neck. These photographs place the (black and white) photographic print in tension with the sexualized European/African divide quite literally across the body of a young African man exploring his identity. As a citizen of postcolonial Africa, he refuses to appear in the guise of the "native" or any of the other received photographic clichés of Africans. His work was amongst the first to use photography to challenge received notions of identity that has since become famous as the postmodern photographic style associated with Cindy Sherman and other American artists.

An interesting complement to Fosso's work can be found in the powerful photographs of Rotimi Fani-Kayode (1955–89), born in Lagos, Nigeria but resident in England from 1966 after his family fled a military coup. He described how his sense of being an outsider stemmed from issues of race, class and sexuality in diaspora:

On three counts, I am an outsider: in matters of sexuality; in terms of geographical and cultural dislocation; and in the sense of not having become the sort of respectably married professional my parents might have hoped for. . . . [M]y identity has been constructed from my own sense of otherness, whether cultural, racial, or sexual. The three aspects are not separate within me It is photography, therefore – Black, African, homosexual photography – which I must use not just as an instrument, but as a weapon if I am to resist attacks on my integrity and indeed my existence on my own terms.

(Oguibe, 1996: 263)

In his photograph *White Feet* (1989), Fani-Kayode shows that his vision is elegiac and graceful, despite the aggressive tone of his words (see Figure 8.8). A naked black man reclines on a chaise-longue, a "feminine" piece of furniture associated in European art with languorous female nudes. Although we cannot see his face, he turns the soles of his feet toward the camera, in an echo of Fosso's self-portrait. Alex Hirst, Fani-Kayode's co-artist, explains that: "Europe is a chaise-longue on which a naked black male sprawls defiantly, showing off the white loveliness of the soles of his feet" (Fani-Kayode, 1988: 3). The scene was lit so as to accentuate the

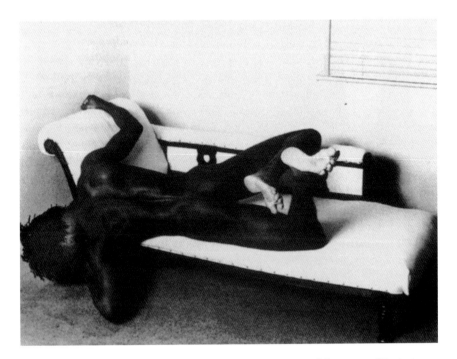

Figure 8.8 Rotimi Fani-Kayode, *White Feet* (1989). Courtesy of the estate of Rotimi Fani-Kayode and Autography, London

contrasts between the white and black skin and between the dark mass of the body and the white recliner. There are both similarities and differences with the work of Robert Mapplethorpe. Mapplethorpe similarly aestheticized and eroticized the black male body but claimed only to be a witness of the gay subculture. Fani-Kayode seeks to bring out the political dimension to the representation of "Black, African homosexual photography," taking his testimony to another level in which it becomes an intervention. In his photograph *Union Jack*, Fani-Kayode depicted a nude black figure carrying the Union Jack, the British flag. The picture serves as a retort to the old racist cry "Ain't no black in the Union Jack," while also imagining the black Briton, a category for which there is no image in official British culture.

Samuel Fosso used this form of visual identity pun to target the invented traditions of the first-generation postcolonial state in his 1997 series of self-portrait photographs. In a visually dazzling composition entitled *The Chief: he who sold Africa*

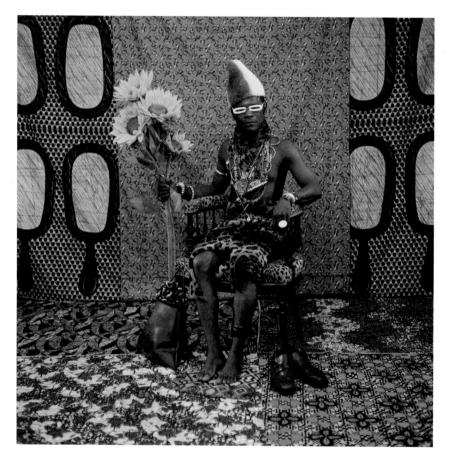

Figure 8.9 Samuel Fosso, *The Chief: he who sold Africa to the colonists* (1997). Courtesy of JM Patras/Paris

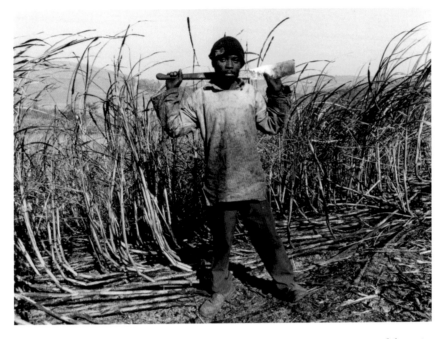

Figure 8.10 Zwelethu Mthethwa, *Sugar Cane Cutters* (2003). Image courtesy of the artist and Jack Shainman Gallery

to the colonists, Fosso poses in the style of Mobutu as a parodically "African Chief." Leopard prints (the mark of a chief in some societies and much used by Mobutu) mingle with a seat covered in wax print fabrics of the kind used by Shonibare. Many elaborate necklaces festoon his upper body, while his gaze is obscured by white frame but lens-less glasses. The Chief's pretensions to power are undercut by the fact that his sceptre or rod of office has been replaced by a bunch of sunflowers. The pastiche character of the "tribal" identity the Chief has created is indicated by his red patent-leather shoes and designer leather bag. By contrast, the large-scale color photographs of Zwelethu Mthethwa usually depict the black South African working class. His well-known photographs of people's homes in Soweto called attention to the design and decoration employed in creating the shanty-town residences. By using color, Mthethwa showed the brightness and patterns such design created in contrast to the standard black-and-white photographs of miserable poverty. His 2003 series of sugar cane cutters created another visual surprise in returning to the primal cash crop of slavery and the labor required to produce it. The cutters stand in poses that show their dignity of labor without concealing their exhaustion. Today as in the seventeenth century, cutting cane is backbreaking work. To Western imaginations, the African sugar worker is a figure from centuries past, evoked now only in cinematic recreations. Mthethwa's photographs show the commodity markets at work, creating and destabilizing the nation-state in the era of global trading.

Notes

1 The figure of 800,000 commonly cited has been revised by Human Rights Watch to 500,000 direct victims of genocide and 300,000 other deaths during the same period that were indirect results of the genocide. See the detailed report of Human Rights Watch, *Leave None to Tell the Story: Genocide in Rwanda* (March 1999), at http://www.hrw.org/reports/1999/rwanda/genocide. All facts relating to the events in Rwanda are taken from this definitive report unless otherwise referenced.
2 The terms are those of Heidegger and Nelson Goodman respectively.

References

Article 19 (1996), *Broadcasting Genocide: Censorship, Propaganda and State-Sponsored Violence in Rwanda 1990–1994*, London: Article 19.

Coughlan, Robert (1961), "Black Magic: Vital Force in Africa's New Nations," *Life*, vol. 50 no. 16 (April 21).

Diawara, Manthia (2004), "Independence Cha Cha Cha: The Art of Yinka Shonibare," in Guidemond (2004).

Dougherty, Carter (2004), "Rwanda Marks Genocide," *Boston Globe*, April 8, p. A12.

Fani-Kayode, Rotimi (1988), *Male Black/White Male*, London: Gay Men's Press.

Fanon, Frantz (2004), *The Wretched of the Earth*, trans. Richard Philcox, New York: Grove Press.

Gourevitch, Philip (1999), *We Wish to Inform You That Tomorrow We Will Be Killed With Our Families: Stories from Rwanda*, London: Picador.

Guidemond, Jaap (2004), *Yinka Shonibare: Double Dutch*, Rotterdam: NAi Publishers.

Harris, Michael D. (1993), "Resonance, Transformation and Rhyme: The Art of Renée Stout," in MacGaffey (1993).

Human Rights Watch (2004), "Rwanda: Reflecting on the Genocide Ten Years Later," interview with Alison des Forges, http://www.hrw.org/update/2004/03/#4, accessed May 20, 2005.

Jewsiewicki, Bogomil (1991), "Painting in Zaire," in *Africa Explores: 20th Century African Art*, ed. Susan Vogel, New York: Center for African Art.

MacGaffey, Wyatt (1993), *Astonishment and Power*, Washington, DC: National Museum of African Art.

Mamdani, Mahmood (1996), "From Conquest to Consent as the Basic of State Formation: Reflections on Rwanda," *New Left Review*, vol. I/216, pp. 3–36.

—— (2001), *When Victims Become Killers: Colonialism, Nativism and the Genocide in Rwanda*, Princeton, NJ: Princeton University Press.

Mbembe, Achille (2003), "Necropolitics," *Public Culture*, vol. 15 no. 1, pp. 11–40.

Mitchell, W.J.T. (2005), *What Do Pictures Want?: The Lives and Loves of Images*, Chicago, IL: University of Chicago Press.

Njami, Simon (2005), *Africa Remix: Contemporary Art of a Continent*, London: Hayward Gallery Publishing.

Oguibe, Olu (1996), *In/sight: African Photographers, 1940 to the Present*, New York: Guggenheim Museum.

—— (2004), *The Culture Game*, Minneapolis: University of Minnesota Press.

Prendergast, John and David Smock (1999), "Postgenocidal Reconstruction: Building Peace

in Rwanda and Burundi," US Institute of Peace, September 15, http://www.
reliefweb.int/, accessed December 9, 2008.

Ranck, Jody (2000), "Beyond Reconciliation: Memory and Alterity in Post-genocide
Rwanda," in *Between Hope and Despair: Pedagogy and the Remembrance of Trauma*, ed.
Roger Simon, Sharon Rosenberg and Claudia Eppert, Oxford: Rowman and
Littlefield.

Roach, Joseph (1996), *Cities of the Dead: Circum-Atlantic Performance*, New York: Columbia
University Press.

Strauss, David Levi (1998), "A Sea of Griefs Is Not a Proscenium," in Alfredo Jaar, *Let There
Be Light: The Rwanda Project 1994–1998*, Barcelona: Astar.

Swain, Jon (1999), "Time is Up for Rwanda's Mistress of Malice," *The Sunday Independent*,
September 12.

NETWORKS

A network is a material means by which ideas, people and goods can be distributed. The network is thereby both a vital support for any society and a means by which that society develops, expands and encounters other cultures. The network is more than a material entity, whether composed of trading posts and roads or routers and fiber-optic cables. The network brings together the dissimilar and creates new hybrids. As Bruno Latour, the philosopher of science, has defined them, "networks are *simultaneously real, like nature, narrated, like discourse and collective like society* " (Latour, 1993: 6, his emphasis). That is to say, network connections are real and make a difference. At the same time, they enable and create certain stories to be told such as our present obsession with "globalization." By their nature, such narratives cannot be told by one person alone but involve the collective social body. If the networked trade routes were once highly specialized means of communication, offering both risk and reward, it has now come to seem that we live in what Manuel Castells has called the "network society."

Networks develop and expand cultures. It might even be said that they are culture. For example, the peoples who have come to be known as the Aboriginals of Australia have described their landscapes as networks, connected by what have been called the "songlines," for thousands of years. The songlines were so called because the Aboriginals believe that the land must be named through the performance of song or else it does not exist. One early material form of the network was the Silk Road linking China to Europe for the supply of that desirable fabric, and other precious goods and plants. Beginning at the Han dynasty capital Changan, the route to Europe was not a single road but a series of options linking oases across the desert region. Held to begin with the explorations of Zhang Qian (138–125 BCE), the road was well-known to the Romans and was

Troy Bennell, *Noongar Song Lines, Part I* (39 × 96, acrylic and sand on canvas). Courtesy of The Brigham Galleries, Nantucket, MA

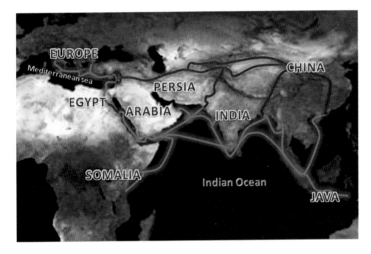

Silk Road Map

used by the Venetian Marco Polo for his journey to China in 1271. Like all such networks, the Silk Road disseminated ideas, such as the spread of Buddhism and the reverse introduction of Christianity into China, as well as goods. Physical networks of this kind had limited options. When the Dutch writer Willem Bosman sent letters back to Holland describing colonial slavery in West Africa in 1700, they went first to the Americas before returning to Europe because that was how the "Atlantic triangle" of slavery functioned. No alternative was available.

Beginning in the eighteenth century, the British government expanded its traditional system of post-roads to allow for multiple places to send and receive mail. Soon letters could be sent to any destination in London, reaching a peak of eight deliveries and collections a day in the late nineteenth century, meaning that it was possible to invite someone for tea in the morning and have their response by lunch. Electronic messaging systems such as the telegraph, telephone and most obviously email have accelerated the delivery of messages and expanded the dispersed distribution but have retained the goal of point-to-point communication. Edward Davy first designed a telegraph in 1838, followed by Frederick Bakewell's design for a facsimile machine in 1848. Paris was connected to a similar system, allowing for the transmission of drawings as well as text in 1865. As early as 1881 it became possible to send photographs by

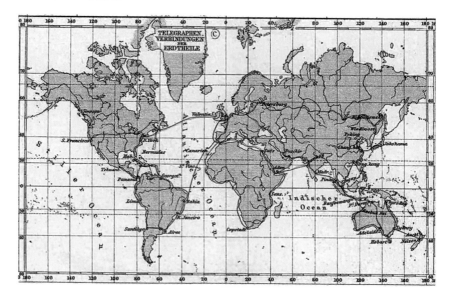

Telegraph Connections (*Telegraphen Verbindungen*) (1891). Stielers Hand-Atlas, Plate No. 5, Weltkarte in Mercator Projection

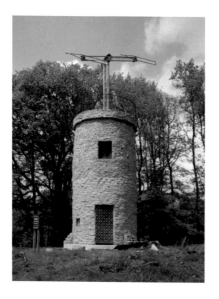

Claude Chappe's Optical Telegraph on the Litermont near Nalbach, Germany (in use 1792–1846)

telegraph. Electronic networks still rely on physical supports, such as the first transatlantic cables laid in the mid-nineteenth century, leading to Guglielmo Marconi's first wireless transmission in 1901. The 1906 San Francisco earthquake was illustrated in New York newspapers by a photograph transmitted wirelessly. It was not until 1969 that four nodes in a decentralized computer

communications system were established by the Pentagon's Advanced Research Projects Agency. Known therefore as the ARPAnet, it was the beginning of the Internet. The network came to connect universities and other government institutions before the development of the World Wide Web protocols led to the dramatic acceleration of the Internet after 1992.

The Internet had to be built, just as the telegraph and postal networks before it. Cables were laid across oceans, often at considerable risk and expense. In 1998, the telecommunications company FLAG Telecom celebrated the creation of what it called the "fiberoptic link around the globe," a cable that extended at that time from Europe to East Asia. The cable was mostly laid underwater but it also crossed the Malay peninsula by land. When completed, it was the longest human structure ever made, surpassing the Great Wall of China by many miles. Whereas the Great Wall is reputedly the only human building visible from space, the FLAG cable is invisible at all points as it is buried undersea, surfacing only at one point in each country it "links." This physical creation of a linked networked world seemed to herald a transition to a new social order in which the cable replaced the wall as the decisive social form. In fact, it was only its carefully bordered approach that allowed FLAG Telecom to survive while other more expansionist global cable companies went spectacularly bankrupt. In July 2001, the fiber-optic communications company JDS Uniphase posted a staggering loss of $50.6 billion. In the aftermath of all this network creation, it has been estimated that only 5 percent of the fiber-optic cable in the United States is "lit," that is to say actively carrying information. The Internet has in many ways replicated the "real" world rather than creating a new "virtual reality," as many had hoped. It is still the case that there is relatively little Internet infrastructure in sub-Saharan Africa with the exception of South Africa, just as there are fewer airline and telephone connections. Repressive regimes have been able to limit Internet access, so that in China, for example, Google does not display information about sites on the Tiananmen Square massacre of 1989. On the other hand, although distance does still impact delivery of electronic information, it is now perfectly possible to have real-time exchanges by text, voice and video across the globe in ways that dramatically change the experience of space and time.

What, then, does it mean to say that the present moment has seen the rise of a network society? At one level, it indicates that goods and services are made available in a way that has fundamentally changed from the era of the Industrial Revolution, described by Marx. Goods are produced in direct response to orders, with parts being supplied when needed, rather than being stockpiled. This "just-in-time" system relies on cheap transportation, reliable communications and the effective absence of labor disputes. For the network allows employers to redistribute employment to cheaper locations, reducing or removing any leverage that workers might once have had by withdrawing their labor. The network has now become the dominant metaphor for social life, just as the factory system was

before it. When industrial production was in its apparent heyday, the majority of people still worked in agriculture, just as today most people do not work directly in digital media or on the Internet. In the nineteenth century, the emergent rail network gave Marx his metaphor for the relationship of the economy to culture and society: the economy was the "base," the tracks, and culture was the "superstructure," or rolling stock. Without the "base," no superstructure was possible or necessary. It is equally the case that no information can be exchanged without the physical structure of the network being in place but there is often more than one way to make the connection. Information travels along fiber-optic cable as light but it is illegible to human eyes until decoded by machines. People engaged in a network society can thus feel at once more decentered and dispersed and, at the same time, permanently connected.

John Tomlinson has usefully described these developments as "complex connectivity" (1999). The regular moments of Blackberry service failure produce something akin to panic among users of the hand-held messaging device, while hard-drive crashes are treated as traumatic events. The new "friendships" of social networking sites like MySpace and Facebook make it possible to claim and experience social networks of great size. Facebook alone had 4 billion photographs and other images posted to its various pages in 2008. Netlife allows people to make connections that might otherwise be difficult as evidenced by such dramatically different experiences as the networking of queer young people on-line and that of jihadists connecting via bulletin boards. The two forms of social identity have absolutely nothing in common but both have been facilitated in new ways by the emergence of real-time social networks. Perhaps the most striking instance of networked culture is the emergence of Wikipedia, the on-line collectively authored encyclopedia. With 6.8 million registered users and 1.8 million articles in 2007, it has become one of the most widely used reference sources, accounting for one in every two hundred visits to the Internet. The first print Encyclopedia was a classic production of the eighteenth-century Enlightenment, with articles being written by luminaries such as Diderot. By

Visual culture

Your continued donations keep Wikipedia running

From Wikipedia, the free encyclopedia

Visual culture is a field of study that generally includes some combination of cultural studies, art history, and anthropology, by focusing on aspects of culture that rely on visual images. Among cultural studies theorists working with contemporary culture, this often overlaps with film studies and the study of television, although it can also include video game studies, comics, traditional artistic media, advertising, the Internet, and any other medium that has a crucial visual component.

Early work on visual culture has been done by John Berger (*Ways of Seeing*, 1972) and Laura Mulvey (*Visual Pleasure and Narrative Cinema*, 1975).

Major work on visual culture has been done by W. J. T. Mitchell, particularly in his books *Iconology* and *Picture Theory*. Other writers important to visual culture include Stuart Hall and Slavoj Zizek. Continuing work has been done by Lisa Cartwright, Margarita Dikovitskaya, Chris Jencks, Nicholas Mirzoeff and Gail Finney. Visual Culture studies have been increasingly important in religious studies through the work of David Morgan, Sally Promey, Jeffrey Hamburger, and S. Brent Plate.

Several major universities now either house or are developing graduate programs in Visual Studies. They include: Coventry University, Duke University, University of Wisconsin, Madison, University of Rochester, University of California, Irvine, University of California, San Diego, University of Southern California, State University of New York, Buffalo, Goldsmiths College, University of London, University of East London, Kingston University, New York University, Middlesex University, University of Art and Design Helsinki, Pori Department of Art and Media, and the University of Copenhagen. Cornell University has been offering both undergraduate and graduate degrees in Visual Studies for the past 5 years.

Northern Illinois University offers programs in studying visual culture in art education at the undergraduate, graduate, and doctorate levels.

Wikipedia visual culture entry

contrast, Wikipedia's entries are worked on by anyone who might wish to do so, with editing being refereed by senior users known as "administrators" and ultimately by the "board." For the most part, entries are the product of anonymous individuals with an intense commitment to the site. At the same time, there is no guarantee that Wikipedia is accurate as the entry for "visual culture" (accessed in July 2007) amply demonstrated, although it has subsequently changed for the better.

Latour argued that the word "'modern' designates two sets of entirely different practices" (1993: 10). The "work of purification" describes, creates and separates two entirely distinct zones known as the human, or culture; and the non-human, or nature. By contrast, the networked "work of translation" creates new hybrids from the interface of nature and culture. Networkers worry about human-generated climate change, while purifiers insist it is impossible. Yet Latour shows that "the more we forbid ourselves to conceive of hybrids, the more possible their interbreeding becomes" (1993: 12). That separation was the work of modernity, defined as the work of "man" in an era when God was crossed-out, or as deconstructionists would have it, under erasure. Whether we like it or not, God seems to be less crossed-out these days, the distinctiveness of "man" is no more stable, and new forms of networked hybridity emerge at a pace that exceeds our ability to classify and understand them in the frameworks we have inherited. The real urgency at hand is less the reconciliation of religions than it is a new form of interface between that half of politics "constructed in science and technology" and the half of Nature "constructed in societies" (1993: 144). The city of New Orleans was one of the great networking nodes of the planet, interfacing both halves of the American hemisphere with the Caribbean and Europe; bringing peoples together in forced and voluntary encounters that produced the greatest in food, music and dance. Now, as the world watched, it lies in ruins, a testament to the new hybridity of the planetary network, a warning that we ignore at all our perils.

References

Latour, Bruno (1993), *We Have Never Been Modern*, trans. Catherine Porter, Cambridge, MA: Harvard University Press.

Tomlinson, John (1999), *Globalization and Culture*, Chicago, IL: University of Chicago Press.

DISCRETE STATES

Digital Worlds from the Difference Engine to Web 2.0

T HE DIGITAL OFFERS difference and change, seeming to present new worlds for exploration and encounter. The creation of engineered machines designed to perform calculations needed for government, especially war, has engendered new spaces for work, leisure and communication. From its inception, the computer has been understood as opening a new space, famously named "cyberspace" by the science fiction novelist William Gibson in his 1984 classic *Neuromancer*. The prefix "cyber" comes from the Greek for steering and the first generation web browsers were called "Navigator" and "Explorer" to suggest that the Internet was a new frontier. By the same token, the use of Ancient Greek to form this most modern of terms shows that computing and its possibilities are by no means brand new. One way of dealing with the seemingly impossible pace of change in digital culture is to consider this history. In the subsequent chapters of this book, digital media are central to the discussion, whether in the case of photography, celebrity or war. In this chapter, by way of introduction to these thematic studies, I want to consider the digital as such: what kind of space is "cyberspace?" What kind of world-making does it imagine itself to be engaged in? By creating a space that is almost the same as what philosophers call the "life-world" but not quite, digital spaces are now the comparative form that most concerns visual culture. At once new and of some age, constantly changing but never quite delivering whatever it is that we want from them, digital worlds challenge our understanding of ourselves.

Digital spaces are the prime instance of what I call "vernacular watching" (see Chapter 12), a watching that is only part of what you are doing or where you consider yourself to be. Whereas the "classic" Hollywood cinema demanded an immobile spectator seated in the dark, for instance, an iPod movie can be watched in any circumstance but almost by definition will not produce the same immersion. However, the awareness of being in two or more spaces at once (the space in which

we are physically and the imaginative space of the representation would be the first two: another might be a space created by being on the phone) does not detract from visual comprehension. In this regard, as Timothy Leary observed, digital spaces are like television because they create a reality which you are aware of and can engage with, without causing you to lose the sense of your actual surroundings. The "suspension of disbelief" required by theater and other narrative media does not apply in quite the same way with digital spaces. This different level of engagement is one reason that television has been so widely condemned as an inferior format but it is becoming clear that vernacular watching does not involve reduced attention. Rather, so accomplished are today's watchers at decoding visual conventions that they can do other things at the same time as watching and still be perfectly aware of what is happening in the film or other format that they are looking at. Film and television producers are well aware of this acceleration so that whereas a classic detective series like *Dragnet* (1951–2004) carefully showed its detectives traveling from one spot to the next, a modern drama like *Law and Order* moves its characters with a simple chime of its signature chord. In other words, the jump cut, whereby the editing makes visible the unreal dimension of the passing of time in the represented narrative, has moved from radical device designed to remind the spectator of the fact that they were watching a fiction to a simple visual narrative device that has no content in itself.

Spaces of looking

During the excitement of the digital moment of the 1990s, it was sometimes claimed that there had always been virtual reality. While it is true that mimetic representation imitates reality, there have been notably different experiences of that representation. In the seventeenth century, a painter like Nicolas Poussin expected his aristocratic audience to spend a great deal of time carefully deciphering his work, as if it were a form of cultural code. It was a conspicuous demonstration of their status as a leisure class, those who did not work, and of their cultural capital as demonstrated by their ability to decipher the complex meanings in the paintings. A 2008 exhibition of Poussin's work at New York's Metropolitan Museum suggested a return to such careful reading, as if the prerogative of the aristocracy of the absolute monarchies could now inspire a new leisure class as to how to while away their time. In contrast to this self-conscious distance, in the revolutionary period of the late eighteenth century, art caused a dramatic loss of self-consciousness. When the poet Goethe visited Rome in 1786, he went to see the famous antique sculpture. In his journal he noted that he had been "transported out of reality" (Massa, 1985: 69). By the same token, when the future American President Thomas Jefferson encountered a Neo-Classical painting entitled *Marius and the Gaul* by the young French painter Jean-Germain Drouais, he was at once in virtual antiquity: "It fixed me like a statue for a quarter of an hour, or half an hour. I do not know which, for I lost all ideas of time, even the consciousness of my existence" (Crow, 1995: 68). Neither Goethe nor

Jefferson (no fools) were able to imagine remaining where they were as they looked at the artwork, being moved into some alternative space that they could not describe or name. Such immersion makes the cinematic suspension of disbelief seem like a relatively minor level of engagement. It does of course depend on knowing that your personal safety was ensured as an elite figure.

A whole medium was created to allow a wider range of people to experience such travel, namely the stereoscope. Invented in the 1830s by David Brewster, the stereoscope was a device held up to the eyes like a mask, containing a holder for the stereoscopic card that consisted of two photographs mounted side by side of the same view, often taken with a special camera designed to produce such negatives. Viewed at the correct distance and with the necessary relaxation of the eyes, the stereoscope produced a startling effect of three-dimensionality. When looking at some stereoscope slides, the American critic Oliver Wendell Holmes found himself in

> a dream-like exaltation in which we seem to leave the body behind us and sail away into one scene after another, like disembodied spirits. . . . I leave my outward frame in the arm-chair at my table, while in spirit I am looking down upon Jerusalem from the Mount of Olives.
>
> (Batchen, 1996: 26)

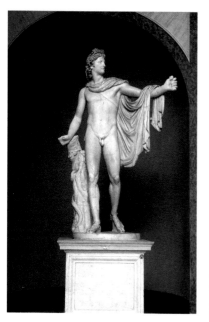

Figure 9.1 (above) *Apollo Belvedere*. Roman copy of a Greek 4th century BC original (marble). Courtesy of Vatican Museums and Galleries/The Bridgeman Art Library

Figure 9.2 (below) An example of a stereoscope and stereoscope slide. Slide: Underwood and Underwood, *View of London*, c. 1860 © Victoria and Albert Museum, London. Stereoscope: Science & Society Picture Library/Science Museum

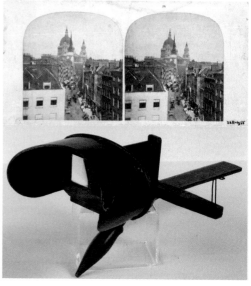

Holmes found himself in a similar virtual space to that experienced by Goethe and Jefferson, except that he now knew exactly where he really was. His description of being on an imaginary journey, while remaining aware that he was in fact seated in his chair, also seems to anticipate the invention of cinema and later television. This condition is virtual in that the viewer is aware of a differential between material reality and the location that seems to be real but is known not to be.

However, these spectatorial analogies do not fully account for the difference of the digital. The digital can be considered as a series of what the computer pioneer Alan Turing termed "discrete states," whereas the analog contains all variations between those states. That is to say, in binary computer code a bit registers either as zero or one and there are no alternatives or in-between states. The analog version would include all the in-betweens. As Brian Massumi has defined it, the analog is "a continuously variable impulse or momentum that can cross from one qualitatively different medium into another. Like electricity into sound waves" (2002: 135). As a numerically based system, the digital on the other hand is a codification. Massumi therefore emphasizes: "the medium of the digital is possibility not virtuality," at least in the present state of affairs (2002: 137). The user converts the digital back into analog for active purposes. Thus a digital recording samples the analog source over and again, creating a digital code. The music player nonetheless produces an analog output that creates the illusion of continuous sound. The digital and the analog are thus differentially related, rather than being opposites. While many listeners of a certain age continue to insist on the superior "warmth" of analog recording, digital sound has triumphed, especially with the rise of the iPod, even though the formats used by portable music players are, from an audiophile point of view, still further degraded from the sound source. On the other hand, digital hearing aids are notably more effective for users because they use an algorithm to compress background noise and other sounds allowing the sound of speech to come through more clearly. In Massumi's terms, the device offers the possibility of a certain "hearing" that changes our understanding of the real. The device-user interacts with others through the medium of language in a more effective and less stressful way even though my actual hearing is poor and the real range of sounds is not fully represented. Which form of reality would the 20 percent of US citizens with hearing loss prefer to inhabit, one might ask? In the same way, Powerpoint and other visual display software has so completely defeated the visually superior color slide that Kodak have ceased to manufacture slide projectors. While slides produce far higher image quality, in my experience any digital display generates a far higher level of student attention.

Engine spaces

It was precisely the question of attention and its automation that motivated the first modern computing device constructed by the British mathematician Charles Babbage (1791–1871). The idea was sparked by his reading of new French mathe-matical texts, hard to get during the then current Napoleonic Wars (1799–1815),

that revealed the ignorance of his instructors at Cambridge University. He wanted to create a calculating machine that would allow people to do arithmetic "without any mental attention once the given numbers have been put into the machine" ([1864] 1969: 40). The calculating machine saved attention and produced accuracy in the logarithmic tables that had yet to be standardized. The advantage of such a machine was that it would not make mistakes and could be operated by someone with no skill in mathematics. Babbage belonged to a group of "moderate radicals" affiliated with the ideas of Jeremy Bentham of Panopticon fame. His biographer notes "the close association between the scientific movement and the liberal revolutionary movement" (Hyman, 1982: 74), meaning the extension of the franchise without challenging property relations. To his credit, Babbage was opposed to slavery and ran unsuccessfully for Parliament in the Reform interest in the great election of 1832. He railed against what he saw as the failures of science in England as compared to Europe and attributed this to the political corruption of the aristocracy, writing: "Amongst all the educated classes of the community, the aristocracy, as a body, are the least enlightened in point of knowledge and the most separated from the mass of the people" (Hyman, 1982: 86). Whereas the aristocratic space of looking was once required by advanced visual technology, Babbage saw his work as part of the formation of a new aristocracy of knowledge.

In 1823, he devised what became known as the Difference Engine Number 1 to calculate tables such as latitude and longitude or actuarial tables by using antinomials. In all these calculations, it was of vital significance that they be absolutely correct but they were long and complicated, often copied and subject to disastrous variation as a result. Consequently, the British government sponsored his work, seeing the potential military and bureaucratic advantages to be gained, a development that has

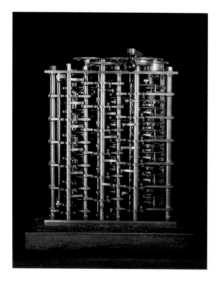

Figure 9.3 A reconstruction of Babbage's Difference Engine No. 1 (1824–32). Science & Society Picture Library/Science Museum

only fully matured in our own time. Working with the engineer Joseph Clement, Babbage constructed the Difference Engine using a highly complex system of toothed wheels that required a new mechanical notation language even to devise the plans. By 1833 the incomplete machine had already run up costs of £17,000, equivalent in the period to two battleships, leading the government to cancel the project. However, a modern reconstruction of the second-generation Difference Engine at the Science Museum, London, has shown that it could have worked as planned. Although some significant details had to be corrected, Babbage had also anticipated certain problems that the twentieth-century scientists did not foresee (Swade, 2000).

Even as he was working on the Difference Engine, Babbage had his sights set on a still more elusive prize that he called the Analytical Engine, designed to be able to perform any calculation, rather than the set parameters used by the Difference Engine. It was to have 50,000 geared wheels, calculating 50 digit numbers in base 10. It was never even begun because Babbage lamented that the device was too complicated to be drawn with the existing skills of mechanical drawing. That is to say, it was not possible to visualize the design and therefore it was not possible to build the machine. The Analytical Engine was conceptually possible thanks to a convergence of the French Revolution, weaving and mathematics. Joseph Marie Jacquard (1752–1834) devised the new form of loom that bears his name in 1801. The Jacquard Loom automated the selection of threads to be woven by the use of punch cards, allowing for more intricate patterns to be created at higher speeds. It is said that he developed his punch cards using hairdressers to cut them, who were out of work following the French Revolution, much as the modern French restaurant was developed by the unemployed chefs of the aristocracy. Jacquard recognized that

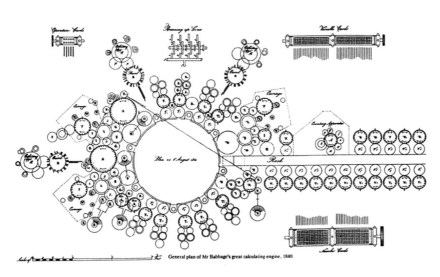

General plan of Mr Babbage's great calculating engine, 1840.

Figure 9.4 Plan for Babbage's Analytical Engine (c. 1837)

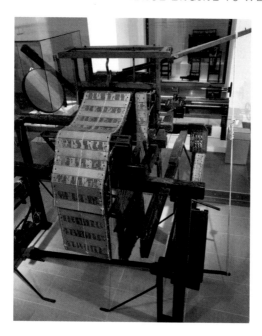

Figure 9.5 A Jacquard Loom
(c. 1825). Science & Society
Picture Library/Science Museum

weaving, although an intricate and delicate task, was highly repetitive. He conceived a system that relied on stiff, pasteboard cards with various patterns of punched holes. At each throw of the shuttle a card was placed in the path of the rods. The pattern of holes in the card determined which rods could pass through and thus acted as a program for the loom.

Babbage in turn saw that such cards could be used to automate calculating devices, later put into practice in 1890 by Herman Holerith for a company that became International Business Machines, or IBM, the first to produce personal computers. Babbage claimed: "the analogy of the Analytical Engine with this well-known process is nearly perfect" (Babbage, [1864] 1969: 117) because the same system allowed for a wide variety of operations to be performed on a given set of variables. The comparison worked because both systems were discrete states: this wool, not that one; this number, not the other. Thus the Analytical Engine was imagined in two parts, as if it were an automated mill: a store, where the variables were kept, and a mill, where the required operations could be performed. The mill was the precursor of the Central Processing Unit (CPU) in a modern computer and it was the place: "*into which the quantities about to be operated upon are always brought*" ([1864] 1969: 117). In Jeremy Bentham's contemporary Panopticon scheme, as we have seen, the individual cells were the location where deviance was "stored" and the visual exchange of information within the mill that was the Panopticon was the processing of that deviance into discipline. In short, the practice of modern, automated weaving made the idea of computer programming possible. One might then see the famous saboteurs, who threw their shoes (*sabots*) into the mechanized looms as the creators

of the first computer viruses. That is to say, even if electronic calculating machines are relatively recent technology, the conceptual metaphor on which they are based is as ancient as weaving and was enacted in other forms of modern social organization. One of the most striking of such consequences was the career of Ada, Lady Lovelace (1815–52). Daughter of the Romantic poet Lord Byron, Ada Lovelace is now celebrated as the first computer programmer, as a result of her *Notes* on Luigi Menabrea's Memoir on the Analytical Engine. Lovelace proposed a method to calculate Bernoulli numbers (don't ask!) and later imagined that such a machine might be used to compose complex music, to produce graphics, and would be used for both practical and scientific use. The US Department of Defense, of all people, named some software they had produced "Ada" in her honor in 1979. Her imaginative leap was to see that the rendition of machine-based discrete state calculation could be used to create a convergence of hitherto separate forms of creation. No previous mechanical device was considered useful for writing music or drawing – again it was not until the Apple computer that such activities became practical possibilities.

Turing machines

It is both a coincidence and not that Alan Turing (1912–54), considered the progenitor of modern computing, was also a Cambridge mathematician like Babbage. His 1936 paper "On Computable Numbers" marked the transition from a human computer (the term originally meant a person who does mathematical computations) to a machine designed for that purpose. Turing highlighted the difficulty that a human computer would have in making the difference between similar very large numbers "instantly recognizable," something a machine could do at once. The problem was a theoretical version of Babbage's practical difficulties in calculating tables. Turing devised the concept of a machine that would be able to perform such operations but at a level of generality conceptually similar to that of the Analytical Engine. Such a computer must be able to perform the table of behavior of any other machine. Whereas Babbage was ultimately stymied by his working in an era prior to the standardization of mechanical parts, requiring him to design every component of his proposed Engines, Turing was completely at home in the era of mass standardized production. Thus he began to devise "the most general kind of code or cipher possible" to enable his machine, a project that he hoped, like Babbage, to sell to the government.

In the event, the government came to him with the outbreak of World War II. The Nazi military were using a complex encoding device called Enigma for their transmissions that transposed the characters of the message multiple times according to the placement of a series of rings within the machine. It was believed that this code was unbreakable and so it was used with confidence. However, the British government assembled a team of experts at Bletchley Park, including Turing, who designed a machine known as the "Bombe" to break the code by testing a series of

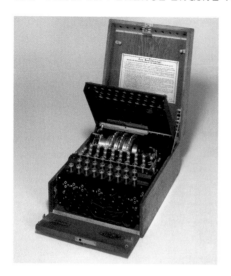

Figure 9.6 The Enigma machine (c. 1930s). Science & Society Picture Library/Science Museum

predictions. Given that the encoded text was originally a written language, this predictability was inherent. (For a simulator of the Enigma machine see http://users.telenet.be/d.rijmenants/en/enigmasim.htm and for a full historical account of the code-breaking see the extensive site constructed by Tony Sale at http://www.codesandciphers.org.uk/enigma/index.htm.) Turing helped solve the naval version of Enigma and was able to theorize information in general, making cryptanalysis into a real subject. Bletchley was also the site of the creation of Colossus, the first electronic programmable computer that was used to decipher a German code known as Lorenz. Because this code was massively complex, Colossus was designed to read 5,000 characters per second, a speed that matched a mid-1990s PC. However, each machine took up an entire room and was composed of thousands of glass electronic valves. All the Colossi were destroyed after the war as military secrets and so it was long thought that the American ENIAC (electronic numerical integrator and computer), designed to calculate ballistic firing tables, was the first electronic computer. In each case, however, it was the necessities of war that had enabled the vast expense required to make the technological breakthroughs that facilitated modern computing.

Turing did not work on Colossus but by 1945 he was considering "building a brain." It was this project that led to perhaps his most influential work, a short essay called "Computing Machines and Intelligence." Like the New Criticism then fashionable in universities, it had no footnotes and was written in plain English that has nonetheless proved curiously ambiguous on its key point. Turing began by describing how the computer is a discrete state machine that can therefore imitate any other discrete state machine. He then proposed the famous Turing test that could be used to see if a machine had attained the level of imitating human intelligence such that another human could not detect which of two respondents was human and which the machine. To be exact, the point of the game was to

determine which respondent was a man and which a woman. It was complicated by the twist that the man was to deceive the interrogator and the woman to convince the interrogator, so that they would both be claiming to be a woman. Turing argued that if the "machine cannot be distinguished from a human being under these conditions then we must credit it with human intelligence" (Hodges, 1999: 38; 2000: 415). His biographer Andrew Hodges insists that, all appearances to the contrary, only intelligence is at stake here whereas "gender depended on facts which were not reducible to sequences of symbols." In her reading of this interpretation, N. Katherine Hayles has argued that

> What the Turing test "proves" is that the overlay between the enacted and represented bodies is no longer a natural inevitability but a contingent production, mediated by a technology that has become so entwined with the production of identity that it can no longer be meaningfully separated from the human subject. To pose the question of "what can think" inevitably also changes, in a reverse feedback loop, the terms of "who can think."
>
> (Hayles, 1999: xiv)

That is to say, the machine that thinks transforms what it is to be a being that thinks in ways that entail the emergence of what Hayles has called the "posthuman body." Or to put it in the terms we have been using here, the enacted and represented bodies can be discrete states dependent on their relation to the digital machine.

Indeed, another mode of critical analysis might look at the suggestion that the body is "no longer" inevitably gendered and ask how and if it ever was. Judith Butler has influentially shown that all gender is a form of imitation, based on a "copy that has no original" (Butler, 1990: 21). That is to say, it is not the feminine that is a masquerade, or drag or other gender work that is performance, but all gender is a performance of a role given in advance. As Judith Halberstam shows, there is a distinction between realness and the real and realness is as close as one can get to the "real": "It is not exactly performance, not exactly an imitation; it is the way that people, minorities, excluded from the domain of the real, appropriate the real and its effects" (Halberstam, 2005: 51). Such distinctions were only too apparent to Alan Turing who was more or less openly gay in a period when same-sex relations were a criminal offence in England. Arrested for having consensual sex in 1952, he was forced to undergo a series of hormone injections, leading to his suicide in 1954 by eating a poison-laced apple. Some believe that the bitten apple on a Mac is a Turing Apple. Certainly he connected his sexuality with his scholarship in a proposition he wrote in 1954:

> Turing believes machines think
> Turing lies with men
> Therefore machines do not think
>
> (Hodges, 1999: 54)

The self-evident bitterness in these lines comes in part from the experience of state-sanctioned homophobia and, at another level, from his realization that the effort to radically distinguish information processing from embodied existence had failed.

Autonomy and autopoiesis

If Turing's test was all about deceiving the observer, the second wave of cybernetics was by contrast concerned with understanding how that observer observes, a key question for visual culture studies. The breakthrough in forming what has become known as "autopoietics" (the making of the self) was a 1972 research paper by Humberto Maturana, a Chilean biologist, entitled: "What the Frog's Eye Tells the Frog's Brain." By wiring a frog's brain into a cybernetic circuit, Maturana discovered that the frog was best able to perceive small, fast-moving objects, whereas large, slow-moving objects generated little or no response. That is to say, the frog sees the insects that it wants to eat but not the elephant that treads on it. The elephant clearly exists, only the frog cannot perceive it. As Hayles summarizes this idea: "the frog's perceptual system does not so much register reality as *construct* it" (1999: 135). That is to say, even the concept that all sight is vision, sense perception molded by experience, is insufficiently radical. For Maturana, "everything said is said by an observer," meaning that no "reality" is knowable without being shaped by observation, or, as Hayles puts it "perception is not fundamentally representational" (1999: 136). In a sense, artists and writers have been saying this for a long time but it made a difference when scientists began to agree.

Maturana's insight was, in his own account, shaped by his experience of the student revolt of 1968, in which he participated, "that took over the University [of Chile] in an attempt to reformulate the philosophy that had inspired its organization" (Livingston, 2006: 85). This political self-imagining inspired Maturana to think of systems as processes in a constant state of renewal, meaning that any autonomous "individual" was sustained by a series of dependencies. Life itself was a network. In 1972, at the height of the radical reform of Chile under President Salvador Allende, Maturana saw that, as Ira Livingston has neatly summarized it, "'circular organization' in cognition and 'the operation of the living system' itself were the same thing" (Livingston, 2006: 85). The living system is that which is capable of sustaining and generating itself. What matters here is the sustaining of the system itself. Rather than the phrase "circular organization," Maturana called this "autopoiesis," self-making, "a word without a history, a word that could directly mean what takes place in the dynamics of the autonomy proper to living systems." Paraphrasing Marx's famous epigram that "men make their own history but in circumstances not of their own choosing," Maturana concluded: "We could not escape being immersed in tradition, but with an adequate language we could orient ourselves differently and, perhaps, from the new perspective generate a new tradition" (Livingston, 2006: 86).

One parallel to the development of autopoiesis in science was the Autonomy movement in Italian politics during the 1970s that openly declared its relationships

with both Allende's Chile and modern biological thought. One participant, the French theorist Sylvere Lotringer defined the movement as follows:

> Autonomy is the body without organs of politics, anti-hierarchic, anti-dialectic, anti-representative. It is not only a political project, it is a project for existence. Individuals are never autonomous; they depend on external recognition. The autonomous body is not exclusive or identifiable. It is beyond recognition . . . In biology, an autonomous organism is an element that functions *independently of other parts*. Political autonomy is the desire to allow differences to deepen at the base without trying to synthesize them from above.
>
> (Lotringer, 1980: 8)

Autonomy was active in Italian factories and intellectual life, interfaced with practical politics, French poststructuralism and American systems theory. After the American-inspired coup against Allende on September 11, 1973, it became clear to them that the "old socialist modes of government were untenable" in relation to modern capital, a lesson learnt elsewhere under the neo-liberal regime of Ronald Reagan in the United States (1980–8) and Margaret Thatcher in the UK (1979–92). Autonomy developed the key strategy of the "refusal of work," meaning demands for greater leisure and wages, as well as an end to the "creative destruction" that Joseph Schumpeter had hailed in the 1940s as the essence of capitalism. Beyond these material points, the refusal of work was the refusal to be a "docile body," as forged by the industrial discipline of the panoptic factory. Autonomy understood American capitalism as a "self-regulating machine," using Maturana's term, that used the State for its own ends. Rather than take over the State, as Socialist and Communist parties had long advocated, Autonomy wanted "liberation from the State." The fact that many right-wing groups have subsequently appropriated this slogan is "another dizzying example of the reversal of signs" in the era of "post-political politics." Far from existing in a "black box" independent of the body, information had been reconfigured as "an inference drawn by an observer" (Hayles, 1999: 149). Imbricated with this reworking was a political displacement in which no single Observer, like the guard in the Panopticon, could dominate the network and discipline the body.

Information wants to be free

In the 1990s digital moment, it seemed that much hinged on how the mantra "information wants to be free" should be interpreted. For coders, it often meant simply that people should be able to have access to software source code to modify as they wanted. The Unix-based Macintosh OS X operating system is one example of a response to this demand, as is the open source Linux operating system and its related software. Even though Linux is a more stable system than the bloated Microsoft

Windows, a combination of inertia and nervousness about altering fundamental computer systems has kept this something of a minority movement. The One Laptop Per Child charitable organization (http://laptop.org/en/index.shtml), dedicated to donating low-cost but high function laptops to all children, is one important part of this movement, using Linux and other open source software to reduce its costs. For many, this movement had political implications, for, as Matthew Arnison of Indymedia puts it, "free software is the main resistance against the privatisation of the Internet" (Meikle, 2002: 107). While the threat of an AOL/MSN dominated Internet appeared to have been seen off, US telecom and cable companies were again introducing differential pricing for Internet access in 2008, meaning that the more one used it, the more it costs. Open source implies that digital software and media should be free of charge and available to all. Perhaps unsurprisingly in a commodity culture, this meaning was widely accepted. File-sharing of digitized music from sites such as Napster produced near panic in the music industry that has only been able to consolidate around the 99c per song formula of iTunes. Bartering of goods and services on-line has its niche on sites like Craigslist but more typical is eBay's selling of new and used goods. When eBay introduced its "Buy Now" feature, its self-declared goal of finding the true market price for an object was marginalized in favor of fast selling. Indeed, the much-hyped interactivity of the Internet could be said to have generated not much more than the now intuitive "click here to purchase" response.

This view is, it should be said, one born out of hindsight. At the time the constant flow of change seemed more important than defining what had in fact changed. For example, stock market trading had been the preserve of Wall Street brokers until the advent of on-line trading companies such as E*Trade. At the peak of the 1990s boom an estimated six million people in the United States were engaged in on-line trading, a new mass phenomenon that was promoted by television advertising. Advertising was critical to the dotcom companies of the 1990s because it was their only form of interaction with the public. In a certain sense, the ad was the company, leading to a very high number of repeat showings. As the once spatially and socially controlled domain of trading in securities became open to anyone with access to the Internet, the first wave of emotion was digital insecurity. E*Trade thus produced a television commercial showing a young man in a one-bedroom apartment hesitating over his computer screen. His face is illuminated by the glow of the screen. He finally clicks to place an electronic trade, and a smile of intense satisfaction lights up his face. The screen fades to black and the caption declares: "Be not afraid." What had at first appeared as a sexual consummation was reregistered as a quasi-religious act. At first sight, the commercial was transferring the visuality of the Panopticon to the digital world. The computer is the source of light and surveillance that produces a disciplined subject who behaves in the manner expected of him. His reward is to feel secure and later to make a financial gain. But the subtext of the commercial played on the far more common practice of young men alone in their bedrooms while on the Internet, that is to say, the endless realm of digitized pornography and

Figure 9.7 An E*Trade ad, "Money Out the Whazoo" (2000)

erotic chat rooms. It implied that a more righteous satisfaction was to be found making money. At the same time, unlike sex, trading was supposed to be safe. The form remains the same – input to a computer – but the pay-off is far greater.

The Internet seemed to offer more than this commercial exchange: it was now becoming possible for identity itself to become fluid. Many people assume a different on-line sex or sexual orientation to that which they perform in everyday life. It is widely held that most of this masquerading is by heterosexual men pretending to be heterosexual women. In other words, men go on-line to have sex with other men under the guise of a digital displacement that allows them to represent themselves as "women." This identification is, however, not the same as considering oneself to "be" queer as a matter of self-definition. Rather it openly plays with the various possibilities of identification in an environment where the consequences for such choices were negligible compared to the homophobia still active in everyday life. One dotcom-era commercial played directly on these role-playing games. An ad for the short-lived City TV showed a teenage boy getting ready to have on-line sex in a chat room, only to realize that he was propositioning his mother. This clash was supposed to be funny not terrifying. The psychoanalytic trope of the mother as a castration threat intersected with the thrill of transgressing the incest taboo, all cathected into a new media purchase in 20 seconds. On-line you could be whoever you wished to be, as new media pundits endlessly reminded us. These pleasures were famously characterized in the period by then Federal Reserve chair Alan Greenspan as "irrational exuberance," as if describing a free play with the body that precedes the moralizing control of the superego rather than a stock-market bubble.

Damming the digital flow

The famous "flows" of globalization identified by Arjun Appadurai in 1990 have now been dammed. In 1997 a Clinton White House policy paper declared that

> The US government supports the broadest possible free flow of information across national borders. This includes most informational material now accessible and transmitted through the Internet, including

World Wide Web pages, news and other information services, virtual
shopping malls and entertainment features.

(Schiller, 2001: 71)

Needless to say, such government policy is now firmly in the dustbin of history,
prompted first by the dotcom crash and then by the rise of international anti-
globalization violence. As early as 1998, the US Federal government had moved
away from the fantasy of digital openness towards the concrete restrictions on digital
property that have become the symbol of the end of that era. With the passing of
the Digital Millennium Copyright Act (1998), a challenge was made to the radical
software belief in "copyleft," the notion that the basic source code of any software
should be available to everyone for free. National governments have made a
concerted effort to close the global circuit and to end the freedom of the Napster
era that became a matter of "national security" after the 9/11 attacks. By 2003,
the Chinese government had shut down some 150,000 Internet cafés, while in
Singapore all Internet connections have to be made through the closely monitored
government provider Signet, and in America, the USA Patriot Act (2001) gives the
government access to all email and other digital information without prior warrant,
an option that has turned out to be have been used repeatedly by the Bush
administration.

As Geert Lovink, creator of the radical site Nettime has put it, "what was lost
after 2000 was the illusion of a rapid overhaul of society as such" (2007: 17). The
Internet for most young people today is a fact of life rather than a transformative
new technology, one that has to be used to register for classes, submit applications
and file data. Email has become a chore rather than the pleasure it was when only
your friends had your address. In keeping with this transformation from radical to
banal, the Internet is now judged by the criterion of "cool" rather than "freedom."
As new media scholar Alan Liu defines it: "Cool is the techno-informatic vanishing
point of contemporary aesthetics, psychology, morality, politics, spirituality, and
everything. No more beauty, sublimity, tragedy, grace or evil: only cool or not cool"
(2004: 4). It is worth adding that "cool" itself has been deradicalized from its specific
meaning within the African diaspora via its emergence as a Beatnik or jazz term to
a generic all-purpose floating signifier. In its earlier manifestations, the idea that a
commercial product or even a country (i.e. "Cool Britannia") could be cool would
have been a contradiction in terms. Now it is precisely a means of distinguishing
that which is worthy of attention, and hence value-generating, from that which is
not. The corollary of "cool" is that the mediated object offered as cool must demon-
strate being "smart." As philosopher Slavoj Žižek – who makes great efforts to be
both cool and smart – defines it,

being smart means being dynamic and nomadic, and against centralized
bureaucracy; believing in dialogue and co-operation as against central
authority; in flexibility as against routine; culture and knowledge as

against industrial production; in spontaneous interaction and autopoiesis
as against fixed hierarchy. Their dogma is a new, postmodern version
of Adam Smith's "invisible hand": the market and social responsibility
are not opposites, but can be reunited for mutual benefit.

(Quoted by Lovink, 2007: 10)

So much for all that fuss, then.

It might be said that there has simply been a switch from digital utopianism to
digital pessimism. I think the critical landscape is more interesting and more self-
aware than that would allow. The so-called Web 2.0 centers on placing users in
contact with each other by technologically mediated means, rather than techno-
logical innovations in their own right. Web 2.0 allows for new forms of interaction
that have so far generated such wide ranging effects as Google mashups, on-line
Jihad, Wikipedia, Second Life and the on-line political campaigning that extends
from "netroots" radicals to Barack Obama. If the fascination previously was with the
machine, its intelligence and the creation of virtual worlds, the generations that have
grown up with these machines seem more interested in what to do with them. In
2008, B'Tselem, the Israeli Information Center for Human Rights in the Occupied
Territories, gave out 100 digital video cameras to young Palestinians in a project
called "Shooting Back." In July, an international furore followed when a similar
video showed an Israeli soldier shooting a rubber bullet at Ashraf Abu Rahma, a
Palestinian detainee who was already in handcuffs. An additional dimension to
the issue emerged when it became clear that the camerawoman was 17-year-old
Palestinian Salam Kanaan from Ni'lin, who was wearing a chador. Far from being
isolated from contemporary life, as we are so often told veiled women are, she had
created international news.

Digital games like *The Sims* allowed users to create their own worlds. Social
networking uses the connectivity of the Internet to bring people into contact,
whether on-line or in real life. In the original *Sims*, a city-planning "God" game
in which the player controlled the urban environment, the digital "citizens" would
run you out of town if you raised taxes over 7 percent. Any attempt to institute a
tax-funded social welfare state led to immediate "game over." By contrast, the video
"Yes We Can" made by will.i.am of the Black-Eyed Peas in support of Democratic
presidential candidate Barack Obama circulated to such effect that it had over one
million views on YouTube alone. By the same token, Obama used social networking
to create a formidable fund-raising apparatus that has given him a secure financial
base without taking lobbyist money. On the other hand, as successful as this
has been, it may well mark the end to state-funded presidential campaigns. The
question is whether that is to be regretted as anti-democratic or whether the Obama
style of millions of small contributions is what democratic financing now looks
like.

In this spirit, I want to end this section with a series of questions that seem as
I write to be at the center of this new digital world-making, in the expectation that,

Figure 9.8 will.i.am, "Yes We Can"

Figure 9.9 YouTube screen

with the passing of time, readers might be in a better position to answer them than I am now. For instance, what do you now think of Google, the currently dominant Internet search company that is seeking to monopolize computing? Google is currently creating the possibility of "cloud computing," meaning access to files and programs would come from local Internet terminals rather than being stored on individual machines. It has absorbed YouTube and many other digital archives and is creating a massive on-line archive of scanned books. At present, all this plus Google documents and Gmail is free: how long will that remain the case? Gmail is notably still labeled as a "beta": will the 1.0 version be billable? Does the Google motto "don't be evil" have a bias toward free provision of software or does it just want to beat Microsoft? If Google is already the next paradigm for computing, what comes after it? Will it be worse or better for ordinary users?

1. How do we study digital cultures?

It has become axiomatic that the Internet changes faster than one can sensibly write about it. For instance, while this chapter was under preparation, articles appeared in the press proclaiming the end of eBay, a collapse in advertising revenue on MySpace, and a $1 billion lawsuit against YouTube by Viacom. Do these issues still seem important as you read this or have the mega-sites shrugged off these challenges? Given the immensity of materials now available on-line, how would one begin to write about them? Perhaps this challenge is not so new. It is said that Erasmus (1466–1536) was the last Western person to read all the books then available. By the time that Jean-Paul Sartre wrote his novel *Nausea* in 1938, the challenge had not changed – he had a character begin to read the library at A, only to die while still in the Ks. Despite the creation of the Internet Archive, it is clear that radically incompatible formats already exist that may not be "readable" without now defunct software or hardware. I cannot now access my own doctoral disser- tation files, for example. In the face of this disappearing past, Alan Liu has suggested "where once the job of literature and the arts was creativity, now, in the age of total innovation, I think it must be history . . . a special, dark kind of history . . . of things destroyed in the name of creation" (2004: 8). In other words, can the writing of the digital present and its implied futures only be accomplished by a counterhistory that refuses to tell a history of progress? How do we write a history of something that changes so fast it can seem like a full-time job keeping up, let alone learning the softwares?

2. How can we map the digital-global?

It was for a while required that any essay on the digital address what was called the "digital divide" between rich and poor within the West and the presumed gulf that existed between the West and the Rest. The primary consequence of this acknowl- edgment was that most digital culture criticism has focused on English-language

based materials. However, by 2007 it was estimated that only 30 percent of the Internet was in English. Moreover, different uses of technology are now becoming apparent worldwide. In some areas, mobile or cell phones have replaced landlines that never functioned to begin with, such as in Italy, whereas in others, like Mali, they have stepped in as first-generation communication. For people of all income levels, a cell phone may be the one fixed point of identification in a migrant economy, with Nokia planning a $5 phone. Tripta Chandola, formerly a member of the Sarai collective in New Delhi and now a new media ethnographer, shows that in India electronics are widely used by the "poor" and may be easier to obtain than clean drinking water (Lovink, 2007: 148). This traveler can report that in locations as diverse as Buenos Aires, Accra and the working-class suburbs of Dublin, Internet "cafés" offer affordable access for a wide range of people who are supposed not to have it because their residences do not. In order to accumulate, analyze and dis-seminate such information within its lifespan of relevance, humanities scholars are going to have to learn to work collectively in the manner pioneered by groups like Sarai and Amsterdam's Institute for Network Cultures. What forms of media archaeology and ethnography are required for this task and how should students (and faculty) be trained in them?

3. What happened to identity?

On-line communities have made new forms of identification possible. For example, queer teenagers can explore and discover their sexualities on-line in ways that might only have been possible for those living in larger cities or who were more than usually self-confident. As the editors of a collection on net porn have put it: "What we emphasise in porn culture is alternative body type tolerance and amorphous queer sexuality, interesting artworks and the writerly blogosphere, visions of grotesque sex and warpunk activism; all agencies relying on robust sex energies for their different purposes" (Jacobs et al., 2007: 2). All that subcultural activity takes place in a context of the massive development of standard Internet porn, satirized by the musical *Avenue Q* in the song "The Internet is for Porn." Even so vanilla a sitcom as *Friends* made frequent reference to Internet porn that seems to have engendered a proliferation of lap-dancing and strip clubs in US and European cities. At the same time, porn is represented as one of the major symptoms of Western decadence by Islamic thinkers of all stripes and is subject to a far greater degree of censorship in the emerging digital economy of India, for example, on similar grounds of corruption. The development of streaming video, on-line credit card payment and even such devices as web browser minimization and "clear all" commands for browser history owe their existence to pornography. If all actual porn is or becomes boring, is the only exciting thing the next link? Should we stop looking and start making?

4. What do we do with vernacular images?

If the answer to the last question accelerates the current trend towards practice-based media research (involving the creation of websites, films and other media as the outcome of research rather than a book or essay), one consequence will be a still greater accumulation of images. Given that there are already hundreds of millions of video clips, still photographs and websites available to anyone at an Internet terminal, how would such work become known? When a YouTube clip, or other vernacular image, does have a wider impact, it is often because it has been adopted by traditional media outlets, sometimes following a "viral" effect on-line. In art world terms, they become canonical, part of the range of materials everyone should know. When new media were in vogue, a "canon" of websites quickly formed featuring such excellent practitioners as RTMark, the Radical Software Group, Shu Lea Cheang and Electronic Disturbance Theatre. With the revival of the commercial art market, the art world has moved in a different direction and no new media art was featured in the 2008 Whitney Biennial. That is to say, the risk of canonization is that the curators and other traditional "gatekeepers" are put in charge of which materials become considered important, get written about and viewed. Given that the intent of such work is often to create social change, access is important. Is it possible to direct people's attention without becoming a talent scout for the galleries, film festivals and museums? If we all want to be image producers now, what happens to viewers, let alone critics?

References

Babbage, Charles ([1864] 1969), *Passages from the Life of a Philosopher*, New York: AM Kelley.
Batchen, Geoffrey (1996), "Spectres of Cyberspace," *Artlink*, vol. 16 nos. 2 and 3, pp. 5–6.
Butler, Judith (1990), *Gender Trouble*, New York: Routledge.
Crow, Thomas (1995), *Emulation: Making Artists for Revolutionary France*, New Haven, CT: Yale University Press.
Halberstam, Judith (2005), *In a Queer Time and Place*, New York: New York University Press.
Hayles, N. Katherine (1999), *How We Became Posthuman: Virtual Bodies in Cybernetics, Literature and Informatics*, Chicago, IL: University of Chicago Press.
Hodges, Andrew (1999), *Turing*, New York: Routledge.
—— (2000), *Alan Turing: The Enigma*, New York: Walker.
Hyman, Antony (1982), *Charles Babbage: Pioneer of the Computer*, Princeton, NJ: Princeton University Press.
Jacobs, Katrien, Marije Janssen and Matteo Pasquinelli (eds) (2007), *C'Lick Me: A Netporn Studies Reader*, Amsterdam: Institute of Network Cultures.
Liu, Alan (2004), *The Laws of the Cool: Knowledge Work and the Culture of Information*, Chicago, IL: University of Chicago Press.
Livingston, Ira (2006), *Between Science and Literature: An Introduction to Autopoietics*, Urbana: University of Illinois Press.
Lotringer, Sylvere (1980), *Autonomia: Post-Political Politics*, New York: semiotext(e).

Lovink, Geert (2007), *Zero Comments: Kernels of Critical Internet Culture*, New York: Routledge.

Massa, Rainer Michael (ed.) (1985), *Pygmalion Photographé*, Geneva: Musée d'Art et d'Histoire.

Massumi, Brian (2002), *Parables of the Virtual*, Durham, NC: Duke University Press.

Meikle, Graham (2002), *Future Active: Media Activism and the Internet*, New York: Routledge.

Schiller, Dan (2001), *Digital Capitalism*, Cambridge, MA: MIT Press.

Swade, Doron (2000), *The Cogwheel Brain: Charles Babbage and the Quest to Build the First Computer*, London: Little, Brown.

BLADE RUNNER

In 1982, the film *Blade Runner*, directed by Ridley Scott, imagined the future in ways that became visually definitive. In this now classic film, appearances are always deceptive, seeing is rarely believing and memory cannot be trusted. It created a look for a dystopian future, dominated by dramatically altered weather and immense disparities in wealth that are perhaps not so far from the actual present. Set in 2019, in a permanently rainy, predominantly Asian Los Angeles the film imagined an economy dominated by off-world colonization, organized by the dominant Tyrell Corporation with the aid of artificial humans called replicants. The replicants were programmed to die after four years of life but some of them rebelled against their fate. In these cases, a form of detective was called in to track them down and "retire," or kill, them. These assassins were known as "Blade Runners." The film details the tracking down of a rebel group of replicants who have made it back to Earth from the off-world bases. The Blade Runner of the title, Deckard (Harrison Ford), is a futuristic version of Raymond Chandler's Los Angeles detective anti-hero Philip Marlow. Like Marlow, his hard-boiled exterior, penchant for violence and wiseguy one-liners concealed a romantic interior, given to piano playing and reflection. The transposition of this 1940s character, known from classic films like *The Big Sleep* (1946) and *The Lady in the Lake* (1947), whose name evoked the lead character in Conrad's *Heart of Darkness*, helped make the future seem familiar and convincing. The 1982 theatrical release relied heavily on this link by using a narrative voiceover by Deckard, a rather old-fashioned device for a science-fiction film. Indeed, it was cut from both the 1992 Director's Cut that came closer to what Ridley Scott had intended, and the reworked 2007 Final Edition with digital enhancements. *Blade Runner* has oddly managed to replicate itself, without ever lapsing into sequel hell.

Stills from *Blade Runner* (dir. Ridley Scott, 1982)

Blade Runner dreamt the future for us, creating a vertically segregated world in which power means being above everyone else. The film took the shadows of black and white film noir and transposed them into the future as intensely polluted smoky air, stirred by fans and shielded by blinds, cut across by high power lights. Everything is hard to see, obscured by shadows and smoke, whether cigarette or chemical. An opening shot shows a flare of burning gas high above L.A., reflected in a blue eye that will later turn out to be that of the replicant leader Roy Batty (Rutger Hauer). Roy claims his right to live in part because of the things he has seen "things you wouldn't believe. Attack ships on fire off the shoulder of Orion." By contrast, human sight is a commodity, as made clear by the replicants' visit to an eye manufacturer, a retailer of bio-power. Even Tyrell, the creator of the replicants, wears enormously thick glasses. The rebel replicants kill humans by pressing their eyes back into their heads. As befits this panoptic world, height is power. The ground is the space of the poor, the migrant and the refugee in *Blade Runner*, while the elite live high above in penthouses and travel by small aircraft, as do the police. Epitomizing this politics of verticality is the head of the Tyrell corporation who lives at the top of what appears to be a postmodern Babylonian ziggurat, accessible only by a password-protected high-speed elevator. The film had, as it were, flipped Los Angeles on its side. Actual lived experience in the city separates the affluent from the impoverished by means of space so that Beverly Hills is physically distant from districts like South Central to which it is not connected by public transport and no public parking spaces are available. Houses and communities in the affluent regions of town are protected by gates and security guards, a model that has become widespread in the United States.

On the other hand, replicants are in effect slaves, as the rebel leader Roy Batty (Rutger Hauer) tells Deckard in an epiphany at the end of the film: "to live in fear, that's the life of a slave." The replicants live under the erasure of physical as well as social death because they are programmed to die after a few years of active life. The latest model replicants known as Nexus 6, at the center of the film, are in some cases unaware that they are not human. The Voigt-Kampff empathy test administered by the Blade Runners detects the lack of emotional response in the replicant's eyes, a physical equivalent to the Turing test designed to separate humans from computers. Because the replicants can easily play such verbal games, the empathy test is designed to be foolproof. Ironically, this lack of anything to see is the one moment in the film in which sight can be trusted but it has to be calibrated by machine. The Nexus 6 replicants even have implanted digital memories that are "authenticated" by their snapshots, vernacular photographs of precisely the kind that people still have trust in today. Yet the entire project is a fake, with the Director's Cut version of the film even suggesting that Deckard is himself a replicant. The policeman Gaff (Edward James Olmos), who recruits Deckard for the hunt, has a habit of making origami figurines. Towards the end of the film, Gaff leaves an origami unicorn in

Deckard's apartment, after he has dreamt about a unicorn, suggesting that the dream is an implant. Personal photographs and dreams are some of the few aspects of everyday life that we feel are not thoroughly commodified but *Blade Runner* was not so sure. Giant advertising billboards dominate the dark city-scape, with corporate logos for Coke and other "real" companies and the face of a Japanese geisha representing the Orientalized future of 2019. It is this evocation of the corruption of personal experience by corporate capital, so that our most private emotions and desires can feel like a copy of some already existing template, that has made *Blade Runner* into a classic. In 2008, plans were announced by the L.A. developer Sonny Astani to display giant 10-story high LED images on his new residential skyscrapers in a manner directly inspired by *Blade Runner*.

In tune with this suspicion of the reality of what appears to be real, *Blade Runner* was uncertain about the visual image because it can always be recon-figured. In a key scene, Deckard is confronted in his apartment by Rachael (Sean Young), who has just learnt from Deckard's tests that she herself is a Nexus 6 replicant. Rachael offers her childhood photographs to prove that she is really human. But Deckard is able to show that her most "private" memories are known to him as an expert on replicant manufacture. Her photographs replicate nothing and she herself is literally a simulacrum, a copy with no original. She is a digitized photographic effect, devoid of photography's until then taken for granted connection to the "real." Deckard's apartment serves as a camera in which the dark room – literally a *camera obscura* – is flooded with light from outside and as a result, something develops: only what develops isn't the truth but the emergence of a manipulation. This failure to represent also challenges the theory of cinematic spectatorship as "regressive to some imaginary anterior moment," as Anne Friedberg has put it, arguing instead for what she calls the "mobilized virtual gaze" (Friedberg, 1993: 132). The numerous accounts of this scene often overlook the ending. Rachael does not disintegrate in the face of this challenge to indexicality. She literally acts out: that is to say, she exits. She is the only known replicant to survive at the end of the film.

By the same token, Deckard's decisive act of detective work in the film involves his computer-aided analysis of a photograph that was being kept by the replicant Leon. Using voice-generated commands, Deckard homes in on an area of anomaly in the photograph that he detects in the image of a mirror, evoking the mysterious concave mirror in Jan van Eyck's painting *The Arnolfini Portrait* (1434) that shows people outside the picture space. In this case, Deckard is able to track down Tura, one of the replicants, who is (inevitably) working as an exotic dancer. Her "retirement" is gruesome and changes the emotional balance of the film in favor of the replicants. After Roy has died, his life expired, Gaff calls out to the wounded Deckard in reference to Rachael: "Too bad she won't live. But then again, who does?" *Blade Runner* pushed past the logic of the Turing test to an indeterminate zone where the distinction between human and

machine is relative rather than absolute. Roy and his friends have to be elim-inated by the police not because they are replicants but because they claim political freedom and the right to look. The police chief refers to them as "skins," which, as the voice-over in the 1982 version of the film laboriously points out, is intended as a racialized insult. At the heart of such racism is the fear of being the same, despite elaborately maintained difference, a fear that is now directed towards machines as well as other people.

In 2005, the Hong Kong director Wong Kar-Wai revisited *Blade Runner*'s science-fiction noir affect in his film *2046*. The "2046" of the title refers at once to a hotel room lived in by the lead character Chow (Tony Leung), the name of a science-fiction short story that he writes which is visualized within the film and allusively as the end of the "special period" in Hong Kong at which point the People's Republic of China will be able to treat the city as simply another locale. The film's narrative begins with the riots of 1966 and 1967 that began as a consumer protest and ended as fully fledged Maoist anti-colonial action. The film is suffused with regret for the lost possibilities of history and indeed for the medium itself, with its remarkable color, editing and lighting. As the voice-over tells us: "Every passenger who goes to 2046 has the same intention, to recapture lost memories." The visual affect of the future is at once recogniz-able to us as that of *Blade Runner*, a vertically segregated world marked by the display of logos. All the characters are tightly constrained by their circumstances, reflected in the tight focus on their faces and the lack of represented space. Many scenes take place on the roof of the Oriental Hotel where Chow lives but the camera cuts off the last two letters so that it reads "Orient" instead. The frame of Orientalism and other modes of imagined difference prevent the characters in *2046* from even being aware of what it is that they want, other than a series of fictionalized narratives that Chow writes for a living, such as the *2046* of the title. *2046* is a train on a journey to nowhere on which passengers are alone except for the attention of attractive replicants. As in *Blade Runner*, the hero falls in love with a beautiful replicant but in this case his affection is not returned. The replicant is already in love with somebody else. Here Wong hints at a different future in which the (artificial) human has desires and needs of its own that are not subjected to those of the Master, the Blade Runner or anyone else.

References

Friedberg, Anne (1993), *Window Shopping: Cinema and the Postmodern*, Berkeley and Los Angeles: University of California Press.

Chapter 10

THE DEATH OF THE DEATH OF PHOTOGRAPHY

B EGINNING IN THE late 1980s and accelerating in the early 1990s, an argument was frequently made that photography was dead or dying. The agent of this murder was held to be the digitization of the image. Looking back on this clamor now, it can be seen that while all of the symptoms of this apparent morbidity were accurately diagnosed, they did not add up to a prognosis of death. Photography is more widespread as a practice than it has ever been, whether in the vernacular format of cell phone or digital camera, or the advertising image or even as high art. There were an estimated 478 billion photographs taken in 2008, mostly by cell-phone cameras. While a mistake of prediction was certainly made, it was not simply an error. What is curious is the use of a vocabulary of death, rather than change or metamorphosis. Investigating what one can call the structure of feeling around the death of photography will prove to tell us a good deal about the time in which it was made and, indeed, about how it might be possible to talk about the photograph in the era of global capital. This structure of feeling was the product of an associated crisis of indexicality in the medium of photography with a newly indexical presence of death itself in the 1980s caused by the AIDS epidemic. By a process of displace-ment, it came to seem that photography was dying: and therefore that we would live. At the same time, photography had to be killed in order to save it, not as an indexical medium, which it never was, but as high art, resistant to the commodity form. Photography is, however, best thought of not as medium but as a very particular form of commodity, one that is as well suited to serve as an example of global capital as Marx's bolt of linen was to the era of imperial industrial capital. The "epidemic of signification" that surrounded AIDS is by no means over but displaced again, now in space, to Africa and Asia. With infection rates reaching levels unheard of in all but a few locations in the West, there is a renewed challenge to representation and critical practice.

Structure of feeling

1. Indexicality

In 1977, Raymond Williams coined the phrase "a structure of feeling." Often used now in a loose sense to mean not much more than a way of feeling common to a large group of people, Williams had a rather precise definition for his idea, calling it "the hypothesis of a mode of social formation, explicit and recognizable in specific kinds of art, which is distinguishable from other social and semantic formations by its articulations of presence" (1977: 135). In this instance, the structure in question can be defined as a visible transition to what was about to be called a post-photographic era, apparent in the work of postmodern photographers like Cindy Sherman and Barbara Kruger, and notable for its sense of absence. Looking back to the emergence of digital imaging now, one can be only be struck by the intensity of belief surrounding the imminent future. As early as 1982, the special effects company Lucasfilms declared that their work implied "the end of photography as evidence for anything." It was announced that in addition to the possibility of adding new elements to a scene, each pixel (picture element) in a digitized image could be manipulated for color, brightness and focus (Ritchin, 1990: 13). By 1992, William J. Mitchell had announced the emergence of a "post-photographic era," in which the photograph would no longer be considered indexical of exterior reality.

One of the most frequently cited examples of this moment came during the O.J. Simpson criminal trial in 1994, when *Time* magazine altered Simpson's photograph to make him appear darker-skinned and thereby, presumably, more threatening to *Time*'s white readership. Yet the very fact that this alteration was so widely and immediately detected should have alerted us to the likelihood that people were not going to be so easily fooled. Far from being undetectable, the digital manipulation of photography is self-evident to amateurs and professionals alike. In the average

Figure 10.1
Cindy Sherman,
Untitled Film Still
(1979). Black
and white
photograph
(8 × 10 inches).
Courtesy of the
Artist and Metro
Pictures

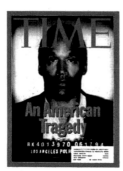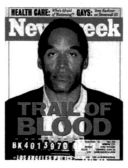

Figure 10.2 O.J. Simpson on the covers of *Time* and *Newsweek*

Manipulerad till mördare

American supermarket today, customers can choose in the check-out line between looking at the latest high-gloss photographs of celebrities in magazines like *Vogue* or their deliberately tacky-looking equivalents in tabloids like *The National Enquirer*. Readers know that neither is equivalent to "reality" and, far from panicking about the disruption to indexicality, take pleasure in the visual contrast. At the professional level, an image technician can tell by the analysis of a digital photograph what software has been used to edit it, just as a skilled sound technician can hear what equipment was used to make a particular recording. The rather mystical idea that imaging could be undetectably altered with grave consequences for truth and evidence has not materialized.

However, it was not beyond the realm of possibility that the photograph could have been displaced in this way. A more significant dispute in the O.J. trial came when a photograph emerged showing the former football player wearing the unusual Bruno Magli shoes that the killer was known to have worn. At once his lawyer objected that the photograph might have been faked and the photographer was forced to produce a contact sheet showing many such images. Given that Simpson was acquitted in the criminal trial, it began to seem that reasonable doubt now intruded as to whether a photograph could serve as legal evidence. Before long, the balance shifted back in favor of the photograph. Digital photography has become accepted in American courts as evidence, with New York State, for example, permitting its use in 2002, even in controversial cases like domestic violence. By 2007, it had been shown that digital photography increased conviction rates in such cases, partly because of the better resolution of the digital photograph, compared to the previously used Polaroids. In Britain, the now ubiquitous speed-cameras prove the guilt of the motorist by taking their photograph, available on request but leading to an increased fine if accurate. As much as people clearly dislike the cameras, there is no suggestion that the photograph cannot serve its judicial function. At a more notorious level, when the photographs taken in the Abu Ghraib prison became public in April 2004, it was noticeable that there was no suggestion of faking. In the roiling world of right-wing cable television and talk radio in the United States, any

such extenuating circumstance is usually seized upon and blown up until the main issue is sidelined. For all the devastating power of the Abu Ghraib photographs to America's image and its war effort, no attempt to label them as manipulated or fake emerged.

Perhaps the question being asked was not quite the right one. In most discussions of photography in the period, there was an assumption that photography was an indexical medium. Such a place is no doubt congenial both to critics and photographers, who might see themselves as the interpreter. For some critics even this was not enough. In a widely quoted remark, John Tagg asserted that: "photography has no identity. Its status as technology varies in the power relations that invest it" (Tagg, 1988: 63). In this view, photography did not have to die because it had never lived. It was simply a means to make apparent relations of power and other social forces. While this was widely held to be a Marxist view, it had the odd consequence of denying the materiality of the photograph as a commodity. The photographer Allan Sekula saw the issue rather differently. He considered the photograph to be a form of currency, whose value was based on "the archive as an encyclopedic repository of exchangeable images" (Sekula, 1986). In other words, like paper money, the photographic image appears to lack identity because it is by its nature exchangeable. It is for this reason that Marx's prime example of the commodity was money, something that was in itself the abstraction of value, which also became a commodity. If money has no "identity," it does have value, as does photography. In the case of the photograph, the exchange is not for a commodity but for another image. The use of paper money can end the circulation process vital to capital by converting the money form irrevocably into the commodity form. But as visible value, photographs can only be in circulation and are in this sense a perfect commodity. As many have noticed, a photograph "works" even if the viewer has no personal connection to the image or any means of identifying its subjects.

As a commodity, photography quickly established appropriate forms for all social strata. In 1852, the same year that the collodion-glass negative process made reproduced prints widely affordable to almost all wage labor, Ernest Lacan, the Parisian editor of the first art photography journal *La Lumière*, argued that

> [photography] was installed first in the attics, on the roofs – it is often from these that great things come: then it entered the study of the man of letters, the atelier of the painter, the laboratory of the savant, the salon of the millionaire, finally the boudoir of our most charming unemployed. It inscribed its name on every street corner, on every door, on the most sumptuous facades of the boulevards and promenades; it goes back and forth on the walls of the jostling omnibus!
>
> (Buerger, 1989: 51)

Just as the Paris apartment block was differentiated by class, with the wealthy taking the mansion apartment on the first floor and the impoverished living in the garrets,

so did photography travel from class to class, taking a different form at each level of the social ladder. Lacan argued that each photograph could be precisely correlated on a map of Paris by price and location: "One can establish this mathematical proportion: a photographer of such and such a street is to a photographer of such and such a boulevard as 2 francs is to 55." In so doing, Lacan refuted democratic notions of the photograph by arguing that the type of photograph one purchased inevitably revealed social class. Quality of photography thus mirrored social quality, to use the nineteenth-century term, that was perfectly reflected by price because photographs were a form of exchange value in themselves. Lacan even subdivided photographers into four classes, corresponding to social class: the basic photographer (working class or artisan); the artist-photographer (bourgeois); the amateur, in the sense of connoisseur, hence aristocrat; and the distinguished photographer-savant, who claimed the classless status of the artist. Thus, those who saw themselves as the photographic elite argued that "legitimate photography" was that which could be identified as belonging to a specific place, time and class. It is hardly surprising that Lacan's belief that social class could be precisely calibrated from a photograph using the twin axes of cost and location was not always accurate in practice (McCauley, 1994). More important was his understanding that the photograph was an exchangable commodity and one that operated with perfect reflexivity through-out society.

In this sense what happened to photography between 1987 and 2000 was not its death so much as its accommodation with the virtual form of money generated by electronically mediated global capitalism. A popular definition of cyberspace is that it is the space where your money finds itself. That is to say, for those paid by electronic bank transfer, wages or salaries are noted by an electronic message from one location to another. This virtual money can then be transferred to other electronic locations in order to pay bills or purchase commodities. The consumer can convert this virtual money to paper money at one of millions of automatic teller machines worldwide, eliminating the need for consumer foreign exchange and hold-ing out the prospect of a cash-free middle-class economy. While these new modes of financial organization seemed quite remarkable when they were innovations, they have now been accepted as banal. This acceptance understands that the limited freedoms involved in this virtualization of money have in fact increased the possibilities of surveillance and made us vulnerable to new forms of theft. By the same token, electronically mediated photography has become predominantly virtual and only occasionally takes physical form. Many people use on-line photography sharing sites such as Flickr as the place where their photographs exist. Whereas this might once have seemed like virtual reality, it now seems like a storage space, only for digital memory rather than excess commodities. Digital photography, exem-plified by the cell-phone generated image, can disseminate itself with extraordinary rapidity that expresses its form as the circulation of commodities. Photographs are a perfect commodity form because they most readily lend themselves to the fetishistic belief that things can mediate between people. More precisely, the current

fascination with the photograph illustrates Debord's concept of the society of the spectacle in which people are mediated by images. Indeed, the recent social uses of electronic media concentrate on mediation itself as pleasure. Young people can be seen walking next to each other while conversing among themselves by cell phone. A 2007 cell-phone camera advertisement in the USA had a family at dinner requesting each other to pass various condiments by means of instant messaged photographs.

Just as the present-day worker in an advanced economy is required to perform a range of tasks with equal facility, so is the modern mediating device capable of a variety of functions. The cell phone or mobile is a "camera" in the sense that it takes pictures but it is entirely distinct from the *camera obscura*, the darkened room with a single lens that permitted a view of the outside world to be seen, but upside down. To borrow Kaja Silverman's useful definition, a camera is "less a machine, or the representation of a machine, than a complex field of relations" (Silverman, 1996: 136). Where Marx could envisage simply inverting the *camera obscura* of ideology as a revolutionary act, today's image radical has a networked and performative task at hand. Debord's strategy of *détournement*, or detour, in which an image is appropriated and then parodied now fails because the appropriated image still does its work. So the endless representations of George Bush as a cowboy failed because they articulated his own image of himself without providing a critique or alternative. The electronically mediated digital rendition of lens-based reality that we persist in calling the photograph is, then, very far from being dead. In fact, even its generic condition as referencing death by means of the permanent assumption of a representation of past time has been transposed in this view to the permanent present that is the "empty homogenous time" of capital (Benjamin, 1940). If there is in that present a hint of a potentially different future, it is one whose power is weak, compared either to industrial labor or especially to global capital.

In a period that has seen the emergence of a highly capitalized global art market, art no longer has a claim to be outside the commodity market. Indeed, it has adapted to the demands of the global market with great speed, revealing in its adaptation how well suited the art form of capital is to the economy of general intellect. Photography that wants to be considered as – and sold as – art has forged itself a series of distinctive new forms in order to mark its separation from the quotidian non-permanent image. I refer here to the outsized color or light-box mounted photograph that has become the staple commodity of art fairs worldwide. These objects announce first and foremost their technically advanced form, as if to say "try making this with your cell phone!" Their literally spectacular nature transposes the spectacle into representation, embodying the present tense of general intellect at work. To take an example, Thomas Struth has created a series of remarkable outsized photographs of people looking at Old Master paintings in Western museums. Printed in sizes of about six feet by seven, the photograph claims the status of painting and, as one reviewer put it, "It's not the sort of snapshot you'd have developed by a drugstore chain or even at a local lab" (Tuchman, 2003). In fact,

there was only one press in the world at that time capable of generating such enormous prints. These color photographs are then themselves displayed in such museums creating a vertiginous sense for the viewer of looking at people looking, while being looked at by the photograph, the presumed camera, the painting in the photograph and by other viewers of the Struth photograph, many of whom will be engaged in re-photographing his work. All of this looking offers little sense of pleasure, reminding us of Beller's maxim: "To look is to labor." The resulting sense of emptiness in the museum photographs matches Struth's photographs of corporate architecture, different depictions of the capitalization of general intellect in a world seemingly without exit.

2. Death

In the postmodern period, two of the mostly widely used theories of photography were centrally concerned with the question of death. In Susan Sontag's *On Photography* (1977), photography was held to be centrally concerned with death: "All photographs are *memento mori*. To take a photograph is to participate in another person (or thing's) mortality, vulnerability, mutability. Precisely by slicing this moment and freezing it, all photographs testify to time's relentless melt" (Sontag, 1977: 15). By the same token, as we saw in the section Photography and Death (pp. 119–26), Roland Barthes also emphasized photography as a medium principally concerned with death in his new classic meditation on the medium *Camera Lucida* (1981). If Barthes's personal relationship to the personal experience of loss was explicit in *Camera Lucida*, it was also an important structural concern for Susan Sontag, who wrote *On Photography* while she was dealing with breast cancer. For both writers, death took on a new urgency in the moment that they were working on theories of photography. Barthes used photography to displace mourning for his mother's death. If she is there in the Winter Garden photograph "as she was," then there was no need to mourn, a postponement of acceptance that Freud called "melancholia." In Freud's view, the melancholic "introjects," or absorbs into the self, the lost object rather than gradually severing ties with it, as is the case in mourning. There was another structural coincidence between these texts. Both Barthes and Sontag were, as it were, semi-closeted queers. Barthes had very gently indicated his desire by means of a Mapplethorpe photograph in *Camera Lucida*, only to be outed after his death by D.A. Miller in 1992; whereas Sontag's sexuality remained an open secret in New York intellectual circles, until she outed herself in a *New Yorker* interview in 1995. At another time, this coincidence might not have mattered but in the moment in which the AIDS epidemic was devastating the New York art world, it may have contributed, if by displacement, to the notion that photography was dying or dead already. Artist-activist Gregg Bordowitz remembers that "illness was visible everywhere in New York in the Eighties," the backdrop to postmodernism and its motivating force for many people (Bordowitz, 2004: 230). AIDS heralded the end of what Walter Benjamin had famously called the "age of mechanical

reproduction"[1] that had enabled endless identical copies of the same photograph to be produced from one negative. By contrast, HIV mutates into a variety of viruses, frustrating any attempt to control the disease with a single vaccine as was at first expected. Accordingly, W.J.T. Mitchell has called the present era one of "biocybernetic reproduction," whose signature is precisely "that which eludes control and refuses to communicate" (Mitchell, 2005: 313). In the transition between mechanical and biocybernetic reproduction, a hope emerged that if photography was to die, perhaps then we might live. In an afterword to the 1996 edition of *The Ballad of Sexual Dependency*, the photographer Nan Goldin reflected that it had not worked:

> photography doesn't preserve memory as effectively as I had thought it would. A lot of the people in the book are dead now, mostly from AIDS. I had thought that I could stave off loss through photographing. I always thought if I photographed anyone or anything enough, I would never lose the person, I would never lose the memory, I would never lose the place. But the pictures show me how much I've lost. AIDS changed everything.
>
> (Goldin, 1996: 145)

It would have been better if photography had died instead but it could not.

For the critic and activist Douglas Crimp, it was necessary to respond to the wave of mourning not with Barthes's melancholia but with militancy. Writing at the height of the New York epidemic, he argued that "mourning *becomes* militancy," or more exactly that "militancy might arise from conscious conflicts *within* mourning" (Crimp, 1989: 8–9). This stance directly contradicted Sontag's call for a refusal of martial metaphor in the contest against AIDS, part of her career-long suspicion of metaphor and interpretation (Sontag, 1989). For example, in her 1978 essay *Illness as Metaphor*, written directly after her engagement with photography, Sontag asserted that "[t]he most truthful way of regarding illness – and the healthiest way of being ill – is the one most purified of, most resistant to, metaphoric thinking." In short, the hope was to use a language that directly accessed reality, made it as transparent as possible, while knowing that this was impossible (Miller, 1989: 97). In this crisis of meaning, Sontag hoped for language to become photographic in the vernacular sense used by her mentor Barthes, meaning that photography asserts the presence of something before the lens. Disease simply "is," like the photograph. Its symptoms must then be envisaged as indexical only of disease, not of any wider cultural issue or phenomenon. By extension, this position was a last-ditch, defiant defense of modernism and its formalist aesthetic in which each medium has its own specific "autonomy" that should not be corrupted by anything extraneous to it. It was met with furious polemics and rebuttals, whose details belong to more specific histories of the period. What matters here is the split between modernism and what was by default and design called postmodernism over the question of art's

relationship to the real, motivated by responses to an epidemic that seemed to have no cure and to be meeting deliberate indifference from government. This was a dialectical moment in the structure of feeling that pertained to photography, death, AIDS and desire. It epitomized what would become the split between medium-specific visual disciplines like art history and the networked, subject-oriented field of visual culture.

Dividing the sensible: time

At this point, I want to set aside the language of structures, while recognizing that this was a terminology current in the period when Barthes and Sontag were writing but was also one that had already been challenged by poststructuralism. Rather than consider the crisis of the photographic as a structure of feeling, it might now be more productive to describe these events as "a division of the sensible." In certain divisions and sharings of the sensible, associations and links between the visible and the sayable can be made that are not possible in other moments. As we have seen, the aura of death that surrounds photography stemmed from its capturing of an irretrievable slice of past time. This narrative entailed a view of history as unfolding calmly from past to present to a more modern future that the photograph both enhanced and disrupted. With new forms of technology, it becomes less simple to define photography as depicting nothing but past time. Streaming video, web cams, video conferencing, photographic instant messaging and the instant rendition of the lens viewpoint onto the screen of a digital camera or cell phone can offer photography in real time. The erasure of the time previously required to develop film, and the various options the dark room offered for image manipulation, has created a sense of the photograph as depicting what one might call an "expanded present," one that intrudes briefly into the past but is experienced as a continuum. The various time-manipulation devices of film and television drama have prepared viewers to live in this expanded present, which can now be accessed daily for those using digital video recording devices. These machines allow even "live" broadcast or cable television programs to be paused as they are transmitted, like a VHS or DVD copy of a film, so that the viewer can fit their viewing into the "expanded present" with other tasks or diversions of short duration. Such recording is not the permanent archiving of disk recording but the option to stop and resume watching as and when one wants. Viewers often use it to avoid watching advertisements, forcing advertisers into ever-expanding product placement within the actual programs themselves.

As photography comes to express a new experience of time, it can also be seen that time is not experienced in identical fashion. Two recent videos that consider the AIDS epidemic in relation to time make this new division of the sensible central to their work. Gregg Bordowitz was a key member of the AIDS Coalition to Unleash Power, or ACT UP, which was engaged in pressuring federal and state government and pharmaceutical companies to take more urgent and effective action to deal with the epidemic. An ACT UP member from its very early days in 1987, Bordowitz

Figure 10.3 A still from *Habit* (dir. Gregg Bordowitz, 2001)

made a number of highly regarded activist videos both individually and as part of the *Testing the Limits Collective*, as well as writing incisive essays about AIDS activism and visual culture. It so happens that he became aware of being HIV-positive in 1987 and has been able to stabilize his health with protease inhibitors since 1995. In *Habit* (2001), he contrasts the life that he now lives with that of AIDS activists in South Africa. In the first sequence of the film, we see Bordowitz engaged in his morning routine, involving washing, food, exercise and the taking of his pills. All of these activities highlight certain forms of global privilege: access to clean drinking water and nutritious food; time and space to exercise the body in controlled and beneficial fashion, rather than using all one's energy in work; and above all, access to complex medical care at affordable cost. What Bordowitz makes us see in this "habit" is how those of us with global privilege are able to use time as a resource, to structure days, weeks and months in more or less predictable fashion and hence to "comply," as the medical rubric has it, with a demanding schedule of pharmacological consumption.

In the second section, Bordowitz documents the AIDS crisis in South Africa as it was during his visit of 2000:

> Edwin Cameron, a white High Court Justice, testifies to the life-saving role treatment plays in his life. Promise Mthembu, a Treatment Action Campaign (TAC) activist and mother, talks about the difficulty she has obtaining medical treatment. Finally, Zackie Achmat, the chairperson of the TAC, explains why he refuses to take HIV medicines until they are available to all the citizens of South Africa who need them.
>
> (Bordowitz, 2004: 273)

These are striking juxtapositions between privilege, unmet need and the principled refusal to help oneself until all can be helped. Achmat's action might remind us that

Gandhi became radicalized by his experiences in South Africa that led him to his later militant non-violence position, involving hunger strikes in protest of communal violence in India (Becker, 2006). Bordowitz also calls attention to the changed environment of AIDS in Africa, where transmission is largely heterosexual. In 2005, 30 percent of pregnant women tested in South Africa were HIV-positive and an estimated 10.5 percent of the entire population is seropositive. Even though Zackie Achmat's campaign for available medications was successful, in the face of wilful government negligence, the TAC continues to stress that not all those who need them are receiving them, especially in the rural areas and in prisons (see their website for details at http://www.tac.org.za/).

When attending a TAC-organized demonstration, Bordowitz was struck by the marchers' use of T-shirts printed with the slogan "HIV Positive" (Figure 10.4). It struck him not only as a courageous and necessary step but reminded him intensely of ACT UP's similar projects in 1989, causing him to feel what he strikingly calls "nostalgia" (Bordowitz, 2004: 274). It may seem unlikely that the terrifying onset of an epidemic of a disease that causes a fatal collapse of the immune system might inspire nostalgia. It is perhaps the same sort of nostalgia that soldiers report feeling for their wartime experience, a heightening of the senses and of camaraderie that cannot be replicated in any other time of life. In similar fashion, Douglas Crimp has talked about mourning for what he calls "the highly creative ethos about sexual pleasure" in US gay men's 1970s practice (Takemoto, 2003: 86). In an essay on time and queer theory, Elizabeth Freeman has discussed Nguyen's short film *K.I.P.* (2002), made one year later than Bordowitz's, in terms of this nostalgia. The film "cuts between a 1970s pornographic videotape and an image of Nguyen's face reflected in the television set" (2005: 65). This interface between an era of white gay male liberation and its unprotected sexual freedom of the 1970s with a young Vietnamese-American, born in 1971, produces a number of unexpected associations

Figure 10.4 A still from *Habit* (dir. Gregg Bordowitz, 2001)

– pleasure, nostalgia, racism, AIDS – in what Walter Benjamin called a "dialectical image." While Nguyen's own response is unknowable, the film is intriguing because it attempts to visualize loss in the expanded present as something other than just loss, as a complex and mediated interface of race, time, sexuality and desire.

In recent work from South Africa dealing with the AIDS crisis, one can see a different configuration of time in response to the epidemic, centering on the figure of the child. In 2005, the AIDS charity AVERT estimated that there were some 15 million children who had become orphans as a result of AIDS, with some 1,200,000 in South Africa alone. In this context, the child becomes a critical symbolic figure. The photographs of Zwelethu Mthethwa were discussed in Chapter 8. Less familiar in international venues is Mthethwa's multi-media work. For the exhibition and subsequent auction *Art Works for AIDS* (2000), first held in the Durban Art Gallery as part of the international AIDS conference that year (also attended by Gregg Bordowitz), Mthethwa contributed a piece called *Open Letter to God*. This work is an assemblage of fragments, many depicting children's ears, with an outstretched hand, a photograph cut off halfway up the body by the frame of the piece, and two headshots that are obscured by a large swath of fabric that dominates the image. It appeals to touch and hearing but refuses sight, as if to say in the manner of the modern police, "move on, there's nothing to see here." The child is not yet a subject, a minor by definition, but has been forced by South Africa's political and now epidemiological history to take on the responsibilities and burdens of adulthood. If it was the Soweto school strike of 1976 that began the collapse of apartheid, there is far less sense of hope in Mthethwa's appeal to fate in the face of a relentless virus.

This crisis of futurity was also addressed by the white South African artist Penny Siopis in her contribution to the exhibition. Her photograph *AIDS–Baby–Africa* (1996) shows a baby swaddled in red ribbon, the international sign for AIDS activism, because, as she explained:

> I wanted the ribbon to seem both threatening and containing. The baby is both mummy and newborn, cold and warm, dead and alive. A generic baby. She/he may thus provoke more general questions about AIDS. But my interest is in Africa and how the "universal" sign of AIDS awareness – the red ribbon – can be empty rhetoric if action is missing.

This use of a very young child seems almost shocking but expresses a direct challenge to the viewer as it confronts our look. We are forced to recognize that although we do not know the name or gender of the child, we will have identified its ethnicity. If this baby is seropositive for HIV, is it a threat or a cause for concern? The placing of ribbon over all the head except the eyes creates an effect of veiling that cannot be avoided post-9/11 but was presumably not intentional. It reminds us of how long we have been at war against an "enemy within," first communist, then viral, now

Figure 10.5 Penny Siopis, *AIDS–Baby–Africa* (1996). Cibachrome photograph, 100 × 80cm © Artist's collection

terrorist. It asks us to what effect and for what results these wars have been waged? Above all, we cannot be sure if the child is alive. In the context, this might lead us to ask what kind of life awaits an African child, especially an HIV-positive child, or one orphaned by AIDS? Looking at this photograph now, it seems that the AIDS Africa baby had a clear vision of the kind of decade that was going to open the twenty-first century. The very metaphor of the "child" itself is in question, suggesting that this is a moment not so much of death as one that is waiting to mature, putting the infantile and infantilizing into dialectical tension. The subsequent chapters therefore explore first the visual culture of celebrity and death in the expanded present and next the tension of this expanded present in the age of permanent civil war waged by and about images.

Note

1 Or in its new and apparently more accurate but less evocative translation, "the age of technological reproducibility."

References

Barthes, Roland (1981), *Camera Lucida: Reflections on Photography*, New York: Noonday.

Becker, Carol (2006), "Gandhi's Body and Further Representations of War and Peace," *Art Journal*, vol. 65 no. 4, pp. 79–95.

Benjamin, Walter (1940), "On the Concept of History," trans. Lloyd Spencer, http://www.sfu.ca/~andrewf/CONCEPT2.html, accessed October 21, 2005.

Bordowitz, Gregg (2004), *The AIDS Crisis Is Ridiculous and Other Writings, 1986–2003*, Cambridge, MA: MIT Press.

Buerger, Janet E. (1989), *French Daguerreotypes*, Chicago, IL: University of Chicago Press.

Burgin, Victor (1996), *In/Different Spaces: Place and Memory in Visual Culture*, Berkeley: University of California Press.

Crimp, Douglas (1989), "Mourning and Militancy," *October*, vol. 51, pp. 3–18.

Freeman, Elizabeth (2005), "Time Binds, or, Erotohistoriography," *Social Text*, 84–85, vol. 23 nos. 3–4, pp. 57–68.

Goldin, Nan (1996), *The Ballad of Sexual Dependency*, New York: Aperture.

McCauley, Elizabeth (1994), *Industrial Madness*, New Haven, CT: Yale University Press.

Miller, D.A. (1989), "Sontag's Urbanity," *October*, vol. 49, pp. 91–101.

Mitchell, William J. (1992), *The Reconfigured Eye*, Cambridge, MA: MIT Press.

Mitchell, W.J.T. (2005), *What Do Pictures Want? The Lives and Loves of Images*, Chicago, IL: University of Chicago Press.

Ritchin, Fred (1990), *In Our Own Image: The Coming Revolution in Photography*, New York: Aperture.

Sekula, Allan (1986), "The Body and the Archive," *October*, vol. 39, pp. 3–64.

Silverman, Kaja (1996), *The Threshold of the Visible World*, New York and London: Routledge.

Siopis, Penny (n.d.), Commentary on *Aids–Baby–Africa*, http://www.thebody.com/visualaids/artworks/siopis.html, accessed January 1, 2007.

Sontag, Susan (1977), *On Photography*, New York: Farrar, Straus and Giroux.

—— ([1978] 2001), *Illness as Metaphor*, New York: Picador.

—— (1989), *AIDS and its Metaphors*, New York: Hill and Wang.

Tagg, John (1988), *The Burden of Representation*, London: Macmillan.

Takemoto, Tina (2003), "The Melancholia of AIDS: Interview with Douglas Crimp," *Art Journal*, vol. 62 no. 4, pp. 80–90.

Tuchman, Phyllis (2003), "On Thomas Struth's 'Museum Photographs,'" on *Artnet*, http://www.artnet.com/magazine/features/tuchman/tuchman7-8-03.asp, accessed January 27, 2006.

Williams, Raymond (1977), *Marxism and Literature*, New York: Oxford University Press.

SPECTACLE AND SURVEILLANCE

The spectacle is not a collection of images, but a social relation between people, mediated by images.

Guy Debord

In 1967, the French filmmaker, theorist and activist Guy Debord published a series of theses about modern consumer society under the provocative title *The Society of the Spectacle*. Debord was a key figure in the Situationist International, a small but highly influential group of artists, architects, writers and activists, dedicated to a radical transformation of everyday life. Rejecting the established political parties, the Situationists saw the primary drama of modernity as being what they termed "the colonization of everyday life." Coined in 1961, this evocative slogan resonated still further in France, which was then engaged in a violent struggle against an independence movement in Algeria that had split French society and caused the collapse of the Fourth Republic in 1958. In this context, Debord suggested that the function of the spectacle is "to make history forgotten within culture" (Debord, 1977: 191). In the society of the spectacle, individuals are dazzled by the spectacle into a passive existence within mass consumer culture, aspiring only to acquire yet more products. The spectacle is at "the heart of the unreality of real society." By the same token, that "reality" is itself massively invaded and formed by the spectacle, which is therefore real.

The spectacle (which, in French, can also mean a theatrical play) is above all a visual illusion. In this view, just as the commodity hides itself using commodity fetishism – "buy me, I'll make you more attractive" – the spectacle conceals the workings of capital. In this sense, Debord argues "[t]he spectacle is *capital* to

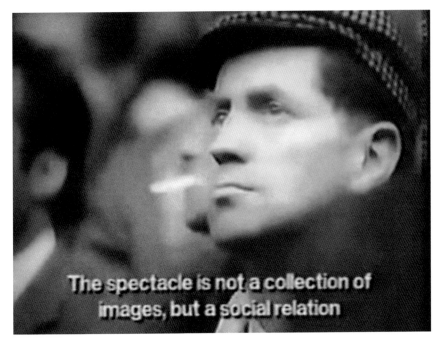

The spectacle is not a collection of images, but a social relation

Guy Debord, from *The Society of the Spectacle* comic book

such a degree of accumulation that it becomes an image" (Debord, 1977: 32). One of the most striking examples of this process is the all but autonomous life of certain corporate logos, like the Nike swoosh or McDonald's Golden Arches, which are inevitably legible in whatever context they are encountered. That is, we see the Golden Arches logo of McDonald's but not the poor nutritional quality of their "food" or the equally poor working conditions of their staff. In this way, the spectacle does the labor of looking for us: find a Starbucks logo and you have found coffee, lifestyle, like-minded people or even an identity. The connection between labor and capital is lost in the dazzle of the spectacle. In the spectacular society we are sold the sizzle rather than the steak, the image rather than the object. Logos have become instantly recognizable, prompting the consumer to buy and assuring the brand of market domination. Similarly, Interventionist artists can use these logos as a form of what Debord called *détournement*, or detour, as in the work of AdBusters or similar groups. These visual puns nonetheless rely for their effect on the recognizability of the logo: the work would not be funny if it was not instantly identifiable.

For Debord, the spectacle was evidence of a decline in social life first from "being" to "having" and now ending at "appearing": "the spectacle is the bad dream of modern society in chains, which can finally only express its desire to sleep." Debord went further here than his predecessor Walter Benjamin who

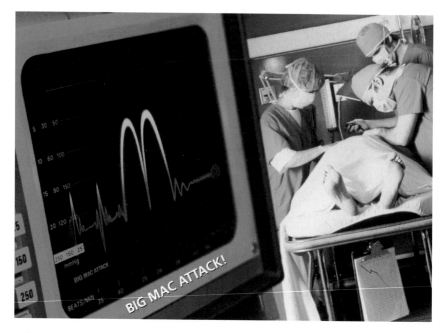

AdBusters, *Big Mac Attack!* Courtesy www.adbusters.org

had also understood the importance of the commodity image in shaping everyday life but hoped for an "awakening" from the sleep induced by consumer society. Debord saw the spectacle as the commodification of all social life, including the critique of the spectacle. He satirically quoted the American sociologist Clark Kerr's calculation that "the production, distribution and consumption of knowledges already accounts for 29% of the gross annual product of the United States" (1977: thesis 193). That is to say, what has become known as "immaterial labor," work that has no concrete expression, from piano playing to surgery and visual culture criticism, was set to become for the latter half of the twentieth century what the automobile industry had been for the first half. Kerr at this time was President of the University of California, Berkeley, and was the target of the Free Speech Movement on campus. He had promoted what he called the "multiversity," based on a concentration of knowledge in expanded institutions that would serve economic and social development. While such goals are now standard university fare, at the time it was seen as an abandoning of intellectual ambitions. Debord equally saw art as being redundant, merely another form of commodity. His tactic against the spectacle was the *détournement*, "the fluid language of anti-ideology" (1977: thesis 208), requiring plagiarism as its means (which might be why plagiarism is the one offence that universities all agree must be punished).

When the French students revolted in May 1968, their slogan "Take Your Desires for Reality" was an optimistic form of Situationism. Debord's work came to seem prophetic and he and the other Situationists were closely involved in the revolution, printing posters and other materials, while leading the occupation of the Sorbonne. In an assessment published in 1969, Debord did not see the restoration of de Gaulle's government in June 1968 as a defeat. Rather he argued that until the class-based society was overturned all revolutions were necessarily failures. For the Situationists, 1968 was the "rediscovery of history," that is to say, the emergence of a place outside the timelessness of the spectacle (Debord, 2006: 918). This rediscovery was not a once and for all event for, as he himself anticipated, Debord's notion of an image-based society has become a truism of popular culture. He mocked those like Daniel Boorstin who criticized the "pseudo-events" of modern image-dominated society for thinking that there could be a return to "real" life outside the spectacle. But there are difficult questions implied by his formula. In the Marxist language he was using, capital must not only continue to circulate in order to survive but it must also be exchanged. To make this possible, societies have evolved the money form as what Marx called the "universal equivalent" for value. Value is itself a socially constructed and mediated relationship that links the object to the use to which it can be put as a commodity and that for which it can be exchanged. The spectacle must also follow this dynamic of circulation and exchange as a form of concentrated capital. How can images themselves, as capital, be exchanged?

One fruitful way of negotiating the question of exchange in relation to the image would be to say that the image itself is now the commodity and that money is exchanged for the image and then reconverted to capital. There are instances where such a formula works very well, such as advertising, pornography or Hollywood cinema. It does not, however, account for all images. W.J.T. Mitchell has usefully suggested that the spectacle needs to be understood as being one part of a structure completed by surveillance. If spectacle distracts by illusion, surveillance claims to see what is real: "Spectacle is the ideological form of pictorial power; surveillance is its bureaucratic, managerial and disciplinary form" (Mitchell, 1994: 327). Thus Foucault and some of his followers liked to argue that modern power was based on surveillance rather than the spectacle but that was to address only one side of the equation. Since the 1970s, one of the striking phenomena that have come to make visual culture seem a vital topic has been the convergence of spectacle and surveillance. In Britain today, for example, there are 4.2 million closed circuit television cameras, making almost every action in public spaces liable to be seen by the cameras. Transport systems encourage passengers to act as surveillance: "if you see something, say something." In New York City, the 1,944 reports to transport police in 2007 were then made the subject of another advertising campaign, even if the figure might seem a little low for a city of 12 million people.

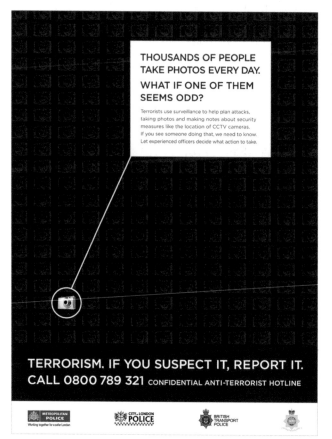

Anti-terrorism CCTV camera poster (Metropolitan Police)

This convergence took cinematic form in the German film *The Lives of Others* (2006), directed by Florian Henckel von Donnersmark. *The Lives of Others* recreated the daily life of the German Democratic Republic, or East Germany, with great fidelity in terms of color, feel and props. It told a story of surveillance by the State Secret Police, known as the Stasi, on one of its leading citizens, a pro-government playwright Georg Dreyman (Sebastian Koch). The surveillance was motivated by a government minister's desire for Dreyman's girlfriend Christa (Martina Gedeck) and ends up producing change, compromise and ultimately betrayal from all concerned. So far so realistic: the Stasi were astonishingly thoroughgoing in their suspicion, like the Spanish Inquisition before them, and ruined countless lives. The film introduces the element of spectacle when it allows Hauptman Gerd Wiesler (Ulriche Mühe), the top Stasi agent assigned to the case, to become sympathetic to those he is watching and to cover their tracks from his superiors. His cover-up allowed Georg to publish an article in the West German magazine *Der Speigel*, highlighting the high suicide rate in the GDR after a fellow playwright, blacklisted for his political opinions, had

A still from *The Lives of Others* (dir. Florian Henckel von Donnersmarck, 2006)

killed himself. *The Lives of Others* wanted us to believe that what brought down the Stasi was people's inability to act inhumanely. A more prosaic approach would have emphasized the failure of the GDR to switch from analog to digital surveillance, despite its immense efforts through its Robotron company that some have suggested contributed to the financial collapse of the system.

At the time of writing, the Bush administration in the United States is campaigning for legal immunity for the telecommunications companies that generated records of tens of millions of domestic phone calls and emails since 2001 at its request. The technical capacity to monitor and store such massive quantities of data was something the Stasi could only envy, even as they clearly aspired to it. In this regard, the politics of the Bush administration were strikingly similar to those of the GDR, although the similar rhetoric had different objectives. Whereas the United States offers absolute consumer freedom to those who can generate the necessary financial means, the GDR offered a social contract based on absolute subjection to the state in exchange for a guaranteed (low) level of social and welfare provision. The official position of the ruling Socialist Unity Party (SED) was that "there exists no objective political or social basis for opposition to the prevailing societal and political order." For George W. Bush, you were "either with us, or you are with the terrorists." Both claimed that they were defending what the SED called "a comprehensive form of democracy." Each would argue that they were sincere and the other merely mouthing platitudes. While the United States has yet to become a police state in quite the same way as the GDR, American audiences clearly recognized something of their own daily lives in *The Lives of Others* and the film won an Academy award.

References

Debord, Guy (1977), *The Society of the Spectacle*, Detroit: Free Press.
—— (2006), *Oeuvres*, Paris: Gallimard.
Mitchell, W.J.T. (1994), *Picture Theory*, Chicago, IL: University of Chicago Press.

CELEBRITY

From Imperial Monarchy to Reality TV

O N AUGUST 31, 1997, I was watching TV in Madison, Wisconsin. The film was interrupted and an emotional British broadcaster announced the death of Diana, Princess of Wales, as she had become known following her separation from Prince Charles. At first this seemed simply another instalment in the series of disasters that had followed from the British Royal family's effort to convert itself from an imperial monarchy into a media phenomenon. Diana's death was certainly a phenomenon but not one quite to their liking. Before her death, Diana was a combination of pop star, fashion model and royal figurehead, the most photographed person in the world. When she died, she unleashed a global mourning that had its most notable, if short-lived, consequences in Britain. A decade later it can be seen that Diana's death did not, as some had hoped, bring about a republican Britain or even a more democratic one. It seems now to mark a watershed in the notion and function of celebrity. Daniel Boorstin had defined a celebrity as someone who was famous for being famous as long ago as 1959. Yet the numbers of people who attained this category were, until the advent of the Internet and Reality television, quite limited. Now celebrity has become a career to which it is possible to aspire: an appearance on *Big Brother*, some talk shows, a game show or two and a re-entry via *I'm a Celebrity, Get Me Out of Here!* When Andy Warhol said that in the future everyone would be famous for 15 minutes, it turned out he exaggerated only how long fame would last.

Inventing traditions

The historians Eric Hobsbawm and Terence Ranger identified a pattern in nineteenth-century imperial societies for what they termed the invention of tradition (1983). Most notable among these traditions was the reimagining of the British

monarchy as an empire. When Queen Victoria was crowned in 1837, there was extensive distrust of the monarchy among the working classes, culminating in the Chartist movement that campaigned for universal manhood suffrage for annually elected Parliaments and an end to aristocratic privileges. The Reform Acts of 1832 and 1867 did remove the worst excesses of the old system and allow for an expansion of voting rights, if a long way short of Chartist hopes. However, following what the British termed the Indian mutiny of 1857, the monarchy reassumed direct government of the subcontinent, starting a trend that saw other colonies such as Jamaica revert to direct rule. Where it had seemed in the early nineteenth century following the abolition of slavery that Britain was likely to convert its colonies into self-ruling dependencies, it had become a traditional empire by the 1870s.

On New Year's Day 1877, Queen Victoria was declared Empress of India in a wholly invented ceremony held in Delhi. As devised by Field Marshall Lord Roberts, the event combined the award of honorific medals and banners to Indian "chiefs and princes," followed by the pageantry of the main event:

> Three tented pavilions had been constructed on an open plain. The throne-pavilion in the center was a very graceful erection, brilliant in hangings and banners of red, blue, and white satin magnificently embroidered in gold with appropriate emblems. It was hexagonal in shape, and rather more than two hundred feet in circumference. In front of this was the pavilion for the ruling chiefs and high European officials, in the form of a semicircle eight hundred feet long. The canopy was of Star of India blue-and-white satin embroidered in gold, each pillar being surmounted by an imperial crown.
>
> (Roberts, 1877)

This pomp and circumstance was imagined out of the medievalism then prevalent in Victorian high culture and has come down to the present as British royal tradition. Then as now it was as much a part of mass popular culture as elite ritual, with postcards of Queen Victoria as Empress being produced alongside oil paintings and the other now familiar commemorative panoply of monarchical kitsch. Hobsbawm pointed out that alongside this invention of monarchy came the invention of working-class culture in Britain with distinctive forms of dress, food and socializing. The "tradition" of fish and chips dates from this period, as does the adoption of the flat cap distinguishing the working man (gender intended) from the businessman's bowler hat and the aristocrat's top hat. Social events such as supporting football (soccer) clubs and drinking beer in pubs further reinforced this identity. The development of trade unions and then the Labour Party gave a political dimension to this formation of a working class. The interface between imperial governance and working-class political culture dominated British life in the twentieth century. The relationship was by no means entirely antagonistic for the white working class were often among the most enthusiastic supporters of imperial ventures.

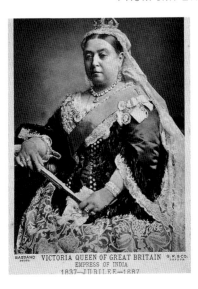

Figure 11.1 Postcard of
Queen Victoria as
Empress of India

The work of the photographer Bill Brandt (1904–83) is often used to illustrate such divides. Understood more closely it can be seen as highlighting the difficulty of making such snap judgments. Brandt was born in Hamburg, Germany; although his father was British, he did not go to the UK until 1931 at the age of 27. Influenced by German Expressionism, he carefully arranged his photographs to offer the maximum in visual contrasts. His evocations of working-class life have become classics, such as *Miners Coming Off Shift* (1931) that showed a group of miners coming up the pit shaft in a lift, covered in dirt but wearing their caps and jackets. The outline of the mine's winding gear is projected in shadow onto their bodies in dramatic fashion, enhanced by Brandt's tendency to print his work so that the contrasts between light and dark were maximized. In his 1936 book *The English at Home*, Brandt highlighted the social contrasts of the period in photographs such as one showing two young men wearing top hats and tails, lying on the grass watching a cricket match. The very low camera angle makes the cricketers appear right at the top of the picture in miniaturized form, while the children of wealth seem oblivious both to the game and each other.

After World War II, the incoming Labour government created the social provisions that came to be known as the welfare state, such as the National Health Service and greatly expanded higher education. At the same time, Britain's empire was coming to an end with the achievement of Indian independence in 1947 and the decolonization of Africa in the 1950s. In this context, the monarchy came to seem marginal and out of touch. Not long after her 1953 coronation, the popular press was criticizing Queen Elizabeth II for being aloof and rarely smiling, a perception that became widespread in the 1960s (Kelley, 1997: 202). In 1969, the Queen wore a simple dress and hat rather than robes and a diadem for the investiture of the Prince of Wales in response to pressure from Welsh nationalist sentiment.

During the Queen's Silver Jubilee in 1977, Britain seemed divided over whether to celebrate or mourn the event. Britain's social fabric was under stress with inflation generating strikes and unemployment. So severe was the financial crisis that the International Monetary Fund had to bail out the government. While many areas organized Jubilee street parties and other celebrations, the Sex Pistols' ironically titled single "God Save the Queen" was at the top of the charts, despite being banned by the BBC. The top chart position in many record stores was left blank, as if it were too much to even acknowledge the single. Punk challenged the postwar consensus in Britain by refusing to see the victory over Hitler as defining everyday life over 30 years later. Some wore swastikas and other Nazi regalia in defiance of the parental dictum "I fought the war for you," a tactic that backfired when resurgent extreme-right activists of the National Front adopted the emblem in its original meaning of racial supremacy.

These tensions were visible in the Anti-Jubilee issue of the *New Statesman* magazine, an influential center-left journal. It recorded the thoughts of some 9-year-olds in North London about the monarchy, such as this typical comment:

> I don't like the Queen because she is too posh. She is too fussy. She looks like the Joker with her white face and red lipstick and she looks like a puff porcupine with those dresses and she thinks too much of herself and she doesn't care about the poor.
>
> (Fenton, 1977)

This critique concentrates on appearances. The Queen's clothes seem out of touch and her self-presentation makes her look like a comic-book villain rather than a hero. In the words of the Sex Pistols, "she ain't no human being." The former schoolchild would have been 29 at the time of Diana's death, typical of so many mourners in the streets of London. Yet in the same issue, the *New Statesman* had editorialized that "the monarchy is a dead hand, and that is bad enough: but it is a dead hand that could come dangerously alive . . . [given that] parliamentary democracy is extensively discredited in the popular mind and not entirely secure." The issue in mind here was the widespread concern as to what the Queen might do if no party secured a majority at the election anticipated for 1978. With no written constitution mandating that the party with the greatest number of seats be invited to form a government, leftists were worried that the Conservatives might be able to use the monarch as a means to return to government. In the event Margaret Thatcher's party won easily in 1979, beginning 18 years of Conservative government that would bring neoliberal economic and social policies not just to Britain but, in concert with Ronald Reagan's presidency (1980–8), to much of the Western world.

In 1981, these policies had generated over two million unemployed, the highest levels of unemployment since the great Depression of the 1930s. So when Prince Charles and Lady Diana were married, many saw the spectacle as a crude attempt to distract attention from such problems. Feminists wore buttons saying "Don't Do

it Di," but the wedding was a dramatic success. Looking back at the photographs circulated after their engagement now, it seems strange that the apparently self-evident lack of empathy between the two and the disgruntlement of Charles were not commented on. Instead, much was made of the presumed shy simplicity of the daughter of an Earl, who had already fashioned her signature look to the camera up through her eyelashes with her head tilted downwards. As Roland Barthes told us, "what founds the nature of photography is the pose" (Barthes, 1981: 78). Like Madonna, Diana had raised the art of posing to new heights. But, as Madonna has often said, there is nothing inherently novel about such self-fashioning, so typical of young women who follow fashion and popular music. Diana and Madonna were able to live out this fantasy on a global stage because of the new capacity of electronic communications to circulate images instantaneously around the world. For the tabloid journalist Harry Arnold, the conclusion was straightforward: "It was, to a certain extent, a marriage made by the media. She was created, if you like, as a bride for Charles." No doubt this was the royal intent. In 1977 it was said of Prince Charles, quoting the usual "sources," that "he will marry someone pretty and respectable quite soon and that she will then 'stay in the background as far as possible.'" Diana's ultimate refusal to be the passive object of such media fashioning upset this simple plan. The various royal writers all agree that Diana's self-perception was transformed by her joining the media monarchy that the Windsors had become. Her biographer Andrew Morton attributes the damage to Charles himself, who commented on her being "chubby" just before the wedding (Morton, 1997: 128). Royal watcher Kitty Kelley asserts that in addition to Charles's comments, Diana was mortified by seeing herself appear "fat as a cow" on television (Kelley, 1997: 276).

Her physical appearance changed drastically so as to meet the media demand for slender, firm bodies, caused first by bulimia and later by her daily workouts at the gym. The media audience endlessly vetted every new look, so that it can be said that it created the princess it wanted to see. For example, in the famous photograph of Charles and Diana kissing on the balcony of Buckingham Palace after their wedding ceremony on July 29, 1981, Diana's face is upturned, her neck fully extended, a pose that was adopted to suggest she was putting her whole being into the kiss. Charles stands upright, his head barely inclined towards his new wife, with his lips slack. Even at the time his hesitation was apparent and it has now become known that he asked his mother's permission to make the kiss at all. The mythology of the young girl marrying a prince is of course sealed with a kiss. In re-enacting this role, Diana in effect made herself into a classic film star. She belonged here to the ranks of the old-fashioned stars in whose films the kiss comes to stand for the highest point of passion, that which Edgar Morin called the "eroticism of the face" (Dyer, 1979: 52). Diana became a representative of a new generation of women, as the journalist Tina Brown pointed out in 1985: "[Diana is] one of the new school of born-again old fashioned girls, who play it safe and breed early. Post-feminist, post-verbal, her femininity is modelled on a Fifties concept of passive power" (*Observer*, September 6, 1997). Like the earlier film stars, Diana's face came to stand not only for her own

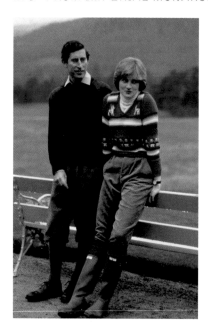

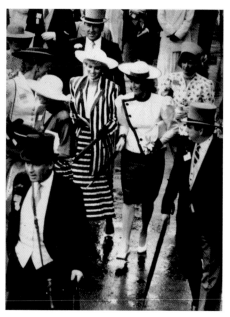

Figure 11.2 Prince Charles and his fiancée Lady Diana Spencer at Balmoral. Photo by Tim Graham/Getty Images

Figure 11.3 Diana and Sarah Ferguson, then Duchess of York, at Ascot (1984)

subjectivity but also for that of the many women who identified with her. Ironically, it was to be Diana who achieved what decades of leftist and republican comment had not, a mass media discrediting of the monarchy.

At first, this refashioning was far from apparent. Early royal photographs of Diana and Charles with their children (the "heir and a spare" required of the next-in-line to the throne) taken by conventional portrait photographers like Lord Snowdon were typically unimaginative depictions. At this point, Diana and other young royals like "Fergie," or Sarah Ferguson, then Duchess of York, were part of an attempt by the monarchy to create a media-friendly modern organization. In one typical picture, Fergie and Diana can be seen at Royal Ascot (a horse-racing event attended by the Royal family), overdressed in typical Ascot style but poking a man in a top hat straight out of a Bill Brandt photograph with an umbrella. As the royal marriages collapsed, Diana came to use the media to signal her discontent. The best-known example, prior to the public separation, was a photograph taken at the Taj Mahal, India, in 1992. This monument to eternal love is a compulsory destination for all Western tourists to India (with the recent exception of George W. Bush) and Diana followed in the photographic footsteps of many celebrities on her visit. The Queen and Prince Philip had visited it on their tour in February 1961, but by moonlight so that there were no photographs. Instead, the royal couple posed for pictures standing behind the corpse of a 9.5 feet long tiger that Prince Philip had shot himself. In

1962, Jackie Kennedy was photographed at the Taj, standing by the bench at the pool. The monument cannot quite be seen in its entirety as the photographer has placed her slightly to the right of center. The result is a sense that she commands the image and the building behind her, as Wayne Koestenbaum elegantly remarks:

> Like Versailles, or the White House, the Taj Mahal is a monument that measures Mrs. Kennedy's scale and sublimity. Photographed in front of it, she seems tiny – but it's also as if the Taj Mahal has become her extension, proxy, and possession, and so she can absorb and claim its size.
>
> (1995:102)

The claim seems grandiose, but events have repeatedly shown the degree of investment that viewers place in celebrity images.

Thirty years later, it was Diana's turn to pose in front of the Taj Mahal, while on a state visit to India with Prince Charles. Like Jackie Kennedy, she visited the monument alone but created photographs with an entirely different resonance. She was photographed in the same classic spot but sitting on the bench, rather than standing. Further, the published photographs used a wider angle for the shot and excluded the pool of water in front of the Princess from the picture. The result is that Diana seems overwhelmed by the monument, rather than in charge of it as Jackie had been. Her figure is almost a detail in the overall image but we can

Figure 11.4 Diana, Princess of Wales sits in front of the Taj Mahal during a visit to India, 11 February, 1992. Photo by Tim Graham/Getty Images

recognize the signature tilt of the head and upward gaze. Without the water in the image, the mass of white marble and cloudless sky give a sense of oppressive heat. Diana's clothing is unremarkable with its red and pink accents emphasizing her loneliness by its discordance with the Taj Mahal. Television coverage of the event showed that there was in fact a veritable horde of camera people and photographers recording the Princess from the other side of the pool. Nonetheless, the resulting photographs became very evocative statements about lost love, all the more effective for their use of such a visual cliché as the Taj Mahal. For the British public, to whom these photographs were primarily addressed, the Indian setting was highly appropriate to the theme of loss. What Salman Rushdie has called "imperial nostalgia" achieved very high profile in the 1980s with the popular television series "The Jewel in the Crown" and films like *A Passage to India* setting the nostalgic tone. These echoes of empire were of course the hallmark of the Thatcher government, especially after its victory in the 1982 Falklands War. Ten years later, John Major's government had no dreams of glory and the royal family were beginning what the Queen was to call her "*annus horribilis*." The loss that Diana represented at the Taj was not just that of her dreams for her own marriage but the disillusionment of many Britons, especially those who had not benefited from the short-lived boom of the 1980s, with the neo-imperial dreams of modern Conservative politics. Diana's image was so notable because it was able to cross the gap from the personal to the political, in ways that academics, politicians and writers had not been able to emulate.

People came to invest photographs of Diana with an astonishing range of meanings. One example is provided by the writer Blake Morrison:

> I met her once at a Red Cross fund-raising event. "Met" is pushing it: I stood in line, along with various other writers, and she shook my hand and passed along. But I have the photograph. She has dipped her head to make her eyes bigger and is giving me That Look, the look that said (slightly mischievously) we're in this together, the look that made you think of Byron ("so young, so beautiful,/So lonely, loving, helpless"), the look you knew she'd given everyone else in the room but sent you away feeling the charity work was worth it, that with a bit more effort the world, in time, might be a kinder, better, more tolerant place.
>
> (Morrison, 1997)

All that came not from the meeting itself, too transitory to generate any memory or association, but from the photograph. Diana saw her charitable work as "awaydays" to meet the "Tescos"; that is to say, one-day round trip excursions to meet ordinary people, who might shop at the standard British supermarket Tesco. So the thoughts running through Morrison's head were very unlikely to have originated with her. The photograph, which comes to serve as his prosthetic memory for this briefest of encounters, in fact creates a virtual meeting with "Diana" that never happened but might have done. In the manner of fans everywhere,

Morrison finds his own range of meanings in the photograph, beginning, as for so many others, with Diana's gaze, the upward look of her blue eyes from her downcast head, creating a powerful sense of presence and need in men and women alike. Her gaze led Morrison, himself a poet, to think of Byron (switching her gender), and then to muse on the very Romantic goal of creating a better world. He is too careful and intelligent a writer to say this without a hint of British irony but I don't doubt that, at least for the instant of his encounter with Diana's photograph, he meant it.

Far from the traditionally dowdy upper-class matron of early years, Diana became a fashion model, paying as great attention to her hair and clothes as any other A-list celebrity. Perhaps the best example of these reinventions was the striking Valentino off-the-shoulder black dress she wore to an opening at the Serpentine Gallery in June 1994 on the same night as Prince Charles announced on national British television that he had committed adultery with Camilla Parker-Bowles. Her confident, sexy image was the perfect counterpoint to the televised confession of a kilted Prince Charles. His awkwardness contrasted with her confidence, his anachronism with her modernity, above all her desirability with his ordinariness. The contrast was so powerful because Diana's image was so familiar and well known. Only through daily repetition in the media of her appearance could she make such a dramatic statement. At this time, her face was unavoidable, a seeming constant in the everchanging flow of global media. It was widely observed after Diana's death that she had been the most photographed person of modern times, that is to say the most photographed person ever. Yet in all the newspaper and television montages of these pictures it quickly became apparent that relatively few of these photographs were in any way memorable. For the most part, they consisted of grainy images of Diana going about her "private life" or photo opportunity shots of the Princess arriving or departing from one function or another. The mass media images were memorable photographs only in that you remembered having seen them, for as Madonna said: "All of us, even myself, bought these magazines and read them" (Morton, 1997: 278). It might be more accurate to say that we looked at these magazines in the supermarket check-out line, but nonetheless we had seen them.

Less widely remarked was the extent to which the late 1990s were characterized by a fascination with mediated looking at women enabled by new media. The webcam format that was one of the "killer apps" of the Internet at that period first achieved notoriety as a view of a Cambridge University coffee pot, designed to let researchers know if coffee was available. It came to have its own unlikely popularity, as did webcams looking at traffic lights or views of cities. Soon people were turning the cameras on themselves, led by young women. In 1995, Dale Spender had pointed out that "Women are being kept out of cyber-communication with an electronic version of interruption and intimidation . . . women are being silenced on the net." Sites like jennicam [sic], one of the best known webcam sites, ended that silence. Jennicam consisted of the view from a webcam attached to a computer in Jennifer Ringley's dorm room at Dickinson College, where she was a student. Set up in 1996 when she was 19, the site refreshed its view of her room every three

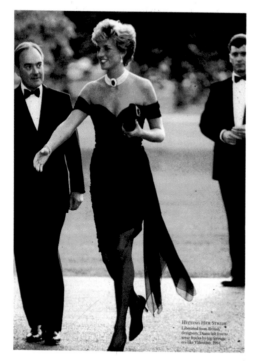

Figure 11.5 (left) Diana in Valentino
Figure 11.6 (above) A still from Jennicam by Jennifer Ringley

minutes. The technology seems quaint in today's world of real-time streaming video, a technology first developed for pornography sites. Much of the time jennicam would show Jenni working on the computer or doing other mundane tasks. As her site homepage stated, "I am doing jennicam not because I want other people to watch but because I don't care if people watch." Whereas the male gaze was structured around voyeurism, a looking in which the looked at was unaware of being under surveillance, the watcher here knew that the watched was not only aware of being watched but had enabled it (Burgin, 2000). Jenni was first adopted by other women and by artists – in fact, I first learnt of the site in a presentation by a self-described queer feminist video artist. As an extension of her willingness to be watched, Jenni would occasionally appear naked and sometimes stripped in front of the camera. As her audience grew, reaching an estimated four million, the site established a premium access category in which for $19.95 a month, viewers had permanent live access. At the same time, this pricing strategy seems to have increased the pressure on Jenni to appear naked or having sex. When she closed the site in 2003, she attributed her decision to PayPal's refusing to process payments for what it saw as a pornography site. Certainly, by this time those in search of sexual imagery on the Internet did not have to wait until a webcam provider happened to show it.

Diana's endless photographic representation, culminating in her death in a car crash while paparazzi were chasing the vehicle in which she was being driven, can be seen as the epitome of such new media stories. The audience "knew" her through

her virtual existence, a disembodied presence that circulated through our conscious-ness whether we wanted it to or not. Her last "photograph" was taken by a CCTV camera at the Ritz Hotel, one of the first such images to dominate the news. In an essay that ironically appeared on the very weekend of Diana's funeral, even though it must have been planned months in advance, the American novelist Don DeLillo described how:

> The fame-making apparatus confers celebrity on an individual in a conflagration so intense that he or she can't possibly survive. The quick and pitiless end of such a person's career is inherent in the first gathering glimmers of fame. And this is how the larger cultural drama of white-hot consumption and instant waste is performed in individualized terms, with actors playing themselves.
>
> (DeLillo, 1997a: 62)

Celebrity is the highpoint of a spectacularized consumer culture, in which the product becomes an image in order to attract the greatest possible attention and hence generate the highest possible return. In her interview on British television in 1995, Diana accurately diagnosed herself as a "product on the shelf." Her implied endorsement was capable of generating significant revenues for companies. Six months after Diana was photographed carrying a Lady Dior handbag costing $1,100, given to her by Bernadette Chirac, wife of the French President, 200,000 similar bags had been sold, with an international waiting list. Inherent in the process of being a commodity is a necessary built-in obsolescence.

The transformation of celebrity into a mass phenomenon has broadened the supply of potential "celebrities" to be consumed by the machine (think *American Idol* early round contestants, eliminated *Survivor* participants and so on) as well as multiplying the opportunities for product placement. *American Idol*, for example, generates one of the few guaranteed successful album releases of the year in the era of digital music, as well as delivering one of the last mass media audiences for prod-uct placements. This example suggests that the very multiplication and broadening of desire in all senses engendered by the mass media digital celebrity is in turn about to destroy itself, as the phenomenon becomes routine. By now "reality" television has become a formula that seems more successful in generating niche audiences for shows like *America's Next Top Model* or *Project Runway* than the ratings blockbuster effect of early *Survivor* and *Big Brother* series.

There was certainly an element of desire at play in the mass display of Diana's image. As DeLillo argued, "fame and secrecy are the high and the low ends of the same fascination, the static crackle of some libidinous thing in the world" (DeLillo, 1997b: 17). Part of our involvement with the famous is our desire to expose their secrets, to see what they do not want us to see. In Diana's case, this desire has usually been described as male sexual desire. Certainly such desire was an important element, especially in photographs of her sunbathing or exercising. Most Diana

photographs did not have such obvious sexualized content, however, and were often published in media aimed primarily at women. *People* magazine ran Diana's picture on the cover no less than 41 times in her lifetime, for example. Women's desire to see Diana was every bit as strong, perhaps stronger, than that of men. If there was an element of homoerotic desire in that looking, there was also identification with her as the leading example of how difficult modern life can still be even for women who seem to have it all. Diana's ability to communicate her difficulties through photography was matched by the ability of her female audience to analyze and give meaning to fragmentary changes in appearance. As numerous commentators have argued, this skill in fragmented looking is learned from the same women's magazines that so frequently featured Diana's image. In Diana Fuss's view, the fragmented body parts seen in fashion photography are a visual reminder of the construction of female subjectivity in relation to the (m)other's *imago*, or image:

> These images of the female body reenact obsessively the moment of the female subject's earliest self-awareness, as if to suggest the subject's profound uncertainty over whether her own subjectivity "took." This subject is compelled to verify herself endlessly, to identify all her bodily parts, and to fashion continually from this corporeal and psychical jigsaw puzzle a total picture, an imago of her own body.
>
> (Fuss, 1995: 95)

In looking at Diana, many women were reworking their own identities. Diana was the perfect subject for such identification both because of the frequency of her appearance in visual media and her own public struggles with identity. For example, the filmmaker Lucy Pilkington commented after her death:

> She was an outsider. That's why black people like her so much. We know what it's like to try to be as good as you can but never be accepted. Plus, she dated Dodi al-Fayed, an Egyptian. Black people liked that. You could say Diana was a black woman in many ways.
>
> (*Independent on Sunday*, September 7, 1997)

Remarkably, the daughter of an earl and wife of the heir to the throne was able to cross the ethnic divides of postcolonial Britain unlike any other white person.

Little wonder, then, that the death of so over-invested a celebrity, or the end of such a fetishized image, caused such grief. It is important to remember that, for all the subsequent writing on Diana, very few academic and left-wing intellectuals anticipated it at all. The then newly elected British Prime Minister Tony Blair got it right by declaring that there would be grief on an unprecedented scale. For most writers with access to the newspapers and other press, in the pre-blogging age, the phenomenon was mysterious. Darcus Howe, editor of the journal *Race and Class*, saw the reaction to Diana's death as a remarkable moment:

It came like a thief in the night: unheralded and unannounced, united, disciplined and self-organized. The manner of its coming, the stoicism of this huge movement of British people suggests that it has been long, very long in its formation. Not simply a rush of blood with its accompanying hysteria, typical of vulgar spontaneity, but a measured entrance released by the death of its commander-in-chief, Diana Spencer. . . . Those of us who comment on social and political matters . . . did not have a clue about its existence, and along with so much else we have been exposed for a lack of careful observation and serious historical negligence.

(Howe, 1997)

In fact, the means by which Diana was mourned had been prepared by other disasters in the previous decade. What Martin Jacques dubbed the "floral revolution" that took place after her death had in fact become a British rite of passage since Hillsborough and Dunblane. After more than 80 Liverpool football (soccer) fans were crushed to death at Hillsborough during a 1989 F.A. Cup semi-final, Liverpudlians carpeted the gates of Anfield, the club's home ground, with the sea of flowers that were to become the sign of British mourning. The flowers appeared again in 1996 after an unstable man shot and killed 16 schoolchildren in the village of Dunblane, Scotland. It was often said that Britain did not feel like itself during the dramatic first week of September in which the country was wreathed in flowers. More exactly, the sentiments that had previously been seen in the North and in Scotland now came home to the metropolitan center as well.

Diana's funeral was an extraordinary media event by any measure. While 750 million people had watched her marriage, and another 200 million her interview on British television in 1995, a staggering 2.5 billion people were estimated to have watched her funeral. If this figure was correct, it meant that of the three-quarters of the world's population who then had access to television, no less than 80 percent were watching. London police had expected a crowd of six million people but in the end most Britons experienced the funeral like the rest of the world on television. The largest portion of the London crowd gathered in Hyde Park to watch the event

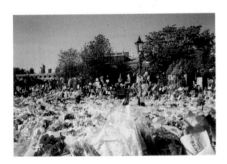

Figure 11.7 Flowers at Kensington Palace

on giant television screens that had been specially flown over from Hong Kong, where they had been used during the ceremonies marking the return of the British colony to China. In two different ways, those screens registered the transformation of the nineteenth-century imperial monarchy created by Queen Victoria.

For all the spectacle of the period surrounding her death, the long-term consequences of the affair were less dramatic. There are parks and memorials to Diana from New York's Lower East Side to Havana, Cuba and Paris, not to mention the constant drizzle of spam claiming to be from the Diana Memorial Fund. The charity created to memorialize Diana built a rather odd fountain, or more exactly a circular waterway. It was plagued with problems from mundane issues like the drains being blocked by leaves to headline-grabbing accidents to children. The British media will often attribute some emotional event that they find vaguely distasteful to Diana's legacy, ranging from tabloid campaigns against alleged pedophiles to the exaggerated support for British tennis players at Wimbledon. The campaign against landmines, Diana's signature issue, remains unresolved with known casualties from mines running at nearly 6,000 in 2007, with the real figure likely to be twice that, given difficulties in obtaining information from places like Afghanistan, Iraq, Burma (Myanmar) and Pakistan, where landmines are prevalent. While Tony Blair's leadership was at first enhanced by his understanding of the Diana issue, the ensuing controversies of his government (1997–2007) were not shielded by her luster. Indeed, Stephen Frears's film *The Queen* (2006) advanced the argument that the Royal Family succeeded in co-opting Blair during the Diana crisis. The film cleverly depicted the surroundings of the royals in 35 millimeter film, giving them all the depth and color of the medium, but shot Blair and his government on video, associating its flat and lifeless feel with the Labour leadership. Little wonder, argued

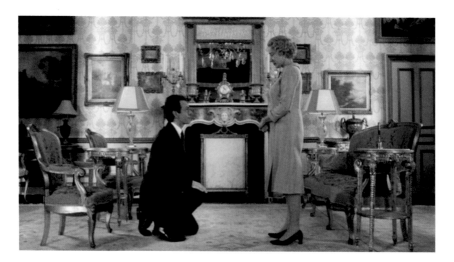

Figure 11.8 A still from *The Queen* (dir. Stephen Frears, 2006)

The Queen, that all Labour Prime Ministers are seduced by royalty. Academy voters agreed, giving Helen Mirren a Best Actress Oscar for her portrayal of the Queen, despite her rather unbelievable epiphany when confronted with a stag. Blair's fatal mistake was going to help George W. Bush in his invasion of Iraq, not the salvaging of the largely irrelevant monarchy.

Nor can it be said that the mass media representation of women has notably transformed itself. Periodically, when a model starves to death, fashion rouses itself to pretend that overly thin women will not be allowed to pose. Even more occasionally, the fashion press laments how few people of color are now being used as models. But the pursuit of women such as Nicole Richie, Lindsay Lohan, Britney Spears and her sister Jamie Lynn Spears – none of whom is necessarily admirable in themselves – has made it clear that the tabloids have no more hesitation in "whacking" women today than they ever did. The difference is arguably only that more women are potential targets because of the expansion of celebrity. The mandatory regime of Botox and plastic surgery (always denied) has been joined by the requirement that actresses now appear with babies, while maintaining perfect figures. Today it's not enough that women do whatever men do but "backwards and in high heels," as Ginger Rogers put it, but those heels must be five-inch spikes from Manolo Blahnik, costing $700 or more. Of course, many women neither live like this nor want to do so but nonetheless feel the pressure to conform. What "reality" television has succeeded in doing is creating a phantasmagoria of reality in which your clothes, hair and personal attractiveness define the real.

While there has not been a long-term politics inspired by Diana's death, the unsuccessful 2008 presidential campaign of Hillary Rodham Clinton seemed to evoke the pattern of mourning she called forth a decade ago. Clinton was not much loved as the "inevitable" frontrunner but once she had lost the Iowa caucuses, she

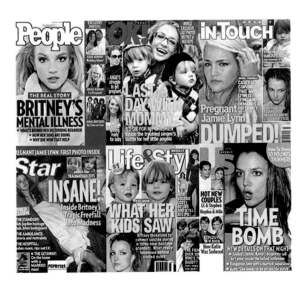

Figure 11.9 Tabloid images of the Spears family

became a passionate cause for many women. The clip of her becoming emotional in New Hampshire did not so much cause this rallying of support as epitomize its structure of feeling as one of mourning. Indeed, the more unlikely her chances of success became, the greater the intensity of support that she attracted seemed to be. Like Diana, who stood as an unlikely champion of the dispossessed, Clinton represented herself as the best hope of both the working-class white man marginalized by globalization and all women's hopes for equality. She won the support of the majority of Democratic women aged 40 and over, and the older those voters were, the greater her margin of victory. For all the iterations of progress, Clinton's campaign evoked an aura of the last, best hope for the women who had experienced the liberations of feminism to see a woman President in their lifetime.

References

Barthes, Roland (1981), *Camera Lucida*, New York: Noonday.

Burgin, Victor (2000), "Jenni's Room: Exhibitionism and Solitude," *Critical Inquiry*, vol. 27 no. 1, pp. 77–89.

DeLillo, Don (1997a), "The Power of History," *New York Times Magazine*, September 7.

—— (1997b), *Underworld*, New York: Scribners.

Dyer, Richard (1979), *Stars*, London: British Film Institute.

—— (1997), *White*, London: Routledge.

Fenton, James (1977), "Why They Hate the Queen," *New Statesman*, vol. 93 no. 2411, p. 730.

Fuss, Diana (1995), "Fashion and the Homospectatorial Look," in *Identities*, ed. Kwame Anthony Appiah and Henry Louis Gates, Chicago, IL: Chicago University Press.

Hobsbawm, Eric and Terence Ranger (1983), *The Invention of Tradition*, New York: Cambridge University Press.

Howe, Darcus (1997), "After Diana," *New Statesman*, September 12.

Kelley, Kitty (1997), *The Royals*, New York: Warner.

Koestenbaum, Wayne (1995), *Jackie Under My Skin*, New York: Farrar, Straus and Giroux.

Morrison, Blake (1997), "The People's Princess," *Independent on Sunday*, September 7, p. 4.

Morton, Andrew (1997), *Diana: Her True Story*, New York: Simon and Schuster.

Roberts, Field Marshall Lord (1877), "When Queen Victoria Became Empress of India," Internet Indian History Sourcebook, http://www.fordham.edu/halsall/india/1877empressvictoria.html, accessed July 3, 2008.

Spender, Dale (1995), *Nattering on the Net: Women, Power, and Cyberspace*, Melbourne, Vic.: Spinifex Press.

THE ABU GHRAIB
PHOTOGRAPHS

When the photographs taken in the Iraqi prison of Abu Ghraib in 2003 and 2004 became public in April 2004, it seemed as if the deployment of the visual media as a weapon by the United States had suffered its inevitable blowback. That is to say, like so many other intelligence assets, the visual image had now turned around to damage its presumed masters. Yet during the subsequent US presidential election campaign of that year, Abu Ghraib never became an issue, so that it was not even mentioned in the debates. Paradoxically, these photographs seem to have remained invisible in the United States even as they were circulated around the world. On the one hand, people find the images too disturbing and upsetting to look at but at the same time, their meaning has remained set for many people from their first moment of revelation. For while the opponents of the war felt that the photographs from Abu Ghraib revealed its truth as torture and barbarism, its supporters could look at the photographs and recognize what was being done as the distasteful but necessary performance of the new imperialism. Several years later, the photographs remain a barbed point of contention, often raised in general terms in public debate but rarely looked at in specific detail. In fact, the United States has taken an official position that justifies so-called aggressive "techniques" of interrogation, never to be named as what they are, torture. The Spanish Inquisition torture now known as "water boarding" being used by the CIA has drawn support from Vice-President Cheney and the then Attorney-General pronounced himself unable to determine whether it was torture or not. The journalist Christopher Hitchens had himself water-boarded and the resulting disturbing video shows the procedure for what it is (see http://www.vanityfair.com/politics/features/video/2008/hitchens_video 200808). At the same time, what kind of world is it in which there are videos of torture to watch?

Academically, the Abu Ghraib photographs stand as a seemingly incontro-vertible "proof" of the importance of the field of visual culture in understanding contemporary society. All the leading critics in the field have published articles or given lectures on the subject and, taken together, these works amount to an impressive display of erudition, insight and political commitment. It has con-tributed to a change of climate, summarized by Major General Antonio Taguba (USA, retired), who was the author of one of the first investigative reports on Abu Ghraib:

> After years of disclosures by government investigations, media accounts, and reports from human rights organizations, there is no longer any doubt whether the current [US] administration has committed war crimes. The only question that remains to be answered is whether those who ordered the use of torture will be held to account.
> (Physicians for Human Rights, 2008: viii)

By contrast, the Fay-Jones report of May 2004 designated the rank-and-file military police as wholly responsible, characterizing them as "morally corrupt" individuals (Greenberg and Dratel, 2005: 1073).

These textual and evidentiary changes are welcome but were in fact always visually obvious. In numerous photographs from Abu Ghraib, detainees were compelled to mimic sexual acts with each other, such as fellatio and anal sex. These strategies were of a piece with the CIA theory, derived from some lamen-tably poor Orientalist anthropology, that such situations would be especially humiliating to what they called "the Arab mind" and would lead to a rapid "breaking" of the prisoners. Another series of photographs produced by British soldiers at Camp Bread Basket, near Basra, reproduced exactly the same scenarios as those seen at Abu Ghraib. They came to light because one soldier took a roll of film to be developed at his local pharmacy, where an attentive assistant reported them to the police. Several consequences can be derived. First, there was a good deal of discussion about the digital character of the Abu Ghraib photographs that the Camp Bread Basket images show to have been misplaced. Certainly, the digital images were circulated more easily but there was no differ-ence in the use of analog and digital photography as a technique of interrogation. More importantly, this use of humiliation constituted a visibly international coalition policy, with links to the similar torture of IRA suspects in Northern Ireland, Palestinians in Israel and, indeed, that of Kenyan prisoners held by the British colonial forces during the Mau Mau rebellion of 1953, who were sodom-ized and even castrated. It clearly beggars belief that ordinary soldiers and reservists from Shropshire, England, and rural Maryland devised such striking visual tactics independently and to exactly the same ends.

Sometimes, however, a superficial look is not enough. For example, the back-ground of the Abu Ghraib guards is important and sheds light on how it was

possible to convince them to carry out such tortures. Metonymically, take Lyndie England. Coming to adulthood in West Virginia, England's only option for employment above minimum wage was a $10 an hour job in a chicken rendering plant. The benefits included management-tolerated abuse of the chickens, ranging from violent methods of killing them to sexualized abuse of the animals. England's boyfriend Charles Graner took her on holiday where he made photographs of them having anal sex that he later showed to her family (McKelvey, 2007: 41–5). No wonder Abu Ghraib seemed more of the same, and England never displayed any understanding of why what she had done was considered wrong. In 1935, W.E.B. Du Bois showed that the cultural benefits accruing to those classified as "white" in fact sustained the economic emis-eration of the working class as a whole. These "wages of whiteness" have undergone a massive devaluation recently, as union and other well-paid jobs have left the South, leaving only the sense of supremacy.

When we first saw the photograph of England leading a man named Hamid on a leash, we were rightly appalled. But the interpretation that blamed pornog-raphy for her action did not read the scenario closely enough. England was enacting a "pornographic" scenario at the behest of Charles Graner, who was in turn carrying out his orders to humiliate Hamid and all others in the "hard" block. According to Susan Sontag and others, pornography was to blame for the actions of the soldiers, inspiring them to create these scenes. That conclusion was not warranted. England's use of a leash may have been intended to make the prisoner into a "dog," an animal that "Arabs" supposedly fear, according to military authorities. If it was designed to evoke sado-masochism, that misunderstands the consensual element that is central to all BDSM, without which it becomes what it is here – simply abuse. In the photograph in question, England does not appear dominant. Rather she seems herself to be acting under compulsion. However, appearances can be deceptive. In the infamous photograph of a hooded prisoner standing on a box, apparently under the belief that he will be electrocuted if he lowers his arms, many commentators have wanted to interpret his posture in the Christian tradition. I would suggest the resemblance is caused because crucifixion was itself a form of torture. Holding limbs in what the Army likes to call "stress positions" is well known to become intensely painful after a brief interval without leaving marks of duress. By the same token, the sandbag on the prisoner's head has been pressed into service as a blindfold across Iraq but has no resemblance to Ku Klux Klan hoods that were used to terrify their victims, not blind them.

It has often been asserted that the military police were out of control in Abu Ghraib. Yet some of the photographs show unidentified figures from the ubiquitous Other Government Agency, assumed to be the CIA, arranging and supervising activity. It took care and forethought to arrange naked detainees into pyramids in which the individual body degrades into piles of flesh. These human ziggurats were one of the many efforts by the occupying force to ensure

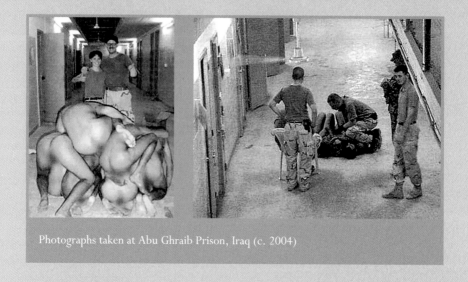

Photographs taken at Abu Ghraib Prison, Iraq (c. 2004)

that Saddam Hussein's glorification of the ancient Assyro-Babylonian past was negated. The photographs have been presented to us in suitably blurred form so that we cannot see the care with which the torturers made sure that each man had his penis touching the buttocks of the man below. This desire to obscure the guards' practice, rather than any belated concern for Islamic sensibility, motivated the digital erasure of this contact. The guards seem to have been proud of these human structures to judge from the photograph of Graner and England posing as a couple, arms around each other behind such a pile of seven men. They are both making the thumbs-up gesture.

One of the reasons that the US Defense Department chose to release the "sexualized" segment of the Abu Ghraib photographs – some 144 out of the estimated 1,400 extant photographs have been released – may have been to distract questions about such unambiguous issues as the death of prisoners. One of the most surreal photographs showed Specialist Sabrina Harman bending over the corpse of a man, who, although he was packed in ice to prevent decay, can be seen to have suffered a severe beating. Harman greets this sight with a full smile and a thumbs-up sign. In an interview with the filmmaker Errol Morris, seen in the film *Standard Operating Procedure* (2008), Harman sought to exculpate herself by saying that she had developed an automatic habit of making a thumbs-up in all photographs. Further, she took a range of other photographs of the dead man that she intended to serve as evidence of possible wrong doing. Of course there is no way to prove or disprove such assertions. It seems fair to wonder how the sight of a man beaten to death would not cause the viewer

to suspend their "automatic" photographic pose or at least to look less happy. Ultimately Harman's response is of no account. The real questions remain as to how her superiors allowed such activity to go on apparently unsupervised. As soon as Specialist Joseph Darby turned over a CD with images to military authorities, the Army offered amnesty to anyone turning in tapes or photographs, so the full extent of what took place at Abu Ghraib may never be known. What the continuing debates over these images suggest is that their force has been in no way diminished by the passing of a few years and that the debates over their meaning may in fact have only just begun.

References

Greenberg, Karen J. and Joshua L. Dratel (eds) (2005), *The Torture Papers: The Road to Abu Ghraib*, New York: Cambridge University Press.

McKelvey, Tara (2007), *Monstering: Inside America's Policy of Secret Interrogations and Torture in the Terror War*, New York: Carroll and Graf.

Physicians for Human Rights (2008), *Broken Laws, Broken Lives: Medical Evidence of Torture by US Personnel and Its Impact*, Cambridge, MA: Physicians for Human Rights.

WATCHING WAR

S INCE THE 9/11 attacks in 2001, it has become commonplace to hear the global contemporary described by expressions such as the "global civil war" (Arendt, 1963). That remark was actually made by philosopher Hannah Arendt in reference to the Cold War between the United States and the Soviet Union (1947–89) that dominated the second half of the twentieth century. If one considers that in the Cold War, two superpowers confronted each other, armed with enough nuclear weapons to destroy the planet many times over, and came close to using them in 1962 and 1973, the current situation cannot compare. If the actual danger is less, the political and cultural use of fear has, however, been as great or greater than during the Cold War. The representation and depiction of war from news to film and television drama and video games has been a key factor in creating the current climate. Equally important are the circumstances in which those representations and depictions are watched. Throughout this book, I have followed Rancière's argument concerning the division of the sensible into that which is permitted to be seen and that which we are instructed to ignore under the rubric "Move on, there's nothing to see here." The extraordinary crisis caused by the rapid rise and fall of the US empire has brought the contemporary division of the sensible into high relief as one of the central issues of our time. At present, these issues dominate the horizon of visual culture studies and it seems likely that they will continue to do so. I look forward to the time when these words appear anachronistic and out of step with a new present.

Image war

The 2001 attacks on the World Trade Center, the 2004 Madrid train bombings and the 2005 London transport attacks marked a determination to make the means of circulation itself both a target and a weapon against the circuits of global capital. As

political violence, these attacks were in many ways a return to the nineteenth-century anarchist practice of "propaganda of the deed." None of the attacks was designed to achieve a specific goal or was likely to produce an outcome favorable to those supporting them. Their function was pure visibility, a calling of attention that was not directed. These were not spectacles because there was no transformation of capital into images. Rather they attempted to turn the speed and mobility that have been the hallmarks of modernity, and especially its images, against itself. The callousness of the calculation was the realization that only significant loss of life would guarantee the coverage sought. US television news had long operated on the mantra: "if it bleeds, it leads," meaning that violence would come first on the nightly news. The attacks were thus perpetrated in major capitals because of the density of media resources available to disseminate the results.

If, as the composer Karlheinz Stockhausen infamously said of 9/11, this was a form of performance art, it indicated a change in the aspirations of such "art." Generalizing broadly, performance art proper has tended to produce its effects via a mode of alienation, as theorized by the Marxist playwright Bertolt Brecht, in which the spectator cannot identify with the actors and so has to consider his or her own position. Performative violence, on the other hand, offers only a narrow range of exchangeable identifications that inevitably leads to more violence. So one of the British 7/7 tube bombers claimed to have been motivated to violent action by watching 9/11 on television, a claim he himself disseminated by means of a videotape that he intended to be seen once he was dead. This "memorial" was intended to incite others to repeat his actions, aspiring to an uncontrollable "viral" effect in which so many people have committed to suicidal violence that the state loses control. Instead, this use of violent spectacle that began on the grand scale has morphed into a seemingly endless network of car-bombs, police actions, rocket attacks, tortures and so on, in which violence has succeeded in propagating itself as and by images not as spectacle but as everyday life. As W.J.T. Mitchell has argued, if one attempts to establish an "economy of violence," that is to say, a system in which violence can be exchanged in the manner of commodities, a considerable risk is involved. For "as a currency, violence is notoriously and appropriately unstable" (1994: 384), meaning that it can both gain in value and lose it unusually quickly.

The response from Western governments, led by the United States, was in line with the military understanding of the relation to media that had emerged from the Vietnam War. This protracted conflict had seen first French and then United States armed forces attempting to destroy and then contain the nationalist movement in Vietnam led by Ho Chi Minh. The US military persistently asserted that with some more troops on the ground, the problem could be ended, a claim that the spectacular Tet offensive of 1968 ended. Although the North Vietnamese attacks were in the end thoroughly defeated, Tet seemed to give the lie to all the optimistic statements of previous years. In 1975, the US Army retreated from Saigon and Vietnam became an independent country. The lessons drawn by military analysts centered on limiting media access to the battlefield on the grounds that reporting had undermined

support for the war, as if the 50,000 dead on the US side had nothing to do with the issue. Beginning with Britain's 1981 neo-colonial war in the Falkland Islands, or Malvinas, Western armed forces strictly contained media access to subsequent conflicts and found that the results met their expectations. During the first Gulf War of 1991, for instance, media and critical attention were focused on the hypnotic film generated by the new automated missiles as they descended on their targets, a film that ended only when the missile detonated. These films seemed to announce a new automated war in which targets could be identified and destroyed at will. Only long after the war was over, and to much less fanfare, was it made clear that the missiles had only the same degree of accuracy as traditional bombing. The film had certainly shown the missile striking something but whether it was the intended target was unclear.

During the invasion of Afghanistan in 2001, the United States decided that this policy of operating unseen was well suited to the new conflict between the last superpower and "rogue" states (meaning states that did not adhere to international law) and non-state actors (meaning groups that broke the state monopoly on violence). Perhaps the most notorious consequence of this policy was the establishment of a detention camp for so-called "enemy combatants" (those fighting for rogue states or non-state actors) at Guantánamo Bay, Cuba. Detained by unknown means and held without trial or legal process, some 600 men, youths and even children were held at Guantánamo Bay. Originally, the detention center was known as Camp X-Ray, as if to emphasize its invisibility. However, from its earliest days, the military allowed a select number of photographs of the camp to emerge, showing prisoners wearing orange jumpsuits, shackled hand and foot and in sensory deprivation masks and headphones. Although the entire camp was supposed to be secret, these images were distributed as a form of weapon, saying to the potential aggressor: "this is what will happen to you." Many domestic opponents of the war also saw the photographs as not so subtle hints about the possible consequences of their opposition. Certainly,

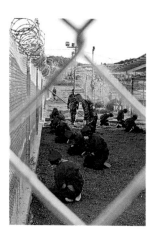

Figure 12.1 Camp X-Ray, Guantánamo Bay Naval Base, Cuba

these photographs can have had no effect on their subjects, who were unaware that they had been taken. Given that it has now emerged that the great majority of those detained at Guantanámo were in no sense the "worst of the worst," as the military must have been aware, it now seems that these functions were a central part of the camp's purpose. If that is the case, the tactic suffered a terrible "blowback" (a military expression meaning the use of your own weapons against yourself) when insurgents dressed prisoners like Nick Berg in Guantánamo-style orange jumpsuits, executed them and posted the images to the Internet.

The zone of indifference

Clearly, "move on, there's nothing to see" means one thing when there's a traffic accident and something altogether different when the state declares a state of emergency. Giorgio Agamben has shown that the state of emergency confuses questions of borders between the norm and the exception, generating a "zone of indifference, where inside and outside do not exclude each other but rather blur with each other" (2005: 23). The deliberate dissemination of the Guantánamo photographs and the accidental release of photographs from Abu Ghraib were thus of a piece, fragments from the "zone of indifference" created around the war. Artists, activists and filmmakers have tried with varying degrees of success to make this zone of indifference itself visible. When the British government passed its "Serious Organized Crime and Police Act" in 2006, one of its provisions forbade any unauthorized demonstrations within a one-kilometer radius of Parliament, marking the zone of indifference rather exactly. One consequence was the removal of a long-standing public display of posters and artifacts by an activist named Brian Haw protesting against the sanctions imposed on Iraq in 2001 (estimated to have indirectly caused hundreds of thousands of deaths by malnutrition). The artist Mark Wallinger (b. 1959) discovered that the exclusion zone ran right through the middle of Tate Britain, the London museum dedicated to British art. He arranged for the line marking the border to be painted on the floor and reconstructed Haw's protest as an installation under the title *State Britain* in 2007.

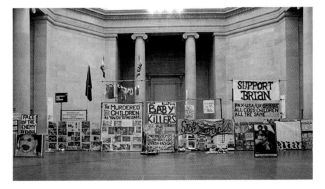

Figure 12.2
Mark Wallinger,
State Britain (2007).
Installation view at
Tate Britain © Mark
Wallinger. Photo
credit: Sam Drake,
Tate Photography ©
Tate, London 2008

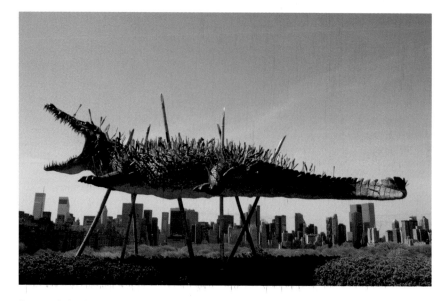

Figure 12.3 Cai Guo Qiang, *Move On, Nothing to See Here* (2006). Painted resin with sharp objects confiscated at airport security checkpoints. Collection of the Artist. Installation view at the Iris and B. Gerald Cantor Roof Garden, the Metropolitan Museum of Art, New York, 2006 (detail). Photograph by Teresa Christiansen. Courtesy the Artist and The Metropolitan Museum of Art, New York

More allusively, the Chinese artist Cai Guo-Qiang installed two 15-foot-long fiberglass crocodiles impaled with bamboo spikes and many small sharp implements on the roof of New York's Metropolitan Museum of Art, under the title *Move On, Nothing to See Here*. The crocodiles were pierced with many objects confiscated by Chinese transport police from passengers attempting to board planes. Cai had requested similar objects from the Department of Homeland Security but in their humorless way, the Department refused "on grounds of national security." The crocodiles looked downtown towards the former site of the World Trade Center, suggesting that the police had diligently collected the various forks and chopsticks but could not see the actual threat, as represented by the crocodiles. Indeed, as is now notorious, Mohammed Atta, presumed leader of the 9/11 attacks, was photographed by CCTV on the way to board a plane in Portland that would take him to Boston. However, despite the fact that his name featured on a terrorist watch list, he was allowed to board. Perhaps his having purchased a first-class ticket reduced the scrutiny. In any event, the irony is palpable – the police constantly tell us that there is nothing to see and, when the test came, they were unable to see what needed to be seen.

The global image war has taught us that mere visibility counts for less than those of us in visual fields would like to think. More broadly, the asymmetrical contestation of global hegemony between the proponents of shock and awe bombing campaigns

and the practitioners of suicide bombing and the appalling web-based dissemination of video executions seems to have marginalized resistant forms of visual representation in the West to an unprecedented degree, many fine exceptions notwithstanding. Indeed, the visual arts became drawn into the image wars in a surprising development. In 2004, the Massachusetts Museum of Contemporary Art in North Adams held an exhibition under the title "The Interventionists." Curated by Nato Thompson, the show examined a new kind of visual art that sought to make a form of intervention in its local environment that might leave no permanent (or saleable) presence but might also have considerable impact on those involved. One example was the intervention by the Critical Art Ensemble entitled "Free Range Grain." It has been estimated that ten giant corporations supply over half of all the food and drink consumed in the United States. The number of people now working as farmers is less than 1 percent of the working-age population, for all the endless evocation of the needs of farmers by the governing class. When they say "farmers," hear "agribusiness." Now that all but the most dedicated of us take home our bread ready baked, the Critical Art Ensemble planned to make the local audience in North Adams reexamine that connection by testing loaves for the presence of genetically modified grains. We are told that these are safe. Then again, we were told that there was no mad cow disease in the United States.

This interesting but necessarily small-scale project never took place. Just before the exhibition opened, CAE artist and tenured professor of art Steve Kurtz woke to discover his wife was suffering from what eventually turned out to be a fatal heart attack. When he called 911, the responders were at least as concerned with the Petri dishes containing the materials for the "Free Range Grain" testing project. Despite his explanations, members of the Joint Terrorism Taskforce in full Haz-Mat protective clothing descended on the house, cordoned it off, and took a variety of documents. They even retained Hope Kurtz's body for over a week. Although it became clear that no bio-terrorism charges could possibly be made, Federal agents insisted on bringing "mail fraud" charges against Kurtz and Professor Robert Ferrell

Free Range Grain
Critical Art Ensemble · Beatriz da Costa · Shyh-shiun Shyu

Figure 12.4 Critical Art Ensemble, *Free Range Grain* (2004)

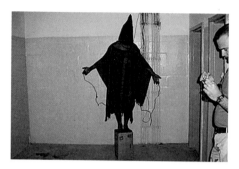

Figure 12.5 "The Man on the Box,"
a photograph taken at Abu Ghraib
Prison, Iraq (c. 2004)

of the University of Pittsburgh, relating to Ferrell acquiring some bacteria samples for Kurtz. The case dragged on until April 2008, when charges were dismissed but not before Ferrell had made a guilty plea because of his ill health. CAE are an internationally known and recognized arts group. Their defense organisation (see http://caedefensefund.org/overview.html) was able to generate significant funds and publicity for Kurtz. Other less well-known artists, especially students, have fared less well (Sholette, 2005: 2–3). More generally, the government's prosecution warned against reconfiguring the public in any way that does not align with the prevalent view. While artists received some latitude during the Cold War, because their freedoms could be favorably contrasted with those of Soviet bloc artists, no such provision exists today. The image has become a battleground.

As the image is now an area of conflict, there is a clearly defined boundary between seeing and not being allowed to see the militarized image. In some cases, the issue is reception. In the 2005 film *Jarhead* (dir. Sam Mendes) that deals with the Marines in Desert Storm (or the first Gulf War of 1991), one telling scene shows the rank-and-file Marines watching the film *Apocalypse Now* (1979, dir. Francis Ford Coppola). One of the best-known sequences in *Apocalypse Now* shows a helicopter attack on a Vietnamese village, set to Wagner's *Flight of the Valkyries* from his opera *The Valkyries* (1870). While this sequence has long been seen as a critique of war, made famous by the line "I love the smell of napalm in the morning," the Marines love it and sing along to the music. Within the militarized zone, *Apocalypse Now* was understood as a celebration of war. Certain images have delineated the sphere of the militarized visual image and those authorized to see it for those of us on the outside. The Abu Ghraib photographs are in this sense simply the most visible example of visual material that has crossed the boundary between the images seen by the military into the zone of indifference. At Abu Ghraib itself, some of the most disturbing images, such as the piles of naked hooded prisoners, were used as screensavers on the computers used by the soldiers at the prison. One photograph from the sequence depicting "The Man on the Box," the hooded prisoner standing with his arms extended, shows how the scene was at least in part concocted to be photographed. In this image, a soldier can be seen standing to the side with his point-and-shoot digital camera, waiting his turn to take pictures. The camera is a Sony

Cybershot, as if to suggest that in the era of digital media, it is foolish to imagine that any event can be kept secret. At the same time, it casts doubt on what is really being seen here: is the prisoner being tortured, or posed for photographs, or both? One of the few permanent consequences of Abu Ghraib has been restrictions on soldiers carrying cameras in war zones.

The militarized image

However, prior to that change, US soldiers in Iraq and Afghanistan created an extensive repertoire of still and moving images, taken in the war zone itself that constitute an extraordinary archive of war from the point of view of the soldier and the "insurgent." Here I will discuss videos made by US soldiers and their supporters, while being fully aware that it would be necessary to counterpose these with videos made by insurgents and their allies to which I lack access or indeed the language skills necessary to interpret them. These images were originally posted to the Internet (especially on YouTube and www.militaryvideos.net) and many remain there, while some have been taken down as we shall see. The soldiers' work came in a series of recognizable genres. In still photography, the two dominant categories might be called "War Tourism" and "Trophy Shots." "War Tourism" depicts soldiers when not at work, at recognized landmarks, or posed for ceremonial photographs. These images are ordinary snapshots taken in extraordinary circumstances. In the current Iraq conflict, scenes of troops at ancient Assyro-Babylonian monuments and Saddam Hussein's palaces are typical. "Trophy Shots" detail the violent work of war, showing death and destruction, in ways that are far more graphic than the self-imposed censorship of Western television and other mainstream media would ever allow. Ironically, viewers of al-Jazeera and other Middle Eastern media are far more likely to be exposed to such images on a more or less daily basis than their counterparts in the West, who pride themselves on their freedom of the press. These photographs are often posted to the Internet as raw TIFF files, whether due to lack of time and expertise or to a desire to show that they have not been edited.

With the availability of cheap moving image cameras, soldiers have also created a variety of video genres, centering on "Action" films, "Performances" and "Memorials." The first 45 minutes of Kimberly Pierce's film *Stop-Loss* (2008) gives a representative feel for this participant imagery of war. Action films are simple records of war experience, often quite banal until a single explosion occurs, whether caused by insurgents or US armed forces. Even though you are expecting something to happen, and it is in a sense why the video exists and why you are watching it, these scenes are always shocking and surprising. Cultural studies scholar Jennifer Terry has created an interactive web essay analyzing such action films that shows the complex modalities of visualization in what seems to be simple point-and-shoot filming (http://www.vectorsjournal.org/index.php?page=8|2&projectId=86). For example, she shows some footage taken from an Abrams tank in Samarra that uses the point-of-view made

familiar by first-person shooter video games. The barrel of the tank's gun determines the camera's direction and is visible in shot, so that as the gun moves our view moves with it. Unlike in a game, it is hard to determine from what is seen who or what was struck by the shooting. Nonetheless, it is clear that the repeated comment by soldiers that combat is like a video game is more than a metaphor, representing the mode of perception in which gaming and fighting feel identical.

"Performance" films show a soldier singing a song that s/he may have composed, usually dealing with the events of the war, or overdub music to imagery. One controversial video performance (http://video.google.com/videoplay?docid= 2836325979243356647&q=&hl=en) shows a Marine corporal performing a song called "Hadji Girl" with acoustic guitar accompaniment. The song describes his affair with an Iraqi woman and how he goes to her home in what turns out to be an ambush. The Marine uses the woman's sister as a human shield and is thereby able to kill all his attackers because, as the chorus says, "[they] should have known better than to fuck with a Marine." The song dramatizes the incomprehension of the Marines in dealing with the local population, whose speech is rendered as "Durka, Durka, Mohammed, Jihad," greeted with much laughter. The line is a quote from the film *Team America* (2004), where it was used as a parody, but in this context it seems to work as a stereotype. The contrast between the attractive melody and accompaniment and the rawness of the words gives this performance a disturbing force. Unsurprisingly, the Council for American-Islamic Relations protested in June 2006 but, despite some initially placatory statements by the Marines, the video was easily found in 2008. Finally, "Memorial" videos record the tours of duty of a unit or pay tribute to fallen individuals. Usually mostly comprised of still photographs and text, with some video footage, "Memorials" are fashioned into a video using a program like iMovie. Although there may be a subtext intelligible only to group members, these videos rarely take a triumphant or conquering tone. Rather they tend to be sad, with emotional songs attached as a soundtrack, with the dominant aspiration being to get home safely.

Non-combatants have also become involved as part of the domestic image conflict surrounding the war. A West Palm beach computer programmer named Ryan Hickman has created a series of pro-military movies (see www.grouchymedia.com), the most notorious of which goes by the title *Die Terrorists Die* (2002). The film takes its title from its soundtrack, a song called "Die Motherfucker Die" by the metal band Dope. The film is a simple sequence of still and video war images montaged together and speeding up to keep time with the music when the song reaches its chorus "Die Motherfucker Die." At these points, pictures of Osama bin Laden, Taliban leaders and other Arab men are shown in rapid sequence, usually in black-and-white mugshots. This represents the "money shot" for the video, its ultimate desire, and is blended in with shots of basic Army training, weapons firing, vehicles and aircraft maneuvering. The unexpected flash of a "Tourist" photograph taken at the entrance to the Guantánamo Bay base shows that Hickman had access to imagery that was usually classified as secret. In fact, his first film, *Taliban Bodies* (2001), had

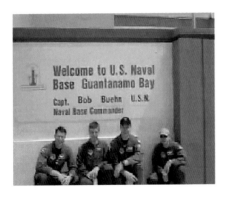

Figure 12.6 "Welcome to US Naval Base, Guantánamo Bay." A still from *Die, Terrorist, Die* (2002). Grouchy Media

been noticed by military personnel and Hickman subsequently spotted it playing on a monitor shown in a television report. At his prompting, his local NBC affiliate ran a feature on his efforts, in which he claimed that his anger at 9/11 was the motive for him to create these films. The Grouchy Media website has become a sprawling mass of materials, with advertisements from the Army and HBO among others. In 2008, Hickman was pleased to advertise a credit to his work in *Stop-Loss*, meaning that his work (or work in his style) has now been seen on television and cinema, as well as on the Internet.

The former Hollywood agent Pat Dollard, who claims to have represented Steven Soderbergh, has made a reverse journey. By his own account (http://patdollard. com), Dollard gave up his movie business career to make a pro-military documentary to be called *Young Americans*. His website details his frustrations in obtaining funding for this project, which he blames on the "left" in Hollywood, as well as posting a radical right political blog. Despite his blatant political manipulations, Dollard's video clips from Iraq in 2005, the most violent period of the insurgency to date, have an immediacy that cannot be denied. The emphasis on the vulnerability of the troops to Improvised Explosive Devices (IED), mortars and snipers and the failure to gain information from the local population cannot help but suggest an occupying force uncertain of its mission. Dollard's own footage is intercut with very brief segments of what he calls "insurgent videos," showing masked men firing mortars, placing IEDs and shooting rifles. With no reference and in such short segments, it is impossible to tell where and when this footage was made. However, it reinforces the awareness that the image war is being contested from multiple directions. Even assuming these films were made in Iraq, the "insurgents" cannot be reduced to a single force because there are extensive divisions among Iraqis between and within different ethnic and religious groups that have been the cause of much of the violence.

This aspiration for public exposure and influence contrasted with the uses of war imagery by the rank and file soldiers. One controversial case centered on a now-defunct website entitled NowThatsFuckedUp.com. This was an eBay-style porn site, in which amateur pornographers were granted access to the remainder of the

Figure 12.7 "Gory" from
http://www.NowThatsFuckedUp.com,
accessed October 25, 2005 (now defunct)

site in exchange for their own imagery. The site was opened to soldiers in exchange for their photographs taken on duty. The war images were filed under two headings, "regular" and "gory," equivalent to the "Tourist" and "Trophy" categories described above. These military photographs were made available to anyone who wanted to see them, not just the users. So, in the "regular" file, you could see photographs of soldiers posing in front of monuments, or, in the "gory" file, a sequence showing how US soldiers approached a car whose driver had been shot. The conclusion showed that the shot had accurately and devastatingly exploded the man's head. The exchange functioned for several years until a web news story jumped into the mainstream media and Florida police closed the site.

The real question to be answered here is why the soldiers wanted to post these images to a website that had non-military access on a regular basis. It could not be the case that soldiers were posting these photographs simply for access to porn because there is porn all over the Internet. Rather it must have been important for them to make the form of fetishized exchange that the site offered as a structure of identification and disavowal. On the one hand, this display functions as a form of disavowal, a means of disclaiming responsibility for the violence depicted. It comes to seem that all violence is perpetrated by the other side, a video game in which the soldier is not a player but a character, a disavowal that allows for psychic survival, as in the case of classic sexual fetishism. Just as the police officers accused of beating Rodney King notoriously asserted that he was in charge of the situation, here the necessity of killing Iraqis is made visible by digital media. The uncontrollable violence of the other forces the suspension of civilized restraint. One photograph depicted a group of soldiers giving the thumbs-up sign in front of a corpse that had been burnt to death. It was captioned "Cooked Iraqi." The hint of cannibalism here is designed to shock and it does. It also forces us to look, to see what is being done and what we are endorsing by not forcing it to stop. The soldiers seem to want us to know what the consequences of our decisions have been and to see them.

There was clearly also a sexualized dimension to the use of a porn site as the place of display. Traditionally it has been held that soldiers expect sexual recompense for their willingness to risk their lives and that it is only such reward that keeps them fighting. Virtual access to porn has replaced physical sex as a trophy. It was important

that the women seen were "amateurs," rather than professional porn actors, precisely the women that the soldiers felt themselves to be fighting for. In the new visualized economy, that assumption of responsibility gives the soldiers the right to see the women naked or having sex, often in modes that would be described under "fetish." When British troops returned from the Falklands/Malvinas conflict in 1982, a number of women stood topless on the docks as a means of greeting them. The exchange here was simple: "because you fought and won, you have the right to see me (half) naked." The exchange of sexualized looking for modern warfare has now become virtual. Militarized heterosexuality forms itself as a mode of identification, via a pornographically mediated form of desire, learned and expressed via digital media. The extraordinary other side to this mode of identification has been the use of pornography and sexual touching as form of interrogation "technique." At Guantánamo Bay, a so-called "Hell Room" was constructed covered in pornographic images. Female interrogators exposed themselves to prisoners and touched them intimately in an attempt to violate religious sanctions against such relations. Male interrogators, by contrast, would offer prisoners access to pornography and even prostitutes as a reward for information.

In all of these different modes of presenting images of war outside the military intranet (addresses ending .mil), the primary intent was for them to be seen by domestic viewers in the United States. That address is in a sense a paradox because the "police" (including the military) ordinarily say to the public that there is in fact nothing to see. However, no one believes that to be the case, so one might see this as being a means of extending of the boundary dividing the combatant from the civilian. Military video addresses US civilians as if they were combatants, or were willing to be so. At the same time, it demands from those opposed to the war a recognition of what it has entailed and the losses that have been suffered. In this regard, the YouTube war has tended to the advantage of the military image-makers. Unlike in Vietnam, there are no domestic voices criticizing the rank-and-file soldiers, who are in fact universally praised and acclaimed. The more the war itself has been criticized, the more the soldiers have been hailed. This is part of their own self-presentation, as professionals carrying out a task that they have been ordered to accomplish, even though they have doubts as to its viability. The price of such acknowledgment is that very little has been said about Iraqi casualties and the other disasters of war that have had to be endured by the Iraqi civilians in whose name the invasion was enacted, such as two million refugees, another 1.7 million internally displaced people and an "absolute poverty" rate in 2007 of 43 percent, according to the charity Oxfam.

Vernacular watching

The watching of the war described in this chapter is a specific form of vernacular watching. Based on work in feminist media studies and cultural studies, vernacular watching refers to the divergent and diverse act of looking in everyday life by which

individuals become situated as visual subjects. I borrow the term "vernacular" from recent calls for the study of vernacular photography, meaning photographs taken by ordinary people and used in everyday life. While this project has been ventured before, it has a new resonance in the era of digital and global culture. In this context, watching has become less predictable and manipulable than political leaders have hoped. Watching is the wide variety of things we do and places we are when we watch television. As we "watch," we eat, cook, do laundry or childcare, talk, speak on the phone, work or read. We might be watching on a plane, in a queue at the post office, in a bar or a hospital, as well as any room in a residential house. So vernacular watching tends to emphasize those moments of drift in which the attention is not fully engaged in gazing at visual media. To this end, it is intrigued by channel surfing rather than appointment television, web-surfing at work, or, to borrow a term from Anna McCarthy (2001), the encounter with ambient media (media out of their "proper" place, such as art outside the gallery or television outside the home). Vernacular watching is perhaps epitomized by the looking that is done while waiting, whether in a formal waiting room, in a car or for some appointment. Waiting engenders boredom and distraction, the marks of a certain counter to modernity as described by Walter Benjamin. Consequently, vernacular watching takes place in the corner of one's eye, the passing detail that catches a glance or the sideways look at a fellow waiter.

When the Bush administration launched its "global war on terror," the main audience it had in mind was the domestic one. The GWOT, as it inelegantly became known, was intended to cement what political guru Karl Rove imagined to be the "permanent Republican majority." The mode of circulation for the imagery of the GWOT was formed by bringing a large-screen television into a supersized house by means of an oversized Sports Utility Vehicle (SUV). "Keep moving, circulating," say the police, even as they claim there is nothing to see. The pattern of that circulation was to link the large suburban house to the superstore by means of the SUV. Although the majority of Americans now live in the suburbs, by no means all of the suburbanites can aspire to this lifestyle, as it is called – not a life, but a "lifestyle." It did, however, coalesce as the dominant variant of the American Dream during the real estate boom of 1997–2007. The hyperhouse, or McMansion as they are often termed, is a newly built wooden frame house offering 4,000–10,000 square feet and up of living space, compared to the average 1,300 square feet in a Manhattan apartment. Whereas the average American living space was less than 1,000 square feet in 1950, that figure had reached 2,400 square feet by 2004, even including apartments. Nearly half of all new houses built in 2004 had nine-feet-high ceilings, compared to the standard seven feet of earlier buildings. Such houses center around the Great Room or Home Theater in which an oversized television takes pride of place. This TV has High Definition cable, six-speaker Dolby stereo, a BluRay DVD player and so on. It may be faced by "theater seating," or cinema-style seats, and have dimmable lights. These products would typically be obtained at a "big box" store, a large climate-controlled metal shed in which the pleasure of shopping, as

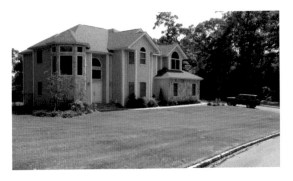

Figure 12.8 A hyperhouse. Photo by author

Figure 12.9 Big Screen
Paradise

formerly experienced in the department store, was reduced to the rapid location of the lowest possible price. In order to transport these goods, the owners of such a house most likely drive a large SUV, usually justified on grounds of safety and storage capacity. However, such vehicles are in fact less safe than standard cars or vans because of their potential to roll over when cornering or turning at speed, while their storage capacity is small compared to minivans or pickup trucks. What they do offer is a high vantage point that generates an illusion of safety from behind tinted glass windows. That is to say, from within the SUV, it is possible to imagine being the police. The Hollywood agent turned war documentary maker Pat Dollard purchased a giant Hummer H2 at the outbreak of the war in Iraq with a customized license plate reading "US WINS." That was precisely the message to be delivered to the LCD televisions, punctuated by Orange and Red terror alerts, in order to sustain the global imaginary of the "war on terror."

After Iraq, the flood

Since 2005, as much as the troops themselves are supported, domestic opinion in the United States has swung against the war in Iraq. From a base of some 25 to 30 percent of those who were opposed from the beginning, opinion polls since 2006 have consistently shown 60 to 65 percent are now against the war. To the frustration of the White House, the purported success of the 2007–8 "surge" in troop numbers did not result in a rise in support for the war. As if to acknowledge that the decision had been taken, US network television news shunted Iraq into the "other news" category. In the first half of 2008, the three network news broadcasts devoted a total of 181 minutes to Iraq, less than 30 seconds each a day. Aside from the political reasons, such as the significant numbers of dead and wounded in what was supposed to be a bloodless conflict (on the US side) and the repeated tours of duty for soldiers, this shift reflects a transformation in vernacular watching. It is noticeable that all the components of the imaginary that addressed vernacular watching have suffered a

major reverse in recent years. As the world now knows, the American dream houses that were being purchased in such large numbers were financed on precarious schemes that did not withstand the first whiff of skepticism. As long as house prices continued to rise, it was assumed that they would always do so and people would continue to seek larger and larger residences. The bubble burst when higher taxes and energy costs made larger houses less desirable, just as wages and salaries were stagnating and unemployment increased. By the summer of 2008, it was said that there were sufficient houses available on the market to satisfy over two years' worth of standard demand and prices continue to fall. Higher oil prices have made the single-digit miles per gallon SUV so unattractive that manufacturers have started to offer consumers guaranteed $3 a gallon gas for three years, plus zero percent interest and cash back – and still find no takers. A commercial for the sixtieth anniversary of Land Rover stresses their role in "peace keeping" missions, rather than wars. While large-screen televisions are popular as display monitors for DVD playback, vernacular watching has become dispersed to small-screen high-resolution devices like the iPod, iPhone and other "smart" phones, and lightweight laptops.

However, all of these changes have been gradual and some, like the housing slump, have come after the shift in opinion on the war. I would argue that it was in fact the experience of watching the devastation of the city of New Orleans and the Gulf Coast after Hurricane Katrina in August and September 2005 that was the moment in which opinions turned. Katrina was an extraordinary experience of vernacular watching. As you watched people marooned on rooftops, struggling though deep water, or stranded on highway overpasses, you could also listen to government officials claiming that everything was under control. Even journalists who pride themselves on objectivity could be heard arguing with Michael Chertoff, head of the Department of Homeland Security and Michael Brown, head of FEMA (Federal Emergency Management Agency), the new F-word for this decade. So militarized had the US government become that natural disasters were being handled as if they were terrorist events, managed by Homeland Security. Time and again, those offering to assist were turned back because they lacked "security clearance." For the administration, convinced by its own rhetoric that there was nothing to see, Katrina could be handled like the war by private contractors and press manipulation. Unfortunately for this strategy, while neither FEMA nor the contractors could somehow manage to find their way into New Orleans, local, national and international media could, ranging from blogs to the local radio WWL that broadcast throughout the hurricane and the BBC. As someone who grew up watching the traditional restrained British news, it was a shock in itself to see BBC journalists railing against the New Orleans Police Department for panicking over a solitary looter while disabled people struggled through the water. In New Orleans, the fragmentary slices of the chaos in Iraq became fully visible as a disaster of American culture.

As Spike Lee's seminal documentary *When the Levees Broke: A Requiem in Four Acts* (2006) amply proved, the marginalized people of New Orleans are in no way

Figure 12.10
Stills from *When the Levees Broke* (dir. Spike Lee, 2006)

unaware of these connections. Time and again, people compared the ability of the US government to move materials to Iraq and its seeming paralysis when confronted with Katrina. More than this failure, the perceptions caused by seeing the world through the lens of GWOT distorted and confused what was happening in New Orleans. Extraordinary stories circulated of people firing at relief helicopters or other officials, of an epidemic of sexual abuse and unrestrained looting. While there were some incidents, it later became clear that these stories were urban myths fuelled by the failure to defeat the insurgency in Iraq and made devastating by the long-standing fear of young African-American men in white culture. Louisiana Governor Kathleen Blanco appeared on television to announce that she was deploying additional National Guard troops to New Orleans to restore order with orders to shoot to kill and, she added, they were just back from Iraq so they knew how to act. One of the most extraordinary sequences in Lee's film shows Lieutenant General Russel Honore arriving in New Orleans on Thursday, September 1, five days after the storm hit, screaming at the National Guard to "put those damn weapons down." That is to say, the soldiers were training their weapons on the storm survivors as if they might represent a threat. It was only with considerable and visible reluctance that the weapons were lowered. As one demonstrator's banner had it, New Orleans

had become "America's Baghdad" in the way that it had become ruined but also in the way that it was policed.

Time and again, people commented that what was seen did not look like America but like a "third world" nation. For all the components of the American dream had come apart. No more symbolic pictures were seen than those showing houses carried away and then dropped by the waters on top of trucks. Housing was revealed to be a contingent form of shelter, subject to the mercy of the elements and not a permanently accruing investment. Later, people realized that insurance was no protection and that government assistance was all but impossible to obtain. The security of homeownership was seen to be just another form of investment. In order to try and minimize the impact of this disturbing insight, it was often claimed that the residents of the Lower Ninth Ward, where the greatest damage was done, were poor verging on destitute. In fact over 50 percent owned their own homes, not far below the national average. How can the lack of response by the US government be explained? Some drew back from the obvious conclusion that it was a hesitation motivated by racism, preferring to stress individual incompetence (Brinkley, 2006).

Certainly, there was no shortage of incompetence. It should be recalled that the state of emergency must be above all distinguished by its capacity for decision (Agamben, 2005: 30–1). Governor Blanco declared a state of emergency in Louisiana before the storm hit and Secretary Chertoff followed by naming it an "incident of national importance." Yet the decision making that identifies the existence of the state of exception was still lacking. There are key occasions when that decision and decisiveness, its only justification, cannot be deployed because its mode of authority is racialized in contrary fashion. That contradiction has most often been seen in effect when a reconstruction of the social fabric is required but cannot be enacted because a prior racialization prevents it. And the name for that contradiction in the US is now Katrina. Katrina showed how the built environment of New Orleans revealed the sedimented racism of slavery, segregation and the so-called New South. The sovereign state of exception could not be deployed on behalf of its racialized other without undoing the forcefulness of the force of law. Further, Katrina is one of many events that have made it clear that the threat to bare life is now planetary, involving animal and plant life as well as human survival.

Climate change is certainly the product of the human deployment of biopolitics but the response to it necessitates a revolution in biopolitical affairs that matches and confronts the revolution in military affairs. Think of all those Humvees, getting at best eight miles to the gallon, not to mention the M-1 tanks that do no more than a mile per gallon, let alone the 104 acre air-conditioned palace that is the new American Embassy in Iraq. At the same time, the visualization of the planet required by this revolution is a proper counter to the visuality deployed by counterinsurgency. Al Gore's Powerpoint presentation, filmed as *An Inconvenient Truth* (2006) with its dramatic but simple images of glacier retreat and dried-up lakes, has shown what can be done. In that film, Katrina stands as one of the key examples of the consequences of inaction. This countervisuality works because it is comparative and

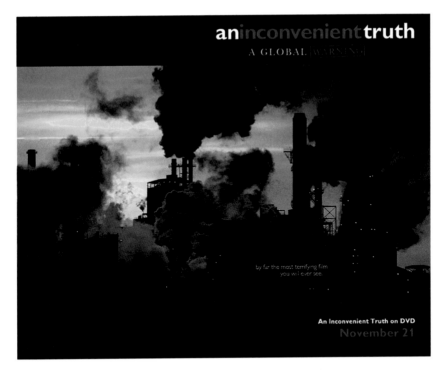

Figure 12.11 Poster for *An Inconvenient Truth* (dir. Davis Guggenheim with Al Gore, 2006)

historical but lets the viewer decide what it is that they have seen, while of course being strongly suggestive. These images of "natural" disaster that are caused by human agency are the counterpoint to war as culture. By suggesting a different way to imagine ourselves and our responsibilities than the permanent fear of being attacked, the visualizing of the interaction of the ecosystem and human networks present a literally vital opportunity for change.

References

Agamben, Giorgio (2005), *State of Exception*, trans. Kevin Attell, Chicago, IL: University of Chicago Press.
Arendt, Hannah (1963), *On Revolution*, New York: Viking.
Brinkley, Douglas (2006), *The Great Deluge: Hurricane Katrina, New Orleans and the Mississippi Gulf Coast*, New York: William Morrow.
McCarthy, Anna (2001), *Ambient Television*, Durham, NC: Duke University Press.
Mitchell, W.J.T. (1994), *Picture Theory*, Chicago, IL: University of Chicago Press.
Sholette, Greg (2005), "Disciplining the Avant-Garde: The United States versus the Critical Art Ensemble," *CIRCA: Contemporary Visual Culture in Ireland*, vol. 112, pp. 50–9.

INDEX

1492 6, 7, 9, 39, 45–61
1492: Conquest of Paradise, The 55, 56
2046 249
3.10 To Yuma 185
5 Year Drive By 186–7

Aboriginals of Australia 60, 218
Absolute monarchy 35–6; and the
 problem of perspective 33–4, 35,
 38–9
Abu Ghraid prison 14, 252–3, 287–91,
 295, 298–9
Achmat, Zackie 259, 260
ACT UP (AIDS Coalition to Unleash
 Power) 258–9, 260
AdBusters 265, 266
Adorno, Theodor 182
advertisements 2–3, 8–9, 177, 202,
 236–7, 241, 255, 258, 267, 301
Agamben, Giorgio 49, 194, 195, 295,
 308
Agassiz, Louis 79–80
"age of the world picture" 116–18
AIDS–Baby–Africa 261–2
AIDS epidemic 250, 256–7, 258–62
Alberti, Leon Battista 27–8, 29
Aldridge, Ira 79
Alien 55, 56, 57
Amadiume, Ifi 164
Ambassadors, The 62–7

American Idol 281
American Studies 128
Amerindians 47, 49, 51–2, 58–9, 106,
 185
Analytical Engine 229, 230, 231
Ancient Greeks 21, 28, 176–7, 224
Anderson, Paul 188, 189
Anidjar, Gil 47, 48
Annales school 21
Apocalypse Now 298
Apollo Belvedere 225–6
Appadurai, Arjun 237
Aristotle 17–18, 19
Arrivée d'un train (à la Ciotat) (
 Arrival of a Train in La Ciotat)
 109–10
art market, global 243, 255
ArtWorks for AIDS 261
Atget, Eugène 122, 123, 125
"attention economy" 8–9
Au Tambour, 63 Quai de la Tournelle
 122, 123, 125
Autonomy movement 234–5
autopoiesis 234
avant-garde 180
Avant-Garde and Kitsch 180
Azevedo, Aluíso 149

Baartman, Sarah 155–6, 160
Babbage, Charles 227–9, 230

Bacon, Sir Francis 54
Bal, Mieke 148
Baldwin, James 199
Ball, James Presley 82–3
Ballad of Sexual Dependency, The 257
Balzac, Honoré de 137
Barbin, Herculine 156
Barthes, Roland 11, 119, 256, 275
Basquiat, Jean-Michel 76
Batchen, Geoffrey 77, 226
Baucom, Ian 77
Baudrillard, Jean 182
Bayard, Hippolyte 120, 121
Bedia, José 42–3
Belisario, Isaac 74, 75
Beller, Jonathan 8
Belting, Hans 3
Benítez-Rojo, Antonio 42, 43
Benjamin, Walter 117, 118, 122, 178,
 179, 181, 182, 194, 255, 256–7,
 261, 265, 304
Bentham, Jeremy 92, 96, 98, 228
Berlusconi, Silvio 194–5
Bermingham, Ann 72
Bhabha, Homi 140
biopower 17, 95–6, 198, 247
"Bishop Tucker and Pygmy Lady" 161–2
Black Codes (1865) 109, 150
Blade Runner 245–9
Blair, Tony 282, 284, 285
Blake, William 192
Blanco, Kathleen 307, 308
Blue Nude – Souvenir of Biskra 104
bodies 11, 12–13, 25, 84, 96, 106, 275,
 282; female 155–6, 169, 201, 282;
 interfacing with machines 175, 178;
 "posthuman" 233; production of
 "docile" 96, 235
Book of Optics (Kitab al-Manazir) 23
Boorstin, Daniel 267, 271
Bordowitz, Gregg 256–7, 258, 260
Bosman, Willem 219
Bosse, Abraham 33
Boucicault, Dion 158, 159
Bounty, mutiny on the 50
Boyle, Robert 37, 38
Boys Don't Cry 175
Bracquemond, Félix 103
Brandt, Bill 273

Brecht, Bertol 191, 293
Brokeback Mountain 187–8
Brown, Tina 275
Brown v. The Board of Education (1954)
 88, 108
Bryson, Norman 148
Buerger, Janet E. 253
Burgin, Victor 120, 280
burials 120–2, 206
Burton, Richard 177
Bush, President George W. 195, 255,
 269, 276, 285, 304
Butler, Judith 90, 166, 233

Cai Guo-Qiang 296
Callot, Jacques 32
Camera Lucida 256
camera obscura 23, 32, 91, 255
Campeche y Jordán, José 74
cannibalism 129, 137–8, 200, 302
Capa, Robert 124, 125
capitalism 68–9, 113–14, 180, 235,
 267–8
Capitalism and Slavery 68–9
Carlyle, Thomas 6, 7, 89, 90, 91–2,
 192
cartoons 58, 178–80, 182
Casement, Roger 134, 163, 164–5
Casid, Jill 50
celebrities 271–86
cell phones 242, 250, 254, 255, 306
Cervantes, Miguel 47
Césaire, Aimé 53
Cha Cha Cha 210
Chakrabarty, Dipesh 46
Chancellor Seguier 35
Chaplin, Charlie 12, 179
Charles, Prince of Wales 273, 274, 275,
 276, 279
Charterhouse of Parma, The 7
*Chief, The: he who sold Africa to the
 Colonists* 214–15
Chile 234, 235
China 29, 218–19, 221, 238, 284
Christianity 51, 132–3, 142, 200, 219;
 the crucifixion 145, 189, 289
church 7–8; burials 120–1; decorations
 206; iconoclastic movement 29
cinema 109–10, 119, 172, 268

circles in African culture in diaspora 72–3
circulation 114, 117, 304–5
cities, modern 115–16
City TV 237
Clark, Lewis 84
Clausewitz, Karl von 7
Clifford, James 39, 46
Clinton, Hilary Rodham 285–6
closed circuit television cameras (CCTV) 268, 281, 298
Cold War 176, 190, 198, 292, 298
Cole, Thomas 192
colonialism 11, 50–5, 63, 140; encounters with Amerindians 47, 49, 51–2, 106; miscegenation under 53, 159, 160–1; and the reinvention of Africa after slavery 129–30; representations of the encounter 55–60; resistance to 51, 140–5, 163, 197, 201; supposed justifications for 106, 137–8, 155, 178; and transculturalism 128, 129, 133, 138, 140, 142, 145; travel narratives 44; violence of 11, 98, 133–4, 163, 206
color 99–104; white 104–7
color-blindness 18, 99–101, 105
Colossus 232
Columbus, Christopher 45, 46, 55, 59
Communist Manifesto, The 113
comparison, modes of 9–15
computers 230, 231–4; operating systems 235–6
Computing Machines and Intelligence 232
Congo 127–46, 159, 166, 199, 200. see also Kongo peoples; civil war 198–9; decolonization and necropolitics 198–200; European travelers to the 133–40; and the myth of the "heart of darkness" 128–40; photography of the 130–1, 134–7, 138–40, 160–1, 199; reclaiming the visual tradition 200–4; resistance to colonialism 140–5, 163; violent excesses of the Belgians in 133–4, 163
Congo River 127, 130–2, 166
Conrad, Joseph 130, 132, 134, 159, 164, 166

consumer culture 264, 281
convict lease-labor camps 109, 150
cool, being 238
Copernicus 114
Coquilhat, Captain Camille 129–30, 131
corporate logos 265, 266
Cortés, Hernán 106, 154
cosmograms 131, 145
Coughlan, Robert 199–200
Courbet, Gustave 169
Course of Empire, The 192
Crary, Jonathan 32, 91
crime and skin color 151–2
Crimp, Douglas 257, 260
Critical Art Ensemble (CAE) 297, 298
crossroads 73–5
Crow, Jim 79, 111
Cuba 41, 42, 49, 69, 108, 109, 197, 284
Culture and Society 11, 91
cyberspace 224, 254

daguerreotypes 79–80, 83
Dalton, John 99
Damiens, execution of 94, 95
Damisch, Hubert 29
Darwin, Charles 51
David, Jacques-Louis 75, 76
Davis, Angela Y. 109, 150
de Beauvoir, Simone 111
de Landa, Diego 53
deafness 96, 106–7, 189, 227
Debord, Guy 3, 85, 255, 264–5, 266, 267
Decline and Fall of the Roman Empire, The 192
deculturation 41, 42, 133
DeLillo, Don 281
democracy 10, 19–20, 274
Demoiselles d'Avignon 203–4
Dening, Greg 6
Derrida, Jacques 9–11, 15, 21, 44
Desai, Gaurav 164
Descartes, René 4, 31–3
Description of a Slave Ship 72, 73
desire 174–5, 271–2
detour 265
Dialectic of Enlightenment 182

Diana, Princess of Wales 271, 274–9, 280–4
diaspora 72–3, 166, 199, 200–1, 211, 238
Diawara, Manthia 210
dictatorships 47, 193–4
Die, Terrorists, Die 300, 301
Difference Engine 228–9
digital 224–44; music 227, 236, 281; video recorders 258
Digital Millennium Copyright Act (1998) 238
disciplinary system 85, 98, 99–102, 107–11, 120
Disney 182
Disneyland 182–3
division of the sensible 14, 17–20, 22–6, 67, 148, 292; and crisis of the photographic 258–62
Docker, John 46, 49
Dollard, Pat 301, 305
Douglass, Frederick 11, 84
Dratel, Joshua L. 288
Dreyfus Affair 94, 108
Drouais, Jean-Germain 225
Drum 199
Du Bois, W.E.B. 92, 108, 148, 289
Durham, Jimmy 53, 54
Dussel, Enrique 52
Dutch artists 30–1

Eakins, Thomas 156–7
East Germany 268
Eastwood, Clint 186
eBay 236, 241
economy 8–9, 12, 178, 205, 222, 254
Edelman, Lee 165, 166
Einstein, Albert 115
electronic messaging systems 219–21
Elgin Marbles 104, 105
Elizabeth II, Queen 273–4, 276
Emancipated Slaves 81–2
Emerson, Ralph Waldo 92
empire 50, 192–4, 195–6, 278; British 9, 11, 70, 77, 79, 183, 197, 273, 278; collapse of 197, 273; monarchy as 272–3
England, Lyndie 289, 290
English at Home, The 273

Enigma code 231–2
Enterprise 59
Epstein, Julia 154, 158
ethnicity 147
E*Trade 236–7
evolution 99–100; and assumptions of European supremacy 101, 106, 128
Experiment on a Bird in the Air Pump, An 38

Facebook 2, 222
Falasca-Zamponi, Simonetta 194
Falklands War 294, 303
Fani-Kayode, Rotimi 212–14
Fanon, Frantz 11, 151, 164, 206
Fantasia 179, 182
fascism 92, 178, 179–80, 182, 194
Fasso, Samuel 211–12, 214–15
Fay-Jones Report 288
Feagler, Dick 151
Fenton, James 274
Ferdinand II of Aragon 46, 47
Ferrell, Robert 297, 298
Fetish No. 2 201
fetishes 52, 54–5, 142
fetishism 14, 15, 154, 169, 201–2, 302; classification of African art under 203; commodity 13–14, 55, 114, 202, 264; female 173–4; of the gaze 156, 158, 169–75
Fetishism 169
fiber-optic cables 221, 222
Fibonacci 26
film 117, 170, 178–82, 190–1, 258
FLAG Telecom 221
Flagellation of Christ, The 27, 28
Flickr 2, 254
Flint, Kate 84
Flood, Finbarr Barry 8
Florence, Hercules 77, 78
flowers 283
Foister, Susan 65
Ford, John 185, 186
Foreman, Carl 184
Foresta, Merry 78
Fosso, Samuel 211–12, 214–15
Foster, Hal 89, 90
Foucault, Michel 11, 95, 97, 98, 108, 120, 163, 267

Frears, Stephen 284
Fredrick, Adolphus 135, 136
Free Range Grain 297
Freeman, Elizabeth 260
French Academy of Painting 33–4, 35, 39
French Revolution 10, 91, 107, 194
French-Sheldon, M. 136, 137
Freud, Sigmund 50, 55, 57, 107, 160, 165, 169–70, 172, 173, 200, 256
Friedberg, Anne 28, 248
Friedrich, Adolphus 134, 135, 136, 137, 140
Froude, James Anthony 192
Fugitive Slave Law (1850) 83
Fusco, Coco 58, 59, 138
Fuss, Diana 282

Gage, John 104
Galison, Peter 115
gaze, the 45, 90, 169; fetishism of 156, 158, 169–75; male 169, 172–3, 280; of the Other 149; queering 163–6; returning the Western 202–4; slavery and 63–7; "trans" 175
Gbagbo, Christian 199
Gell, Alfred 8
gender 153, 156–8, 164, 233; binary 110–11, 156–7, 175; and identity 158, 166, 171, 175
genocide 14, 204–9
Gibbons, Edward 192
Gibson, William 224
Gilchrist, Alan 22–3
Gilroy, Paul 76, 91, 128, 163
Girodias, Maurice 164, 165
Gladstone, William 100–1
global warming 13, 14, 25, 308
globalization 9, 14, 42, 69, 178, 186, 205, 210, 218; of the digital 237–41, 242; and empire 192–4, 195–6; and state of emergency 192, 194–6
Goethe, Johann Wolfgang von 225
Goldberg, Jonathan 53, 106, 154
Goldin, Nan 257
Gómez-Peña, Guillermo 58
Goncourt brothers 121
Google 221, 239, 241
Gordon, Douglas 186

Gore, Al 307
Gramsci, Antonio 92
Graner, Charles 289, 290
Greenberg, Clement 180, 182, 183
Greenberg, Karen J. 288
Greenberg, Kenneth S. 81
Greenblatt, Stephen 49
Gross Clinic, The 156–8
Guantánamo Bay 109, 294–5, 301, 303
Guess Who's Coming to Dinner? 149
Guilbaut, Serge 183
Gulf War 190, 294, 298
Guyatt, Mary 72

Habit 259
Hadith 8
Haiti 10, 69, 74, 76
Halberstram, Judith 175, 187, 233
Hall of Mirrors 33–4, 98
Haraway, Donna 5, 175
Hardt, Michael 178, 195
Harman, Sabrina 290–1
Harris, Michael 200
Haussmann, Baron 115–16
Haw, Brian 295
Hawarden, Lady Clementina 174–5
Hayles, N. Katherine 57, 233, 234, 235
hearing aids, digital 227
Heart of Darkness 130, 166, 245
Hegel, Max 7, 64
Heidegger, Martin 21, 116–17
Helmholtz, Hermann von 25, 99
Hero, the 6, 90, 91, 92, 195
Hickman, Ryan 300
High Noon 183–5
Hillsborough disaster 283
Hisab al-jabr w'al-muqabala 26
History 36, 46, 47, 89; Carlyle's pictorial 91–2; and the everyday mode of comparison 9–11; and visuality 5, 6, 7, 9, 36–7; Wars 60
Hitchcock, Alfred 172
Hitchens, Christopher 287
Hobbes, Thomas 36, 38–9
Hobsbawm, Eric 271, 272
Hodges, Andrew 233
Holbein, Hans 62–7
Holmes, Oliver Wendall 226, 227
Holmgren, Fithiof 101

Holocaust 205, 206, 209
Homer 100
homoeroticism 105, 187, 282
homosexuality 106, 108, 154, 163–4, 213, 233
Horkheimer, Max 182
Hotel Rwanda 209
How We Are Now 85
Howe, Darcus 282–3
Hughes, Langston 127, 163
Human Rights Watch 208, 216
Hurricane Katrina 13, 306–9
hybridity 41, 50–2, 53, 223
Hyman, Antony 228
hyperhouses 304, 305, 306

Ibn al-Haytham 21–5, 27
Ibn Ezra, Moses 48
identity 44, 59, 73, 171; and gender 158, 166, 171, 175; on-line 237, 242–3; racialized categories of 43, 148, 154, 158; sexual 153, 165–6, 175, 204, 242
idols 52–5
Illness as Metaphor 257
imperialism 89, 91, 108–11, 176, 178, 192
Impressionists 25, 102, 103, 116
In the Heart of Africa 139
Inconvenient Truth, An 308–9
Independent on Sunday 282
indexicality 148, 250, 251–6
India 192, 197, 242, 243, 260, 272, 273, 276–8
Internet 2, 11, 221, 236–41, 243; access to 235–6, 237–8, 242; on-line identities 237, 242–3; pornography 242; webcams 279–80
interrogation techniques 287, 288, 303
Interventionists, The 297
invention of tradition 271–2
iPods 2, 224, 227, 306
Iraq 5, 12, 284
Iraq War 125, 285, 295, 299; public opinion on 305, 306; still and moving images 299–303
Irigaray, Luce 173
Isabella I of Castille 46, 47
Islam 7–8, 42, 47–8, 243

Israeli Information Center for Human Rights in the Occupied Territories 239

Jacobs, Joseph 18
Jacobs, Katrien 242
Jacquard, Joseph Marie 229–30
James, C.L.R. 10, 69
James, William 109, 148
Japanese artists 29
Jarhead 298
Jay, Martin 64, 90, 91
Jefferson, President Thomas 225
Jeffries, Dr Benjamin Joy 101
Jenks, Christopher 33
Jenkyns, Richard 105, 106
jennicam 279–80
Jewsiewicki, Bogomil 203
Jonkonu 74, 75
Journal des Savants 39
Judaism 7–8, 18, 46, 48, 91, 101, 108, 194, 205

Kagame, Paul 206
Kant, Immanuel 19
Kaplan, Amy 110, 128
Kelley, Kitty 273, 275
Kemp, Martin 27, 29, 31, 99
Kennedy, Jackie 277
Kepler, Thomas 30–1, 32
Kerr, Clark 266
Kimball, M.H. 81
K.I.P. 260–1
Koestenbaum, Wayne 277
Kojève, Alexander 64
Kongo peoples 51, 128, 131–2, 137; European destruction of the kingdom 128, 129, 132, 133, 139; reclaiming the visual tradition 200–4; resistance to colonialism 141–5, 163, 201; and transcultural exchange with the West 128, 129, 132, 133, 138, 140, 142, 145; women 160–3, 201
Kruger, Barbara 10, 251
Kurtz, Steve 297, 298

La Lumière 253
Lacan, Ernest 253

Lacan, Jacques 45, 64, 67, 169, 171–2, 173
Lacquer, Thomas 152, 154
Laforgue, Jules 103
landmines 284
landscapes, colonial 50–1
Lang, Herbert 131, 138–40, 162
Language of the Eye, The 84
Las Casas, Bartolomé de 52
Latour, Bruno 7, 37, 218, 223
Le Bon, Gustave 193
Le Brun, Charles 33, 36
Le Mur des Fédérés 122, 123
Lee, Ang 187
Lee, Spike 306
Leighton, Frederick Lord 105
Leonardo da Vinci 25, 28–9, 76
Les Demoiselles d'Avignon 130
Les Magiciens de la Terre (Magicians of the Earth, The) 203
Lévi-Strauss, Claude 49
Leviathan 36, 38
Levinas, Emmanuel 44
Lewis, Gordon 70
Liber abaci 26
Life 198, 199
light 31, 102–4
Lincoln, President Abraham 194
Lindberg, David 28, 31
Lindqvist, Sven 60
Linux 235–6
Little Revenge from the Periphery, The 43
Liu, Alan 238, 241
Lives of Others, The 268, 269
Livingston, Ira 234
Lloyd, Albert 134, 135, 161
Long, Edward 154
Lotringer, Sylvère 235
Louis XIV 35
Louis XIV, King 33–4, 35–7
Lovelace, Lady Ada 231
Lovink, Geert 238, 239, 242
L'Ultima Cena 69
Lumière brothers 109, 110
Lumumba, Patrice 198–9

MacGaffey, Wyatt 133, 142, 143
magic 30, 199–200

Magnus, Hans 100
Malick, Terence 57
Mamdani, Mahmood 205, 207
Mangbetu people 138, 139–40, 162, 163
Mann, Charles 46, 47
Mannoni, Octave 59, 169
Mapplethorpe, Robert 214, 256
maps 39, 129, 130, 197, 219
Marius and the Gaul 225
Marx, Karl 17, 18, 70, 113, 114, 162, 180, 234, 267
Masaccio 28
Massumi, Brian 227
Matisse, Henri 104
Matrix, The 3, 12–13, 22
Mattison, H. 80
Maturana, Humberto 234, 235
Mavor, Carol 173–4
Maya 26, 53, 154
Mayne, Judith 166
Mbembe, Achille 127, 198, 205
Mbuti peoples 133, 137, 138, 161
Mbwira Ndumva (Speak, I'm Listening) 208
McLuhan, Marshall 3, 166
Melas, Natalie 6
Melville, Herman 106, 107
Mesquita, Ivo 42, 44
Metz, Christian 38, 90
Michelangelo 33
Mickey Mouse 178–80, 182
migrants 10–11, 13, 15, 150
Miller, D.A. 256, 257
Miller, Perry 128
Miners Coming off Shift 273
minkisi 141, 142–3, 145, 199, 200–2
Mirzoeff, Nicholas 33, 138
miscegenation 53, 73, 79, 82, 147, 148–9, 154, 159–61
Mitchell, W.J.T. 5, 20, 50, 55, 206–7, 251, 257, 267, 293
Moby Dick 106–7
Modern Times 12
modernity 6, 48, 90–1, 94–9, 107–11, 113–18, 120, 127, 182, 264; slavery's role in shaping 11, 68–71, 85; and transculturation 128, 129, 145, 199

monarchy 272–3. *see also* Absolute Monarchy
money, virtualization of 254
monsters, stories of 49, 50, 51, 57
Morrison, Blake 278–9
Morse, Samuel B. 77–8
Morton, Andrew 275, 279
Mothers of the Plaza de Mayo 14, 15
Move On. Nothing to See Here 296
"move on, there's nothing to see" 9, 14, 20, 261, 292, 295, 296
Mthethwa, Zwelethu 215, 261
Mudimbe, V.Y. 51, 133
Mulatto, The 149
Mulvey, Laura 172, 173
museums 3, 8, 11, 116, 140, 143; in Rwanda 206, 207
Mussolini, Benito 193–4
Muybridge, Eadweard 118, 179
MySpace 222, 241

Nadar 122, 137
Napoleon at the Saint-Bernard Pass 75, 76
Napoleon I 7, 11, 75, 76
Napster 236, 238
nationalism, African 199, 200, 210
"Natives" and "Strangers" 6–7, 39, 53
Natural Magic 30
Nausea 241
Nazism 92, 95, 178, 182, 194, 205, 206
necropolitics 198–200, 204–9
Nègres dansant dans la rue (Blacks dancing in the street) 110
Negri, Antonio 178, 195
Nelson's Ship in a Bottle 211
neo-culturation 41, 42
"network society" 218, 221–2
networks 11–12, 218–23
New Statesman 274
New World, The 57–8
New York Times 183, 206
New York Tribune, The 83
New Yorker 78, 256
Newton, Isaac 99
Nguyen 260, 261
Niceron 30
Njami, Simon 210
Nnobi society 164

No Country for Old Men 190
Nochlin, Linda 103, 121
Noor-Eldeen, Namir 125
"norm," concept of the 94–5, 107–11
normal/pathological binary 95, 98, 107–8, 156
nostalgia 260, 278
NowThatsFuckedUp.com 301–2

Obama, President Barack 239, 240
Octoroon, The 158
Oguibe, Olu 199, 210, 213
On Computable Numbers 231
On Heroes 91
On Painting 27
On Photography 256
One Laptop Per Child 236
Open Letter to God 261
"optical unconscious" 118, 179, 181
optics 4, 5, 21–5, 33, 39
Orientalism 176
orientalism 177–8, 180
Origin of the World, The 169
Ortiz, Fernando 41, 42, 129
Othello 78–9
Other, the 44, 59, 111, 149, 178

panopticism, global 107–11
Panopticon 96–8, 151, 230
Paris 115–16, 122, 203–4
Paris Est Propre 203
Pater, Walter 105–6
Pease, Donald E. 128
Peck, Raoul 208
Peirce, Charles Sanders 148
People 282
perception 4, 21, 24–5, 31, 32, 234
Persians, The 176
perspective 26–39; 17th century Dutch artists use of 30–1; French Academy of Painting's theory of 33–4, 35, 39; a geometric theory of 33, 34, 35; modern theories of 38; a problem for Absolute monarchy 33–4, 35, 38–9; use by the the Renaissance artists 27–30
Pew Charitable Trust 150
phallus, the 149, 168, 170, 171–2, 173
Philippines 108–9

photography 32, 134, 181, 250–64; on cell phones 250, 254, 255; as a commodity 250, 253–5; in the Congo 130–1, 134–7, 138–40, 160–1, 199; and death 119–26, 256–8; digital 251–2, 254; and division of the sensible 258–62; and fear of the camera 136–7; feminine "reduplicative desire" in 174; and indexicality 250, 251–6; memorial to the Rwandan genocide 209; on-line storage and sharing 2, 254; postmodern 211–15, 251, 256; royal 273, 275, 276, 277–9, 280, 281; and social class 254; specificity of time and space 119–20, 256, 258–62; stop motion 118, 179; at the Taj Mahal 276–8; vernacular 304; visibility of slavery in 68, 76–83; war 122–5, 299, 301–2

Physicians for Human Rights 288
Picasso, Pablo 130, 203
Picquet, Louisa 80, 158
"pictorial turn" 5
Pierce, Kimberley 175, 299
Piero della Francesca 27, 28
Pilkington, Lucy 282
Piula, Trigo 201–2
Plato 18, 19, 21–2, 51, 52
Plessey, Homer 108, 109, 110
Pocahontas 58
Pointon, Marcia 156–7
popular culture 169, 178–83, 272
pornography 15, 242, 267, 280, 289, 301–3
Porta, Giovanni Battista Della 30
Portrait of Dorian Gray 105
postcolonial 6, 197; visual culture 200–4, 210–15
postmodernism 145, 207, 257
Potato Eaters 70, 71
Poussin, Nicolas 225
primitivism 51, 128, 130, 145, 197, 209; depictions in the Congo 131, 132, 145, 198, 199
Primitivism in 20th Century Art 145
prison 96–8, 150–1, 230
product placement 258, 281
psychogeography 85–7

Puerto Rico 74–5, 108
punishment regimes 94–5, 98, 151

Quadroon, The 158
Queen, The 284–5
queer: culture 166; on-line networking 222, 237, 242; sexuality 166, 242; theory 260
queering the gaze 83–6, 163–6

race 147–52; classifications 43, 110, 147–8, 154, 155, 158–9; and European assumption of supremacy 101, 106, 128; mixed 73, 82, 147, 149, 154, 155, 158–9; theory 102, 107, 129, 149, 205
racial prejudice 18, 100–1, 151–2
racial segregation 79, 108, 110, 147–8
Raleigh, Sir Walter 49
Ramsey, Elizabeth 80, 81
Rancière, Jacques 10, 14, 17–18, 19–20
Ranck, Jody 206, 208
Rathbone, William 70
Rear Window 172
refugees 10, 13, 150
religion 2, 7–8, 27, 47, 52, 55, 94, 131
Renaissance artists 27–30, 91
Renan, Ernst 129
Rendition 190
representational theory 31–2
resemblance, the notion of 30–2
Riding With Death 76
Ridyard, Arnold 143
Rigaud, Hyacinthe 35, 37
right to look 14–15
rivers 127, 130–2, 166
Roach, Joseph 120, 158
Roberts, Field Marshall Lord 272
Roby, Marguerite 135, 136
Rockwell, Norman 180, 181
Rome, Ancient 10, 105, 192, 194
Rowlands, Michael 140
Rudd, Kevin 60
Ruskin, John 77
Rwanda 14, 204–9

Sabra, A.I. 31
Sahagún, Bernardino de 52
Said, Edward 176, 177

Sainte-Hilaire, Isidore Geoffroy 153
Samba, Cheri 202–4
Sartre, Jean-Paul 171, 241
sati 160
Saturday Evening Post 180, 181
Schildkrout, Enid 51, 139
Schiller, Dan 238
Schoch, Richard W. 91
Scott, Ridley 55, 245
Scourged Back, The 81
Scramble for Africa 210–11
Screen 172
sculpture: African 133, 144, 201; Greek and Roman 104–6, 225
Searchers, The 185–6
Second Sex, The 111
Sedgwick, Eve Kosofsky 106, 165
Sekula, Allan 80, 81
Self-Portrait as a Drowned Man 120, 121
Semple, Janet 96, 98
Sepúlveda, Ginés de 51, 52
Serious Organized Crime and Police Act (2006) 295
sex/gender binary 110–11, 156–7, 175
Sex Pistols 274
sexual classifications 156–8, 175
sexual identity 153, 165–6, 175, 204, 242
sexuality 153–68, 174, 175; African 201, 204; female 154, 160, 173–4, 201, 204; queer 166, 242
Shaheen, Jack 190
Shakespeare, William 53, 78–9
Sharpe, Jenny 159
Shelton, Anthony 145
Sherman, Cindy 212, 251
"shoemakers" 18–19
Shonibare, Yinka 210–11
sight 3–5, 21–40; physical process of 21–5, 30–2; reconceptualized as vision 21, 22, 23–6, 30, 31, 32; slavery's effect on 84
sign language 107–8, 189
Silk Road 218–19
Silverman, Kaja 255
similitudes 28, 30
Simpson, O.J. 251–2
Sims, The 2, 3, 239–40

Sinfield, Alan 166
Singleton-Gates, Peter 164, 165
Siopis, Penny 261–2
Situationist International 264, 267
Slave Ship, The 76, 77, 85
slave ships 69–70, 72–3, 76, 77
slavery 68–88; abolitionist campaign 68, 69, 71–2, 81, 82, 85; and Atlantic culture 72–6; Atlantic triangle of 11–12, 44, 65, 68, 72–5, 128; and the effect on sight 84; formative role in modernity 11, 68–71, 85; and the gaze 63–7; Kongo people forced into 128, 132; and miscegenation 73, 79, 82, 147, 159–60; narrative on an escape from 84; and psychogeography 85–7; visibility in photography 68, 76–83
Slavery! Slavery! Presenting a GRAND and LIFELIKE Panoramic Journey into Picturesque Southern Slavery 86
Smith, Adam 69, 239
Smith, Mark 22, 24, 25, 84
social Darwinism 100
socialism 182
Society of the Spectacle, The 264, 265
sodomy 106, 163, 288
Sometimes in April 208, 209
Sontag, Susan 119, 256, 257, 289
Sopranos, The 59–60
Souls of Black Folk 108
South Africa 215, 221, 259–60, 261
Souvenir d'un Africain (An African's Recollection) 204
space and time 114–16, 119–20, 258–62
spaces: digital 224–5; engine 227–31; of looking 225–7; transformations of modern 115–18
Spain 46, 47–8, 49, 51–3
Spanish-American War 108–9, 110
Spanish colonies 52–3, 106, 154
"spectacle, the" 3, 14, 48–9, 255, 264–9, 281
speed-cameras 252
Spender, Dale 279
Spillers, Hortense 169
Spinoza, Baruch 25, 39
Spivak, Gayatri 9, 15, 160

Standard Operating Procedure 290
Stanley, Henry Morton 128, 132
Star Trek 59
State Britain 295
state of emergency 192, 194–6, 295, 308
"state of exception" 194–5, 308
Steamboat Willie 178, 179
Stendhal 7
stereoscopes 226
Stockhausen, Karlheinz 293
Stop-Loss 299, 301
Stout, Renée 200–1
"Strangers," "Natives" and 6–7, 39, 53
Strauss, David Levi 206
structure of feeling 250, 251–9
Struth, Thomas 255–6
student revolt 1968 266–7
sugar cane workers 215
surveillance 2, 11, 96–8, 151, 236, 254, 264–9, 280
Syriana 190

Ta Tele 201–2
Tagg, John 253
Taj Mahal 276–8
Talbot, William Henry Fox 77
Taliban 8, 300
Taliban Bodies 300
Tanger, Terence 272
Tate Britain 85, 295
Team America 300–1
technologies of reproduction 180, 181
television 202, 225, 258; Diana's funeral on 283–4; oversized screens 304–5, 306; reality 271, 281, 285
Tempest, The 53, 54, 59
Tempête, Une 53
Tenepatl, Malineli 154
terrorist attacks 2, 238, 268, 292–3, 296
Terry, Jennifer 299
Thatcher, Margaret 235, 274, 278
There Will Be Blood 188–90
Third View of Toulon 70–1
Thirty Years War (1618–48) 32
Thomas, Dylan 122
Three Kings 190
Through the Dark Continent 128

Time 251, 252
time and space 114–16, 119–20, 258–62
Tisquantum 47
torture 94, 287, 288
Toussaint Louverture 75, 76
trading on-line 236–7
transculture 41–4, 128, 129, 133, 138, 140, 142, 145
Treatment Action Campaign (TAC) 259, 260
Tribute Money 28
Truth, Sojourner 82, 83
Turing, Alan 227, 231–4
Turley, Joseph 84
Turner, J.M.W. 76, 77
Two Undiscovered Amerindians 58–9
Tyler, Carole-Ann 171

Unforgiven, The 186
Union Jack 214
United Nations 5, 198, 199, 206, 209
Untitled (Caliban's Mask) 53, 54
USA Patriot Act (2001) 238

value 8, 267–8
Van Gogh, Vincent 70, 71, 103–4
Veditz, George 189
vernacular images 243
"vernacular watching" 224, 303–6
Vernet, Joseph 70
Victoria, Queen 272, 273
video games 2, 3, 239–40
Vietnam War 14, 293–4
Virginian, The 183
virtual reality 221, 225–6, 227, 254
vision 3–4, 5, 45, 64, 84, 102, 234; Cartesian theory of 31–3, 64; color 99–101; reconception of sight as 21, 22, 23–6, 30, 31, 32; and visuality 64, 90–1
Vision and Visuality 89, 90
"visual power" 29, 31, 142
visual pyramid 23, 24, 26, 27, 28
visuality 3, 5–9, 14, 36, 44, 64, 68, 89–93, 98, 179, 192, 308
visualization 6
Vitagraph 110
Vodou 74, 76

Walker, Kara 85–7
Wallinger, Mark 295
Wallis, Brian 79
war 7, 12, 14, 32, 178, 197; image 292–5; media access to 293–5; militarized images 14, 299–303; photography in 122–5, 299, 301–2; vernacular watching of 303–6; zone of indifference 295–9
war on terror 195, 261, 269, 296, 306; and circulation of the imagery 304–5
Washington, Augustus 83
webcams 279–80
Wedgwood, Josiah 71, 72
Weeks, Jeffrey 163
Weibel, Peter 7
Western, the 183–91
What the Frog's Eye Tells the Frog's Brain 234
When the Levees Broke: A Requiem in Four Acts 13, 306, 307
White Feet 213
White, John 29
whiteness 104–7
Wikipedia 222–3, 239
Wilde, Oscar 92, 105, 106, 108, 163
will.i.am 239, 240
Williams, Eric 68

Williams, Raymond 11, 91, 251
Willis, Deborah 82, 83
Winckelmann, Johann 105
witnesses 37, 38, 39
Wollaston, A.F.R. 138, 159, 163
Woman on Horseback 74
women 172, 173, 279; African 111, 155–6, 158–63, 164, 201; Diana as representative of 275–6, 282; Hindu 160; mass media representation of 285–6; veiled 1, 13, 239
Wong Kar-Wei 249
Wood, John 78
Wood, Marcus 72
Work of Art in the Age of its Technical Reproducibility 179
working-class culture 272–3
Wright, Joseph 38

Young Americans 301
Young, Robert 160
YouTube 2, 60, 239, 240, 241, 243, 299, 303

Zealy, J.T. 79, 80
zero, concept of 26–7
Žižek, Slavoj 238
Zohar 48
zone of indifference 295–9

Titles in the *In Sight: Visual Culture* series

The Feminism and Visual Culture Reader
Edited by Amelia Jones

Feminism is one of the most important perspectives from which visual culture has been theorized and historicized over the past thirty years. Challenging the notion of feminism as a unified discourse, *The Feminism and Visual Culture Reader* assembles a wide array of writings that address art, film, architecture, popular culture, new media, and other visual fields from a feminist perspective.

The Feminism and Visual Culture Reader combines classic texts with six newly commissioned pieces, all by leading feminist critics, historians, theorists, artists, and activists. Articles are grouped into thematic sections, each of which is introduced by the editor. Providing a framework within which to understand the shifts in feminist thinking in visual studies, as well as an overview of major feminist theories of the visual, this reader also explores how issues of race, class, nationality, and sexuality enter into debates about feminism in the field of the visual.

In Sight: Visual Culture
Series Editor: Nicholas Mirzoeff

ISBN13: 978-0-415-26705-2 (hbk)
ISBN13: 978-0-415-26706-9 (pbk)

Available at all good bookshops
For ordering and further information please visit:
www.routledge.com

Titles in the *In Sight: Visual Culture* series

The Object Reader
Edited by Fiona Candlin and Raiford Guins

This unique collection frames the classic debates on objects and aims to generate new ones by reshaping the ways in which the object can be taught and studied, from a wide variety of disciplines and fields.

The Object Reader elucidates objects in many of their diverse roles, dynamics and capacities. Precisely because the dedicated study of objects does not reside neatly within a single discipline, this collection is comprised of numerous academic fields. The selected writings are drawn from anthropology, art history, classical studies, critical theory, cultural studies, digital media, design history, disability studies, feminism, film and television studies, history, philosophy, psychoanalysis, social studies of science and technology, religious studies and visual culture.

The collection, composed of twentieth- and twenty-first-century writing also seeks to make its own contribution through original work, in the form of 25 short 'object lessons' commissioned specifically for this project. These new and innovative studies from key writers across a range of disciplines will enable students to look upon their surroundings with trained eyes to search out their own 'object studies'.

In Sight: Visual Culture
Series Editor: Nicholas Mirzoeff

ISBN13: 978-0-415-45229-8 (hbk)
ISBN13: 978-0-415-45230-4 (pbk)

Available at all good bookshops
For ordering and further information please visit:
www.routledge.com